HIDDEN GEMS
VOLUME II

For Isabella

'A word is a bridge thrown between myself and another.'
M.M.Bakhtin/ V.N.Volosinov (1986)

hidden gems
vol. II
Edited by **DEIRDRE OSBORNE**

A BITTER HERB
Kwame Kwei-Armah

THE FAR SIDE
Courttia Newland

IDENTITY
Paul Anthony Morris

URBAN AFRO SAXONS
Kofi Agyemang & Patricia Elcock

THE LIBRETTO OF MARY SEACOLE
SuAndi

ABSOLUTION
Malika Booker

OBERON BOOKS
LONDON

WWW.OBERONBOOKS.COM

This collection first published in 2012 by Oberon Books Ltd
521 Caledonian Road, London N7 9RH
Tel: +44 (0) 20 7607 3637 / Fax: +44 (0) 20 7607 3629
e-mail: info@oberonbooks.com
www.oberonbooks.com

A Bitter Herb copyright © Kwame Kwei-Armah, 2001
The Far Side copyright © Courttia Newland, 2001
Identity copyright © Paul Anthony Morris, 2009
Urban Afro Saxons copyright © Kofi Agyemang & Patricia Elcock, 2003
Mary Seacole copyright © SuAndi, 2000
Absolution copyright © Malika Booker, 1999

Editorial and General Introduction © Deirdre Osborne 2012

Introductions © the individual contributors 2012

The Authors are hereby identified as authors of these plays in accordance with section 77 of the Copyright, Designs and Patents Act 1988. The author have asserted their moral rights.

All rights whatsoever in these plays are strictly reserved and application for performance etc. should be made before commencement of rehearsal to the author c/o Oberon Books. No performance may be given unless a licence has been obtained, and no alterations may be made in the title or the text of the play without the author's prior written consent.

The contributors are hereby identified as authors of these introductions in accordance with section 77 of the Copyright, Designs and Patents Act 1988. The contributors have asserted their moral rights.

You may not copy, store, distribute, transmit, reproduce or otherwise make available this publication (or any part of it) in any form, or binding or by any means (print, electronic, digital, optical, mechanical, photocopying, recording or otherwise), without the prior written permission of the publisher. Any person who does any unauthorized act in relation to this publication may be liable to criminal prosecution and civil claims for damages.

A catalogue record for this book is available from the British Library.

PB ISBN: 978-1-84943-148-4
E ISBN: 978-1-84943-698-4

Cover image 'The Lamp' by Romare Bearden

Visit www.oberonbooks.com to read more about all our books and to buy them. You will also find features, author interviews and news of any author events, and you can sign up for e-newsletters so that you're always first to hear about our new releases.

ACKNOWLEDGEMENTS:

My sincerest thanks: to James Hogan as ever for enabling this project to take place, to Andrew for continuing it, to George for his exemplary coordination of all its parts and immense patience. My gratitude to Kwame, Courttia, SuAndi, Malika, Patricia, Kofi and Paul for trusting me with their precious works, and to Fiona, Mina, Winsome, Imani, and Chris for their critical introductions. I thank Paulette Randall and Patricia Cumper for initial conversations and salute them both as writers and directors who have sustained a formidable longevity in the history of theatre and drama in Britain – traditionally inhospitable terrain for cultivating Black women's creativities.

I could not have put this together without the ongoing personal kindness in the UK from Diana, Gotti, Marion, Caroline, Maria, Kadija and SuAndi. For this, I remain immensely grateful.

Table of Contents

INTRODUCTION TO VOLUME II .. 11
 Deirdre Osborne (Goldsmiths, University of London)

A BITTER HERB .. 21
 Shady Adoptions: the One-way
 Traffic of Children in Care .. 23
 Fiona Peters (Goldsmiths, University of London)

 A Bitter Herb by Kwame Kwei-Armah... 29

THE FAR SIDE ... 93
 Laying Ghosts to Rest .. 95
 Winsome Pinnock (Kingston University)

 The Far Side by Courttia Newland .. 101

IDENTITY .. 169
 Revealing the Revolution: a Few Home Truths 171
 Chris Searle (University of Manchester)

 Identity by Paul Anthony Morris .. 177

URBAN AFRO SAXONS ... 251
 Putting it Together: An interview
 with Kofi Agyemang and Patricia Elcock ... 253
 ed. Deirdre Osborne (Goldsmiths, University of London)

 Urban Afro Saxons by Kofi Agyemang and Patricia Elcock 268

THE LIBRETTO OF MARY SEACOLE ... 321
 SuAndi's *Mary Seacole*: A Hybrid Cartography in Libretto 323
 Mina Karavanta (National & Kapodistrian University of Athens)

 The Libretto of Mary Seacole by SuAndi .. 330

ABSOLUTION ... 381
 'The Waltz Gone Mad: the Poetics of Departure and Arrival
 in *Absolution* ... 383
 Imani e Wilson

 Absolution by Malika Booker ... 389

APPENDIX .. 419
 I Will Not Put Another Dead Young Black Man on Stage 419
 Patricia Cumper

 References and Bibliography of Indicative Critical Studies 421

Introduction

The Introduction to *Hidden Gems* (2008) foregrounded the unprecedented profile achieved by black British dramatists in the first decade of the 2000s seen in the proliferation of black-authored plays in London's mainstream and off-West End theatres. However, at the time of publication of *Hidden Gems Volume II*, this presence has tapered dramatically. In the second decade, fewer than ten plays per annum (as distinct from eleven in 2003 alone), have been staged in the same arena.[1] Prospects for today's black theatre-makers still remain ostensibly in the side-lines of Britain's theatre complex. A familiar spectacle of special inclusion (such as an all-black cast in Gregory Doran's production of Shakespeare's *Julius Caesar* for the Royal Shakespeare Company, 2012) is still a feature of the reduced opportunities afforded to Britain's sizeable pool of black actors. Furthermore, Catherine Johnson notes how black experience in the new millennium is being filtered consistently through white writers, who act as a buffer between the material and the white-majority audience member or reader. While Johnson applauds the increased recognition of minority perspectives in mainstream contexts, she probes the authority of what is visible when she asks, 'wouldn't it be even better if people didn't wait for a white person to say what other people have been saying for ages before they take any notice?' (Johnson 2011:31). In reclaiming or valorising experiences erased or discounted by hegemonic versions of theatre historiography, care should be taken not to replicate the dominant culture's information and knowledge-creation dynamics. Insider work is crucial to this enterprise. For, as Maria Shevtsova reports, Pierre Bourdieu's reticence to address theatre was premised upon, 'knowledge

1 There is also a sex-gender parallel to dissolving traditional bedrocks of control seen in the circulation of a letter to 46 Artistic directors of Britain's leading subsidised theatre companies by Actor's Equity questioning the lack of women's roles in the programmes and casting they employ. For press coverage of this see: Topping (2012), Higgins (2012) Newspaper articles periodically still draw attention to the limited prospects for black and Asian British theatre artists as indicated by: Armstrong (2006), Baluch (2009), McAlmont (2012) and Sherwin (2012).

of the subject 'from the inside', as he put it, necessarily had to provide the competence or *savoir faire*, as he also termed it, for dealing with this field' (Shevtsova 2009: 83).

The staging of black British experiences and its uneasy relationship to a context which is predominantly white can claim what T.S. Eliot attributed as being the vital ingredient for any society's cultural health, a '*friction* between its parts' (Eliot 1949:126). Although the HMS *Windrush* had docked at Tilbury in the year preceding his definition, Eliot clearly confined this to English, Welsh, Scots and Irish cultures, discounting the constituent of race even as it became an increasingly prominent factor in mass migration from the ex-colonies, and despite his centrality in 1940s literary circles which included black Jamaican writer and broadcaster Una Marson. His model is bipartite, 'I now suggest that both class and region, by dividing the inhabitants of a country into two different kinds of groups' will 'lead to a conflict favourable to creativeness and progress' (Eliot 1949:132) The friction between parts underpins the upending of notions of cultural homogeneity that were created by the post-war momentum of migration, settlement and indigeneity. It underpins the heritages and standpoints of the plays in *Hidden Gems Volume II*.

Resisting, rather than capitulating to conditions where staging whiteness is an invisibilised norm and staging blackness continues to be exceptional and noted, the writers in *Hidden Gems Volume II* reach out beyond local, regional and national parameters towards the receptive possibilities of a globalised slipstream via their individual artistic paths, and in the subject-matter they dramatize.[2] The form through which this is channelled varies: from an interface between monodrama and the dramatic monologue of Malika Booker's *Absolution*, to the vehicle of the libretto as it serves to lyricize the epic adventures of SuAndi's *Mary Seacole*, to the well-made play of Kwame Kwei-Armah's *A Bitter Herb* and the problem play echoes to be found in Agyemang and Elcock's comedy, *Urban Afro Saxons*. Moreover,

[2] For example, SuAndi and Malika Booker are well-established poets, performing their work in tours abroad and through residencies with cultural organisations. Kwame Kwei-Armah is currently Artistic Director of Centerstage repertory theatre in Baltimore, USA.

temporality is not always reliant upon chronological ordering. The strategic use of anachrony seen in the analepsis and prolepsis of Courttia Newland's *The Far Side* or the *in medias res* of Paul Anthony Morris's *Identity*, can meld ghost story techniques with conventions of the courtroom drama, where retrievals of social history are intertwined with intimate domestic chronicles. These dramatists tailor traditions of city comedy, social realist, agit-prop and magic realist genres to represent the multi-cultural, trans-national and African diasporic inheritances that have emerged from a British-born context and creative development. Their plays offer recalibrations of history from black-centred perspectives and the multiple ways in which personal destinies have always been contoured by international politics and geographical mobility. The introductory commentaries to the plays are provided by people with insider knowledge of the subject-matter, and for whom the material provides a special resonance spanning the personal, political and aesthetic. With authorial profiles that embrace poetry, performance, song lyric, screenwriting and prose fiction, the seven dramatists in *Hidden Gems Volume II* create figures from the *parvenu* to the *revenant*, in settings from the battlefield to the playground. Their work is infused with the fruits of multiple expressive modes and literary-dramatic traditions, inviting further detailed critical attention beyond the scope of this book.

The significance of the subject-matter's diversity cannot be over-estimated. Late-twentieth century British theatre has seen the evolution of a grim motif across a range of plays centralizing black people's experiences, that of 'a young black male character dying of wounds, centre-stage' (Osborne 2011c:186).[3] Coinciding with and even encouraged by the 'new writing initiatives' of

3 For indicative examples of young men dying from or subjected to wounding in the period (2003-12) see: *Fallout* by Roy Williams (Royal Court Theatre) which opens with a young African student being murdered off-stage, Kwame Kwei-Armah's *Elmina's Kitchen* (Royal National Theatre), *Frontline* by Che Walker, (The Globe Theatre), *Gone Too Far* by Bola Agbaje, (Royal Court Theatre), the film of Roy Williams's *Fallout* (aired on Channel 4 as part of the *Disarming Britain* season on gun and knife crime), debbie tucker green's *random* which records the teenager's murder off-stage (Royal Court Theatre), Williams's *Category B* (Tricycle Theatre), Mojisola Adebayo's *Desert Boy* (The Albany) and most recently, Agbaje's *Belong* (Royal Court Theatre).

mainstream (overwhelmingly white-male-dominated) theatre venues, this macabre cul-de-sac of representational scope has not gone uncontested.[4] The writer and director Patricia Cumper as Artistic Director of Talawa (Britain's foremost black-led theatre company), memorably posted her manifesto of refusal to commission this subject-matter on the *Guardian* newspaper's theatreblog (2009).[5] In a comparable move, *Hidden Gems II* showcases a range of plays by writers who provide dramatic alternatives to 'the media-driven, (over-determined) link between the young black male body and public violence and most specifically, gang affiliation, drug offences and knife crime' (Osborne 2011c: 186). It counteracts the self-affirming overlap created between these media narratives and dramatic representations.

In her introductory comments to Newland's *The Far Side*, Winsome Pinnock, whom Helen Kolawole describes as 'the godmother of black British playwrights' (Kolawole 2003), identifies thought-provokingly (from the standpoint of her own playwriting history), the acknowledgement needed of the traumatising effect that Stephen Lawrence's murder has had upon dramatic writing, namely that young black men's experiences can only be rendered in relation to violence. While Kwei-Armah's *A Bitter Herb* opens with a family's grappling with the aftermath of their son's murder by white racists, in her introduction, Fiona Peters recognises another key dimension of the play, that of transracial adoption. The significance of black and mixed-ethnicity writers' prominence in restoring these experiences of adoption, fostering and care to the nation's narrative heritages is connected to the post-war migration period onwards, where black and mixed children continue to remain disproportionately over-represented

[4] New writing initiatives burgeoned in a number of state-subsidised British theatre organisations at the close of the twentieth century and into the new millennium. One significant factor for their proliferation was as a 'response to charges of gerontocracy and a lack of contemporary relevance', and another, as 'part of an objective to generate new and younger audiences from social groups for whom theatre-going was an experience of white cultural autocracy.' (Osborne 2008a: 206)

[5] The blog is published for the first time in this volume. Cumper has affirmed recently, 'That piece has been quoted back to me so often that I'm glad you made me go back and read it again. I still stand by what it says!' (Email to Deirdre Osborne 28/08/2012).

in the care system in comparison to white children. The play complicates the composition of the expected trans-racial equation as a white child has been reared in a black family.

The resonance of a theatrical motif with daily media reports of a recurring subject, and its intensification in popular awareness, also exposes a criteria (by which audiences and readers engage with representations of black people's experiences), susceptible to multiple discourses of interference. Mieke Bal's observation of these susceptibilities as delineated for a visual arts exhibition context – 'the thoughts art articulates in its own way become framed and addressed by discourses surrounding the exhibition and interfering with it' (Bal 2010:10) – is correspondingly applicable to any black British play's positioning within Britain's theatre complex. As Mina Karavanta observes of SuAndi's libretto in this volume, 'SuAndi's rewriting of Mary Seacole's history and story performs a double task: it rewrites the history and story of Mary Seacole's autobiographical text by colouring and accentuating the pauses and silences sedimented in her narrative' (p.358). Its performance at the Royal Opera House Studio, Covent Garden similarly provided an opportunity not only to colour and accentuate the overwhelmingly monochrome environment of a typical opera season, but also enabled the virtuosity of black performers to be acclaimed within a bastion of elitist culture – although this has not sustained any permanent cultural shift.

The discourses of interference are thus manifested in plural ways: in the implicit influence exacted by socio-cultural and political representations; in the commissioning and producing of what theatre programmers and artistic directors (overwhelmingly white males) tend to look for in plays, (either by black dramatists or, about black people's lives); and in what the theatre-going public are drawn to, reject, or are thankful to see (at last) on stage, where audience composition is inflected by numerous differentials in opportunities and means for participation in theatre-going. In this respect, the theatre critic is one angle from which audience experience can be viewed. Wole Soyinka expresses the following view on critics –

'To my knowledge, very little has been attempted in studies

of the critic as a socially-situated producer, and therefore as a creature of social conditioning, a conditioning which in fact offers no certitudes about the nature of his commitment to the subject which engages him, his motivations, or indeed, about the very nature of his social existence. About the writer, on the other hand, we are traditionally over-informed' (Soyinka 1988:148).

The difficulties faced by black theatre-makers in Britain has not been made any easier by the 'closed-shop' white coterie of drama critics who have found their influence upon the shape of contemporary British theatre tested by neo-millennial black British dramatists. The unwitting testimony of reviews allows the critical eye to be turned revealingly upon the critics themselves – as they contend with the culturally unfamiliar – frequently traceable in the language and register of their reviews. As no comparable body of black theatre critics exists in Britain's broadsheet press, theatre reviewers co-opted clearly to give 'a black perspective' provide insights (born of authentic agency) that is often at odds with those of the perennial reviewers. In guest reviewing Roy Williams's *Fallout* (2003), longstanding black activist Darcus Howe voiced his disapprobation (towards Williams's representation of black people) while part of a Royal Court Theatre audience whom he accounted for as, 'Almost wholly white except for four or five blacks including myself'. The fishbowl visibility factor did not go unnoticed by Howe who concluded that 'This was not a slice of real life, but of low life sketched by the playwright for the delectation of whites.' (Howe 2003:760) In another context a black journalist, Afua Hirsch was disturbed by the communitas shared by a primarily white middle-class Royal Court audience who laughed uproariously at the escalation of racist jokes in white American playwright Bruce Norris's inter-text *Clybourne Park* (2010) as it continued the story of black American playwright Lorraine Hansberry's classic *A Raisin in the Sun* (1957). Yasmin Alibhai-Brown has pointed out, the perpetual mediation by the white dominated coterie of theatre critics' reviews, means that a tendency for misguided praise of the culturally unfamiliar rewards stereotyping, rather than encouraging artistic experimentation (Alibhai-Brown 2005). Curiously, off-Broadway reviews of *Clybourne Park* were

reasonable, while white theatre critics in London utterly lauded it. Caroline McGuinn found the work to be 'so committed to boundary-testing' (McGuinn 2010). The critics became part of a grand, self-affirming, licensing of the unpalatable which Mark Shenton recorded as –

'I have seldom heard a Royal Court roar louder with laughter, but you could hear the unease underpinning it: should we be laughing so freely at such naked racism? But I defy you not to.' (Shenton 2010)

In contrast Hirsch made a grim parallel between the underlying racist legacy of exclusion of the play's subject (desegregated housing) and Britain's theatre houses as constituting similar no-go cultural areas for Britain's black citizens –

'The problem is that jokes intended for middle-class white people are likely only to be funny for middle-class people…To watch a play about what happens when black people enter a white environment and yet still be one of only a handful of black people in the audience, is a doubly disarming experience.' (Hirsch 2010)

The standpoints of Howe and Hirsch illuminate the issues of social exclusion and exclusiveness that continue to frame programming and the tenuous right of access to theatre-going that many British citizens still face, which Agyemang and Elcock underline in their interview in this volume. For access to cultural citizenship for black writers has been as problematic as political citizenship was historically for black people migrating to and settling in the UK. The Runneymede Trust Report (2000) concluded, 'Britishness, as much as Englishness, has systematic, largely unspoken, racial connotations. Whiteness nowhere features as an explicit condition of being British, but it is widely understood that Englishness, and therefore by extension Britishness is racially encoded' (2000: 38). Such findings inform the debates staged in *Urban Afro Saxons* where the notion of Englishness as indicative of indigenous black identity is resisted due to its equation with whiteness. However, the play, like Kwei-Armah's *A Bitter Herb* does not allow the audience to feel it already knows the story. Through the conduit of comedy, the implicit parodying of the British Citizenship Test is displaced by family squabbles, separation anxieties and interactions between

ordinary individuals – who just happen to be of different races.⁶

While these British urban-centred plays have firm migratory foundations, the routes reaching from the Caribbean are explored in different ways by Booker and Morris. In using the monodrama form, Booker's *Absolution* as Wilson points out, is indebted to her poetry. Like SuAndi, Booker has made particular stylistic in-roads into developing the medium of the solo voice in both theatre settings and in poetry as performed live rather than read aloud which activates a reading voice in amplification. Their work sharpens the divergences between poetry as written to be read on the page – as an act of introspection – and poetry written to be relayed as an extroverted utterance to an audience in the vehicle of a play with a solo performer. For contemporary black British writers, where the conditions of theatre (and a heritage of historical redaction), present indubitably contributory factors in negotiating poetic-dramatic authority, the monodrama's performative extension of the dramatic monologue does not dramatize a story to be read in isolation, but against the backdrop of Britain's post-war seismic shifts in demographic composition. Similarly, Chris Searle identifies how Morris's *Identity* 'continues the cross-generational consequences of these off-stage momentous events which provoke the happenings on-stage' (p.193). A legacy of trauma accumulated through surviving the Grenadian revolution and exile, shapes family interactions between those members who were directly involved and those who were not born at the time.

* * *

Interferences in the creative development of black dramatists have contoured writers' chosen topoi, artistic quality and reception of their work in contexts where white heritage prevails as the dramatized experience. Black British-born writers for the theatre are invariably sited within European traditions and lifestyles. These are further inflected by American globalising

6 The BBC noted at the announcement of its implementation from 16 July, 2005, 'The government is launching the citizenship test for foreigners who want to become British. If you want the passport, then you'll have to read Life in the UK, a special book, and sit a 45-minute test on society, history and culture. But do you know what it is to be British?' http://news.bbc.co.uk/1/hi/magazine/4099770.stm Accessed 12/05/2012.

capitalist culture, even as diasporic heritages are claimed as primary sources of inspiration. John McLeod believes, 'it is very difficult to think of a writer, past or present, who has not borrowed from or engaged with cultures and traditions different to the ones they consider their own' (McLeod 2002:56). As these plays in *Hidden Gems Volume II* testify, and as Pulitzer Prize winning African American dramatist Suzan-Lori Parks writes, there is 'no single 'Black Experience', and correspondingly, 'no one way to write or think or feel or dream or interpret or be interpreted' (Parks 1995: 21). Instead, there is a complex matrix of knowledge and experiences of people who gain a sense of identity and belonging as members of cross-hatched communities in ways, and for reasons meaningful to them. When this is not reflected in what appears on the British stage (as is the case in the second decade of the new millennium), it is salutary to recall Pinnock's observation nearly ten years before, 'Theatre is a sort of moral conscience of a society, an arena where a society can examine itself. If some voices are missing, I don't think that it's honestly fulfilling that role and is, in fact, practising a subtle form of censorship' (Kolawole 2003).

Deirdre Osborne
(Goldsmiths, University of London)

А BITTER HERB

Shady Adoptions: the One-way Traffic of Children in Care

At the beginning of his career, Kwame Kwei-Armah was Writer-in-Residence at the Bristol Old Vic Theatre (1999-2001), where he wrote *A Bitter Herb* (2001), and two musicals: *Hold On* (originally titled *Blues Brother Soul Sister*), and *Big Nose* co-written with Christopher Monks. The dominant theme of *A Bitter Herb* concerns how we understand the role of race in family life, assumptions about the constitution of family as reliant upon racial sameness, and the impact of these ideas as played out in the arena of adoption. *A Bitter Herb* dramatizes, with acute insight, what have again become contemporary debates around the proposed re-introduction of trans-race adoption. Historically, this referred to Black and Mixed racial and ethnic children being raised by white parents. In the play, this is given another slant as Kwei-Armah portrays a white child who has been adopted by a Black family.

Valerie and Willard McKenna have three children John, Peter and Jaime. The play opens during the wake of John, their eldest son. Evoking resonance with the Stephen Lawrence case, John has been murdered in a racially motivated crime. The police investigation is hampered by rumours that John (a chef) was a drug dealer. An anti-racist organisation known as the Law Coalition offers to represent the McKenna family and keep the case in the public eye. Jaime the adopted (white) youngest daughter of Valerie and Willard is chosen to be the media representative for the family. The public attention the family receive problematises Jaime as being truly one of the family which is intensified personally when Peter openly questions her belonging on the grounds of race, despite the fact that she has lived her whole life with them. Kwei-Armah thus evokes the time-old framework of nature vs. nurture as determining identity.

Race as a point of unremarkable but irreconcilable difference is most often discernible within the intimacy of family life and enacted in the private sphere. Even though race has an historical trajectory, it is a 'complex, lived, material reality' (Frankenberg

1997:22). Theoretically, race as a classification has dubious underpinnings in terms of pseudo-scientific claims to there being essential differences among human populations. However, one's race identity does have socio-political consequences with particular manifestations, expressions and outcomes, located in specific contexts, as mobilised according to the logic of the individuals who participate in these contexts. As an ideologically generated category, it relies on the antecedents established historically in socio-political and cultural relationships.

In the context of the British Empire's aftermath, the legacy of an imperial valorisation of whiteness continued to inform the horizons of those who sought to migrate from the Caribbean islands post-1945. The parents in *A Bitter Herb* originally migrated from Grenada to make a new life in England and hence had been recipients of the colonial education system which inculcated Caribbean children with a sense of belonging to England, the Mother Country. England as both a country within Britain and an idealised centre of civilization was actively promoted in the Caribbean. In the post-war devastation, England's broken urban landscape required loyal (now) Commonwealth citizens to help in its re-building. For the courageous and ambitious Caribbean people who made the migratory journey, England was a place where their educational training in being English could be practised and where aspirations might be realised in both creating security for their own families and in belonging to the Mother Country.

However, the body of recorded and represented experiences of the first-generation migrants prove that racism, discrimination in employment opportunities, and poor material living conditions defined their family and community lives. In everyday life, they were treated as second-class citizens – considered unworthy of being English. The hierarchy of pseudo-scientific racism was powerful in its application to political, cultural and family life. Original dreams were soon crushed, replaced with determination to be seen to be as good as the English. The McKenna family's, (more specifically Valerie's), aspirations to fit in, to belong, to be seen as 'good enough' to be English, underpin the play. With her nursing home business Valerie exemplifies that first generation

of migrant women; ambitious and hardworking, but whose effort neither reflects their true aspirations, nor rewards them with the appropriate social status. This issue arises as to the motivations over the McKenna's decision to adopt a white child:

JAIME – You see, you see. They shouldn't have allowed it Valerie. You purchased me. You only wanted me to show the world that you're as good as them. That's the truth isn't it? (In this volume).

Was the adoption of their white daughter the final act of assimilation or status that Jaime claims? The persistent underlying theme of *A Bitter Herb* is how race is organised within intimate family relationships and how this functions through the lens of adoption. The fragile and conditional belonging of adoptees is dramatized through Jaime's skin colour marking her out as different, despite her cultural socialisation as West Indian. Her ethnicity – her Englishness – is questionable as she experiences herself on the fringes of her adoptive family. The debate over what constitutes Englishness rests upon its synonymous link with whiteness. It is her whiteness and a seeming lack of English cultural values that present a mis-match over who she thinks she is, and where she belongs. Testimony from trans-racially adopted adults tends to support this viewpoint.

In a British context, the adoption of white children by black families is remarkable and against the trajectory and norms of adoption practices both past and present. Adoption has always been a 'trans-class' practice; (Cohen 1994:54) poorer children living with more affluent families and also a 'trans-race' practice; black children living with white families. While the one-way traffic of children to be cared for by white families is the norm, how Jaime came to be adopted by a black family is never made apparent in the play. Why is it permissible for white families to adopt black children, and yet, black families are not routinely able to adopt white children? It is alleged that the scarcity of black families willing to adopt means they are reserved for black children. However, Flynn claims that in geographical locations with a surplus of black adopters and foster carers, social worker assessments ought to focus on the skills an adoptive or foster parent is able to offer a child and 'Considering the placing of

white children with black carers forces an examination of good placement practice' (Flynn 2000:51). Current government guidelines address the very real issue of black and mixed children remaining in care too long waiting for families. New guidance states that as long as adopters can show they can care for a child, race will not be a factor – white adopters will be sought for black and mixed children, congruent with trans-race and trans-class adoptions. Theoretically, this shift also means that white children could be adopted by black families, if they can show they are able to care for the child.

Valerie and Willard question their adoption of Jaime through the lens of race, culture and ethnicity.

WILLARD – Maybe we were wrong not growing her up to be proud of, well you know what I mean.

VALERIE – Proud? How were we going to tell her about being... English?

WILLARD – You know about being English more than the English they self Mrs McKenna. (In this volume).

Questioning Valerie and Willard's skills to prepare Jaime for being English corresponds to the problem of white families not equipping black children with strategies for tackling the racism they would experience in society. Families are assumed to be homogenous units, with everyone looking visually similar; the underlying premise of same race adoption is that the child should not stand out as visibly different to the rest of the family. However, as Olumide argues, mixed families have always been outside of this norm (Olumide 2002:105). The challenge to the social legitimacy presented by multi-racial families has led to perceptions of such families as not truly belonging together. In the play, the lawyer representing the family observes of Jaime –

NAVEEN – I think in denying or ignoring her 'difference', although done for the absolute most honourable of reasons, you have run the risk of creating problems for her in adulthood. (In this volume).

This transmission of culture through family socialisation is at the crux of debates concerning trans-racial adoption and whether children can be successfully adopted and subsequently socialised by families who are racially, culturally and ethnically different

to them. Valerie describes Jaime as 'a West Indian', despite her ethnicity, her Englishness. Her adoptive family steeps Jaime in Caribbean culture at all levels, even those of which Valerie disapproves.

JAIME – *(Impersonating dad.)* Eh eh you losing you manners. You must want me to cut you arse!

VALERIE – Who are you speaking to in that vulgar manner? (in this volume).

The assumed inherited difference of skin colour that dictates how a family expresses their culture underpins how adoption works in practice. As Olumide states, 'Present-day discourses of cultural heritage carry in similar ways intimations of race thinking' (Olumide 2002:83). Through the testimony of adults adopted into white families, evidence emerges about the importance, or not, of feeling a match between skin colour and cultural preferences (*cf.* Harris 2006). Caribbean children were removed from families due to assumptions about dysfunctional family forms; in particular matriarchal family structures were misunderstood. The high numbers of black children in residential care did not bring attention as to *why* they were in care, but rested upon willingness to pathologize African Caribbean families. Often race and culture were collapsed into one seamless category, impossible to unravel, particularly in the emotive world of adoption and fostering.

During the 1980s the critique led by the Association of Black Social Workers and Allied Professionals (ABSWAP), the increasing presence of black social workers and testimony from trans-racially adopted adults, resulted in the move toward a more anti-oppressive practice. Debates against trans-racial adoption and fostering used the language of racism to describe the experiences of trans-racially adopted people: identity stripping, assimilation, cultural hegemony, authentic black identity, confusion and survival techniques for racism.[1] As the political tide gathered momentum, race became the primary factor for

[1] The Association of Black Social Workers and Allied Professionals (ABSWAP) gathered support for opposing all Transracial Adoptions and fostering practices bringing their objections and solutions to the House of Commons Select Committee to support a same race policy, arguing that black children should be placed exclusively with black families.

matching in adoptive and foster families, and same race adoption became widespread in policy and practice. The supposition that there is an authentic black culture that is somehow genetically transmitted vis-à-vis race is the fallacy that has supported the move toward same race adoption. As Gilroy (1994) argues, 'cultural sameness and common bodily characteristics do not, by themselves, promote good parenting' (quoted in Kirton 2000: xi). There is no singular black culture discernible in all families. Identifications such as class, faith, geography and ethnic background also contribute specifically. Furthermore, same race adoption has been problematic due to the apparent shortage of culturally appropriate families willing to adopt the still disproportionate numbers of African Caribbean and Mixed children in care. The emphasis on same race matching glaringly ignores placement of Mixed children (the fastest growing ethnic group), coming from white mother homes.[2]

The Conservative and Liberal Democrat coalition government have heralded a return to trans-racial adoption as a means to ameliorate the disproportionate numbers of African Caribbean and Mixed children waiting for adoptive parents, of the appropriate ethnicity, who are able to transmit culturally appropriate socialisation. The assumption that white families will once again be the dominant adopting group presupposes a consistent demand for alternative families for African-Caribbean and Mixed children. *A Bitter Herb* is again a timely lens by which to regard (via its inversion), an adoption model that has been tried and tested previously – and seen to fail.

Fiona Peters
(Goldsmiths University of London)

[2] Mixed children are the largest group of children of colour in care, a more acute analysis of the factors that comprise this statistic is needed beyond that of signalling the plight of lone white mothers and absent black fathers which characterise sociological studies to date.

Characters

VALERIE
The matriarch. She is a West Indian Woman in her early fifties. Having done very well for herself in business, her accent swings from RP to West Indian when she's angry or upset. It would seem that she does not like Black people very much.

WILLARD
Her husband. A laid-back fifty-something.

JAIME
Their White daughter. Twenty-two years old.

PETER
Their youngest son. A shy twenty-one-year-old.

NAVEEN
Law Coalition's head man. He represents the family.

A Bitter Herb was premiered at the Bristol Old Vic Theatre, Bristol on 2 Febuary 2001. The cast were as follows:

VALERIE MCKENNA	Ellen Thomas
WILLARD MCKENNA	Malcolm Fredrick
JAIME MCKENNA	Amelia Lowell
PETER MCKENNA	Mark Theodore
NAVEEN PATEL	Shan Khan

Directed by Andy Hay
Design by Penny Fit
Lighting Design by Tim Streader

A Bitter Herb was awarded the Peggy Ramsay Bursary 1998.

ACT ONE

SCENE ONE

The stage is empty. We are in the front room of the comfortable home of the McKenna family. A middle-class black suburban household. The furniture is more Heal's than Ikea. We hear a car pull up in the drive and the sounds of a person getting out and closing the door. A key turns and the front door opens, but we do not hear it close. There is a big picture hanging on the wall of a young man at his graduation. On either side of it are two smaller pictures of him. One of him laughing, the other of him as a three-year-old. We will later discover that the young man is John, the eldest son of the family.

Enter VALERIE, looking very elegant in her funeral blacks. She is in her fifties but looks younger. She is the major breadwinner in the family and is pleased that everyone knows it. Unlike WILLARD who has more or less retained his native accent, much to VALERIE's annoyance, VALERIE is a very well-spoken West Indian woman, her native accent only really coming out when she is angry. VALERIE owns and runs three nursing homes for the elderly, employing nearly a hundred people, and WILLARD, who after receiving redundancy from British Rail, helps her to run them.

Just as VALERIE steps into the room the phone rings. She rushes to answer it

VALERIE: McKenna residence, oh Yvonne... Fine thank you, how are things at the home? Good... The vicar gave a very moving speech and you know, he's in the ground now. What can you say! Is everything all right with Mrs. Anderson? Her drugs? Good. OK I'll be back in tomorrow morning...listen I must go. Thank you very much, I'll pass it on to the rest of the family.

While VALERIE is on the phone she sees a fax that arrived while they were out. She collects it and reads. She tuts aloud.

VALERIE: Oh for heaven's sake, I can't deal with this now.

While she is reading the lights suddenly dim. The pictures of John on the wall are the only things that are illuminated. It is like that for a few beats before VALERIE calmly and playfully says –

VALERIE: Jaime stop playing the fool and put the lights back on.

Enter JAIME, the family's white adopted sister. She is in her early twenties, in fact there is only a year between PETER and her, and is the personnel officer for the business.

On the whole she is a very happy-go-lucky kind of girl. Although race has never been an issue in the home, she sees herself as a woman who is Caribbean. She does not play or attempt to impersonate black street cultural habits, but due to her life-long environment has a deep understanding of West Indian culture.

JAIME: How did you know it was me?

VALERIE: *(She smiles.)* Who else does stupidness like that? You really are your father's child.

JAIME: Oh but when you want to show me off I'm your child eh?

VALERIE: *(Jesting.)* Who'd ever want to show off an ugly child like you.

JAIME: Funny I'm always told that I look like my mother!

VALERIE: Your mother may be ugly but she shrubs up nice.

JAIME runs up and hugs her.

JAIME: You're the most beautiful woman in the world and I adore you. Still think your bottom looks a bit in that dress though

VALERIE: Does it?

JAIME: Only kidding. You left the front door open?

VALERIE: Did I darling? I knew you were close behind.

JAIME: I take it the boys haven't arrived yet?

VALERIE: No. But they should be here. Then again who knows with those two. I'm just going to check on the food.

She runs up to the photo of John, kisses her hand and then places it on his face.

JAIME: Love you bra. Thank you for making it a nice day. It was a nice day wasn't it? I mean you could have disrupted it and that. *(Playfully.)* Your angry spirit could have come and mash up the place. But you didn't. I felt peace. Thank you John.

VALERIE enters the room while she is talking to John. She watches her for a bit.

VALERIE: You are such a loving child huh Jamie.

JAIME: All your children are.

VALERIE: *(Purposely correcting her.)* Were.

Beat.

VALERIE: You know what really vexes me about this thing, it's that those thugs didn't just take away our John, they are slowly eating away at my family. Look at Peter, anger is eating away at him. I am his mother, I should be able to find a way to help him through this.

JAIME: But you're angry mum!

VALERIE: Well yes of course I am. But I'm angry at the injustice of it, Peter's angry at the world. When it's that wide you can't focus. Has he talked to you?

JAIME: He hardly speaks to me. Maybe Dad should…

VALERIE: *(Kisses her teeth.)* Who? Your father?

JAIME: Once they've been caught he'll settle down. He's a big softy you know that mum.

VALERIE: Yes but will he be our big teddy bear anymore?

JAIME: No. He is a big man now.

VALERIE: Eh, never mind how big your children get, they're still your babies. Remember that.

JAIME: For what? I'm not having any.

VALERIE: So you don't want to make me a grandmother?

JAIME: Oh yeah sorry I forgot. I'll just pop down to the local sperm bank on the way home from work tomorrow.

VALERIE: If I was young enough, the moment John died I would have another child. Bam. Just like that. I thought about it, hard. Just five years younger. As I laid in that bed howling like a wounded beast, I kept trying to find reasons to get back up. You know what on the seventh day got me out of that bed?

JAIME: *(Tongue in cheek.)* The hand of God?

VALERIE: Don't mock the Lord child.

JAIME: Sorry.

VALERIE: Someone whispered in my ear, I don't know who, 'Get up. Who's going to be strong for the children you

have left?' And you know the next day I got up out of my bed, and have never cried since.

JAIME knows because it was her but she listens.

VALERIE: And I know people were looking at me today thinking 'What a hard woman I don't even see a tear come from she eye,' but I know what was going on in my heart.

JAIME: I knew that you were being strong for us mum.

VALERIE: Good.

We hear another car pull up.

VALERIE: Right, let's fix up before the men arrive. Should never let them see you weak.

JAIME hugs her mother. Then as if shaking off the grief returns to her former self. They go into a routine that they are familiar with.

VALERIE: Who are the rightful rulers of the earth?

JAIME: Women folk.

VALERIE: Who do you go to when you want a proper job done?

JAIME: Women folk.

JAIME: And who are called birds because they pick up worms?

VALERIE: Women folk.

BOTH: That's right.

Enter WILLARD. The father of the family in his funeral blacks. He is in his mid-fifties. Even though he is a quiet man by nature, he has sadness about him that is very tangible.

WILLARD: All you still doing that stupidness?

JAIME: Hi Dad.

She runs up to him and gives him a kiss.

WILLARD: I hope you doesn't do that to every man you know.

JAIME: *(Playing him.)* Just you Daddy.

WILLARD: You mouth too damn sweet.

JAIME: Well who I learn from? *(She takes his jacket.)*

WILLARD: Thank you darling.

He walks up to the photo of John, looks at it for a second and then enters the room.

VALERIE holds up the fax.

VALERIE: Willard, the builders needed a decision before midday about the disabled entrance at Elm house. Isn't this your responsibility? Why are they sending the fax for my attention?

WILLARD: I'll call Harold tomorrow.

VALERIE: That was midday today.

WILLARD: I'll call them tomorrow Valerie.

VALERIE cuts her eye at him and picks up the phone.

VALERIE: Hello, can I speak to Mr Thompson please? Hi, Harold! This is Valerie McKenna, McKenna nursing homes. I'm so sorry we've not got back to you but look, could you bear with us until close of play tomorrow? We would be ever so grateful! Thank you so much. OK. Goodbye.

She cuts her eye at WILLARD again.

VALERIE: In business, a little courtesy goes a long way.

Enter their twenty-one-year-old youngest son PETER. PETER is shy and forgiving by nature, however now is developing into your classic angry young man. We can see he is in a bad mood. He puts on the TV and sits on the sofa.

WILLARD: Peter you lock the car door properly boy?

PETER: Yes.

WILLARD: Yes who?

PETER: Yes Dad.

WILLARD and VALERIE clock each other. JAIME tries to be playful with PETER but he does not respond.

JAIME: *(Impersonating Dad.)* Eh eh you losing you manners. You must want me to cut you arse!

VALERIE: Who are you speaking to in that vulgar manner?

JAIME: Can you believe that Michael Andrews asked me out at the graveside.

WILLARD: Who?

JAIME: Michael Andrews, Auntie Julie's eldest.

VALERIE: Well, that family's hardly known for their subtlety. I mean look how Julie was dressed. Breasts were all hanging out of that thing. I was praying that she didn't come to the edge of the grave, they'd have pulled her in I swear.

JAIME giggles.

VALERIE: But wait, doesn't that boy Michael drive for some courier company or something?

JAIME: I think so?

VALERIE: What would make him think that *my* university educated daughter would have anything to do with a manual worker?

JAIME: Mum!

VALERIE: West Indians! They will always amaze me! Tell me why we must make a spectacle of ourselves at every occasion? I saw some people breaking down and damn right bawling today that hadn't seen John since he was about five-years-old

From the kitchen.

PETER: At least they showed some emotion.

VALERIE: Jaime now that the boys are here could you help me get the food out.

She gets up and heads for the kitchen.

JAIME: But Peter's right there!

VALERIE: *(Kisses her lips.)* What does he know about food and kitchen, hurry up girl before the food boil down for true.

WILLARD: I don't like that timer thing all you does use.

VALERIE: Huh, it was different when John was here eh, I didn't have to go near the stove. Every night a different cordon bleu meal.

PETER: It wasn't every night!

VALERIE: He'd come home and experiment on his next dish, follow it with the most superb desert. Huh.

She exhales. Silence.

VALERIE: Those were the days huh. *(As if talking to John.)* Hmm John my child, they got me right back in front of the stove.

JAIME: You know I dreamt John last night. He was smiling all over his face.

WILLARD: That's good. It means he's happy. And after six months in a fridge, time the boy body thaw out in the earth.

VALERIE changes the subject slightly. She will not tell anyone but she is upset that JOHN has not revealed himself to her yet in a dream.

VALERIE: Peter don't just stand there. Get the wine from the fridge. And it's White.

PETER kisses his teeth. VALERIE stares at him while the rest of the family gently look up.

PETER: What?

VALERIE: Something wrong with your teeth child?

He leaves for the kitchen with much attitude. VALERIE picks up a card from the neighbours.

VALERIE: This is such a beautiful card. Listen to this. 'Some people are sent here for a short time, but the light they leave behind will shine forever.' We miss you John. Isn't that lovely?

JAIME: Who is that from?

VALERIE: The Goulds next door.

PETER: Considering they hardly spoke to John in his life, I'd say it was closer to amazing.

VALERIE: I don't know what you have against those people.

JAIME: They think we're freaks.

VALERIE: What are you talking about freaks? The only thing freaky about this house is that I have, had three West Indian men in here and not one of them is on state benefit!

JAIME: Mum you are so out of order.

VALERIE: You're talking to me about freaks and I'm telling you what is freaky about this family. I despair for some of the younger generation I really do.

PETER: And why's that?

VALERIE: Because they're lost. The Government gives them all this social security for nothing, it's taken away they're desire to work. I'm sorry to say but too many young people today are under-educated and work shy.

JAIME: That is not true mum.

VALERIE: Yes, it is. Alright look at that girl Sawera, Sabina.

JAIME: Saniqua.

VALERIE: Saniqua or what ever her name is at Elmhurst home, that girl is work shy, the same for Joan at Dane house, and

Eric at Pivot house, these people do not like to work. But mention the word party, oh my god.

JAIME: We are very hard working, those are only three people…

VALERIE: Those are three West Indians that we employ, or should I say that you employed. I asked Eric the other day, no I said to Eric 'Did you go to see your mother this weekend' and do you know what he said, 'No Mrs Mac, I didn't went.' I mean, a boy born and bred in this country answers 'I didn't went!'

JAIME: He didn't.

VALERIE: I promise you he did.

JAIME: No he didn't went I saw him on Sunday *(Laughs.)*

VALERIE: Stop it.

WILLARD smiles.

VALERIE: Tell me who other than my liberal-minded daughter is going to employ some one who cannot even speak his native tongue.

PETER: Mum did you ever stop to think that they might be creating their own language?

VALERIE: That's ridiculous. Own language! They should learn to speak English first.

JAIME: Mum you are so reactionary.

WILLARD: *(Half speaking to himself but pointing at VALERIE.)* You'd never think it was English boys that killed our John would you?

PETER looks over to the TV. PETER calls his mother very nonchalantly.

PETER: Hey it's on. I knew it was Network South East cameras.

WILLARD looks up at the TV and then gets up and leaves the room. VALERIE comes out of the kitchen area and sits on the sofa next to PETER

VALERIE: Unmute the thing na!

TVNEWSREADER: …was buried today in his home town of Southham. Tension between the local community and police have risen significantly over the last six months, due to what the some believe to be a racially motivated attack. We spoke to a person close to the McKenna family

VALERIE: Who is that?

(She looks to PETER.)

Oh my God it's one of your Black Nation cronies.

PETER: What you looking at me for?

NAT'MAN: Justice is a fallacy for many people in my community. The killing of John McKenna, another innocent Black youth is testament to the fact that we live in a nation where the Black life is valued less that that of his fellow white countrymen. Where are the perpetrators of this hideous crime? Still out there on the streets posing a real threat to decent families. The question we have to ask ourselves is, is this because of police apathy or police conspiracy…

VALERIE: My god, people like that infuriate me. Take it off, switch it off.

JAIME: Well at least it made the local news. That's more than we've had since John died.

PETER switches it off.

VALERIE: Don't they realise that they are only making it worse for us. Every second it's race this and race that. John was killed. All I'm interested in is finding and punishing the killers. That's it.

PETER: It's not as simple as that mummy.

VALERIE: Not for you and your cronies obviously, you want to wrap it up with all of your political nonsense. I spoke to the police liaison officer only yesterday and he assured me that they are doing all they can to gather enough evidence to successfully charge the boys.

PETER: How long have they been saying that?

VALERIE: Rome wasn't built in a day. I'm telling you Peter, you and I are going to fall out over this Black Nation thing.

PETER: Why are you taking out your rage on me? I didn't talk to the TV people.

VALERIE: Yes, but it's you that has bought those people you associate with into our family business. What you children don't realise is that the English do not respond to all this noise you want to create. Quiet dignity, that's what impresses them. The sooner you learn that the better.

PETER: So they respect a woman whose child has been killed yet she remains silent?

VALERIE: Relying on the proper authorities to do the job they are paid to do is not remaining silent.

JAIME: *(She shouts.)* Dad, dinner.

WILLARD enters the room, sits down at the table. As does VALERIE and PETER. WILLARD senses that something has been said. So tries to soften the atmosphere.

WILLARD: Ah fish broth. A good choice Valerie.

VALERIE: Well it was the boy's favourite. The dumplings aren't as fine as John made them...

WILLARD: ...and you is the West Indian, shame on you. Huh, that boy made dumpling like my mother. And he was an Englishman you know.

PETER: *(Slight edge.)* That's because you taught him Dad.

WILLARD: No because he was interested!

JAIME: Mum, aren't you going to say grace?

VALERIE: *(A thoughtful pause.)* Let your father.

WILLARD: For what we are about to receive may the lord make us truly thankful amen.

VALERIE: *(Half whispers.)* Is that it?

WILLARD opens his eyes and looks at VALERIE. She does not return the look but instead coughs to encourage him to finish the prayer. He closes his eyes again and continues.

WILLARD: And em, thank you father for allowing the family to share this meal together. I thank you for my family. Amen.

JAIME: Amen.

VALERIE: Amen. Let's help ourselves shall we.

PETER: Kushangilia, Tamshi La Tambiko

VALERIE shoots PETER a dirty look.

VALERIE: What nonsense are you saying child?

PETER: It's African, to be exact it's kwaswahili for ancestors thank you for being with us, and...

VALERIE: *(She gets a little West Indian.)* Don't tell me anything about no African business.

He stares at her with contempt.

PETER: Mother we are...

VALERIE: Better still don't bring that inside this house. You understand?

PETER: I understand mother, the question is do you? You know what, if you'll excuse me I'll have my dinner in my room.

VALERIE: You'll do no such thing.

She looks to WILLARD for support. He looks at VALERIE and then to PETER. He attempts a compromise that will give PETER a little space but will get him back to the table.

WILLARD: Peter, go and put me tie in my room and then come back make we eat as a family na?

PETER nods and exits. VALERIE calms down. The others are looking at her.

VALERIE: Willard you really must take responsibility and deal with that child. I don't know how much more I can take of this, believe me.

WILLARD: I go talk to the boy.

VALERIE: Talk? I've been talking till I'm blue in the face, talk is not enough. This Nation business is sending him crazy. It's them that make him drop out of university you know that don't you?

WILLARD: *(To JAIME.)* My grandfather use to say there's no place like your parent's house, I remember...

VALERIE: Oh darling let's not have another of your grandfather stories, really.

JAIME: Ignore her Dad, I like your Grenada stories.

VALERIE: Ah! Go on then.

He was going to anyway.

WILLARD: Well I was simply reminded of the fact that my grandfather never lived with my grandmother. They had a house together had several children but every morning before the sun would rise he would be back in his mother's house.

JAIME: Why?

WILLARD: I don't know, apparently his father did it and every time I asked him why he'd simply say 'There's no place like your parent house boy'.

VALERIE: *(VALERIE cuts in.)* Go on you've missed out the best bit. He use to always say 'Boy I like all kind of tea, bush tea, china tea, every tea except...

JAIME and VALERIE finish the sentence.

FAMILY: …responsibilit-tea'.

WILLARD chuckles to himself. The others smile.

WILLARD: Yes granddad, responsibility, can be a bitter herb.

VALERIE: It's that kind of lazy attitude about responsibility that has kept us West Indians down.

There is a knock on the front door. JAIME jumps up

VALERIE: Willard get the door will you.

JAIME: It's all right Dad, I'll get it.

PETER enters the room. She quickly moves towards the door.

WILLARD: Thank you Jaime. You see, when I leave every thing in my will to that girl people go say she's me favourite. But see how that girl always look out for she father?

JAIME opens the front door. She sees NAVEEN, a smartly dressed Asian man in his mid thirties. He is from the Law Coalition.

We hear off stage.

JAIME: Can I help you?

NAVEEN: I am so sorry to disturb you. My name is Naveen Patel I'm from the… May I come in, I'll only take a minute of your family's time must speak to your family urgently, it's about John .

JAIME: What about John?

NAVEEN: I think I can help

JAIME pauses for a while and then lets him in.

She leads him into the front room. We see that he has a card in his hand and a newspaper.

JAIME: Mum, Dad, there's gentleman at the door says that he has…

WILLARD: Yes we heard

NAVEEN: Good evening my name is Naveen Patel and I'm a partner at South East Law Coalition. First of all may I extend my deepest condolences and my profoundest apologises for disturbing you on a day like this but, I couldn't stop myself. I had to come over and talk to you.

He hands them the condolence card.

VALERIE: Thank you. How can we help you Mr Patel?

NAVEEN: I'm here because I'd like to offer my services and that of the Law Coalition to your family.

VALERIE: Thank you Mr. Patel, but we already have legal representation.

NAVEEN: Yes I know that, but with respect, I think now, you'll need more than that. You'll need people that have real punch and clout with the media.

VALERIE: Why would we need that?

NAVEEN: Well because in light of today's events, if you do not your case will simply disappear. If we were to represent you for no fee whatsoever, we would not allow this tragedy to be sweep under the carpet.

VALERIE and WILLARD look at each other.

WILLARD: Why would you do all of this for no fee?

NAVEEN: Because we believe in Justice.

VALERIE: Mr Patel, thank you for your offer but at this time I can't see a reason why we would need further representation. The Police are doing their job, why would we need lawyers?

NAVEEN: You have read this evening's papers haven't you?

VALERIE: No, I can't say that I have?

NAVEEN: Oh.

WILLARD: Why?

NAVEEN: Page twelve.

PETER: What does it say?

He hands VALERIE the newspaper.

NAVEEN: The police released a statement today stating that they have taken the case as far as they could with the three youths suspected of John's murder. That in fact now they're enquiries have lead them to believe that John could have been involved in a gangland drug feud not a racially motivated attack.

FAMILY: What? I can't believe that, let me see. My son.

PETER: What?! It wasn't about drugs

VALERIE: … Drugs?

NAVEEN: It's been on the local television news all evening.

WILLARD: No.

PETER: I suppose that's what they meant when they said they are doing all they can eh mum?

This piece of news hits VALERIE particularly hard. She hands the paper to WILLARD and sits down to compose herself. However now she is more interested.

NAVEEN: I'm so sorry.

The family are stunned.

NAVEEN: Mr and Mrs McKenna I know this has come as a shock to you but let me assure you that this is not unusual.

JAIME: Really?

NAVEEN: In my experience if after six months a murder has not been solved or as in this case, the evidence against the suspects is deemed insufficient to secure a successful prosecution, the file is marked 'Enquires complete'. N.F.A. No further action. That file is then put away. It is not a coincidence that on the day of your son's burial that this kind of statement is released to the press. They are burying him too. What I am saying is that I live in this area. I cannot stand by and allow your son's character to be systematically assassinated and the three suspects released because they do not have the proper resource or inclination to solve this case.

WILLARD: Em look, please don't think that I'm being rude but what experience do you and your Coalition have in cases like these?

NAVEEN: We looked after the James Wood case last year...

VALERIE: Really, I remember that.

VALERIE and WILLARD look at each other.

WILLARD: We are in the middle of our dinner Mr. Patel.

NAVEEN: Please excuse me, I'll leave you to it. *(He hands his card to JAIME.)*

He turns to leave.

WILLARD: Would you care to join us?

He stops.

NAVEEN: Thank you.

WILLARD: Peter set another place at the table. Jaime get the plate please. It would give us more time to hear your

thoughts. It's only a simple meal but it was our son's favourite

They leave to do that.

VALERIE: So Mr. Patel, tell us about yourself?

NAVEEN: I live but five roads away. My parents are from India, and we moved from Glasgow to Southall, West London when I was young. I've been with the Coalition for about the last five years. Before that I worked for a solicitors firm in the temple.

VALERIE: Right. And this Law Coalition deals with?...

NAVEEN: ... Humanitarian concerns

VALERIE: Why would you leave a prestigious firm in the temple to do that?

NAVEEN: I feel you should put a little back.

PETER: Is that it?

NAVEEN: Yes. What else is there?

PETER: I don't know, you tell me?

NAVEEN: When I was about fourteen my father came home from work and whisked us to the top of our street. He pointed to what we knew was a N. F. pub, in an area that was 98% Asian, and said 'Look sons, justice'. It was being burnt to the ground. Suddenly a van filled with the later disbanded Special Police Group, crashed on to the pavement. Out jumped hundreds of policemen who just started throwing their batons at people. We ran. Luckily, we got into the house and I ran straight upstairs to look at the proceedings from out of the window. You know what I saw? Behind the front two lines of policemen were tattoo wearing skin heads with batons and shields. The police had armed them! Does that answer your question?

PETER: It'll do. For now.

WILLARD: Please let we eat.

They do.

NAVEEN looks to VALERIE. She has become very still and silent. It is as if the memory of the night of her son's death has suddenly revisited her.

JAIME: Are you alright Mum?

VALERIE: Yes. I simply thought of John while I was listening to the story. So what are you proposing Mr Patel?

NAVEEN: What in my opinion you need to do immediately, this is with or without us, you must immediately refute the allegations of John's alleged drug connections in the loudest possible way. If not the case is dead. Myself, OK I would set up a press conference straight away.

JAIME: We don't know anything about the media?

NAVEEN: In cases like these, what you need to know is that they are a necessary evil. Speak to them in the language they understand, they'll come running. You need to grab the country's attention. Get decent law abiding people to pressure the authorities to bring justice to your home. Smearing your son's name to validate inaction well… But it will be their downfall. If there is one thing you can say about this country we have a keen sense of fairness. Now the key issue here is justice but as much as we would not want to use race, John was killed in what appears to be an unprovoked racist attack. The point for me is not whether the attackers were Black or White, it is that they are still at large. The question you need answered is why?

VALERIE: Must we bring up the race thing?

PETER: Of course we should…

PETER is just about to pile in when NAVEEN indicates that he is better poised to deal with it.

NAVEEN: Regrettably I think so. It is a major factor. Had it been the other way around I doubt if we'd be sitting here having this discussion.

JAIME: *(With a slight attitude.)* Don't you think the public are fed up with hearing Black people moan about being Black?

NAVEEN: I agree. But on the James Wood case it was nigh impossible to get the media to give us any meaningful coverage. What John's case needs in this world of Satellite, cable and digital media is something that will capture the public's attention. And you have it.

VALERIE: Really.

NAVEEN: Yes you have it in Jaime.

He pauses for a second. PETER laughs.

PETER: Ha. Very good. Very good.

JAIME is stunned.

JAIME: Wait a minute, if this is a skin tone thing I need to tell you that we don't see that in this family.

VALERIE: That's right, I haven't raised my children to concern themselves with that.

NAVEEN: Forgive me. But this is not about you or the way you see the world. It is about the way the world sees you. They will listen to you Jaime more than any other member of this family. It's a horrible fact but it's true. If you want public pressure to bear down on the authorities then we need to grab their ears. You simply have the loudest voice.

JAIME: What about Peter, my brother died in his arms. He looked in the faces of the killers.

NAVEEN: You have to look at it with the media's eyes. *You* want something from *them*.

PETER: They kill my brother and now we're trying to find the best way to get their sympathy???!!!!

Silence.

WILLARD: And this is your plan?

NAVEEN: Mr and Mrs McKenna, let me be straight with you. If Jaime were to be the family's spokesperson, I could near enough guarantee that within two months your son's case will be in the minds of every person who cares about justice in this country. I will work for you, if you let me, which ever direction you choose to go in. But I believe in success and I, we at the Coalition believe that success lays in our ability to stir the public's sense of injustice. But we have to grab to them first.

WILLARD: And what if this doesn't succeed?

NAVEEN: Then we'll find another way. Let me assure you, we are not prepared to accept the taking of your son's life and the defiling of his family name, lying down. We would do what ever is necessary to bring this matter to the courts.

The family acknowledge his commitment in silence.

VALERIE: I see. Do you have children Mr Patel?

NAVEEN: I have an eighteen-months-old daughter.

VALERIE: Huh. Thank you for talking to us.

NAVEEN: You can contact me for whatever on the numbers on the card.

VALERIE: Thank you. Peter see Mr Patel to the door.

NAVEEN: Mr and Mrs McKenna, Jaime.

WILLARD: Bye Naveen.

PETER sees him out. We hear the front door close. VALERIE grabs the phone. PETER is in militant mood.

VALERIE: I need to speak with somebody about this.

WILLARD: Who you calling?

VALERIE: Our liaison officer.

PETER: So, what's your view on this mother?

VALERIE: *(Losing it a bit.)* Peter give me a chance. Answerphone. Inspector Williams this is Valerie McKenna. I wonder if you could call me back as soon as you pick this message up. It is a matter of great urgency. Thank you.

PETER: So Mum what is your view? Should we follow the advice of the Mr Patel's Law Coalition or is there an alternative you've thought of?

VALERIE: I said Peter give me a chance. *(Looking at the paper.)* Drugs?

PETER: Mum it's not quantum physics we're dealing with here. A/ we go along with this Naveen guy and fight for John or B/ we don't and John's known forever as a drug dealer.

VALERIE: It's not as Black and white as that Peter. I don't know if their strategy is one I would like to go along with.

PETER: You mean you don't know if you want Jaime to feel uncomfortable.

VALERIE: I don't know if it is right that Jaime should be used in this way.

PETER: Used?

JAIME: Yes used.

PETER: How would you be being used?

JAIME: He said it!

PETER: Said what?

JAIME: He said because they see me as...

PETER: See you? *(Beat.)* I know we've never acknowledged this before but you are not a light-skinned Black woman *(He says it with a certain amount of venom.)* You are white. Why are we deceiving ourselves? Jaime is one of them, let's use that to our advantage.

JAIME: How dare you talk to me like that?

VALERIE: Stop it Peter.

PETER: Stop what? Stop the truth? My brother died in my arms, my arms. If having Jaime do the talking will help to put those bastards behind bars…

JAIME: *(Overlapping.)* If Jaime what?

PETER: …then what is the problem? It doesn't stop you loving her.

WILLARD: Watch your mouth boy.

PETER: I'm sorry Dad, but is it just me or are we more interested in protecting Jaime than the memory of my brother?

JAIME: He was my brother too?

PETER: Oh yeah?

VALERIE: Stop behaving as if you are the only one who's lost John. He was all of our flesh and blood.

PETER: *(Screams.)* Then act like it.

JAIME: What is that suppose to mean?

PETER: Read between the lines.

JAIME: Oh I get it. I'm not blood now. I'm your sister Peter.

PETER: You may be my sister but you are not my blood, get it.

WILLARD: *(Screams.)* Stop this, stop this now.

PETER: Why? This is the first time we've had an honest conversation about this. We have lived all our lives denying and hiding and avoiding what is before our very eyes…and that was cool…

WILLARD: I said stop it Peter.

PETER: But now they are calling my brother a drug dealer and we are debating the only proper offer of assistance we have had. Why? Because we don't want to face the facts that Jaime is what she is?

WILLARD: I said stop it Peter.

He cools down.

WILLARD: We are family. Do you understand what that means? It means it's us against the world. Now I for one would rather do nothing than do anything that will harm us. We are all we have. Now I suggest we leave this subject and tomorrow we will decide on the right course of action. Goodnight Peter, goodnight Jaime. Goodnight.

They at first do not move. Then realising that they are being dismissed like children they both leave the room.

He sits next to VALERIE. She looks well shaken by the argument. WILLARD is distracted.

VALERIE: Why would they do that?

WILLARD: Do what?

VALERIE: Drugs!

WILLARD: Why do they do anything?

WILLARD wanders off. He ends up next to the mirror. WILLARD pauses.

WILLARD: You know Valerie, I look into the mirror and see these grey hairs and say 'But what is this, I'm still a child, I'm not no middle-age man'. And then it hits me that I am and that my child is dead, twenty-five and he's dead. And what have I done about it? I have waited and relied on the people that now call my son a drug dealer.

VALERIE simply looks at him. JAIME enters with her coat on.

JAIME: Mum, Dad...

WILLARD: I thought I told you to go to bed? *(Playfully.)*

VALERIE: Are you OK love?

JAIME: Yes.

VALERIE: Are you sure?

JAIME: Yes I am Mum.

VALERIE: Ignore your brother

JAIME: Which one?

Beat.

VALERIE: Peter was being very silly.

JAIME: The night after John died someone came up to me and said 'It must be so horrible for you knowing that the killers were...' and they substituted the word 'English' for white, as we do. So I came home and waited for us as a family to have the discussion about how we were going to deal with that. Tonight we had it.

WILLARD: Tonight was not a discussion Jaime.

JAIME: Do you remember the time John came home from school, we were about eight and five, and he asked you mum why 'He were so dark and I so light', and did that

mean that he was wickeder than I was. Auntie Pearl who was at the house at the time said to him 'No, but if you are good, when you grow up you will have children that look like Jaime'. And then she turned to me and said and you madam are Lena Horne's shade, and no one questioned where she belonged. That was the last time I remember talking about it. I need a little air. I'll see you later.

VALERIE: Please be careful out there.

JAIME: I will. *(Beat.)* You know I will do anything for John don't you Mum?

VALERIE: Yes I know.

She leaves.

WILLARD: Maybe we didn't do this thing right you know Val.

VALERIE: How'd you mean?

WILLARD: The boys come out so English and Jaime… Maybe we were wrong not growing her up to be proud of, well you know what I mean.

VALERIE: Proud? How were we going to tell her about being… English?

WILLARD: You know about being English than the English they self Mrs McKenna.

VALERIE: What we have had in this family is what they out there can only talk about. How could we have been wrong?

WILLARD: My head hurting me. I think I'll go and run a bath.

VALERIE: OK. Let me know when the bath is run.

WILLARD: Why you going to join me?

VALERIE: *(Kisses her teeth.)* I'm going to do the washing up. You can't run two hot waters at the same time.

WILLARD: Right.

WILLARD leaves the room looking at picture of JOHN.

SCENE TWO

McKenna's front room. PETER is sat on the sofa reading. WILLARD walks into the room. He stops looks at PETER and searches for something to say to him. WILLARD has been ordered to talk to PETER about his Black Nation connections, so is looking for a smooth way in. PETER is momentarily surprised by his father's interest.

WILLARD: What you reading son?

PETER: Oh hi Dad. Em, seminal writings on Slavery and the English mercantile system by Michael Jones.

WILLARD: A little light read I see! *(Tongue-in-cheek.)*

PETER: Actually it's fascinating. Do you know that when slavery was abolished in *(He looks in the book.)* 1833, we were given the names of our slave masters. Isn't that weird, we carry the names of the people that once owned us.

WILLARD: Really! *(Not really interested in that subject.)*

PETER: Yes but listen to this, it just hit me when I was reading last night. Why have we set up a memorial plaque for John, is it not to remember him, to make sure that his name is never forgotten, that's right isn't it?

WILLARD: Yes it is.

PETER: *(Thinking it through.)* Well then, us carrying the names of our former slave masters allow their memories, their names to live forever! Can that be right?

WILLARD: People don't study things like that anymore Peter.

PETER: Of course we don't, but we should. I remember a time in school when the teacher was going through all of the children's surnames in the class and telling them what it meant. Tony Baker probably meant his forebears baked, or was from a baking area. Etc. etc. and when she came to me, she said McKenna, well you're surely not from a Scottish clan are you Peter. And the whole class burst out laughing at me. I found it halfway funny too. Me with a Scottish name. How stupid. But I never stopped to think why, until now.

WILLARD takes the book from PETER.

WILLARD: You know I use to play cricket with Michael Jones back home.

PETER: Really?

WILLARD: Yes, he was a bigger boy to me back then, but I joined the cricket club young. They use to call me Little L.B. – Lightning Balls

PETER: Lightning Balls?

WILLARD: Yes because my ball would just flash down the pitch.

PETER: Yer.

WILLARD: And a few other things. Um huh. Michael had just returned from University in England. He could have been a first class cricketer if he didn't want to be in this politics thing.

PETER: Really?

WILLARD: St George's CC. Boy we were the best in the Island. You know two boys from our team got selected for the West Indies. Tour of '84 me and you uncle went to The Oval to see them play and Curtley Roberts shouted from the slips, 'Eh eh, look who in the stand na, not L.B.' *(He laughs.)*

PETER: What the Curtley Roberts?

WILLARD: Yes. We went out for a drink after the game, boy we laugh about the old days.

PETER: Dad you've never spoken about that before?

WILLARD: When you get to a certain stage in life you get so bored with you own stories boy, you stop telling them.

He stops for a second remembering JOHN.

Your brother knew. He asked me one day if I had any broken dreams. First class cricketer I said. I think I could have been a first class cricketer.

PETER: Why didn't you do it then?

WILLARD pauses and looks at PETER. He decides to carry on.

WILLARD: What you can't hide from God you can't hide from man. I made a local girl pregnant. It wasn't any old local girl. It was the daughter of a chief selector for the West Indian team. He was also our team coach.

Pause.

PETER: What happened to the child?

WILLARD: Oh she didn't have it, but everybody knew she was pregnant for me and, a powerful man in a small island is, powerful. It got so bad that eventually I couldn't get any

kind of work. So my grandfather gave me his life's savings and sent me to England.

PETER: Your granddad gave you the money?

WILLARD: He was a great man you know. Simple, but yet he said things then that I would have to wait thirty years to fully understand.

PETER: Did he ever talk to you of his family, you know his father, grandfather?

WILLARD: A little, I think. He would always say the McKenna's had strong blood. His grand father died at seventy-nine, his father died at eighty-four and he'd probably kick in at ninety, just so in heaven he could bust style on them.

PETER: His grandfather must have been a slave then?

WILLARD: *(Mood changes.)* I don't know. Old people never spoke about those things.

PETER: But he must have been cos if they abolished slavery in…

WILLARD: Peter let me tell you something, all this slavery talk; it's not good. That was the past, looking back to that can't help anybody, you understand?

PETER: No Dad, I don't understand. I don't understand how we can forget that!

WILLARD: Because we have to, it doesn't take you anywhere.

PETER: Do you think a Jew would say that about their holocaust?

WILLARD: *(Momentarily losing his temper.)* I'm not concerned about what a Jew may or may not do, but I am about the hate in my own son's heart.

PETER picks up his book and starts to read again.

WILLARD: I know you loved your brother, but he wouldn't have wanted you to hate, and I can see that in you Peter, we all can, especially Jaime.

PETER: He'd have wanted me to fight though.

WILLARD: Fight? What is the backside you young people have to fight?

PETER: *(In near disgust.)* You see that's what I'm talking about, how can you say what is there to fight? We are in

a warzone dad, and we've already had one casualty at the hands of the very people we moved close to to escape own.

WILLARD: Listen, all that Black Nation things that you're reading, don't you realise that it is hate their preaching. Hate destroys you from within son.

PETER: *(Loses his temper.)* Dad I don't understand you. At least they stand for something. What do you stand for? You know at first I blamed mum for John's death. But now, I blame you. You for not standing up to her like a man when she wanted to move us into this area, when she wanted to make us be so comfortable around these people that we would not see their danger. Why didn't you stand up to her when she wanted to assimilate us Dad, why didn't you do something when we became more uncomfortable among our own than with the enemy.

WILLARD: Enemy! Peter what are you saying?

PETER: You know why John died? Not because some racist jumped him, but because you were not man enough to warn us about the evil inside of them. Your complacency father, contrived to make us an easy target. You killed him Dad, so don't tell me there's nothing to hate.

WILLARD: What did you want me to do, say 'No Valerie, I want my kids to stay here and grow up in this stinking council estate'? I did what I thought was best for my children. You make choices in life Peter. And once you've made them, a real man sticks with them. You want something to hate? Well hate me for that.

PETER: *(Sarcastically.)* Oh do you want a medal or round of applause?

WILLARD: You can be rude, but life is long. I hope you'll be able to say what I've just said when you're my age.

PETER: When I'm your age I won't be like you I can tell you. I'd have stood for something my children could be proud of.

He walks out of the room.

At that point VALERIE and NAVEEN enter the house. They are a little joyous. They had a little too much wine at the celebratory lunch they just attended. However they are nowhere near drunk.

NAVEEN: And it's because of you Valerie honestly. Ah Willard. Did you see us in today's *Telegraph*? 'WHITE SISTER

CALLS FOR REOPENING OF MCKENNA CASE.'
Page four. *The Telegraph* is not one of our usual allies. For them to feature this is a big breakthrough for us.

There is no reply. WILLARD is still thinking about PETER's outburst.

VALERIE: Willard, did you hear what just Naveen said?

WILLARD: *(Snaps back.)* Em, yes. Well done.

VALERIE: Well done! Is that all you can say?

WILLARD: You two look a little sweet.

VALERIE: We had a celebratory lunch at the office.

WILLARD: I see.

WILLARD responds with a little smile.

VALERIE: So what!? People can't let off a little steam?

WILLARD does not reply. She kisses her teeth.

VALERIE: Anyway what are you doing here? One of us needs to be at Elm house at all times. You know what that family are like. *(To NAVEEN.)*

WILLARD gets up and heads out.

WILLARD: There are about ten messages by the phone for you.

He leaves.

VALERIE: Thank you. One of our more difficult patients fell and the family is threatening to sue. Sit down.

NAVEEN: Is it serious?

VALERIE: Maybe, maybe not. We've been threatened before. Once they've seen that we are taking them seriously, they'll calm down. Anyway carry on with what you were saying.

VALERIE picks up the messages pad and reads while talking to NAVEEN.

NAVEEN: Oh yes, I was saying that you are the rock that this family is built upon. I wish I had half your courage. And stamina, my god I couldn't keep up with you at the meeting this afternoon

VALERIE: When you have a hundred old people and their children running after you day and night, you learn to move pretty quickly.

NAVEEN: That's good because now that that we've positively engaged the press things will be moving very quickly. We'll be keeping a constant vigil outside of Scotland Yard and if they don't budge, we'll move to outside of the houses of Parliament.

VALERIE: Will they allow that?

NAVEEN: Yes, it's our constitutional right.

VALERIE: Really?

NAVEEN: After twenty years of paying taxes in this country the rights and mechanisms of the world famous British democracy are there for you to use.

VALERIE: I understand that but Naveen it's the ethnicity bandwagon thing I have difficulty with. I have avoided it all of my life. I never hide, but I distance myself. That is how you survive in this country.

NAVEEN: *(He thinks.)* How many times a week would you say you think about what it's like to live life with a severe disability?

VALERIE: Hardly ever.

NAVEEN: Me too. Yet when we meet say a person in a wheelchair we automatically start to talk to them about wheelchair access into restaurants and access to cabs and all sorts of thing. But in that conversation they will tell you one thing about their everyday life that you could not have thought of. And it will stay with you.

VALERIE: So you're saying being like us is a disability?

NAVEEN: No. I'm saying this thing is about exposure. If we want the quality of our lives, our children's lives to improve we must be visible we must challenge their negative perceptions at each possible opportunity.

VALERIE: But I have challenged them Naveen. What I do for a living, the way I've raised my children…

NAVEEN: … It's not enough Valerie. A reporter asked Denzel Washington what it was like being a rich famous actor and he replied 'Well I still can't get a taxi in New York after dark'.

VALERIE: *(Laughs acknowledging the truth of the statement.)* That's just people being ignorant Naveen.

NAVEEN: Or is it us that are being ignorant believing that we can truly live in a colour blind world?

VALERIE: Sorry?

NAVEEN: To ask people intellectually to ignore what is physically before their eyes is dangerous. It has huge political and mental implications. And when it is decided that we do see it again what then becomes of those that bought into that?

VALERIE: So what do you say about Jaime and us?

NAVEEN: The truth or a polite reply?

VALERIE: The truth.

NAVEEN: I think in denying or ignoring her 'difference', although done for the absolute most honourable of reasons, you have run the risk of creating problems for her in adulthood.

VALERIE: So you're telling me to see my Jaime as different? She's just my daughter Naveen.

NAVEEN: With respect, I know when you enter the big bad world out there, you are very conscious of what she is. You have to be in order to protect her.

VALERIE: This is very uncomfortable Naveen. Of all my children my little girl child is the one most like me.

This line of argument has seriously challenged VALERIE, in only a way that NAVEEN can.

NAVEEN: I tell you where all of this has come from Valerie. I'm a little worried. BBC radio called to ask us if Jaime would appear on a new talk show called Britain today. One of the other panellists will be Peter Wright from the BNP. Apart from being evil incarnate, he's very bright. He'll come prepared to well, hit at Jaime.

VALERIE: Then we'll just say no.

NAVEEN: Yes we could, but a senior official from the home office will be on the show and it will be our best chance yet of connecting with the only people that really count.

VALERIE: I see.

NAVEEN: What ever the outcome of the programme, the campaign will benefit, but if Peter Wright turns the heat on Jaime, she could come out very bruised. In a way it would be better for us if she did, because public sympathy and outrage would come to bear in front of the home office. I suppose what I'm saying is that maybe the time is approaching when you and Jaime have a direct discussion.

VALERIE: A discussion about what Naveen? Jaime is a together child. Trust me.

NAVEEN: At one of our media briefing sessions she told me a story once. She said that when she was younger she would get into the bath and scrub as hard as she could. You'd told your children that we all have seven layers of skin, but if you were good and clean, you'd get to the one you wanted most one day. So she kept scrubbing, and being good, but it never came. That is the discussion I am talking about.

VALERIE: Do you know what it's like the first time you hear your innocent child mention skin colour? It terrible Naveen. Because up until then you've lived in hope that maybe things have changed, that this new generation have lost the curse of race. But when you hear them say, 'mummy the white man over there' you know it is the end of the ride. From this point on they will either be oppressed by it or use it to oppress. Well I had both in my house and I was determined that neither would do either. If Jaime's problem is that she doesn't know what side she is on well it's because I wanted all my children to see that there was only the human family. So don't you worry she'll put the family first.

NAVEEN: Will you be around when I speak to her about the program?

VALERIE: Of course I will.

NAVEEN: Good. We're making a difference Valerie.

VALERIE: Well I can't have them saying that my son was a drug dealer. And I will take this to the top if I have to.

The phone rings. PETER walks into the room. He is on his way out. VALERIE turns the collar on his coat down as she picks up the phone. He heads towards the kitchen. While VALERIE is on the phone PETER eyes NAVEEN up. We see that it makes NAVEEN feel slightly uncomfortable.

VALERIE: Hello aunt Marge…Was she really?… Good…she's a bright girl…thanks for letting us know. *(Excited.)* Naveen, that was a friend who just heard Jaime's interview on the radio, said she sounded great.

NAVEEN: Good.

We hear the front door key turn. Enter JAIME. When PETER sees that it is JAIME he leaves the room quickly but with much attitude.

JAIME: Hi yer.

VALERIE: Hello Darling, I've just put down the phone from Auntie Marge. She called to say she'd heard you on the radio.

JAIME: Really!

VALERIE: She said you were excellent.

JAIME: Good.

NAVEEN nervously decides to grab this opportunity.

NAVEEN: And we've got some great news. The BBC have called and asked if you could appear on Britain Today with the Home secretary... And a few others.

JAIME: Right. Guys I'm a little tired would you mind if I had my tea upstairs?

VALERIE: They're isn't anything ready. I can rustle you up a quick tuna something?

JAIME: Don't worry I'll eat later.

VALERIE: OK. How was your day?

JAIME: Rubbish.

VALERIE: How were the people you interviewed for the Elm house vacancy? Find anyone decent?

JAIME: It was more like they were interviewing me. Every single one of them went on for half an hour about how they felt so sorry for us and our injustice blar blar blar.

NAVEEN: That's good. It means we're getting through to the people on the street.

JAIME: It means that I can't properly assess people because they're so busy emoting over me.

VALERIE: Don't worry dear. It's all for John.

JAIME: Yes, that's what I keep telling myself.

NAVEEN: I know you've had a long day but can I run a few things by you about this BBC interview.

JAIME: Go ahead Naveen!

NAVEEN: I've said it to Valerie and I'll say it to you. We need this one. It's as simple as that. But one of the other panellists is Peter Wright...

JAIME: Peter Wright? The guy from the BNP?

NAVEEN: That's right.

JAIME: Isn't he the one that said he could not condemn the stabbing of that mixed couple because they themselves were committing racial genocide.

NAVEEN: I'm afraid it is.

JAIME: *(Outraged.)* I'm not going on any programme with him. The man is a monster.

NAVEEN: I know he is but…

JAIME: *(Calmly and coolly.)* But nothing, Naveen I wont do it. God can you imagine what he's going to have to say about me.

VALERIE: What can he say about you?

NAVEEN: I know that Jaime that's why…

JAIME: …You're trying to soft soap me.

NAVEEN: Support you.

JAIME: Oh Naveen, come on, as much as I hate it, I do all the radio, TV and demo's that you ask, but how do you justify this one?

NAVEEN: Jaime this one programme will reach more important people than a thousand demo's and local radio interviews combined.

JAIME: Mum we need to talk, would you excuse us Naveen.

He realises he is being asked to leave.

NAVEEN: Of course. I'll call you later Valerie.

She nods. He leaves. VALERIE sits next to JAIME.

JAIME: Mum this is ridiculous. I am finding this really hard.

VALERIE: I know it must be a strain. Coming home from work then shooting off to some interview or other, but I am so proud of you. We wouldn't be where we are today without you. I know it's hard but ultimately it will be worthwhile.

JAIME: Will it?

VALERIE decides to broach the sensitive subject.

VALERIE: Jaime, have you ever felt, would you describe yourself as different from…

JAIME doesn't like where she thinks this is heading.

JAIME: What are you asking me Mum?

VALERIE: Oh nothing. Nothing. Forget it.

JAIME: You mean different from you?

VALERIE: Well...

JAIME: Or different from John and Peter...?

VALERIE: ... Well

JAIME: *(With attitude.)* Well of course I was adopted.

VALERIE: I don't mean that, come on.

JAIME: Oh you mean as in, racially different?

VALERIE: Like I said let's forget it shall we.

For a moment she is in a stunned silence.

JAIME: Ha. Wow. OK. When it was Peter that was one thing. When people in the street started pointing at me that was another, but now my mother is telling that I am different?

VALERIE: Jaime that's not what I meant.

JAIME: Well what did you mean Mother when you asked me if I felt different?

VALERIE: I was simply enquiring...

JAIME: Enquiring were you? Well how come you've never enquired about that before?

VALERIE: Because...

JAIME: ... Because you've never had a son killed by people that look like your daughter is that right? Or am I not that as well now?

VALERIE: Jaime calm down.

JAIME: No I suppose I'm not. I will not bloody calm down. I'm going to these meetings right and people are shouting and screaming about the wickedness of White people and then they ask me to stand up... I don't know whether they are going to cheer me or stone me. How secure do you think that makes me feel? All the Black people I know don't see colour and then suddenly I'm exposed to that level of rage. I'm frightened to look at any one in the eye in case suddenly they realise that I'm White too and I get lynched. Then I come to the place I'm suppose to have peace and my own mother wants to debate my difference! *(Screams.)* I know I'm different all right I don't need you to remind me. Look at this leaflet. Someone shoved this in my face.

She pulls out a leaflet out of her bag.

JAIME: Read it. Go on read it mother of mine.

VALERIE looks at it quickly and then looks away.

JAIME: Tell me what it says then. What you can't read?

VALERIE: *(She reads it.)* How long are we going to let these white devils kill our children in the street? What are we going to do?

JAIME: Is that what I am to you Mum, now that I'm different?

Offended by the question VALERIE doesn't answer. Taking that to mean that she can't JAIME picks up her coat and storms out

VALERIE: Jaime. Where are you going? Jaime... Jaime

End of Act One.

ACT TWO

SCENE ONE

Three months later.

Lights up. The only thing lit is WILLARD sat on the sofa. His eyes are closed and he is mumbling to himself. We disappear into his mind.

WILLARD: John child? I know we didn't really see eye to eye in your last days, but. *(Suddenly changing theme.)* Tell you one thing that I have learnt, never let an argument fester. Boy I don't know what I could have said that would have bridged our schism, but I wished I'd have tried. It is one thing to lose your first son, to never be able to regain his respect. John I'm not a praying man as you know, but if you are in a place that is closer to God than I am, ask him to give me the wisdom to find a way to heal this family. Jaime and her mother, Peter and his hate, me and my… lies. I don't ask for your forgiveness but help me find the strength to keep this family together. I know that you are listening child, I just know.

Lights snap up. VALERIE walks with a pile of posters. She rests them on the table.

VALERIE: Mumbling to yourself again Willard?

WILLARD: To John actually. How long have you been here?

VALERIE: You talk more to that boy now, than you did in the last year of his life. I've just got in.

WILLARD: You could well be right. What are these for?

VALERIE: Tonight's rally in Welling. I hope your going to be at this one, your absence was very conspicuous at last weeks. Naveen had to make up all kind of excuses for you. People are coming from all over the country to demonstrate for your son.

WILLARD: To tell you the truth Val, I don't really feel comfortable around those political types, I don't know what they want me to say.

VALERIE: They don't want you say anything, just be yourself.

WILLARD: And to be really honest I don't even feel comfortable around Naveen.

VALERIE: I'll not have you say a bad word about Naveen. If it wasn't for him we'd all be sitting around the front room moping and soaping.

WILLARD: Really. Your vicar must have seen you on TV last night. He's called about five times.

VALERIE: What did you tell him?

WILLARD: That you've been avoiding him and the church for the last six months and you'd prefer it if they stopped calling.

VALERIE: As you've never said more than three words to him I doubt if you'd have delivered that sermon. What did you really say?

WILLARD: That you would be back in late. He said they were in the area tonight and wanted to come and share a little fellowship with you.

VALERIE: I see. *(She kisses her lips meaning subject closed.)*

WILLARD: I went to see your daughter in she new place today you know.

VALERIE: Who? *(Deliberately provocative.)*

WILLARD: Jaime!

VALERIE: Really?

WILLARD: Yes really? I think you two are being very silly Valerie.

VALERIE: Did you read that letter she wrote to me? Did you hear the wicked, ungrateful and vile things she said about me? Me the one that loved and raised her she's going to call 'the dirty bitch that caused her confusion'.

WILLARD: She didn't call you a dirty bitch.

VALERIE: She may as well have, she called me everything else. These ungrateful people.

WILLARD: So she's people now?

VALERIE doesn't answer him.

WILLARD: Valerie write back to the child please.

VALERIE: Who me? Huh. Is she that move out of the house you know, she that leave the family business, that leave me to struggle on for John by myself. She must think that me and she is companion, writing abusive letters and expecting me to reply? She should know me better than that Willard. Anyway as Naveen always says, the struggle

is a great distiller. When your back is against the wall you'll know where a persons loyalty falls.

For VALERIE the subject is closed.

WILLARD: Huh! *(Changing the subject himself.)* I'm toying with the idea of going to Grenada when all this is over, what do you think?

VALERIE: How long for?

WILLARD: For good.

VALERIE stops what she is doing.

VALERIE: For good? What have you got back home Willard?

WILLARD: I don't know, we could sell one of the nursing homes and build a house or a little something!

VALERIE: And what would you do for money?

WILLARD: I don't know, I haven't thought about details. We're not too old; maybe we could start a little business or something?

VALERIE: I'm not going home Willard, there is nothing there for me.

WILLARD: What is here for you Val except heartache and bills?

VALERIE: You think you don't have bills in the West Indies?

WILLARD: But we'd be among our own people.

VALERIE: Willard you think it's easy home?

WILLARD: It's not any harder than here, and at least you wake up with the sun shining.

VALERIE: And mosquito's biting, congari, centerpea, you forget all of that?

WILLARD: No, it's just easier to deal with than hypocritical smiles and two faceness. The police, the political people who really don't give a damn about my son. I am tired of these people Val. It's as simple as that.

VALERIE: You think that I'm not? Every time I have to clean one of those old peoples shitty backside, you think I don't remember that one of their children, killed my child? Do you think that every Saturday when I am standing in the cold holding some placard begging for their mercy, that I don't remember that they taught their children the hate that killed mine? Not a day goes past without me remembering my son and what they have done. But what

you want to do is run Willard, and I've never ran away from anything in my life, and I'm not going to start now.

WILLARD gets a little irritated.

WILLARD: Look at these letters, I've not shown you because you have so much on your plate. 'Leave good White folk alone', 'Your nigger arse is as good as dead, ha', 'How does it feel to have a dead nigger son.' I don't have to live like this.

VALERIE: *(Changing subject.)* I hear your woman is going home next month? Is that what this is about?

WILLARD: I'm sorry?

VALERIE looks at him. Enter PETER, who even though he hasn't really spoken to VALERIE and WILLARD properly in the last few weeks, is so excited that he's bubbling over with the need to tell them of his new discovery.

PETER: Mum, Dad, the best thing happened today, you would never believe it, it was like, oh my god.

VALERIE: *(Offish.)* What?

VALERIE kisses her teeth and walks off.

WILLARD knew she knew but she had never mentioned it before. He tries to pay attention to what PETER is saying but for a little while is more concerned with VALERIE.

PETER: I haven't told you but I have been going down to the Colonial records office at Kew, where they keep all the historic papers regarding the Caribbean.

WILLARD: You haven't told us very much at all lately

WILLARD retaining a little of the tension they had after PETER's last outburst at him. He has forgiven him but he has not forgotten.

PETER: I know, I know, but look I have to tell you this. With the information that you gave me Dad about your family and I went there and asked for Grenada's yearbooks. I'd roughly worked out that my great great grandfather must have been around when they abolished slavery so I ask for the book of 1833,4,5. The woman behind the desk asked me what I wanted it for, so I told her that I was trying to trace my family tree. 'Were they slaves,' she asked, 'if so you're wasting your time, as they never kept records of slaves or about slaves'. Just give me 1833 and shut up.

WILLARD raises his eyebrow as if to say 'I know you didn't say it like that.'

WILLARD: Boy is you ever going to get to the point?

PETER: I'm getting there wait a minute. So she gives me this book right and it's huge. I mean three hours later I'm still on January. To cut a long story short…

WILLARD: Thank you.

PETER: Four forty-five arrives and I'm still in April. Woman over the speakers asks everyone to finish reading and return the books. I'm so vex that I just flip over the pages and it lands on September 5th 1833. And what's on that page, swear to god. My great great great great grandfather's name, George McKenna.

WILLARD: What?

Suddenly interested.

PETER: I swear. I couldn't believe it. There before my eyes. Dad I just screamed. And every one in the office started to applaud, cos they all knew that I must of found what I was looking for. Can you believe it?

WILLARD: What was he doing there?

PETER: Well as it happens your Gt.x4 grandfather's brother was given his freedom when he was really young, and inherited his White father's plantation. However he was a bit of a dodgy character and was selling bootleg rum to the neighbouring island, which at that time was owned by the French so it was a treasonable offence. To cut a long story short he was caught and the biggest trial of 1833 was his.

WILLARD: So how did his brother's name get into the book?

PETER: They listed all of his family members, but his brother in particular because Alexander McKenna, bought his own brother but only gave him partial freedom, I know it's amazing isn't it? Anyway that's as far as I got today. They had to drag me out of there.

WILLARD: You know what's funny about that, my grandfather always said his father never touched a drop of rum in his life. Said it was the source of all evil. What's more he said that we were suppose to be rich, he never explained why we weren't, but every now and then when things were really hard, he'd keep saying to himself, 'Boy we suppose to be rich.'

PETER: Wait, your grandfather told you that? That was Angus McKenna right?

WILLARD: Angey and his father was called Joseph. One big funeral he had.

PETER: Dad this is fascinating stuff, I might even go to Grenada and check this stuff out properly. I photocopied loads of stuff, so I've got a lot of reading to do. I should have known I was onto something, I dreamt of John last night.

VALERIE clocks this as she enters with pieces of wood to stick onto the placards she bought in earlier.

WILLARD: Hurry up, I'm looking forward to hearing about we family.

He leaves the room.

VALERIE: I don't know why you are encouraging that boy in all that African business.

WILLARD: I am not, the boy is interested in the family, I think that is most commendable.

VALERIE: It's probably some project that Black Nation leader has given him.

WILLARD: You confuse me sometimes you know Val. One minute you, you talk of the contempt you have for these people and the next you slam your son for finding out about his family.

VALERIE: You're only interested because it's your family, if it was my side he was looking into, it would be looking back to that slavery thing.

WILLARD: I am not going to go into a your family my family thing.

The doorbell rings.

VALERIE: Get that for me please, it's probably Jack come to collect some of the banners, God I've only done two, it's you and your stupid son's fault. Oh no, if it's any one from the church, I'm not in. I've gone away for a month or something.

WILLARD gets up to open the door.

WILLARD: By the way, she's not going home.

VALERIE: Is that so!

WILLARD leaves to open the door. It's NAVEEN. He rushes into the front room.

NAVEEN: Valerie Valerie, have you seen it?

VALERIE: Seen what?

NAVEEN: This evening's *Standard*

VALERIE: No. Why?

NAVEEN: We are on the road, if Willard weren't here I'd kiss you.

WILLARD: Feel free.

NAVEEN: Yesterday's cabinet reshuffle. The new Home Secretary, he's ordered the reopening of the case, and I quote 'Deputy commissioner Jackson has assured me that no stone will be left unturned in the pursuit of justice for the McKenna family.'

VALERIE and WILLARD jump into the air and scream with delight. They both hug NAVEEN.

VALERIE: I can't believe it, I can't believe it.

WILLARD: Oh my God, John did you hear that? Peter!

NAVEEN: I was driving home from the office and by chance I saw the headline. I told you that we were on course for victory. We are going to nail them.

PETER, hearing all of the noise, runs into the room.

PETER: What's happened?

VALERIE: The Home Secretary has reopened the case.

WILLARD: It is great news!

PETER: Ha! Masser says he's going to look into the problem so let's have a party. When has he ever done what he's promised? Do you think they are ever going to prosecute three of their own for doing what they have been doing for centuries? It's another nigger out of the way. So excuse me if I don't get out the banjo and bite into my watermelon.

NAVEEN: Personally, I think that is a very negative attitude Peter. We don't have many occasions to celebrate, I think, if I may say that it's really very churlish of you to destroy this one.

PETER: Do you now?

NAVEEN: Yes I do. Your mother and I, and of course the rest of the family have worked very hard to get even this far.

PETER: I must tell you Naveen, I don't trust or like you, please do not lecture me.

VALERIE: Peter that is enough.

NAVEEN: No Valerie let him get it off his chest.

PETER: Don't patronise me either, I have nothing on my chest I simply told you how I felt.

VALERIE looks to WILLARD to say something.

NAVEEN: Personally I'm getting rather tired with your angry young man act. I think you need to grow up.

PETER loses it and charges at NAVEEN.

PETER: Don't you talk to me like that you bloody Asian. Are you crazy?

WILLARD jumps in the way and holds PETER who is about to hit NAVEEN.

WILLARD: Peter what do you think you are doing?

VALERIE: Oh my god Peter stop it!

PETER screams at NAVEEN.

PETER: No I'm not having him talk to me that way. What are you getting out of this eh, Mr. Humanitarian of the year. I know you people. When there was government money about you guys were Black, now it's gone you're Asian again. I see right through you, you money grabber.

NAVEEN: I have not charged your mother a single penny for this case.

PETER: Yer yer yer. You're getting paid, think I don't know that you're getting paid. Who they going to run to every time for a sound bite?

VALERIE flips.

VALERIE: Peter, you're going to swear and talk to people like that inside my house? It's quicker you leave, before I'll tolerate behaviour like this. Apologise to Naveen for this outlandish behaviour.

NAVEEN: Really Valerie, he doesn't need to apologise.

PETER: You would put me out of my home for him?

VALERIE: I didn't say leave the house I said quicker…

PETER: It's the same thing.

VALERIE: I am not debating this with you. I said apologise.

PETER: I meant everything I said, an apology would be hypocritical, if that means you want me to leave then I will.

VALERIE: Peter I said apologise, don't test me child, apologise.

PETER: *(Half to himself.)* I don't need to be here I'll tell you that.

VALERIE: You don't need to what?

WILLARD: Stop this now. I can see were this is going to end up.

VALERIE: Don't undermine me like this Willard

WILLARD: I won't stand by and see our family further destroyed Valerie. He's the last child we have. Let them work this thing out themselves.

VALERIE: That's why they are as they are. What a weak father you are. The child will swear up in here like any old junk yard dog and you will condone it? Naveen come. The air in here is too rank.

She leaves the room. NAVEEN slowly follows her. WILLARD falls into the chair. PETER looks at this tested man.

PETER: I don't know what came over me Dad, I'm sorry.

WILLARD: So am I. *(Pause.)* I don't understand the point in fighting for your dead family, and destroying your living one! Do you?

SCENE TWO

The lights come up to see an empty front room. The house is not looking as tidy as it normally does. In fact it's looking quite ragged. VALERIE enters with her coat on. She is about to go out. But is not looking her usual tidy self. She notices a fax in the machine. She takes it out and starts to read it. She picks up the phone and makes a call.

VALERIE: The small business section... Gerald Peterson please... Valerie. McKenna of McKenna nursing homes... Hello Gerald, so sorry I haven't returned your calls, yes I've received your fax... Um yes I realise we are pushing the boundaries of our overdraft...no we haven't achieved those targets but I fully expect within the next few weeks we'd have replaced the patients that we have lost...how do you perceive we restructure? Turn the overdraft into a loan using the equity in our home as security? Right... let me have a little think about that before you send the

surveyor round... I'll get back to you in the morning... I know you are on our side. I just...that it's the only thing we have that's our own and one would be loathed to... Yes I'll speak with you tomorrow.

She puts the phone down.

Damn.

WILLARD comes out of the kitchen area. VALERIE jumps back in shock.

VALERIE: You frightened me, I didn't know you were home.

WILLARD: I'm not, I'm on my way out!

VALERIE: As usual

WILLARD: Did you see today's paper?

VALERIE: No? I haven't had time

WILLARD: Read it.

He passes the paper to VALERIE.

VALERIE: The crown prosecution service announced that it is to review its case against the three youths accused... A spokesperson for the C.P.S. said that the decision to review came amid mounting pressure from the Black community to secure the successful prosecution of the three accused and at present that could not be guaranteed.

She goes into a rage.

VALERIE: I don't believe this.

WILLARD: Do. I knew something was wrong. I did dream John last night.

VALERIE: You did?

WILLARD: Yes and it was as if he was crying and pointing to something on the floor. When I look I couldn't see nothing. I looked back to ask him what did he want me to see and he was gone. I'll see you later.

He leaves the house. She goes to the phone and calls NAVEEN.

VALERIE: Naveen? Hello, listen have you heard...you have... What is that about then, in our meeting with the C.P.S last week they assured us that with Peter now accepted as the main witness, the case was watertight... What are they talking about serious doubts? ... Need more witnesses? For what?

NAVEEN: Valerie I'm here. Willard let me in.

NAVEEN enters the house.

VALERIE: Oh. This is outrageous. Peter has identified them several times…

NAVEEN: I know.

VALERIE: I mean why do I have to read this in the paper, couldn't they have called or something. God what is wrong with these people.

NAVEEN: Valerie…

VALERIE: When will this thing come to an end Naveen?

NAVEEN: *(Trying to placate her.)* When they stop protecting their own.

VALERIE: *(Bitter.)* And who do we have to protect us eh? No one, that's why they treat us this way. Like nothings, nobodies. But I won't take this laying down, even if I have to die too, those boys are going to pay for killing my son.

NAVEEN: Valerie if you are going to run this course and survive it you must expect these people to let you down at every juncture. The Police, the courts, the public.

VALERIE: And God?

NAVEEN: Valerie don't lose heart. I know right now it's hard to see but look at what you've achieved. Your lovely home, your successful business, things turn out right for you Valerie.

VALERIE: What of my family Naveen? My daughter's left home and we do not talk anymore, my youngest son has run off to Grenada rather than live in the same house as me, I am married to a weak man who now practically lives around the house of the woman he has been seeing for the last twenty years. How right is that?

At that point the fax machine starts to churn out a fax! VALERIE goes to get it.

NAVEEN: All I know is that it's going to weigh in on our side.

At the same time there is a knock on the door and the sound of something being pushed through the letterbox.

NAVEEN: I'll get that for you shall I?

VALERIE: Yes thank you.

He goes to the front door. VALERIE reads the fax.

VALERIE: God, these people have no concept of grammar... *(She struggles to find the word.)* 'Niggers you are worser than shit.'

NAVEEN comes back into the front room. He is carrying a piece of turd on some paper. VALERIE sees it.

VALERIE: Well one can't say that they're not coordinated

NAVEEN: I'll run out and see if any of the neighbours got the registration number

VALERIE: I'll take that.

NAVEEN: No. I'll deal with this.

He exits.

VALERIE: John why is this happening? Is God laughing at me or what? It's as if he's making me into the parable of she who thought she had everything only to find out that she had nothing. Even you, John. You've come to everybody else in dream but you don't come to me? Why? You don't think I need a encouragement too?

The lights come back up and NAVEEN comes back in on the phone.

NAVEEN: No good, no one saw anything except the couple next door and all they said was that the car was green. Hello, Inspector Graham Please. Yes... Vandals just posted some excretion through the letterbox of the McKenna household. Along with a threatening fax... Yes could you get some one over straight away. Thank you.

To VALERIE.

They'll be here in a wee while.

VALERIE: Would you mind terribly if I was left alone.

NAVEEN: Nonsense. This is no time for you to be on your own.

VALERIE: *(Slightly strained.)* I wouldn't make good company right now.

He understands.

NAVEEN: OK. I'll call by later. Tell the police they can call for my statement.

He leaves. When it is clear that he has left the house VALERIE sobs. After a few beats JAIME enters.

VALERIE instantly pulls herself together.

JAIME: I didn't know you'd be in.

When she hears JAIME's voice she spits out venomously.

VALERIE: What do you want?

JAIME: *(Almost apologetically.)* I came to leave this for Dad.

She places a wrapped birthday present on the table.

VALERIE: Well you've left it.

When JAIME can see that her mother is not going to communicate with her she places the house keys on the table.

JAIME: And to return these.

Without looking VALERIE clocks them. Pauses for a second and she leaves the room without even looking at JAIME or the keys.

JAIME understands now that her mother has washed her hands of her. She turns and leaves the house.

SCENE THREE

We are in the family's front room. WILLARD is dancing to his favourite soca calypso cassette. He is singing and whooping, busting his favourite moves.

WILLARD: *(Singing.)* If I only hold you tonight it's thunder, I giving whole night, caressing you whole night, I giving you… *(Speech.)* BOYYYYYY you still have the moves, them young people can't touch this…

He pretends he's dancing with a woman. The doorbell rings. WILLARD jumps up and answers it. Enter PETER in his Caribbean shorts suit, suitcases etc etc. Near PETER burst into full Grenadian lingo.

PETER: So wha 'appen, England cold hit all you so bad that you can't open you mouth?

WILLARD: Pardon. You're early boy!

PETER: Got a lift from Gatwick. So what, you can't say hello?

WILLARD: What happening bwoy?

PETER: Well I dere. Happy birthday old man. *(Gives him a bottle of rum.)*

WILLARD: Thank you thank you. What, well you is real Grenadian now wee.

PETER: Well what else I is? I could hear that you enjoying you self.

WILLARD: Boy, all I need is me Soca tape and a little home rum on me birthday and I is happy. Well for a while at least.

PETER: Till you realise that you to old do bust the moves that you use to.

WILLARD: What!?! You could match me for moves?

Smiles.

PETER: Yes, any day of the week.

WILLARD puts the cassette on again and busts a move that he was doing earlier.

WILLARD: Boy you drunk? You young people don't know moves. Watch this.

PETER stands amused.

PETER: Eh eh! But you too old to do this though.

He winds down to the floor and up again. WILLARD starts to laugh.

WILLARD: Bwoy you bad!

PETER: I know!

Acknowledging defeat he switches off the stereo.

WILLARD: You know looking at you now reminds me of when you lot was little and we use to dance together.

Laughing as he recalls.

Remember how good Jaime use to move. The family use to look and say, but wait that child is a West Indian.

Beat.

PETER: Where's mum?

WILLARD: Out on some march or the other with Naveen. She is going to cuss you.

PETER doesn't answer.

WILLARD: How was it? How was home sweet home?

PETER: Wicked Dad, just wicked.

WILLARD: You like the young girls down there, more importantly did they like you?

PETER: Of course the girls in your village liked me. I was Mr. prim and proper young English as they called me.

WILLARD: Boy I hope you did leave the people them girl children as you find them?

PETER: What! Like you use to?

WILLARD: That is a different subject.

PETER: Yer yer, any way people were overjoyed at the mention of your name. They would cook for me, give me drinks, well the first one anyway, after that they expected English to pay for the rest of the night. I wonder where they got that idea from? No wonder you go home every decade. You'd be bankrupt the way you spend money.

WILLARD: Boy you have to spend money otherwise people think that you do all these years in the cold for nothing. Remember it was a simple trade off, sunshine for money, they provide the sunshine, you the…

PETER: Not me spending my money though, I didn't have it for that. Aunty Anniseata, sends all of her love, and a big frozen Lambi, I don't know what you guys see in that thing it's horrible.

WILLARD: You English people know anything about food, hush your mouth.

PETER: I'm not English thank you.

WILLARD: So what you's West Indian?

PETER: I'm African dad, like we all are.

WILLARD: I'm not no African, I'm a Grenadian.

PETER: Well we'll see about that, anyway your old friend Time sent you a bottle of rum, and Bam sent you some seamoss, I hope all this stuff hasn't stained my clothes you know.

WILLARD: Bam, boy that was a character. You know why he was called Bam?

PETER: No.

WILLARD: Because he use't to knock man out with one punch. Man that boy did like to fight. If you were going to a dance in another village, every one would give him a dollar each just for him not to come. But if he did guarantee there'd be bacchanal.

PETER: That's why he said to me that if I got into any trouble I should call him and he'd sort it out.

WILLARD: At his old age, Bam should rest heself. Tell me about we family na.

PETER stares into his eyes.

PETER: Dad, I have said some harsh and horrible things to you over the last year and I'm sorry.

WILLARD: Never apologise for what you meant. But thank you. So, home?

PETER: Well I discovered the exact location of the plantation your great great great Grandfathers owned *and* slaved on. The funny thing is, I didn't feel the memory of that time in the land, in the island as a whole actually. It was as if the earth had forgotten. Anyway I found some distant family in that area. They told me some stories. Wow. Apparently the woman who married your great great grandfather, had put a curse on him. If he wouldn't be with her, he would never be able to live with another woman in peace, and what happened, you told me that your granddad never lived with his wife, he simply went there in the day and returned to his mother's at night.

WILLARD: But I don't believe in that obea thing.

PETER: Believe in it or not this woman said that no McKenna has ever been able to live with his wife since. That shit frightened me.

WILLARD: Watch your mouth boy.

PETER: Shit isn't a swear word!

WILLARD: All right. Carry on anyway.

PETER: I went back to the library and eventually was lead to Alexander McKenna plantation books. He had a whole page about the buying of his brother George. Now this is the exciting part. George McKenna our great-great-great-grandfather, was a single man when he was bought, but married the daughter of a freshly imported African, named Coffee.

WILLARD: Who was named Coffee his wife or the African?

PETER: His wife was called Angnes; her father was called Coffee. Listen to this dad, Coffee was simply the Anglicisation of the Ghanaian name Kofi, spelt K.O.F.I. Meaning born on a Friday. Dad do you know what that means, your great-great-great-grandmother was Ghanaian, her father came over on the slave ship 'Forever tomorrow' summer of 1799. Dad I have got us back to Africa.

WILLARD: My God, that's fantastic. How do you know all of this information is true?

PETER: Oh I've got the birth certificates and copies of the ledgers, everything. I've even done a chart so that we all can see. Dad this is a glorious day.

WILLARD looks at the chart.

WILLARD: Wow. So what do you gonna do with this new-found information?

PETER: Dad I don't want you take this the wrong way but I've decided to change my name. From now on I'm going to be called Kwaku Kofi.

WILLARD: Boy don't think that I am being negative but even if we did come from Africa once, we are not African now, and they'll tell you that themselves son. I don't want you to go down a road that may lead to disillusionment.

PETER: I understand that dad, but this is a new day, we don't have that African West Indian thing going any more.

WILLARD: Really.

PETER: It's like for the first time since John died I'm beginning to find some peace. When I was in Grenada I felt part of something.

WILLARD: Ain't that the truth.

PETER: All that rage has gone Dad. I feel as if I was put on this path to find myself.

WILLARD: Well then you do that son, but remember you have the benefit of being the first generation of West Indian children that can legitimately say 'This country is mine. Don't waste that.'

PETER looks at the state of the house.

PETER: The place looks rough. What's been happening?

WILLARD: It's been rough. The CPS has actually dropped the charges against the three boys due to lack of evidence they say. Further to that, the boys say the only reason that you have identified them as the killers, is because you'd had an argument with them the night before, got into a fight and lost. They have witnesses to prove this.

PETER: Are you crazy, I'd never seen them in my life before that night.

WILLARD: Well that's not what they're saying.

PETER: I attacked them, that's ridiculous.

WILLARD: I know.

PETER: They're just using me to get off the charges.
WILLARD: Uh ha.
PETER: Nooo, Dad that can't be right.
WILLARD: Who said anything about right.

PETER is fuming.

PETER: Na, these people are bloody taking the piss. I gonna have to do something about this. This has to stop. Those boys ain't getting away with this again.
WILLARD: Something like what? You could take the law into your own hands?
PETER: That's exactly what I'm talking about doing!
WILLARD: Don't be stupid that's just what they want you to do?
PETER: Is it?
WILLARD: Yes it is. Haven't you just told me about this new peace you've found?

We hear the front door close. Enter VALERIE. She walks in and ignores the men. She looks around the room. PETER cools somewhat.

PETER: Hello Mum, I've just heard about…

She walks into the kitchen. PETER looks to his father. He looks to the floor as if to say that it's been that way of late. We hear VALERIE slamming the pot covers.

VALERIE: So if I don't cook you mean no one can find their way to the kitchen?

It sounds now as if the pots are being thrown onto the floor.

VALERIE: I have to be the man and the woman in this house, go to work, come home, go to the grave, go to the meetings, go to the police, go to the lawyers, me. I'm the only one inside here that can do anything? I mean what kind of men am I surrounded with?

We now hear plates being smashed up.

How can I come home after a long day's work and find dirty plates in the sink? This is outrageous. The people inside this house think that this must be a bloody hotel. Eat shit and do as you please, but me the arse will cook clean and serve for them? Well you lie, things around here are going to change, believe me.

She walks out of the kitchen and into the front room. PETER stands.

VALERIE: Do you live here?

PETER: Yes.

VALERIE: Then how come the day before your leaving, you choose tell me that you're going home?

PETER: You were so busy and I...

VALERIE: You what? You have no blasted manners that's what.

He starts to get a little annoyed.

PETER: It was an impromptu thing.

VALERIE: Did you not stop to think that as the trial was approaching we would need you here?

His tone increasingly irritated.

PETER: Well it's not happening now is it? So what's the problem?

VALERIE slaps him in his mouth.

VALERIE: Don't use that tone with me young man, you understand.

PETER puts his hand to his mouth. It is bleeding. The blood rushes to his head but he calms himself.

WILLARD: Valerie!

Slow with deep meaning.

PETER: Don't, ever do that again Mum.

WILLARD: The boy didn't deserve that.

VALERIE: You shut your mouth, if you were any type of man you would have done it. But as usual you fulfil your brief, weakness.

WILLARD: I wish you wouldn't take out your rage on us.

VALERIE: What do you know of rage Willard? You think you see rage yet. Rage is what I feel when I look at you see my dead son's face in yours and realise that he was more man than you will ever be. When I see how incapable you are of doing anything about my son's death I am outraged.

WILLARD turns to PETER.

WILLARD: Boy go and clean your mouth.

PETER slowly turns and leaves the room.

VALERIE: It has taken the death of my son for me to see you as you really are. Your weakness disgusts me. I am holding this thing up by myself, me Willard. I am the one at the

meetings, I am the one facing all of the pressure alone, alone Willard. Where are you? For Christ sake he was your child too, why are you not sharing this with me?

Overlapping each other.

WILLARD: Because I'm tired god damn it, I am tired Valerie. All of us aren't made of the stuff that you are.

VALERIE: You think that I'm not tired too? That's a lame excuse.

WILLARD: It's not an excuse. I don't want my photographs taken Valerie.

VALERIE: You think that I do?

WILLARD: I don't want people whispering as I walk past them in the supermarket, that's the father of the boy that get murder you know... Don't him have a White child too!

VALERIE: What are you talking about, it happened!

WILLARD: *(Shouting.)* I know it happened, but I don't want to live it every day of my life.

VALERIE: *(Shouting back.)* That's because you're a coward.

WILLARD: I don't care. I want my life back Valerie. John is dead and God knows I want those that did it to pay, but I can't take this. Now I admire your strength, but I don't have it, and I'm not going to live what I am not.

VALERIE: *(With meaning.)* You coward. Every time I look at you, I feel sick.

WILLARD: I'm sorry to hear that.

VALERIE: You suit each other, you and that woman. Any person who can sit waiting for you for twenty years is a loser.

WILLARD: Some might say it takes strength?

VALERIE: Yes fools. Why don't you just leave and go and live with her full time?

WILLARD: You'd like me to do that wouldn't you, take what ever blame there is for this sham we call a marriage, huh I'm not going to give you the pleasure. I don't hate you, and when I look at you I don't feel sick, I just feel sorrow for a woman who is so racked with pain that she can no longer see the wood for the trees.

VALERIE: I don't want your sorrow. I don't want your sorrow. I'm going to sell the house.

WILLARD: Isn't it our house?

VALERIE: No Willard it's my house and I'm going to sell it. Some of us are responsible for loans, campaigns, legal fees the lot.

WILLARD: Isn't that why Elm house is for sale?

VALERIE: Yes, and now this one is too.

WILLARD: You know what Valerie, do what you want, I'm too tired to fight anymore. I'm going somewhere where I can find a little peace.

He picks up his jacket and leaves the room.

VALERIE: Give her my love won't you.

WILLARD: I will.

PETER enters the room after WILLARD has left. He wants to talk to VALERIE but is not sure how to approach her. He has a gift in his hand. He still is annoyed about the slap but is trying to fight that mood off.

PETER: Mum.

VALERIE: Yes.

PETER: I bought this back for you. It's not much but well, it's the thought that counts isn't it.

VALERIE: (*She takes it from him.*) Thank you.

Silence. PETER heads for the kitchen.

VALERIE: Where you going?

PETER: To clean the kitchen.

VALERIE: When you've smashed something up, you want the time to savour the destruction. Leave it, when I'm ready I'll do it.

He turns around. VALERIE very matter of factly.

VALERIE: So did you have a good time?

PETER: It was excellent.

VALERIE: Good.

PETER: I thought of you a lot when I was out there.

VALERIE: Really? What about?

PETER: About some of the stories you use to tell us as children.

VALERIE: Oh not you as well.

PETER: I kept thinking about the time when I asked you how we got to the West Indies, I must have been about six or seven, and you said that we were angels that flew all the way from Africa. However when we landed in Grenada for a rest, we saw the mortals eating salt and decided that we should too. But we ate too much, and it weighed us down so badly that we lost the ability to fly back. And that meant that we had to stay there forever.

VALERIE: Did I say that?

PETER: Yes, and I've never forgotten it.

VALERIE: Boy the rubbish you tell children just to shut them up.

PETER: I don't think that was rubbish, I think you were right. Maybe that's why we are here now, paying the price.

VALERIE: What sin could we have committed so bad, that we have to face the crap we face now eh?

PETER: Maybe we gave up being angels by being too much like the mortals?

VALERIE: We were never angels child.

The fax machine rings. VALERIE collects the fax.

VALERIE: Oh my god. One of the old ladies at the home has had an accident. This is what I mean about me having to do everything.

She gets a sharp pain in her chest.

VALERIE: Ahhhhhhh

PETER: What mum?

Easing out of the pain.

VALERIE: Nothing. It's just wind.

PETER: Are you sure?

VALERIE: Yes. Lets get one thing straight young man. I have not forgiven you for your behaviour. Don't get too pally pally with me you hear? If I tell you I'm all right, then I'm all right.

PETER: I see.

VALERIE: Pass me my jacket.

PETER: A wise man once said to me 'What's the point in fighting for the dead and killing those who are living?

VALERIE: Sometimes those who are dead have more life in them.

She puts on her coat and exits the stage.

SCENE FOUR

We are back at the McKenna household. It is ten p.m. We hear the front doorbell going ten to the dozen.

VALERIE enters the space in her dressing gown.

The bell keeps on ringing. She gets a little worried. She decides to call NAVEEN.

VALERIE: Hello Naveen, I'm so sorry to call you at this hour but I'm on my own and someone's at the front door. I'm not expecting anyone. OK see you soon.

VALERIE approaches the door.

VALERIE: Who is it? I won't answer unless I know who it is so you can ring all night.

JAIME: Valerie it's me, please open the door.

VALERIE realises that it is JAIME but does not move.

JAIME: It's cold and wet out here. Please.

VALERIE slowly undoes the chain and bolt and opens the door. VALERIE quickly walks back into the front room. JAIME enters a little after her. She is soaking wet and looks freezing. VALERIE switches on the light. The place is a tip.

VALERIE: You look a mess.

JAIME: Do I?

VALERIE: Yes you do.

She looks at her then leaves the room for a moment and comes back in with a towel.

VALERIE: Here.

JAIME: Thank you.

She takes it and starts to dry her hair. She attempts to explain her presence.

JAIME: I was walking past the house and as it was a year since John… I just didn't want to walk past and not say hello.

VALERIE doesn't say anything at first.

VALERIE: Well you've said it now!

JAIME: Don't be cold with me Valerie, I really need you not to be cold.

Silence.

VALERIE: *(Still without warmth.)* You gonna just sit there in your wet clothes?

JAIME: I don't have anything else to put on.

VALERIE: Use some of your father's, I'm sure he won't mind. I'm going back to bed. Let yourself out when you're ready.

JAIME: I'm thinking about trying to find my birth mother, what do you think?

VALERIE looks at her sharply.

VALERIE: The one that left you on the steps of the hospital?

JAIME: Yeah!

VALERIE: If you think you need to do that go ahead. I've no more pain to get from you Jaime.

JAIME: I don't want to give you pain. You're the only one that can answer…

VALERIE: Go to your birth mother na. You and her is same people right?

JAIME: Why did you adopt me Valerie?

VALERIE: Since when have you and I been companions child?

JAIME: Pardon?

VALERIE: Since when do you address me as Valerie?

JAIME: *(JAIME loses it.)* Since you stopped being my mother.

Unbeknown to VALERIE and JAIME, PETER enters the house and stands watching the women argue.

VALERIE: You walk out of this house, you walk on your family and then you have to nerve to tell me that I stopped being your mother? How dare you. You West Indian children are too damn fast with yourselves?

JAIME: Listen to you. West Indian! You know what I think. I think you adopted me because you wanted to fuck me up the way they've fucked up West Indians.

VALERIE: Don't come in here and swear at me.

JAIME: After what you have done to me you have a cheek. You have messed me up Valerie. That's the truth. I'd have been better off left on the steps.

VALERIE: That's the thanks I'm gonna get? You ungrateful little…

JAIME: You see, you see. They shouldn't have allowed it Valerie. You purchased me. You only wanted me to show the world that you're as good as them. That's the truth isn't it?

VALERIE: How dare you accuse me of that?

JAIME: I'm not accusing you.

VALERIE: Jaime go, if you have come here to provoke my soul go. Come out.

JAIME: I came here for help because I need answers and all you tell me is come out me house? Aren't you tired of that one yet?

Flashes of temper.

VALERIE: No I'm not. This is what I have. I've paid for it with sweat and blood and God's grace. Get out of my house. Go and find the bitch that gave birth to you na. See if because you and her share the same blood if you have anything else in common.

PETER enters the room. Calmly and coolly he says:

PETER: You heard my mother, Come on Jaime.

VALERIE: What are you doing sneaking up on people?

JAIME: *(To PETER.)* I just came here to talk.

VALERIE: To cause confusion you mean.

PETER: My mum's asking you to leave.

JAIME: Peter.

PETER: That's not my name. Now Jaime before I have to physically remove you from this house, please leave.

JAIME: You wouldn't put your hands on me, not in the house I grew up in?

PETER: Yes I would.

VALERIE gets a sharp pain in her chest. She holds it. She suddenly loses all strength in her legs and falls to the floor.

JAIME: Are you all right?

PETER: Mum!

VALERIE: *(To JAIME.)* As if you care. Stop you all stupidness. I'm all right.

JAIME: You don't seem right to me Valerie.

VALERIE: Listen don't let me have to tell you people again that I'm....

She gets another seizure. She screams and falls back to the ground.

JAIME: Oh my god.

PETER and JAIME stand paralysed for a moment.

JAIME: Mum? Mum? Can you hear me?

VALERIE doesn't respond. JAIME checks pulse and breath.

PETER: Is she all right?

JAIME: I don't know, pass me the cushion. Quick.

PETER: I'll call an ambulance. Hello could I have an ambulance please at 25 Grantham Rd.

At this point NAVEEN and WILLARD enter.

NAVEEN: I think she was worried there might be an intruder.

They see VALERIE.

WILLARD: What's happened?

JAIME: She just collapsed. Peter's called an ambulance.

WILLARD: I'll get a duvet.

JAIME: OK Mum, we're gonna make you comfortable.

NAVEEN walks away and dials a number on his mobile.

NAVEEN: Hello, news desk... Yes hello, this is Naveen Patel, representative of the McKenna family. Yes well Mrs. McKenna...

PETER: Ambulance is on it's way

NAVEEN: ...has just had a heart attack, an ambulance will be here soon, maybe you might want to get some photographers down here?

JAIME screams at NAVEEN.

JAIME: Naveen you can't, that's disgusting, it's no time for the press.

NAVEEN: I'm afraid it is Jaime. Why do you think she got this heart attack? The world needs to know. It'll help our cause.

JAIME: Tell him he can't get the press over to see Mum like this.

NAVEEN: Hello Newsdesk, Yes hello, this is Naveen Patel, representative of the McKenna family... Yes well Mrs. McKenna has just had a heart attack, an ambulance will be here soon, maybe you might want to get some photographers down here?

JAIME leaves her mother's side and runs up to NAVEEN attempting to take the phone away from him.

JAIME: Give me that phone, I said give me that phone.

As they struggle WILLARD puts the warm towel on VALERIE's forehead.

JAIME: I'll not have you prostitute her like this.

NAVEEN explodes.

NAVEEN: Can you not see that what I am doing will help? This kind of media attention can only bring weight to bear on the authorities. They put her here! We need to show them that. If Valerie were conscious, she would want to me do this. Guys, I need you more than ever right now to see the big picture?

JAIME: Naveen there are lines of decency that should not be crossed. This is one of them.

NAVEEN: Justice is dirty work. We are taking here about the straw to break the jury's back. We'd miss this opportunity why? Because we didn't have the courage to seize the day I couldn't live with myself if that were to happen?

PETER takes the phone from JAIME and hands it to NAVEEN. As he is exiting the house we hear him back on the phone.

NAVEEN: Hello, is this the newsdesk? Yer, if I were you I'd get your photographers here as soon poss. Valerie McKenna has just had a heart attack. Ambulance is on it's way.

He slams the door on his exit. We hear the sound of the ambulance approaching. JAIME goes back to her mother's side.

JAIME: They're coming mum, everything will be all right.

Lights Out.

SCENE FIVE

We are in the front room of the family home. Most of the furniture is packed away in boxes or covered over. The house has been sold and they are ready to move. JAIME wheels her mother on in a wheelchair. VALERIE has a notepad and pen, and a handkerchief to wipe the side of her mouth with. Her voice sounds very weak and she paralysed on one side. She can hardly speak.

JAIME: Everything's packed up and the removal men will be here soon.

VALERIE looks at her child. She looks sad.

VALERIE: Your father.

JAIME: He phoned from the court, he said everything was everything. They should be here now but then again you never know with those two.

Beat. She doesn't answer.

JAIME: Tomorrow all these years of memories will be gone. Our spirit won't own the new house. When I walk into the front room I won't see dad dancing to his Soca tapes, John cooking in the kitchen... Mummy I so want to wave a magic wand and have everything the way it was.

Enter WILLARD.

JAIME: Hi Dad. How did it finish in court today?

WILLARD: OK I think. The prosecution will complete tomorrow, then we go see.

JAIME: Where's Peter?

WILLARD: Kwaku.

JAIME: Sorry Kwaku.

WILLARD: Parking the car. Everything ready to leave?

JAIME nods. He walks up to VALERIE.

WILLARD: How are you today Val?

She nods her head.

VALERIE: Fine.

She attempts to continue but WILLARD stops her.

WILLARD: Don't try to talk Val, write it down.

She starts to slowly write. Enter PETER. We can see he's a distraught young man. He sees JAIME, they greet each other cordially.

JAIME: Hey Kwaku.

PETER: Jaime.

He bends over and kisses VALERIE on the forehead. She feels his pain more than ever.

VALERIE: How's it looking?

PETER: Don't you worry mum I've got everything under control. I've set up an all night vigil at outside of the court tonight, they'll be demonstrations all day tomorrow from Peckham to Tottenham. The jury will have to find them guilty or else they'll be…

VALERIE: … Sssssshhhhhh *(VALERIE cuts him off and indicates to him to go and get.)* Your father's rum.

WILLARD: How you know where I does hide me rum?

VALERIE attempts to kiss her teeth.

VALERIE: I dream John.

WILLARD: You did?

VALERIE smiles from cheek to cheek.

WILLARD: That's great Val.

PETER returns with the rum. She beckons WILLARD over to her and gives him the rum and notepad.

VALERIE: Bless the house.

He reads VALERIE's words at first while sprinkling some rum around the house. But after a sentence or two he stops and continues from his heart.

WILLARD: Dear Lord any wrongs that I may have done, remove them from the path of my family. Rebuke the hate, confusion, lies and denials that have beset us. Heal us. Be with us as we leave this place. And whatever family inherits this house, let them find the peace we once had.

He finishes the libation. They're ready to leave.

WILLARD: You ready?

VALERIE nods her head. He fixes her coat and they turn and exit the house.

The End.

THE FAR SIDE

Laying Ghosts to Rest

The racist murder of Stephen Lawrence in 1993, and the following high profile police investigation, the subsequent court trials, and the Macpherson Inquiry (1999) into the failings of these confirmed that the Metropolitan Police were beset by institutional racism. These events, a grim watershed in British history, have continued to haunt black playwrights in Britain; so much so, that the crime has become a grand narrative, one in which, the issues of race and identity are (re)played both overtly, and implicitly as a backdrop to the plays.[1] It is a grand narrative that resonates with Aristotle's original model for tragedy – the police investigation replete with heroes and heroines, villains, fatal flaws, and reversals of fortune. With the murder conviction of two of the five suspects in 2012, a conclusion of sorts was effected (rather than closure), while the chance for a complete resolution still remains as an open-ended drama.

This case has influenced the direction, aesthetics and development of contemporary black drama, giving rise to a new genre of black plays in which the main focus is on a black (invariably male), youth or youths, often a generic hoodie (who serves as a shorthand or visual cue for youth disaffection or anti-social threat), in whom the roles of victim and perpetrator are conflated.[2] The male youth is usually placed in a position of danger, the dramatic tension being derived from the desire of other characters to either save him from a life of crime such

1 Macpherson concludes, 6.34 'Institutional Racism' consists of the collective failure of an organisation to provide an appropriate and professional service to people because of their colour, culture or ethnic origin. It can be seen or detected in processes, attitudes and behaviour which amount to discrimination through unwitting prejudice, ignorance, thoughtlessness, and racist stereotyping which disadvantage minority ethnic people (Macpherson, 1999: Chapter thirty-six; n.p).
2 In her production of Agyemang and Elcock's *Urban Afro Saxons* (this volume), director Paulette Randall employed enigmatic hooded youths as silent presences who pass fleetingly across the stage at certain points in the play but never interact with the characters. See Osborne's critical introduction and interview with Agyemang and Elcock in this volume that refers their symbolism.

as Ashley in *Elmina's Kitchen* (2003) by Kwame Kwei-Armah, or, to bring about justice in order to atone for his death such as Emile in *Fallout* (2003) by Roy Williams. Taking a different angle, debbie tucker green's *random* (2008) follows the arc of a Greek tragedy. The audience is provided with clues to deepen the sense of foreboding regarding the fate that awaits Brother who will be killed in an act of random violence. However, it has to experience the excruciating tension of waiting as the account of a day unfolds, filtered through the joy of an ordinary family's mundane activities.

There is another key trope in plays of this genre, the appearance of the ghost of the black youth who returns from the dead in order to persuade the living to avenge him by bringing those responsible for the killing to justice. My own play for young people, *Can you Keep a Secret* (1999a) dramatizes a young boy (who has been murdered by a racist), returning as a ghost. The ghost of the boy tries to persuade the murderer's girlfriend who witnessed the event to speak against her boyfriend in court. Similarly, in *Blacklands* (2011) by Levi-David Addai (winner of the Alfred Fagon Award of the same year), a youth killed after a fight over a trivial matter re-visits the world he has left behind, in order to make the youths who killed him atone for their crime.[3] The implicit message is that justice cannot be gained in a judicial system without an almost supernatural intervention to provide the momentum.

The genre sets up very clear oppositions of good versus evil. It has heralded a shift from plays that examined the various oppressions of the black community and reactive anger, to plays that explore the way in which anger has been turned inward on the community itself resulting in 'black on black' violence. This mirrors the shift in media coverage that has occurred in the years since Stephen Lawrence's death where racist murder is given

[3] Mojisola Adebayo's *Desert Boy* commissioned by Nitro and directed by Felix Cross has the wounded youth open the play but then embark upon an odyssey of history reclamation aided by griots, anansi figures and the spirits of ancestoral figures. (*Plays One* London: Oberon 2011) In Bola Agbaje's comedy *Gone Too Far* (London: Methuen, 2007) where the youth does not die for, as the comedy genre prevails, he recovers from his wounds. Che Walker's *Frontline*, where the black youth character dies of wounds centre stage is an example of the genre written by a non-black British playwright.

relatively minor media attention (not withstanding those few highly reported cases such as the murder of Damilola Taylor), compared to the major profile stabbings and shootings of young black men by young black men.[4]

At first glance Courttia Newland's play *The Far Side* adheres to the genre outlined above. It begins two years after the racist murder of Black Youth Danny who was killed by White Youth, Luke. Newland's chessboard-like oppositional naming endows the two characters with a distinctively adversarial quality and also evokes a personalization of the pair as they have first names rather than simply a sociological category of 'youth'. Set in a warehouse in present day central London, the play opens with a monologue by Danny's ghost narrator who functions as Chorus, witnessing and commenting on the play's events. As these 'youth as knife crime victim' plays are more often than not realistic, one of the significant aspects of Newland's play is its resistance to realism. Indeed with its dream-like or nightmarish quality, the play seems to owe its style more to expressionism or the ghost story. Any expectations for the plot to develop along certain familiar media lines or for character to be revealed as part of plot are thwarted. The setting itself is both nowhere and everywhere, the characters allegorical. It becomes apparent that there is no real evidence that Chamberlayne is an existing borough of London (although Chamberlayne Road is a well-known North-West London street). It could well be that for gang members in the world of this play boroughs are broken down into smaller territorial units, so that a single road can be under the ownership of a particular gang – which would explain the naming of Chamberlayne as a specific area. Influences are detectable from a number of dramatic heritages. There is a nod to Jean Paul Sartre's *No Exit* (*Huis Clos*) in the group of characters, citizens, who arrive at the warehouse having been summoned by unseen Bosses who have put the Chairman in charge of them. They will act as jury in a Kangaroo Court where Luke, who was acquitted of Danny's murder, is to be put on trial. The play also alludes to another courtroom

4 Lynette Goddard has argued the opposite point of view, that murders of black youths are overwhelmingly perceived as gang-related and therefore low status whereas when a white youth is murdered, the press coverage is extensive (Goddard 2009).

drama, Reginald Rose's *Twelve Angry Men* where members of a jury deliberate over the guilt or otherwise of a young man charged with murder. Much of the pleasure of courtroom-based drama based upon two sides presenting a case for judgment lies in the absorbing adversarial struggle to arrive at the truth, so it is notable that in Newland's play we are not made privy to the deliberations of this jury. This is another way in which the play resists the 'dead young black male' genre. The reason that we do not witness this event is because the play is not only examining the morals of the youths. It is the jury members themselves who are really being scrutinized, not to mention the two mothers of the youths. The generic names given to the adult characters suggest the way in which the older generation is dependent on the younger for their livelihoods, that they have some responsibility (as Danny later suggests) for producing their failings. Naming Dole Worker, Youth Worker, Nurse and Nightclub Owner suggests the relationship between youths and the older generation, by marking out the narrow parameters within which the youths are allowed to exist.

This new genre has inherent dangers – the proliferation of plays in which young black men are portrayed either as murderers or victims of murder runs the risk of consolidating racial stereotypes. *The Far Side* confronts this possibility head-on, redefining the certainties of race, identity and racism: the oppositions of black and white collapse into each other. Racism – usually straightforward in its suppositions of a black victim and a white racist – is turned on its head when Danny admits that his gang is as racist as Luke's. Indeed, much as they proclaim their differences, there is little that distinguishes Danny from Luke, they are almost like blood brothers. This means that Danny even though he is a murder victim, cannot claim the moral high ground.

In Harold Pinter's plays, characters famously struggle to communicate, and similarly, in *The Far Side* there is much that is left unsaid. At times the tone is absurdist. When the characters argue over custard creams, the unspoken subtext is reminiscent of the famous Pinteresque menace. This may be because Courttia

Newland refuses to adopt simple narratives to explain away or make sense of complex societal changes that cannot yet be explained away.

Winsome Pinnock
(Kingston University)

Characters

DANNY
Black Youth, nineteen

LUKE CRENSHAW
White Youth, nineteen

JASON BONSU
Chairman, thirty-one

LUCY WARNER
Youth Worker, twenty-seven

RONNIE PRICE
Dole Worker, twenty-nine

ARTHUR DOYLE
twenty-nine

ROSE
Black Mum, thirty-eight

ANNETTE WILSON-BROWN
Young Nurse, twenty-three

BOBBY JONES
Unemployed Man, twenty-eight

TILLY CRENSHAW
White Mum, thirty-six

The Far Side was premiered at The Tricycle Theatre, London, in association with The Post Office Theatre on 13 August 2001. The cast were as follows:

DANNY	Leon Barr
LUKE	Daniel Booth
JASON	Jamini Jani
LUCY	Roni Mariqueo
RONNIE	Micheal Palmer
ARTHUR	Dominic Golding
ROSE	Carol Moses
ANNETTE	Romy Bellamy
BOBBY	Akpome Macaulay
TILLY	Sasha Oakley

Directed by Riggs O' Hara
Design by Roma Patel
Lighting Design by Don Atherton

ACT ONE

INT. WAREHOUSE/STOREROOM.

A warehouse somewhere in central London, present day. A lone chair is in the STOREROOM area, to the right side of the stage. A staff room type of set-up – sofa, kettle, and stereo – is on the left side, the TEA ROOM. An upper level denotes the CONFERENCE ROOM, where there's a long table and eight chairs. All is silent, as though the warehouse waits for occupants.

A BLACK YOUTH sits alone in the warehouse, also waiting. After a while, the noise of someone entering the warehouse makes him turn in that direction. A tall man takes the stage, dragging another badly bruised teenage boy with him – the only difference is, this boy is White. The man rushes past the BLACK YOUTH – it's made obvious he can't see him – then he throws the WHITE YOUTH onto a chair and stares at him. His victim is tearful, his clothes battered and torn, his face grimy with dirt.

WHITE YOUTH: Where am I? Wha' you gonna do with me?

The tall man continues to stare at the youth, while his unseen spectator looks on.

WHITE YOUTH: You ain' gettin' away wiv dis, I'm tellin' ya, you ain' gettin' away! When my uncle 'ears about dis 'ee's gonna cut you up mate. Think I don't know 'oo you are?

The tall man slaps the youth, then takes some rope out of his bag and ties him to the chair. When he starts to thrash, the man puts a knife to his throat until he calms down. The WHITE YOUTH sobs.

WHITE YOUTH: Untie me… Un-*fuckin'*- tie-me…

The tall man leans over his victim's shoulder, a finger to his lips.

CHAIRMAN: Sssh… Sssh…

The WHITE YOUTH stops talking, but can't hold back his tears, which leak onto his ripped T-shirt. CHAIRMAN ties him quickly, then walks away from the chair surveying his handiwork. He lights a cigarette, while BLACK YOUTH rubs his hands together in the background, looking eager.

CHAIRMAN: Got you now ain't we? Not so tough in here are you?

WHITE YOUTH: *(Screams.)* I ain' done nuffin' to you!

CHAIRMAN: *(Calm.)* Nah. Not to me you ain't.

CHAIRMAN turns and leaves the STOREROOM, going into the TEAROOM area. He sits on the sofa and spies a magazine. Picking the magazine up, he flicks through it. The WHITE YOUTH thrashes some more, then begins to scream.

WHITE YOUTH: Let me go you bastard, I ain' done nuffin'! Oi! Oi! You're dead, d'you 'ear me? You're dead when my family catch ya, they'll cut ya balls off and feed 'em to ya mate, they fuckin' will! You wait... You wait...

He begins to cry again, loudly. CHAIRMAN goes over to the stereo and switches it on to drown the noise. BLACK YOUTH goes into the STOREROOM and stands over WHITE YOUTH, who continues to behave as if he isn't there.

BLACK YOUTH: My turn now, my yout. My turn now...

WHITE YOUTH ignores him and gasps in pain.

WHITE YOUTH: You better let me go before you fuck things up worse. My uncle... My uncle's gonna kill you... You better let me go! D'you fuckin' 'ear me! Let me go!

WHITE YOUTH repeats this last over and over, while BLACK YOUTH chuckles, then goes back out of the room, to his observation seat. CHAIRMAN sighs, puts his magazine down, goes into the STOREROOM and pulls a rag from his pocket. WHITE YOUTH freezes.

WHITE YOUTH: You're gonna strangle me int ya! Get away from me! I'm sorry, I'll shut up then all right, I won't say nuffin' more...

CHAIRMAN moves slowly towards him.

WHITE YOUTH: Jesus Christ, didn't you 'ear me? I won't say nuffin' more!

CHAIRMAN: I know you won't.

CHAIRMAN takes the final step and gags the WHITE YOUTH, who sags onto the chair in relief. CHAIRMAN smiles at the kid, then walks back into the TEAROOM. He picks his magazine back up, flicks through. BLACK YOUTH gets to his feet and steps towards the audience.

BLACK YOUTH: One time I was in school and we was studying English. I always used to like that subject man. I liked writing short stories and reading books. *Animal Farm... Of Mice and Men... Kiss Kiss.* And even the debates, I used to like the debates you know – no one could test me when it come to dat. I remember that time in my class it was a hot summer's day, all the windows was open, true it was bakin an dat.

I used to love off this one girl called Lizzie. Should have seen her man – dark-skinned – I love dark-skinned girls man, there's suttin about their skin... It's kinda smooth like satin, you know dem ones? Anyhow, I wasn't even paying no attention to what the teacher was saying all dem times, all I was watchin was Lizzie boy. I clocked her till she look my way, then I just –

He winks.

Drop it like a dapper, y'get me? When she smile back, I know I had her on lock man, mind, body and soul! Then Mr Paisley said suttin that made me forget about Lizzie, an for man to take my mind off a gully, you know he said suttin deep. He said – what was it? 'Revenge is a dish best served cold'. An I had to stop and think about dat. At the time I thought, nah; but now I don't know man. Now I think I kinda like revenge.

BLACK YOUTH exits the stage. Moments later, two people, a man and a woman enter the room. They are DOLE WORKER and YOUTH WORKER respectively. They come into the warehouse at the end of a joke DOLE WORKER has just told.

YOUTH WORKER: Oh, that was disgusting, you ought to wash out your mouth...

DOLE WORKER: Ah, but it was funny wasn't it?

YOUTH WORKER: Bloody hilarious... Hold on... Hello! Hello, is anyone home!

She giggles, while CHAIRMAN switches off the music.

Listen to me, home. You'd think someone lived 'ere.

DOLE WORKER: How d'you know someone doesn't?

CHAIRMAN: *(Calls.)* Hello! I'm in the Conference room!

YOUTH WORKER: Oh well, 'ere we go...

DOLE WORKER: I still don't like the idea of this, I tell you...

They go into the TEAROOM.

DOLE WORKER: Hello.

YOUTH WORKER: Hello.

CHAIRMAN: All right early birds! What brings you two so fast?

YOUTH WORKER: The number 53. Came on time for once...

CHAIRMAN: Wonders will never cease... I knew the world was coming to an end... First it was the ozone layer... Then global warming... Now the 53 bus is on time.

DOLE WORKER: Tonight the sea level will rise and drown us all.

YOUTH WORKER: Well at least it'll wash the leaves from the train lines. Tea anyone?

CHAIRMAN: You sit down I'll make it. Jesus, you just come in and you're off.

He guides her to the sofa.

YOUTH WORKER: I've got to keep busy. I've a restless nature you know. Can't keep still for a minute me. My mum reckons it's cos she got stung by a bee when I was in 'er belly.

Both men look at her strangely.

YOUTH WORKER: Don't look at me like that, it's the God's honest truth! When I was three months old my mum got stung in 'er belly by a bee. She went mad, what wiv being pregnant and all that rubbish, so she rushed down the hospital, belly all red and swollen, crying and screaming that she was gonna lose me... The doctor assured her I was fine, but up to now she still insists my restlessness is all down to that bloody bee.

CHAIRMAN: *(Grinning.)* Was she hurt? Or did her waters shield her from the sting?

YOUTH WORKER: What d'you reckon?

She notices his grin.

Oh, piss off, you ain't funny.

DOLE WORKER: You asked for that…

YOUTH WORKER: And you're supposed to be on my side!

CHAIRMAN hands out the tea. They sip at the brew until, in the STOREROOM, WHITE YOUTH begins to thrash again, banging his chair against the floor.

DOLE WORKER: What was that?

CHAIRMAN: What?

YOUTH WORKER: That banging sound?

CHAIRMAN: I didn't hear anything.

DOLE WORKER: I'm sure I heard something.

WHITE YOUTH thrashes again.

YOUTH WORKER: There! Hear it?

It's too obvious for the CHAIRMAN to dismiss anymore. He gets to his feet.

CHAIRMAN: I'll check it out. Back in a sec.

He leaves the TEAROOM and walks into the STOREROOM, his expression growing more menacing as he approaches his captive. WHITE YOUTH freezes in fear as CHAIRMAN produces the knife.

CHAIRMAN: One more noise… Do me a favour, go on.

WHITE YOUTH's eyes are wide in fear. DOLE and YOUTH WORKER talk in hushed tones.

DOLE WORKER: What do you make of him then?

YOUTH WORKER: Seems all right. He's better than the last one already. Right sexist bastard he was. Used to stare right through my clothes.

DOLE WORKER: I don't blame him. Human int he?

YOUTH WORKER: Shut up you! Anyway, this guy seems friendly enough.

DOLE WORKER: Yeah. I recognize him, dunno where from though.

YOUTH WORKER: I think he works for the council. Maybe you've seen him in the town hall.

DOLE WORKER: He better sort out that noise. No one's supposed to know we're here.

CHAIRMAN comes back.

YOUTH WORKER: What was it?

CHAIRMAN: Someone in the building next door. I think they've left now.

He sits back down, looking relaxed and comfortable, and addresses DOLE WORKER.

CHAIRMAN: So! First time is it?

DOLE WORKER: Yes. My very first time. Suppose that makes me a virgin, right?

CHAIRMAN: If you're a virgin, I was born by Immaculate Conception.

DOLE WORKER: No, I meant –

CHAIRMAN: I know, only joking. Welcome aboard. You must be Ronnie, right?

They shake. YOUTH WORKER busies herself getting out biscuits from her bag as they talk.

DOLE WORKER: That's right. And you are – ?

CHAIRMAN: Jason. Jason Bonsu.

YOUTH WORKER: You're the chairman then?

CHAIRMAN: *(Smiles.)* That's right.

DOLE WORKER: So Jason, any idea what happens next?

CHAIRMAN: Yeah... We wait for the others to arrive. Won't be long now I reckon, none of them have got far to come.

YOUTH WORKER: Biscuit anyone?

DOLE WORKER: What are they?

YOUTH WORKER: Custard creams and Wagon Wheels.

CHAIRMAN: Put 'em out on a plate, so the rest can help themselves when they come.

YOUTH WORKER: Will do...

YOUTH WORKER does this and places the plate on a small coffee table. She takes two custard creams and sits on the sofa.

YOUTH WORKER: Amazing thing about custard creams... They transcend everything; gender barriers... racial barriers...social deviants... No matter who you are, where you come from – everyone loves custard creams...

DOLE WORKER: That's not true.

YOUTH WORKER: Who says?

DOLE WORKER: Well I do dun I? While, yes, I do admit that people of all persuasions eat custard creams, I wouldn't go as far as to say everyone loves them.

CHAIRMAN: Well they have them all over the world.

YOUTH WORKER: Yeah!

DOLE WORKER: No they don't; they don't have them in America.

CHAIRMAN: Yeah they do.

DOLE WORKER: No they don't; they have – uhhh...uhhh...

The men sit, heads bowed, straining to think. YOUTH WORKER shakes her head.

YOUTH WORKER: Oreo's... Idiots...

CHAIRMAN: That's it! Oreo's. See, I told you they got 'em.

DOLE WORKER: You didn't. You said custard creams.

CHAIRMAN: Listen mate, its two bits of biscuit, stuck together with a blob of creamed custard innit? Ain't that a custard cream? If not, what is it?

DOLE WORKER shrugs.

CHAIRMAN: Exactly!

YOUTH WORKER: Which proves the earlier point I was attempting to make! Everybody loves custard creams!

DOLE WORKER: *(Sarky.)* Well done!

She pulls a face, but it's obvious she's joking. They sit in silence for a moment, drinking their tea and crunching biscuits. YOUTH WORKER addresses CHAIRMAN.

YOUTH WORKER: So you got the first call?

CHAIRMAN: I think so. Got it three weeks ago.

DOLE WORKER: Three weeks! That's bloody ages ago.

CHAIRMAN: Well, I suppose it takes more preparation to chair the whole thing.

YOUTH WORKER: I only heard five days ago.

DOLE WORKER: I heard three.

CHAIRMAN: I'm not being rude or anything, but what do you need more time to do?

YOUTH WORKER: Live our lives perhaps? You know, we aren't the sole property of this town, at the beck and call of all its whims, as if it was some spoilt little brat. We got families to feed, children to take care of... It's all right for you with your three weeks advance notice, but us...

DOLE WORKER: I don't even suppose you've got kids. You're probably too busy with all this kind of thing.

CHAIRMAN: I've got two actually.

He takes out a photo.

Marcellus and Oscar. Gorgeous aren't they?

DOLE and YOUTH WORKER peer at the photo.

DOLE WORKER: Fine looking lads...

YOUTH WORKER: Aahh, they're lovely...

CHAIRMAN: Yeah, my little men they are. Got big plans for them, they're gonna play for England when they're old enough. You two got any kids?

YOUTH WORKER: *(Quickly.)* Oh, we're not together or anything, we just live close.

CHAIRMAN looks at both.

CHAIRMAN: You're not? Sorry about that.

DOLE WORKER: That's OK, easy enough mistake to make...

CHAIRMAN: *(Slowly.)* Yeah...

DOLE WORKER: Anyway, I've got two girls and Lucy's got two boys and a girl.

CHAIRMAN: Do they all go to Chamberlayne Wood?

YOUTH WORKER: Yeah, apart from me youngest. She's only five. She'll go when she's old enough.

CHAIRMAN: Good school... Good school. I went there, didn't turn out too badly.

DOLE WORKER: Yeah, it's not so much the teachers as the kids I reckon. No discipline or manners, especially around here. Kids have got nothing to do with themselves, nowhere to go. They get bored and restless, then they make mischief.

CHAIRMAN: I blame the parents myself. You gotta take kids in hand, be prepared to show them what's what. Always be firm but fair, that's my motto.

DOLE WORKER: Wait until those little ones are teenagers, then come and tell me that.

YOUTH WORKER: Yeah you, you grew up around 'ere. What were you like when you were sixteen? Not so different from the kids around 'ere now I imagine.

CHAIRMAN: Ah, but I was different. I had respect...

A suavely dressed man enters. He wears the latest designer gear and carries a plastic bag with cartons of orange juice and plastic cups. This is NIGHTCLUB OWNER. He takes stock of the building and its occupants.

NIGHTCLUB OWNER: Nice... Reservoir Puppies...

He looks towards DOLE WORKER.

Who are you, Mr Pink?

DOLE WORKER looks offended.

DOLE WORKER: What's your problem?

NIGHTCLUB OWNER: Only kidding mate, don't take me seriously.

CHAIRMAN: *(Dour.)* Evening Arthur... Thanks for coming...

NIGHTCLUB OWNER: Jason...

NIGHTCLUB OWNER walks over to the table and starts putting out the orange juice and cups. He offers his hand and introduces himself to DOLE WORKER, then YOUTH WORKER.

NIGHTCLUB OWNER: Arthur Doyle. Like the writer.

DOLE WORKER: Ronnie Price...

YOUTH WORKER: Lucy Warner...

NIGHTCLUB OWNER: Well, this is all nice and cosy innit? Your choice Mr Chairman?

CHAIRMAN: They use the same place all the time as far as I know.

YOUTH WORKER: Nice and warm, I didn't think it'd be so hot in 'ere. Warmer than me 'ouse.

NIGHTCLUB OWNER: Do a nice little conversion in 'ere you could, one ah them open plan, New York apartment jobs nah what I mean? Have ya jacuzzi in the back room, bedroom somewhere up there... Invite your closest mates and the sauciest women you know, the best DJs, the deadliest bit ah coof and ya away mate. Hollywood, west London. Knew some geezer up East who did that, fuckin' place was like a mansion, remote control gates, intercom, video system, massive fuck off rottweilers... Had to put the dogs down, buggers got loose and ran down the street, bit some cable worker on his arse, poor bastard. Give 'im thirty stitches I heard... Tea anyone?

They all stare a moment.

YOUTH WORKER: No ta, we just brewed a round.

NIGHTCLUB OWNER busies himself making his own cup of tea.

NIGHTCLUB OWNER: So, how you doing Jase? Don't see you around much these days.

CHAIRMAN: Ah, just keeping myself busy and working hard, that's all. Trying to build something to leave my children.

NIGHTCLUB OWNER: Saw your sister the other day. On the high street.

CHAIRMAN says nothing, face tight.

NIGHTCLUB OWNER: We had quite a long chat actually. Never spoken to her before, but we were in the chemists and I was buying some...

Looks at LUCY.

THE FAR SIDE: ACT ONE

You know, some protection... Anyway she noticed what I was buying and she made some joke, right dirty it was, bloody shocked me, I didn't realise your sis was like that. We was chatting for ages mate, and she told all about your plans, you little Rockafella. 'Ere, I should marry into the family while I still got time, eh? Wha' d'you reckon Jase?

CHAIRMAN simply looks at NIGHTCLUB OWNER. He doesn't seem happy. NIGHTCLUB OWNER realizes he's gone too far.

NIGHTCLUB OWNER: That was a joke! I was kidding, I don't really wanna marry your sister mate; not that she ain good enough, she's a stunner, but she's not the type of girl you *marry*... Oh mate, I'm putting my foot right in it ain I?

CHAIRMAN suddenly laughs.

CHAIRMAN: Jesus, some people don't change! Actually, I'm glad you're here. I need some help setting up the conference room. Fancy giving me a hand?

NIGHTCLUB OWNER: Little bastard, making me think you was pissed wiv me! Course I'll help ya! Been looking forward to this lark for the last two days!

CHAIRMAN: Back in a minute you two. If anyone else turns up, tell them to make themselves at home.

DOLE WORKER: No problem.

CHAIRMAN and NIGHTCLUB OWNER head to the upper level CONFERENCE ROOM. Once there, they set out pads, pens, and water jars. In the TEAROOM, DOLE and YOUTH WORKER sit staring at each other. YOUTH WORKER smiles. DOLE WORKER rushes to the sofa where she's sitting and embraces her. They grapple at each other until she pushes him away.

YOUTH WORKER: You're mad...

DOLE WORKER: I couldn't take it any more, you sitting over here and me over there. I need you. How are we going to get through this?

YOUTH WORKER: *(Hisses.)* By being sensible and not acting like a couple of alley cats! Supposing one of them sees us? Have you thought about that?

DOLE WORKER: Of course I have.

YOUTH WORKER: Well I ain convinced by your actions! All you have to do is act normal for one night, and then we never have to see these people again. Now I'm not sure how you feel about your family, but I've a lot to lose! I'm not kidding, we can't risk getting caught tonight.

DOLE WORKER: I miss being with you. *Really* being with you.

YOUTH WORKER: *(Softer.)* I miss you too... But you said you were OK on the bus and now we're here it worries me... Why do things have to be so difficult?

DOLE WORKER: It's OK. I won't let us get caught. I promise.

YOUTH WORKER: Don't do that!

DOLE WORKER: What d'you mean?

YOUTH WORKER: Don't you go promising anything, we both know what'll happen! I promise I'll spend more time. I promise not to talk about Sandra. I promise not to forget Valentine's Day *again*. All those promises and what do they amount to?

She spits.

About as much as that bit of spit in the air.

DOLE WORKER: I wish you wouldn't do that.

YOUTH WORKER: *(Smug.)* Well I wouldn't have to if you managed to keep promises.

DOLE WORKER holds his hands up.

DOLE WORKER: All right – all right, I'll make it up to you. I'll get through this somehow and then we'll go away somewhere...

YOUTH WORKER: Ronnie... You know we can't...

CHAIRMAN and NIGHTCLUB OWNER are chatting as they come down the stairs. They seem friendlier now. DOLE WORKER runs back to his old seat and attempts to look nonchalant. WHITE YOUTH reacts animatedly as he hears the men's voices, but they walk past and head back to the TEAROOM.

NIGHTCLUB OWNER: Yeah mate, we 'ad eight hundred ravers, all giving it the large to the sounds of Sphere, ruffest DJ in

the world, you mark my words. He's only coming up but he's coming strong. The smart money's all over the git.

CHAIRMAN: How long's that been running? A year? Two years?

They sit.

NIGHTCLUB OWNER: Oh, more like three mate. Bigger and stronger all the time.

CHAIRMAN: I remember when you bought that building.

NIGHTCLUB OWNER: Yeah, you do innit? Oi, tell 'em Jase, before I owned that place, what was it like? Go on, tell 'em.

CHAIRMAN looks as though he's sorry he's said as much.

CHAIRMAN: *(Hesitant.)* It was an old butcher's or something wasn't it?

NIGHTCLUB OWNER: That's right. Go on mate.

CHAIRMAN: *(Sighs.)* You fixed it up innit?

YOUTH takes an interest.

YOUTH WORKER: Sorry, I missed all that, what is it you own?

NIGHTCLUB OWNER: A club. I own a nightclub, though I dunno why it was so 'ard for 'im to tell yuh that.

DOLE WORKER: I always wanned to own a club.

NIGHTCLUB OWNER: Every man's dream you mark my words, but few ever make it a reality...

DOLE WORKER: Right...

NIGHTCLUB OWNER: You shoulda seen the place the first time I did. Blood everywhere, rotting bits of meat still hung up in the massive freezer at the back – fuckin terrible. We knocked the whole place down and now we got the hottest club in Chamberlayne, right where all the dead meat used to hang.

He smiles.

I love irony. You know – the freezer used to be packed with dead meat, nowadays it's a packed meat market. Fuckin love it.

CHAIRMAN: Yeah, my sister goes there sometimes. Says it can get right seedy.

CHAIRMAN's baiting NIGHTCLUB OWNER.

NIGHTCLUB OWNER: Well there's no accounting for a decent lady's taste, though I noticed she 'ad taken a shine to our Gareth, one ah the weekend bouncers.

Says last with a straight face.

Maybe she likes a bit ah seed...

CHAIRMAN sits bolt upright while the others either cover their mouths, or try not to laugh. NIGHTCLUB OWNER looks off into space, as if his thoughts are elsewhere. CHAIRMAN looks at NIGHTCLUB OWNER with hate in his eyes until BLACK MUM walks into the warehouse. She pauses at the sight of everybody. YOUTH WORKER waves as if they're all on a camping trip.

YOUTH WORKER: *(Waving.)* Oh 'ello, you all right there luv?

BLACK MUM stares. CHAIRMAN turns around and sees her.

CHAIRMAN: Rose! Rose, how are you?

She walks further into the room, her eyes vacant. The others, even NIGHTCLUB OWNER, have fallen silent. CHAIRMAN stands and greets her royally.

BLACK MUM: So this is it...

CHAIRMAN: You've never been to one of these before?

BLACK MUM: Never had cause to.

CHAIRMAN: Well, that's true. Take a seat, make yourself at home. Would you like some tea, coffee, orange juice?

BLACK MUM: I'd like a glass of water please.

CHAIRMAN: No problem.

CHAIRMAN gets out a bottle of water while BLACK MUM sits on the sofa. She's quite fidgety, yet regal, something that the others can't fail to notice.

YOUTH WORKER: Nice and warm in 'ere innit?

BLACK MUM: Yes. Yes it is.

YOUTH WORKER: I didn't expect it to be so warm, the way it looks.

To NIGHTCLUB OWNER.

Your club must've been like that.

NIGHTCLUB OWNER: I suppose it was. Still gets cold when there's no one in it though.

DOLE WORKER turns towards BLACK MUM.

DOLE WORKER: Come on the 53?

BLACK MUM: *(Deep breath, as if talking is a major effort.)* No. My brother dropped me here. He'll wait until it's over then take me home.

DOLE WORKER: That's good of him.

BLACK MUM: He's a good man.

CHAIRMAN comes back with the glass of water and hands it to the woman, who nods gratefully.

CHAIRMAN: We're just waiting for the others to arrive. As soon as they're here, we can get started.

BLACK MUM: *She* hasn't come yet?

CHAIRMAN: No, not yet. But she definitely got a call. She'll be here.

BLACK MUM nods, sombre.

CHAIRMAN: Let me show you around. The conference room and where everything is.

She nods again and gets to her feet. CHAIRMAN slowly leads her to the steps, talking while he goes. He takes her to the CONFERENCE ROOM. The others talk mutedly in the TEAROOM.

CHAIRMAN: As you'll see, we've taken a lot of care with the seating arrangements, and on behalf of the bosses we hope you're happy with the way they are. If there's any problem, please let me know...

NIGHTCLUB OWNER: So. There she is.

BLACK MUM: Wherever they are is fine with me as long as I'm far enough from Tilly Crenshaw.

YOUTH WORKER: Amazing women. Dunno how she can stand it.

BLACK MUM and CHAIRMAN continue to talk, but their actions are mimed and the focus is on the TEAROOM.

DOLE WORKER: She's strong, that's how. Stronger than I'd be, I know that for a fact.

YOUTH WORKER: Yeah, but can it last? After all, the human body and mind can only take so much.

DOLE WORKER: *(Smiling.)* Oh, 'ere we go...

YOUTH WORKER gives him a small grin, but lets it go.

NIGHTCLUB OWNER: Well, if that's the way God tests you, I must've failed mine years ago mate – I'm telling yuh, I can't just can't let things go. I remember one time I was running an Amusement Arcade up West for this idiot who'd won it on the cards. Trouble was, that was the only bit ah luck the cards sent 'im – every other time he played, he lost everything he owned and then some. Course, this tended to make his fellow players very happy, until he ran out of money and eventually started owing. Trouble was, this cunt – beg yuh pardon, s'cuse my French – this geezer – neglects to tell me that he was ten thousand pounds, his car and his fuckin' council flat in debt didn't he? Instead he does a runner quicker than Linford, leaving muggins 'ere locking up one dark night, only to face four of his many 'acquaintances', all looking for money or blood. Luckily, one of the goons recognised me from me younger days – he used to go to school wiv me cousin or something. He convinced the others that my former friend's debts were in no way anyfing to do wiv me, and so, there was no reason for me to be punished.

He shrugs.

Then they let me go.

There's another long silence as his listeners take a second to digest this. Then:

DOLE WORKER: That's got absolutely *nothing* to do with anything we was talking about.

NIGHTCLUB OWNER: *(Slowly.)* ...Yeah it has...

YOUTH WORKER: Nah it hasn't. We were saying how strong that Rose is and you start going on about amusement arcades and Vinnie Jones look-a-likes. One ain' got nothing to do with the other.

NIGHTCLUB OWNER: Well if you'd let me finish the bloody story…

The 'listeners' react with horror.

DOLE WORKER: Jesus, you mean there's more?

NIGHTCLUB OWNER: Oh that's charming that is, I can *feel* the community spirit *oozing* out ah the both of yuh. I'll keep my stories to myself then shall I?

DOLE WORKER: All right, I apologise mate, that didn't come out quite like I meant. I just thought you'd made your point. Go on.

YOUTH WORKER's looking daggers at DOLE WORKER, but he ignores her and concentrates on making NIGHTCLUB OWNER feel at home. NIGHTCLUB looks a little upset, unsure whether he should continue or not. It's clear he would like to.

NIGHTCLUB OWNER: Are you sure?

DOLE WORKER: Course we are. Aren't we Luce?

She shoots him a terrible glare.

YOUTH WORKER: Yeah. Sure. I'm all ears.

NIGHTCLUB OWNER ignores her sarcasm. One eager listener is better than none. He continues.

NIGHTCLUB OWNER: What I was *saying*, was that three years later I'm over Stratford sides, and I'm strolling down the high street wiv me bird, when who do I see but this – geezer – driving a Lexus through the rush hour traffic wivout a care in the fuckin world. An there's me standing shocked in the middle of the high street, while me bird keeps walking and nattering a mile a minute about some snakeskin boots she saw three shops back… And I'm watching this guy who nearly got me *killed*, drive past in a car that cost four times more than me 'ouse!

Quieter.

Then I realised the lights had changed and the guy had stopped, hanging his arm out the window cos it was summer. I was so happy, I coulda cried at that minute, no word of a lie.

Now his listeners are hooked. They lean forwards in anticipation.

YOUTH WORKER: *(Breathes.)* So what did you do?

NIGHTCLUB OWNER: I chased him innit. While me bird's standing there screaming and asking me what's the problem, I run up to the car, grab him and wrench him right through the fuckin open window mate. Then I threw him on the floor and –

He stops, realising this is not some group of dealers and cutthroats at the local bookies. This is the real world. A world that frowns on his lifestyle. DOLE and YOUTH WORKER sit open mouthed.

NIGHTCLUB OWNER: Well, you can kinda guess the rest. It wasn't pretty I tell yuh. And that's what I'm saying, I could never be as strong as that Rose. I'd be in jail right now wiv me roll ups and phone cards, maybe a little bit ah hash if I can get it. Nah what I mean mate.

DOLE WORKER: Yeah. Yeah.

DOLE clearly doesn't.

NIGHTCLUB OWNER: Well enough about me, what about this lark eh? What d'you reckon, bit spooky innit? Know what you're gonna do yet?

DOLE WORKER: Ain got a clue 'ave we Luce?

YOUTH OWNER is not happy with the way DOLE WORKER constantly shines attention on her. She cuts her eye at him yet again.

YOUTH WORKER: No. No I haven't got a clue.

NIGHTCLUB OWNER: You two together then or what? Husband and wife? Boyfriend and girlfriend?

YOUTH WORKER: *(Quick.)* Neither actually. We just know each other from around Chamberlayne. Don't we Ron?

DOLE WORKER's acting somewhat subdued. YOUTH WORKER's message seems to have hit home.

DOLE WORKER: Yes that's right. Just from the neighbourhood.

Convo dries up. They sit there in silence while we see WHITE YOUTH silently trying to untie himself. He doesn't know if the people that have arrived are out to harm him, but from their talk, he knows it would be better if they didn't know he was there.

A girl enters. She's young and fresh, peering timidly at the surroundings – this is YOUNG NURSE. She makes her way into the TEAROOM and seems surprised when she spies the gathering. NIGHTCLUB OWNER takes immediate interest.

YOUNG NURSE: Oh hello, I didn't think anyone was here you know. It's quiet as a cemetery in here, don't you reckon?

NIGHTCLUB OWNER: Yeah, it is a little – why, are you scared luv?

YOUNG NURSE: No – it's a bit creepy though.

NIGHTCLUB OWNER: Come on in, sit down, take the weight off your feet. You're like family in here, you remember that – you're at home.

He gets to his feet and takes her bag from her hands. DOLE and YOUTH WORKER grin.

YOUNG NURSE: Thanks. That's very kind of you.

NIGHTCLUB OWNER: No trouble, no trouble at all.

YOUNG NURSE looks around the warehouse.

YOUNG NURSE: Is... Um... Is Jason Bonsu here yet?

YOUTH WORKER: He's upstairs now. The mum's already here.

YOUNG NURSE: Oh... You mean Rose?

YOUTH WORKER: Yeah, that's right. D'you know her?

YOUNG NURSE: Nah, but I saw her at the hospital...

YOUTH WORKER: At the hospital? What are you then, nurse or a doctor?

YOUNG NURSE: *(Laughs.) Doctor?!* I wish. Nah, I'm a student nurse and I've got a year and a half to go. I was on late shift when Rose came in that night. Poor thing. I couldn't believe it when I found out.

NIGHTCLUB OWNER: Yeah, it's tragic what's going on in the streets these days, I'm tellin yuh, tragic. The younger kids coming up are a danger to themselves an' all of us around

'em. I see 'em every week in my club – pilled up, drunken wastes most of 'em, chuckin up all over the place, pickin fights wiv me bouncers...

YOUNG NURSE: You own a club?

NIGHTCLUB OWNER: That's right darlin.

YOUNG NURSE: And what's it called?

NIGHTCLUB OWNER: The Chamber. Know it?

YOUNG NURSE: Yeah, yeah I do, I go there all the time! Every Friday for R&B, Saturday for House and Garage, Sunday for the Chill Out Lounge...

She sits down, taking everybody in with more interested eyes. NIGHTCLUB OWNER laughs.

NIGHTCLUB OWNER: Right little regular aren't yuh darlin? Or are you just trying to get on the guest list?

They laugh together.

YOUNG NURSE: My friends would go mad if they knew I'd met the owner of The Chamber... *(She peers at him.)* Even though I'd imagined a night club owner to be the older type of man actually.

NIGHTCLUB OWNER shrugs and smiles in reply. She giggles.

I'm so rude, talking about you when you don't even know me. My name's Annette.

NIGHTCLUB OWNER: *(Eager.)* Arthur.

DOLE WORKER: Ron...

YOUTH WORKER: Lucy...

They shake hands and greet each other. YOUNG NURSE is still regarding NIGHTCLUB with a slightly flirtatious gaze.

YOUNG NURSE: A mature name to go with your job. You're not one of those guys that are older than their time or something?

NIGHTCLUB OWNER: A little older, but still young enough to have fun luv, nah what I mean? Course you do, you're a pretty girl, fun must be all around ya!

YOUNG NURSE blushes.

DOLE WORKER: Come straight from work?

YOUNG NURSE: Yeah. I always do actually. I live in the hospital flats, so I'm never far from the job.

DOLE WORKER: I think I'd top myself if I had to live in, or near, that bloody Dole office. I more or less run out that door every night I leave the place.

NIGHTCLUB OWNER: See that's what I couldn't do. A job I had no pride in, no will to drive me onwards. *That* would be criminal mate.

DOLE WORKER: Well, you take what life gives out don't yuh? I certainly don't intend to do this job forever. *Mate.*

NIGHTCLUB OWNER: Now don't get me wrong, I think it's great that your not one of those idle layabouts with nothing better to do than cash their Giro and fart once a fortnight. You must get right pissed off seeing them trundle along, day in and day out, getting paid for nothing while you're slaving away just for the likes ah them. You're a better man than me. It'd drive me barmy.

YOUTH WORKER: That's a bit harsh ain it? Not all of the unemployed are worthless layabouts you know. Some of them do want to work.

DOLE WORKER: That's right, and not everyone's as fortunate as you've been. You shouldn't look down on people that aren't.

NIGHTCLUB OWNER: Lissen luv, I'm not from some over privileged background or something, and I certainly wasn't born with a silver spoon in me gob. I come from the same shit as any as those guys mate, probably much worse. Even signed me name on occasion meself. I ain opposed to someone scratching on temporarily, to tide themselves over for a bit... But anything longer than six months and you're a scrounger, straight up.

DOLE WORKER: You're quiet over there Annette. What d'you think, ever signed on before?

YOUNG NURSE: No, I haven't – but my mum did. She didn't have any qualifications, and couldn't afford to get a job and

pay for a babysitter, so she had to take benefits until we were old enough to look after ourselves. By the time she *could* work or study, I was already doing both. There were four of us, four girls, but she still managed to put three of us through Uni, and the last is on her way in two years time. I never once looked at my mum as a scrounger, or a layabout, or any of the things Arthur said.

She shoots NIGHTCLUB a disappointed glance, which he weathers bravely.

NIGHTCLUB OWNER: Well, there're exceptions that prove every rule luv… Like I said, I signed on and look at me now. No one could describe me as a layabout.

YOUTH WORKER: *(Quietly to DOLE.)* Nah, not when there's shorter, more descriptive words that sum him up…

NIGHTCLUB: Whassat?

YOUTH WORKER isn't paying him any mind, and continues to whisper in DOLE's ear. YOUNG NURSE is unsuccessfully stifling her laughter.

YOUTH WORKER: *(Quiet.)* … Words that rhyme with stick, trick and thick, although the last could have a double meaning if you really want…

NIGHTCLUB OWNER: Whassat, can't 'ere yuh luv. I'm a bit deaf in this ear, nearly drowned when I was a kid didn't I, and ever since then me 'earing's bin fucked. Ever so funny it was, me dad took me to Cyprus when I was about nine an a little tearaway, always inta something I was… Anyway, so we've only bin there an hour or sumthing, when…

He stops as BLACK MUM and CHAIRMAN return from CONFERENCE ROOM. All four listen intently as they come down the stairs, as does WHITE YOUTH, who is the picture of terror as they pass his STORE ROOM.

NIGHTCLUB OWNER: Ssssh… Here they come.

BLACK MUM and CHAIRMAN enter.

CHAIRMAN: Bloody hell, still no Tilly? What's she playing at, she was supposed to be one of the first.

YOUNG NURSE: Maybe she's stuck in traffic?

DOLE WORKER: What traffic, the roads are crystal clear!

YOUNG NURSE: Oh... Yeah, you're right...

She visibly withers. CHAIRMAN looks her way.

CHAIRMAN: Annette? Annette Wilson-Brown?

YOUNG NURSE: Yeah. That's me. You're Jason Bonsu right?

CHAIRMAN: Yeah, pleased to meet you. Get here OK?

YOUNG NURSE: Fine thank you. Sorry I'm late.

BLACK MUM: It doesn't surprise *me* that Tilly Crenshaw isn't here. That woman has a bad habit of making things that much harder.

CHAIRMAN: But something like this? Something that concerns her and her family, maybe more than any of us?

BLACK MUM: Well you know what they say. You can lead a horse to water... And my animal training skills are long dead, so don't expect any help from me.

CHAIRMAN: That's all right Rose. I'll take care everything. You're not to lift a finger tonight.

BLACK MUM stares at him as though getting the measure of the man, before slowly allowing a tired smile to pass over her lips.

BLACK MUM: Thanks Jason. You've been a great help through all of this you know. I won't forget that. Neither will my family.

CHAIRMAN: It's the least I can do. So don't you worry about it.

NIGHTCLUB suddenly stands.

NIGHTCLUB OWNER: Anyone up for another cuppa? I'll make 'em.

Everyone declines except YOUNG NURSE.

YOUNG NURSE: Yeah sure, I'd love one.

NIGHTCLUB OWNER: How'd you take it?

YOUNG NURSE: White and very sweet.

NIGHTCLUB OWNER: That's enough about me, now how'd you like your cuppa?

YOUNG NURSE collapses in embarrassment. DOLE and YOUTH WORKER roll their eyes at each other, while BLACK MUM attempts to take no notice. CHAIRMAN, however, is not amused.

CHAIRMAN: Oi! Enough of that Arthur, this isn't one of your teeny bopper rave ups, this is a civilised meeting of minds all right? We don't need that type of shit here.

NIGHTCLUB's busy making the tea and talking over his shoulder.

NIGHTCLUB OWNER: All right all right, no need to get touchy mate, I'm just attempting to lighten the atmosphere. Anyway, I know you're the Chair and all that, but it don't mean you can be ordering everyone around like tin soldiers, does it? We got freedom of speech in this country, ain' that right you lot?

The others grunt, or nod, but are quite slow to vocalise their support. CHAIRMAN knows he had to crush this little display in the bud.

CHAIRMAN: Yeah that's right, freedom of speech... But you just watch what you say... Got it?

NIGHTCLUB OWNER: Hark at Mussolini! *(This gets a laugh from all.)* Oi, you wanna stop listening to old Ice T albums mate, that kind of attitude got 'im dropped from Warner Records, innit? Bloody hell, it's the year 2001, not 1984.

CHAIRMAN laughs again, yet this laugh is more strained than before.

CHAIRMAN: Listen to you is like trying to watch two cheetahs playing table tennis on speed. Your all over the place mate!

NIGHTCLUB OWNER: I try... *(Over his shoulder to BLACK MUM.)* You sure you don't want any tea love?

BLACK MUM: No thank you Arthur...

YOUTH WORKER: We've got juice, biscuits and loads of other nik-naks if you're interested Rose...

BLACK MUM: I'll have some biscuits if you don't mind.

CHAIRMAN: Course we don't. You sit right there, I'll get 'em.

As the others continue a convo behind them, CHAIRMAN grabs the biscuits from the coffee table, puts an arm around NIGHTCLUB and stage whispers into his ear.

CHAIRMAN: Listen Arthur – I know you mean well, but be careful what you come out with here. Especially around the race issue, you get what I'm saying?

NIGHTCLUB takes a deep breath, looks CHAIRMAN in the eye then swallows his pride in one huge gulp. It's not the town hall worker he sees, but the image of 'the bosses' – who will be none too pleased to hear his name again.

NIGHTCLUB OWNER: Yeah… Yeah, course I do Jase… I'll be more careful in future.

CHAIRMAN: *(Slapping him on the back.)* Thanks. That's all I ask.

CHAIRMAN gives BLACK MUM the biscuits, addresses everyone.

CHAIRMAN: I'm just going to do a last minute check, take care of a few more things. Arthur, you handle any late arrivals, and just yell if you need me. I'll be around somewhere.

DOLE WORKER: Don't worry, we'll be fine.

CHAIRMAN lights up another cigarette.

CHAIRMAN: Cool…

He leaves and goes straight into the STORE ROOM, where WHITE YOUTH sits looking exhausted. They stare at each other for a long while, as the convo in TEA ROOM continues.

YOUNG NURSE: Jason Bonsu eh? Didn't expect him to look like that…

YOUTH WORKER: Why, what did you expect then?

YOUNG NURSE: I dunno… Someone a little more African looking with a surname like that.

CHAIRMAN pulls out the knife again, which causes wide-eyed alarm from WHITE YOUTH. He begins to walk towards him. WHITE YOUTH thrashes again.

YOUNG NURSE: I suppose I imagined this whole thing would have a more tribal feel you know? That's how I justified it anyway, telling myself this was all an old practice, stemming from way back with our ancestors in Africa…

BLACK MUM: You're right. In some ways it is.

YOUTH WORKER: But does that make it OK?

BLACK MUM: *(Stern.)* Yes… It's perfectly OK.

Silence. No one has the heart to argue. In the STORE ROOM, CHAIRMAN reaches the WHITE YOUTH, lifts the knife, takes the smoking cigarette out of his own mouth.

CHAIRMAN: Stop making all that noise, or I'll cut you.

The YOUTH nods vigorously, is still.

CHAIRMAN: Now I'm gonna take off that gag, so you can smoke this. You make a sound and it's over. I'll kill you and deal with the consequences. Got it?

WHITE YOUTH nods silently. CHAIRMAN pushes the fag between his lips. WHITE YOUTH inhales. CHAIRMAN takes it out and waits, before repeating his actions. Meanwhile, back in TEA ROOM, YOUTH WORKER has gathered some courage…

YOUTH WORKER: I'm sorry – I appreciate your loss and everything, but I really don't see how you can justify –

DOLE nudges her.

DOLE WORKER: … But we both understand your point of view. Don't we Lucy?

YOUTH gives him another one of her withering looks and turns away, saying nothing. BLACK MUM directs her next sentence towards her.

BLACK MUM: I don't expect any of you to know what I know, or feel what I'm feeling. Just trust me when I say that I would exchange all of this for one simple, irreplaceable thing – something I'm sure I don't need to spell out to you, Ms Lucy Warner, Chamberlayne Park head youth worker…

YOUTH WORKER looks up in shock.

BLACK MUM: Yes. I know you. Just like you knew my son. How many times did you see what was going on and let it pass you by? 'It's none of my business, it's nothing to do with me…'

YOUTH WORKER's speechless. DOLE and YOUNG NURSE are too.

NIGHTCLUB, terrible as he is in awkward situations, steps in to save the day. It doesn't work.

NIGHTCLUB OWNER: Oi, I'm not being bad or nothing, but don't you think that chairman's a right wanker? I do. I tell

yuh, he right gets on my tits mate, sometimes I wanna *(He mimes a slap of comic proportions.)* right across that belly of his, know what I mean mate? Fuckin little Budda.

BLACK MUM: *(Vex.)* Excuse me... Do you mind?

NIGHTCLUB OWNER: Oh... Sorry luv, I was only havin a laugh...

YOUNG NURSE: *(Gentle.)* I think you better sit down...

He does as he's told. For once. An uncomfortable silence falls again. In the STORE ROOM, CHAIRMAN is attempting to communicate with his captive.

CHAIRMAN: Almost time. Can you feel it? They're nearly all here. Only two to go.

WHITE YOUTH: You're fuckin crazy... She won't turn up anyway....

CHAIRMAN leans close.

CHAIRMAN: You better fuckin well hope she does.

He snatches the burning cigarette from WHITE YOUTH's lips, drops it on the floor and stamps it out. After that, he replaces the gag and makes sure WHITE YOUTH's hands are thoroughly tied. A voice comes from off stage, making CHAIRMAN freeze.

UNEMPLOYED MAN: *(Off stage.)* Hello! Hello!! Anyone here? Anyone at all? Somebody talk to me will you!

In the TEA ROOM...

NIGHTCLUB OWNER: Oi mate, we're all here in the back! Just keep walking across the ware'ouse and yuh can't miss us!

UNEMPLOYED MAN: Where's the bloody lights....

There's a huge crash, which like our victim, is unseen. All the TEA ROOM occupants begin to laugh, except BLACK MUM, who sits solid and silent. In the STORE ROOM, CHAIRMAN's shaking his head.

CHAIRMAN: Jonesy... Damn idiot...

DOLE WORKER: *(Shouts.)* You all right mate?

No answer. CHAIRMAN strides out of the STORE ROOM.

CHAIRMAN: Oi Jonesy, you ain't broken anything 'ave yuh?

UNEMPLOYED MAN: *(Off stage.)* Nah... Nah, I don't think so... I think I might be bleeding, but it's too dark to tell. There's a sodding great wet patch on my elbow....

This causes YOUNG NURSE to collapse in giggles until she realises nobody finds it as funny she does. Or even remotely as funny she does. She stops and composes herself in the blink of an eye while the others peer at her. UNEMPLOYED MAN steps onstage and is greeted by CHAIRMAN.

CHAIRMAN: *(Laughing.)* All right there, made it through no-man's land did yuh?

UNEMPLOYED MAN: Just about... Cor, some of that stuff's right deadly, sure you ain't got man-traps or something sinister like that back there... Bloody hell...

CHAIRMAN: Thanks for coming anyway...

They shake hands.

UEMPLOYED MAN: I'm a bit late...

CHAIRMAN: Never mind that, let's go through and meet the others...

They walk into the TEAROOM where the other are poised, waiting to see the next entrant. Everyone is looking UNEMPLOYED MAN up and down when he comes in.

CHAIRMAN introduces everyone in turn.

CHAIRMAN: All right everyone, we're almost ready. This is Bobby Jones, 'the voice of the people' as the bosses call him. He's the last of our jury. Bobby, this is Rose, Annette, Arthur, Ron, and Lucy. We're still waiting on one more.

UNEMPLOYED MAN: I see... Nice to meet you all.

The others give varied greetings.

CHAIRMAN: It's getting a bit packed in here, don't you reckon? I wouldn't mind a little bit more of a hand shifting things around upstairs now there's enough men to help. Gents?

DOLE WORKER: No trouble mate, I was getting a bit restless just sitting here and waiting anyway.

The men get to their feet.

CHAIRMAN: Jonesy, you don't have to come up yet. Get yourselves a cup of tea and settle yourself in, then join us when you've finished.

UNEMPLOYED MAN: Thanks, will do...

NIGHTCLUB, DOLE and CHAIRMAN all wander off upstairs, which causes great distress to WHITE YOUTH. They all disappear behind the back wall. In the TEA ROOM, UEMPLOYED MAN gets to work brewing the kettle and munching on biscuits.

UNEMPLOYED MAN: Tea anyone?

BLACK MUM and NURSE decline.

YOUNG NURSE: I'd just like to take the opportunity to tell you how sorry I am about this entire business Rose. I know what you're saying about no one being able to feel what you do, but I can empathise can't I? If it was my little brother... Or *my* son...

BLACK MUM: You have a son?

YOUNG NURSE: Yeah, he's only two... He lives with his Grandmother at the minute, while I finish my studies, but I see him every weekend. His name's Carl.

BLACK MUM: He must be very proud of his mother.

YOUNG NURSE: *(Smiling.)* Yeah I think he is... I *hope* he is...

UNEMPLOYED MAN: Well I think it's disgusting you've been made to go through everything you have Rose – you don't mind if I call you Rose do you? *(She shakes her head.)* What kind of justice do we have in this world anyway? I'm telling you right here and now, between the two of us, that I already know which way I'll vote. It's just a matter of when I do it, not what I'm going to say.

BLACK MUM: I think you should hear all the evidence, and make your decision based on the facts. A vote based on anything else isn't justified.

UNEMPLOYED MAN: But don't you want to see someone punished?

BLACK MUM: Yes I do – but I also want to see justice done. I can't have it any other way.

UNEMPLOYED MAN nods and lifts the teacup to his lips, then winces in pain. YOUNG NURSE notices.

YOUNG NURSE: You OK?

UNEMPLOYED MAN: Yeah, I think so... Just banged me elbow when I fell down out there... It feels like it's bleeding.

YOUNG NURSE: Let me have a look. I'm a nurse...

YOUTH WORKER: There's a first aid kit underneath that table.

YOUNG NURSE: Great...

UNEMPLOYED MAN watches her retrieve the first aid box from underneath the table with a little more interest. He makes an A-OK signal to BLACK MUM, who, for the first time, cracks a tiny smile in reply, gone in an instant. YOUNG NURSE gets back to her feet.

YOUNG NURSE: OK, off with that jacket so I can take a look at you.

UNEMPLOYED MAN: Sure.

He takes off the jacket and roll up his sleeve. YOUNG NURSE sits beside him and inspects his wound.

YOUNG NURSE: Oh, you've got a bit of a gash, but nothing too serious to handle. I'll just put some antiseptic cream and a plaster on it.

UNEMPLOYED MAN: Thanks. At least I can be sure I won't die while I'm here tonight.

YOUNG NURSE: You never know – you're not even sure whether I'm a good nurse yet.

She starts work on his arm.

BLACK MUM: So have you all grown up in Chamberlayne?

YOUNG NURSE: All my life...

YOUTH WORKER: Me too.

UNEMPLOYED MAN: Not me – I was brought up in Shepherd's Bush, moved to Manchester when I was seventeen, lived there till I was twenty-two, moved back down to Finsbury Park for a year, then came to live here and I've been here ever since.

YOUNG NURSE: So why stay in Manchester so long?

UNEMPLOYED MAN: I got married.

YOUNG NURSE: *(Concentrating on her work.)* Oh. That's nice.

Her disappointment is clear.

BLACK MUM: How long have you been with your wife?

UNEMPLOYED MAN: Oh I'm not with her now. We broke up two years ago – it's a long, complex story, but basically we grew apart.

YOUNG NURSE: *(Still concentrating.)* That's sad. It's always hard when you split up with someone you love.

YOUTH WORKER: So were you married too?

YOUNG NURSE: *(Wistful.)* No… No, I never made it to the altar, unluckily…

WHITE MUM walks onto the stage slowly, dreamily, her face hard and her manner tense, as if waiting for something to pounce. She's the only one to arrive empty handed and walks straight into the TEAROOM where she stands staring at BLACK MUM. BLACK MUM stares back, and even UNEMPLOYED MAN senses her entrance, and stares at her in shock, as does YOUTH WORKER. YOUNG NURSE keeps applying salve and a plaster to his elbow, talking steadily as she gets into her work.

YOUNG NURSE: I was always the bridesmaid never the bride unfortunately… And I can't tell you how many times I caught those bloody flowers, but I never managed to find a guy that wanted me for life *(She laughs.)* Cor, the way make it sound you'd think I was one of those stray dogs off the adverts… A wife is for life, not just Christmas…

WHITE MUM: What the fuck are you doing here?

She's talking to BLACK MUM, who just stares back and doesn't say a word. YOUNG NURSE finally sees who has arrived. There's a thick silence.

WHITE MUM: You 'eard me. I said what-the-fuck-are-you-doing-'ere? If I'd have known you were coming I would've stayed in bed.

BLACK MUM: That doesn't surprise me Tilly, seeing as you spend most of your time in beds. Not always yours from what I've heard…

WHITE MUM: Don't you fuckin' start, I'll 'ave yuh right here and now you bitch!

WHITE YOUTH reacts to his mother's voice much as though he's been struck by lightening. BLACK MUM gets to her feet.

BLACK MUM: Yeah you try it – go on girl, give it your best shot. I've been waiting for you to do something for two fuckin' years. And I'm sure the bosses'll be pleased with you...

At the mention of the bosses WHITE MUM wilts. UNEMPLOYED MAN shakes himself out of his trance and also gets to his feet.

UNEMPLOYED MAN: Ladies, ladies, the very reason we're here is so there's no need for this type of thing... Can't we be civil to each other, for just this one night? Please?

BLACK MUM: I think I better get Jason...

She walks across the stage to where WHITE MUM is standing with everyone watching. The woman stands in her way and they stare at each other, sizing one another up.

BLACK MUM: Do I have to ask?

WHITE MUM moves out of the way. BLACK MUM walks past.

WHITE MUM: Bitch.

BLACK MUM stops, then shakes her head and goes upstairs to the CONFERENCE ROOM. WHITE MUM moves over to the chair that BLACK MUM vacated and flops onto it in a very unlady-like way.

WHITE MUM: Look at this shit. Fuckin rubbish. Ain even got any real drink.

She takes a can of Kestral from her pocket and pops it, drinks. YOUTH WORKER stares at her.

YOUTH WORKER: Are you sure you should be drinking now?

WHITE MUM: And you are? *(She pauses.)* Wait a minute I remember you... You're that slaggy youth worker int cha? Int cha?

YOUTH WORKER: Listen you – *(She looks at the others.)* I'm going upstairs... See you lot there...

She also leaves and goes to the CONFERENCE ROOM.

THE FAR SIDE: ACT ONE

WHITE MUM: ... *Slapper*... Bin with every fuckin parent in west Chamberlayne, some ah the kids too. Even seen her with my son's spunk on her face, dirty cow. You should watch her, she's trouble mark my words.

YOUNG NURSE: That's not very nice.

WHITE MUM: Well I ain a very nice person love, int yuh guessed? Anyway, you can all go to hell as far as I'm concerned, I don't give a toss what you think of me... Bloody bastards, always someone with something to say around 'ere...

CHAIRMAN comes down the stairs at a rapid pace, bounds into the TEA ROOM, stops when he sees WHITE MUM.

CHAIRMAN: Bloody hell, you took your time. I was wondering if you bottled it.

WHITE MUM: Yeah, you would think that. But you don't know nuthin about me or my family.

CHAIRMAN: All right Tilly, I'm not here to argue with you, I'm here to make sure everything goes right. Now you're here we can get started, that's all I'm saying. We're a bit behind time, so if everyone can make their way upstairs to the Conference Room...

WHITE MUM: Can't I finish me drink and get settled in?

CHAIRMAN: You know the rules Tilly. No alchohol, weed or hash. You'll have to throw that away, or leave it for whenever we finish.

WHITE MUM: I ain throwing away me drink for no one!

CHAIRMAN: Then leave it on the table. I guarantee nobody will nick it.

WHITE MUM does as she's told, then marches past CHAIRMAN, and upstairs to the CONFERENCE ROOM, where the others are appearing, taking their seats and pouring water, talking quietly. UNEMPLOYED MAN and YOUNG NURSE are still sitting in shock.

CHAIRMAN: Go on you two, don't mind her... Jonesy you can take your tea up. I'll be there in a minute.

He waits while they leave the room and follow the others upstairs. When he sure they're gone, he goes back into the STORE ROOM. He

stands looking at WHITE YOUTH for a long time. WHITE YOUTH's eyes are wide, his skin pale.

CHAIRMAN: And now the games begin. I'm gonna make sure Rose comes out a winner. You got that you little piece of shit? You *will* pay for what you did to her. I'll make sure you pay.

He leaves the room and goes upstairs, to join the others in CONFERENCE ROOM. As they're seated, the drums begin again, and DRUMMER, followed by BLACK YOUTH, come onstage. They jam together a moment, before the drums fall to a lower volume, and BLACK YOUTH addresses the audience once more.

BLACK YOUTH: At fifteen years old I was running tings around dis manor, truss. I had a crew of boys I'd give my life for, enough money to be wearing the livin' Click suits, Armani jeans and all that other shit – plus the respect of all the mans dem, you wid me? Life was sweet like grape wine back then... But the only thing I didn't have was the love of a good woman. All my bredrins dem was inta abusin gullies... They'd sex dem and cuss dem next day, treat 'em like shit... Or even cuss dem before they done anything, make dem know their place. But I couldn't work dat way... The way I saw it, the way my mum brought me up meant I should have nothing but respect for dem – so even if I was two-timing gullies, they'd both get treated like they was my one an only – bare love! To tell the truth though people, dat player lifestyle just weren't for me. It's a head fuck trying to run two girls at once, truss. So when I started seein' Lizzie about my way again, I was like – perfect – dat's who I want.

So I started trying to speech her, but my girl was going on the living stush. All giving man her number, then pretending she wasn't in when I called... Making her sister cuss me when I knocked by her house... Moving with other brers like they was her man, when she was blatantly single... I didn't care though, cos I know say how she felt about me – cos every now and then she'd give me a look – or a smile – and I'd feel like tings was cool.

So around about the time when things got real hectic wid that Crenshaw lot, I went to the shops and I see Lizzie wiv some of her girls. I called her over and laid my shit on the line, cos I was tired of all the games man, and – to tell the truth – I think I knew even then my time was short. So I took her to one side and told her that I just wanted to be with her. Stop trying to be a player and be with a girl like her 'cos I didn't want no one else. I told her from dat day on I wouldn't look at another gully, and even if we split, or she didn't want to be wiv me, she'd always be the closest to my heart. *(He laughs.)* I know I was getting deep an' dat, but I didn't expect her to *cry*... I was worried she was scared or suttin – until she said she thought she loved me too. An' I felt cris you know... I felt like the Crenshaws', even the President of the United States couldn't fuck wiv me... And you know what? Me an' Lizzie... We *never* split up...

BLACK YOUTH *looks pleased with himself, before he walks off stage, his* DRUMMER *following behind. The lights go down.*

End of Act One.

ACT TWO

INT. WAREHOUSE.

With a dramatic roll, the DRUMMER comes back on stage. BLACK YOUTH follows once more. He comes out looking somehow older, wiser, yet harder and less innocent than previously. The Drum Beat has also changed; it's more serious, less about dancing, more about aggression. BLACK YOUTH halts the DRUMMER at his peek and turns to his audience.

BLACK YOUTH: All right people, here's the ku; I know your wondering what went on that day. You know what I'm talking about. An if you're not, you're probably acting like all the gossips in Chamberlayne, giving my mum bere theories on why tings went they way they did. I was a 'out dere yout', causing trouble all over the ends. The Crenshaw's were racist, and they'd been lookin to do me suttin from way back. Me and my *boys* was racist, and we were lookin to do the Crenshaw's suttin from way back. I suppose you could take a little bit from each of those things, cos all of dem are a little true, to some degree. But there was a lot more than that going on people, I afta tell the truth. A lot more.

My problems wiv the Crenshaw's was more like an association ting to start off wiv, you wid me? I had a real close friend, name of Martin Oswald, but we used to call my man Fly; I don't even know what for. Anyway, Fly's older brother Trim was movin bits and pieces for the Crenshaw's – you know, likkle Ash, likkle weed, sometimes suttin a bit more substantial from the powder dept, you know what I'm sayin'? Dis time now, one time my man Trim was on a powder run and he musta just disappeared man. No one could find trace ah him. No car, no powder, no Trim. No one ain seen 'im till this day. Amazingly enough, the Crenshaw's aren't too happy about that...

Of course that was a big man ting – nuttin to do Fly, even if it concerned his brudda – and definitely nuttin to do wiv

me. But one ah the younger Crenshaw lot – Luke – used to go to our school as well. He had a likkle white boy crew who used to do tings around school as well. Now Luke had taken it upon himself to try and get the tings and Trim's whereabouts from Fly, even though his older brothers left my bredrin alone. Day after day, Luke would be in Fly's face, asking him about his brother. Fly got pissed off and had a fight wiv Luke. They roughed each other up a little and that was that. Or that's what I thought anyway.

Over the years it turned into a little feud. Even when we left school, there were still fights and shit – at the youth club, at a rave, or even just on street when we passed each other. An I ain' ashamed to say it – I buss nuff mans head frequently. What could I do, it was a life and death situation, y'get me? Life. And death. So I started walking wiv my shank, even though Lizzie warned me I'd get nicked. But I had to have it man.

While BLACK YOUTH has been talking, BLACK MUM storms out of the CONFERENCE ROOM angrily. She bounds down the steps, heading for the TEAROOM, then stops dead when she sees her son's figure moving around in the warehouse area of the building. She's stunned.

BLACK YOUTH: So I'm walking around West Chamberlayne – the Badlands as some people like to call it – when I see Luke Crenshaw and his crew coming my way. They looked like they was coming from the yout' club, and there was six ah dem – I only had me and Fly. So we run innit – and the Crenshaw lot chased us. I remember I was scared, cos that was one time I'd listened to Lizzie, and left my switchblade at home. Fly didn't have nuffin either, so we was completely defenceless. To cut a long story short, they caught up. I heard them coming, so I turned to Fly and says, 'We better fight you know.' So we turned and stood our ground. We were way outnumbered man.

I went straight for Luke; me and him had been fighting for years now – and it was the usual thing, you know – punchin, swearin, cussin each other. But then I heard a scream. I turned and saw Fly was gettin killed by at least

four ah dem yout's. They were stamping on his head. I could hear it hitting the pavement like they were bouncing a basketball. So I let go of Luke, then someone next to me says – 'You fuckin black bastard'. And the knife went into my side.

It's funny man, it's a little like being punched you know – then a second later you realise there's something cold inside you that's worse than any punch could be.

I fell on one knee *(BLACK YOUTH acts out his words.)* I looked up and I could see Luke and the guy who'd stabbed me, grinning hard. I was *bleeding*, all over my criss jacket, my jeans and trainers. All over the pavement, all over my hands. I was weak like a baby. Luke pushed me on the ground, and I felt that cold kinda punch again. In my chest, this time. I couldn't breath. Luke's boys surrounded me. I felt that cold punch over and over... I was bleeding everywhere. I tried to scream for help, but I couldn't see Fly and I couldn't get my mouth open. I called my mum...

At that instant, BLACK YOUTH looks up towards the stairs. He sees BLACK MUM – they look at each other for a minute...

BLACK MUM: Danny?

BLACK YOUTH: Mummy, help me... It hurts...

He disappears in BLACK MUM's world, though the audience can still see him.

BLACK MUM: *(Screams.)* Danny!!

She runs down the stairs, to the spot where she last saw her son – who is backing away looking as shocked as her. While she stands there unsure of what to do, BLACK YOUTH gets over his fear and reaches for her while her back is turned. DRUMMER stops him with one hand, shaking his head – no. DRUMMER gestures offstage, then lightly tugs BLACK YOUTH that way. They leave, with BLACK YOUTH looking over his shoulder. BLACK MUM screams his name over and over, going from room to room, searching for her child, until she collapses in the TEAROOM, her tears taking over. Voices come from the CONFERENCE ROOM.

CHAIRMAN: *(VO.)* Now look what you've done – Rose! *Rose!*

WHITE MUM: *(VO.)* Leave the stupid cow, she's just looking for attention!

CHAIRMAN: *(VO.)* Shut up and stay here all right. You lot, make sure she doesn't come downstairs. Annette, come with me would you?

YOUNG NURSE: No problem…

They come down the stairs in a hurry to find BLACK MUM in a huddled heap on the TEAROOM floor.

BLACK MUM: My son… My son…

CHAIRMAN: Rose, what's going on? Don't let that woman get to you, she's nothing –

YOUNG NURSE nudges him and puts a finger to her lips.

YOUNG NURSE: You poor thing, you must be feeling terrible… Come here… Jason, make the Tea will you? Would you like a cup Rose?

BLACK MUM: Yes, thank you.

YOUNG NURSE puts a consoling arm around BLACK MUM.

YOUNG NURSE: I know it must be hard to listen to all that stuff about your son, even after all this time. But the way I see it, you've got through it all now. Those kids are guilty this time, it's all agreed. It was a means to an end, that's what it was, and I know it must be hard to believe for you, but it's finally over. It's the end of a long, hard, struggle and you've won. It's finished now.

BLACK MUM: No, I haven't won. It's not over.

YOUNG NURSE: But surely –

BLACK MUM: What makes you think I could possibly be a winner in all this?

Silence.

BLACK MUM: *(Points.)* I just saw my son's death re-enacted right in front of me! And you have the nerve to tell me I've won!

CHAIRMAN: *(Laughing.)* Now come on Rose, I know you've been through a lot, but that's a bit much to expect us to swallow –

Her look in his direction is the sole reason he shuts up so fast. BLACK MUM's words are almost murderous in intent.

BLACK MUM: Now you two listen to me. I know you both mean well, but all this 'we care so much' kind of humouring bullshit has got to stop. I'm tired of you all treating me like a cripple, when I know I've got two working legs! Now if you're gonna come down here and talk to me, stop telling me what I should feel and what I've seen. I know I saw my son in this warehouse. I've been feeling his spirit since I came here. He's watching us right now; I don't know how, and I don't know why, so you better be careful what you say Mr Bonsu. And as for what Tilly Crenshaw's got to say, you know what? I don't give a damn. All I ask is the same thing I've been asking for from day one. *Keep her away from me or there's gonna be war.* D'you hear me Jason?

CHAIRMAN: Yeah I hear you Rose. Loud and clear.

BLACK MUM: Annette?

YOUNG NURSE: Yes. Of course, you're perfectly right. I apologise.

BLACK MUM: Apology accepted.

NIGHTCLUB OWNER comes down from the CONFERENCE ROOM looking worried.

NIGHTCLUB OWNER: Cor blimey, it's going off up there something chronic – that Tilly Crenshaw's a right nutter int she? Who yanked her chain?

CHAIRMAN: You don't wanna know. What's going on?

NIGHTCLUB OWNER: Ah, she's just making a right old fuss about the verdict innit. Cursing everyone in the vicinity, saying her kid's innocent, threatening to kill that youth worker… I dunno if the bosses were very smart about the way they've done this mate. I mean, it's obvious that if her kid's found guilty, she'd kick up an almighty stink. The way she's acting up there, I wouldn't be surprised if she tries to murder us all.

CHAIRMAN: Oh, she won't.

BLACK MUM: You sound sure of yourself.

CHAIRMAN: Well I dunno about you guys, but I've always looked at life like a game of chess. You've got to be skilful, filled with utmost concentration, thinking two steps ahead of your opponent. That's what I do.

A small silence.

NIGHTCLUB OWNER: You're a bit cocky int cha?

YOUNG NURSE: Yeah, but I think I know what he means. I saw that film *Fresh* years ago. Have you seen it?

BLACK MUM puts her head in her hands.

NIGHTCLUB OWNER: No.

CHAIRMAN: Yeah. Yeah, I saw it.

YOUNG NURSE: Oh Rose you gotta see that film, it's a classic I'm telling you. This boy right, this little boy, lives somewhere in America and he sells drugs on the street, poor thing. He's only like, twelve or thirteen, or whatever, but he's really clued up man. Anyway, his sister's, like, a heroin addict or something like that...

NIGHTCLUB OWNER: Jase? Oh sorry, luv, didn't mean to interrupt your story. Jase, can I 'ave a word outside a minute mate?

CHAIRMAN: Sure.

They get up and walk into the area between the TEAROOM and CONFERENCE ROOM. NIGHTCLUB OWNER lowers his voice. YOUNG NURSE continues miming her story to BLACK MUM, who doesn't look the least bit interested.

NIGHTCLUB OWNER: Bit of an upset this, don't yuh reckon?

CHAIRMAN: It's nothing that can't be handled. *This* was anticipated.

NIGHTCLUB OWNER: *(Quick.)* By who? The big guys? How did they know the verdict?

CHAIRMAN: Stop being paranoid will you? We made plans for Rose as well, in case it happened to go the other way. No one's been fiddling with the verdict.

NIGHTCLUB OWNER: Well I gotta tell yuh mate – we got a right dodgy one 'ere. I mean, this whole thing's bin a bit skewiff if yuh ask me.

CHAIRMAN: *(Insulted.)* What d'you mean?

NIGHTCLUB OWNER: It's a bit too much of a dead cert, that's all. Look, for a start most of this jury are – you know – of the darker hue?

CHAIRMAN: *(Stern.) And?*

NIGHTCLUB OWNER: Don't gimme that look mate, I'm just saying it could seem a bit biased... Which of them would vote against Rose?

CHAIRMAN: That's just how the bosses wanted it. All right?

NIGHTCLUB OWNER: All right, fair enough, but what about this thing of having both mums here? Are you lot mad or what? You'll have to hold another trial to find out who's guilty of the murder that takes place *tonight*, never mind two years ago. I mean, look at all the tension flying around that table Jase – that Crenshaw woman stinking and spitting...

CHAIRMAN: Keep your voice down will you?

NIGHTCLUB OWNER: *(Lower.)* ... Stinking and spitting all over the place... Swearing and licking her lips... That's right mate, licking her lips right at me she was, leery cow. I'd put one on her but she'd probably pickle me dick, amount ah Kestral she drinks... Pull it out and it'd look like one of those Gerkins in a jar you get from the chippie...

CHAIRMAN: *(Laughing.)* You're something else...

NIGHTCLUB OWNER: That's right mate, only no one can tell what. Anyhow, as I was saying, 'avin' the two mums' in the same room is ludicrous, you're asking for nothing but trouble. Don't you think you guys impaired the way our jury voted?

CHAIRMAN: But... You still stand by your guilty vote?

NIGHTCLUB OWNER: Yeah, definite. I knew the kid was guilty even before I came here, everyone who knows anything about him does. I wonder how many of the others voted

with their hearts rather than their heads… I can't believe that geezer voted Not Guilty…

CHAIRMAN: Well it's done now. There's no going back.

NIGHTCLUB OWNER: Yeah; you still managed to do a good job mate.

NIGHTCLUB turns and walks back up the stairs to the CONFERENCE ROOM. CHAIRMAN watches him with a contemplative gaze.

CHAIRMAN: Arthur?

NIGHTCLUB stops and looks back.

NIGHTCLUB OWNER: Yeah mate?

CHAIRMAN: *(Low.)* Come back down. I wanna show you something.

NIGHTCLUB OWNER: *(Cupping one ear.)* What's that?

CHAIRMAN: I said 'come back down'. I've got something I want you to see.

NIGHTCLUB comes back down the stairs slowly, a little tentative, but curious, like a teenage girl on a first date.

NIGHTCLUB OWNER: Sounds a bit ominous, that. What's the story big guy?

CHAIRMAN: Just follow me and keep your mouth shut.

NIGHTCLUB finally feels the gravity of CHAIRMAN's aura.

NIGHTCLUB OWNER: This isn't a jokey thing is it?

CHAIRMAN: It's the furthest from a jokey thing you'll ever see.

You can almost witness NIGHTCLUB's happy-go-lucky attitude evaporate. With no more words, CHAIRMAN leads NIGHTCLUB into the STOREROOM. WHITE YOUTH looks up into NIGHTCLUB's eyes, who is standing frozen by the door, while CHAIRMAN hides from his gaze by checking the rope that holds the youth in place. NIGHTCLUB is dumbstruck.

NIGHTCLUB OWNER: Nah… You're 'avin' me on…

CHAIRMAN ignores him.

NIGHTCLUB OWNER: Luke?

WHITE YOUTH looks up when he hears his name called. NIGHTCLUB doesn't take this well.

NIGHTCLUB OWNER: Oh Jesus. Oh no, you gotta be kidding. Tell me he came of his own free will. At least tell me that.

CHAIRMAN pulls at the gag.

CHAIRMAN: Does he look like he came of his own free will?

NIGHTCLUB OWNER: And you brought him here?

CHAIRMAN: I'm in charge ain't I?

NIGHTCLUB OWNER: Oh, you've got to be kidding me – Jason, are you mad? Have you forgotten where you live? Hello? Hello? Earth to Chamberlayne...

CHAIRMAN: Yeah, yeah, yeah, but you're missin' the point – a kid was killed. Could have been someone from your family. Or mine. And this wank stain got away with it.

NIGHTCLUB OWNER: What about the rest of them?

CHAIRMAN: Oh, they'll get their due.

CHAIRMAN is already going for his knife.

NIGHTCLUB OWNER: *(To himself.)* You gonna kidnap them as well? Along with the whole Crenshaw family? You do realise you're dead when Luke gets home and tells them about all this. Oh *shit*. His mother's only sitting upstairs... Jase... Jase, wha you doin?

Before NIGHTCLUB can move, CHAIRMAN has taken the few steps needed to ram the knife against NIGHTCLUB's throat. His face is twisted with fury.

CHAIRMAN: Kneel down...

NIGHTCLUB's kneeling.

CHAIRMAN: I thought that maybe I could trust you, and I was wrong. It happens. You know that from the position you're in, I could rip out your windpipe? I bet you didn't know that...

NIGHTCLUB OWNER: What d'you want?

CHAIRMAN: Sssh... Don't talk, you might graze your windpipe. And as your asking, I'm looking for one small thing from you – weighs nothing, costs nothing, no bigger than a word.

NIGHTCLUB OWNER: You've gone barmy int yuh? What the fuck are you talking about?

CHAIRMAN: Silence. I want your silence.

NIGHTCLUB OWNER: *(Quick.)* Listen mate – you know me – I never breath a word of anything to anyone, keep yuhself to yuhself that's my motto. I came here to vote and I've done my job, all I want is my pay, then that's it. I'll never breath a word of any of this to a living soul, I already promised. Seriously Jase, come on mate, you know me!

CHAIRMAN: I need. To be able. To trust you. Understood?

NIGHTCLUB OWNER: Yeah, of course… D'yuh wanna cut my fingertip, take my blood as me bond or somefing along dem lines?

CHAIRMAN: Just get up Arthur. Go and make sure Ron and Lucy can cope with Miss Scum up there.

NIGHTCLUB OWNER: No problem mate, easy as pie.

CHAIRMAN steps back. Eyeing him warily, NIGHTCLUB almost runs for the safety of the CONFERENCE ROOM. CHAIRMAN turns and looks towards WHITE YOUTH. He's smiling.

CHAIRMAN: Fun innit? And it's gonna get better… Much better…

CHAIRMAN puts the knife down, walks out of the STOREROOM and offstage. In the TEAROOM, YOUNG NURSE and BLACK MUM continue.

YOUNG NURSE: … And so the dealer's taken away by the police and the boy's left with his sister. He's saved his family. It's good, don't you think so Rose? You have to see it.

BLACK MUM: Well there's no need now.

YOUNG NURSE: *(Bright.)* That true!

BLACK MUM looks around the room.

BLACK MUM: If all this was a film I would have saved my family long ago. I certainly wouldn't be sitting in a warehouse with that looney upstairs. I would have moved them out of West Chamberlayne by the time my

Danny was nine, and we'd be living in Ealing or Fulham, somewhere posh like that. He would've gone to college, then Uni like you, got a job somewhere. You'd have been around the same age too. You probably would have liked each other. He was a good-looking boy.

YOUNG NURSE: I know. I saw the pictures.

BLACK MUM: It's just… You know, I wasn't lying a minute ago. All evening I could feel Danny around me. Even upstairs, with Tilly Crenshaw screaming in my face, the only reason I got up was because I could hear his voice.

YOUNG NURSE: Calling you?

BLACK MUM: No… Not calling, just talking, like I'm talking to you. He always used to like the sound of his own voice. Good to see that hasn't changed… *(She gives a bitter laugh, shaking her head.)* So, d'you believe in spirits?

YOUNG NURSE: I believe in God so… Yeah. Yeah, I suppose I do. I've never thought about it that much.

BLACK MUM: Have you ever seen a ghost?

YOUNG NURSE: No, never… I think I'd freak if I did.

BLACK MUM: My mother died back when I was six. She had this massive chest of drawers in her bedroom that she loved like it was one of the family. On the day of the funeral I was cleaning the mirror on top of the chest of drawers when I stopped to look at my reflection. I saw my mother looking over my shoulder; then the mirror cracked, right down the middle. My father came running up the stairs the minute he heard, but I was all right. I knew she was just looking over me.

YOUNG NURSE: Wow. Was that the only time you saw her?

BLACK MUM: No. I've seen her many times over the years. Now it looks like Danny's continuing the tradition.

YOUNG NURSE: You're handling things so well. I don't think I could take it.

BLACK MUM: You think I'm taking it? Seeing your dead mother is one thing, seeing your dead son is an entirely

different kettle of fish. I just want to get this over with and go home. I don't see why we haven't left yet.

UNEMPLOYED MAN comes down from the CONFERENCE ROOM. He's obviously flustered by the sight of BLACK MUM, who looks at him with contempt. He goes straight for the tea.

YOUNG NURSE: You all right?

UNEMPLOYED MAN: Yes, I'm fine… *(He modifies his tone.)* Just a bit distressed, that's all.

He continues to make his tea. No one says a word. After a while, the silence is too much for him.

UNEMPLOYED MAN: I honestly can't believe the way you guys voted up there! Not you Rose, your vote was a moot point, we all knew that – but you, Annette. I can't believe you.

YOUNG NURSE: Which part of my vote can't you believe?

UNEMPLOYED MAN: All that evidence… All that evidence and you still went guilty.

YOUNG NURSE: Because I thought he was. I don't see how that's so unbelievable.

CHAIRMAN comes back on stage, heading for the TEAROOM – but when he hears what's being said, he stops and listens at the doorway

BLACK MUM: What I find unbelievable is someone who comes in making a big fuss about which way he's going to vote, then turning around and voting completely opposite. What was the purpose of all your lip service Mr Jones?

UNEMPLOYED MAN: I simply did as you advised Rose. I looked at the evidence in front of me and found that something was wrong. No disrespect, but your son was not the innocent you would lead us to think…

BLACK MUM: I beg your pardon? When did you ever hear me say my son was innocent?

UNEMPLOYED MAN: Well you couldn't do that, you'd never get away with it! Drug dealing, street robbery, burglaries - no disrespect, but is there anything he *didn't* do?

YOUNG NURSE: Now hold on –

BLACK MUM: It's all right Annette, let me deal with this. Now, Mr Jones. You keep bawling no disrespect, no disrespect all the while. At the same time, you conveniently seem to forget that my son was *murdered.* Think about that a moment. Murdered. So you weigh up every little bad thing about Danny you can remember, then put them up against that word and ask yourself this question. Did he deserve to *die* for those crimes? And did Luke Crenshaw have the right to stand as his executioner?

UNEMPLOYED MAN: You *do* know they're discussing whether or not the kid should die?

Pause.

BLACK MUM: *(Confused.)* Which kid?

UNEMPLOYED MAN: Luke Crenshaw. Now they've finally found him guilty of murder, Chairman Bonsu reckons we can push for a retribution death. Apparently, the bosses allow that type of thing.

BLACK MUM's face is hollow.

UNEMPLOYED MAN: Didn't know that did you? Happened while you were downstairs. Actually, Jason seemed quite eager –

YOUNG NURSE clears her throat. UNEMPLOYED MAN turns to see CHAIRMAN standing in the doorway to the TEAROOM. His face is set in stone. Now, it's as quiet as a cemetery.

CHAIRMAN: You finished Jonesy? *(UNEMPLOYED MAN nods.)* Good. Now I'm gonna get everyone out of that Conference room and down here, so we can sit and talk about this in a civilised manner. Due to circumstances, not everyone's been brought up to speed on what goes on from here. We'll sit down, all have a cup of tea together –

BLACK MUM opens her mouth to protest, but CHAIRMAN holds up a hand.

CHAIRMAN: *Together,* Rose. I know you and Tilly will argue for a bit, but we can't do anything about that now, except to make sure we get this done quick and right. So I'll go and get the others and we'll soon sort this out, OK?

No answer.

CHAIRMAN: All right guys?

A low mumble from all three. CHAIRMAN sighs.

CHAIRMAN: All right then. Back in a bit.

He leaves and goes upstairs. YOUNG NURSE, BLACK MUM and UNEMPLOYED MAN look at each other, forlorn.

UNEMPLOYED MAN: I tell you something for nothing, that guy's still weird. I've known him for a while. Always gave me the creeps.

Lights go down. When they come back up, everybody is crammed into the TEAROOM, looking uncomfortable to be in such close proximity. NIGHTCLUB is a mere shadow of his former self. CHAIRMAN is standing, thus asserting his authority. He's talking, as usual, but no one else is.

CHAIRMAN: All right. Now we're all together again I want you to listen to me a moment.

WHITE MUM: Why the fuck should I listen –

CHAIRMAN: Tilly – remember where you are, and what you promised…

She subsides.

CHAIRMAN: For all of you here, I have to tell you, the night's almost over. When I disappeared earlier it was to post a copy of the verdict form outside. A messenger should have picked it up by now, so if the bosses haven't received it yet, they will in about an hour. Once that happens, they'll know what we decided. So it's done…

WHITE MUM bursts into tears. It catches everyone by surprise, embarrassing them all. BLACK MUM and NIGHTCLUB are the only people who don't take any notice. YOUNG NURSE attempts to try to comfort her, but WHITE MUM pushes her away. Everyone else leaves her alone.

CHAIRMAN: All right Tilly. I know it's hard to deal with, but you've got no choice, so you better get on with it. Like I'm saying, there's no going back now. Luke's been found guilty – end of story. Next comes the hard part.

BLACK MUM: And what's that meant to mean?

UNEMPLOYED MAN: He means the bit you missed. The sentencing. Don't you Jason?

The two men stare at each other.

CHAIRMAN: That's right. The sentencing.

YOUTH WORKER: So how does that work?

CHAIRMAN: Well, usually the way it works in a real court of law is that the judge passes sentence, as you all know. As you also know, there isn't a judge here.

DOLE WORKER: So you're not taking the role of judge?

CHAIRMAN: In most cases I would, but in a murder case it was felt that the sentence shouldn't rest with one man – or woman. It was decided that there should be a majority vote, just like the verdict. That's what we need to do now.

There's a horrified silence.

WHITE MUM: So, hold on a fuckin minute… Yuh tellin' me I gotta sit 'ere and listen to you lot vote whether or not my son dies?

CHAIRMAN: I'm afraid so.

WHITE MUM: You're fuckin crazy!

DOLE WORKER: How many times has this happened before?

CHAIRMAN: Well… To be truthful, this is our first murder trial.

WHITE MUM: The first!

UNEMPLOYED MAN: *(Sarky.)* I never would have guessed. Jason, you can't be serious about this?

CHAIRMAN: I'm deadly serious. Listen, didn't you guys read your rules and regulations letter? Everything was written down. We have to vote on the sentence too. I mean, you all know what the options are.

WHITE MUM: Well they know he ain goin to jail. *(She stands.)* Can't I miss this out? I'll wait in the little room next door.

CHAIRMAN gets up.

CHAIRMAN: No! *(Quieter.)* Tilly, can you please sit down? I need you to be here too.

WHITE MUM: You're really starting to piss me off mate, I'm warning you.

She sits.

BLACK MUM: This is hardly fair. Neither of us should be here.

WHITE and BLACK MUM look at each other, wary. They've both agreed on something. It's a strange turn of events for both.

CHAIRMAN: We've got no choice – where are you gonna go? No one can leave until the trial's completely over, you know that Rose. We've got to make this decision now, so we can all go home.

BLACK MUM: So what are the options then? I missed that bit.

CHAIRMAN clears his throat. This is the part he hasn't been looking forward to.

CHAIRMAN: I'll outline each option for you guys one by one; and would you all please let me finish the lot before you comment? All right. Number one option. Cash payment method. The Crenshaw's, namely Luke, but this could also involve the rest of the family, would pay Rose a yearly sum, the amount and time period to be decided on by the bosses at a later date.

He pauses, expecting some comment, but the others wait for him to continue.

CHAIRMAN: Number two. Voluntary expulsion method. The Crenshaw family is given enough money by the bosses to set up a new life somewhere far from Chamberlayne. They're forbidden from coming back, or maintaining contact with anyone other than their family. For all intents and purposes, the Crenshaw's… Disappear.

TILLY's fuming, rocking back and forth, teeth clenched, remaining silent. CHAIRMAN studies her as he speaks.

CHAIRMAN: The third option is the hairiest. This is the one for all of those who feel that the previous punishments *in no way* fit the crime. It's the one to take the most time over, and the most thought, cos it's no small thing this third option. The decision will probably stay with you for the rest of your life.

UNEMPLOYED MAN: I think you should get on with it. Half of us know what you mean anyhow.

CHAIRMAN gives UNEMPLOYED a dirty look. NIGHTCLUB is obviously agitated.

CHAIRMAN: So, for the sakes of all those that *don't* know what I mean... I'm talking about the retribution killing method. The death penalty.

The room erupts in a chorus of voices and arguments. CHAIRMAN stand with his hands in the air, calling for quiet. NIGHTCLUB is the only person who's speechless, sitting in a corner looking dazed. The lines below are all said at the same time.

WHITE MUM: I ain' sitting here listening to this! You must be mad expecting me to listen to your bullshit!

UNEMPLOYED MAN: This has gone too far! You really are crazy! I think you better re-think your strategy, instead of acting like a Nazi...

BLACK MUM: Jason, I want no part of this I'm telling you. Punishing someone is one thing, but murder...

YOUNG NURSE: I can't believe I'm hearing this. I want to go home...

DOLE WORKER: Well, I don't know what the fuss is about. An eye for an eye it says in the Bible and I tend to agree. Look at all the evidence we heard...

Out of the chaos a voice is heard:

YOUTH WORKER: Yeah, that report said that Danny was stabbed forty times. What kind of animal does that?

WHITE MUM: Who you callin animals, you little slut? What makes you think you're any better than me?

TILLY stands up, grabs her bag, puts it over her shoulder. She's stopped by CHAIRMAN.

CHAIRMAN: Hold on everyone, hold on! Tilly, will you sit down a minute and stop flying off every handle in the room! All we've done is outline the different options – no one's voted. You don't know which way it's gonna be. As you've heard, many of our jury don't agree with the death penalty...

WHITE MUM: *(Looking at DOLE and YOUTH WORKER.)* Many don't necessarily mean *all*... And as far as I'm concerned, number three ain a option. I don't care what you say, I never agreed my son's death should be discussed by some panel. I brought him into the world. You lot certainly ain taking him out. D'you hear me, you shit?

CHAIRMAN: You might not have a choice you know Tilly.

WHITE MUM: Fuck you Jason. There's always choices. Sometimes choices are all you 'ave left.

CHAIRMAN studies her a long time. She isn't reacting with half as much venom as he would have imagined at this stage. Something doesn't feel right to CHAIRMAN, and it's all over his face.

CHAIRMAN: Regardless of that fact, there happens to be seven other people in this room with equal choices, all of them relevant. When you agreed to take part in this jury, you agreed to abide by the rules laid out before us, whether you bothered to read the letter or not. Any backtracking on your part could mean trouble at a later date. Like one day, when you maybe need a trial like this?

WHITE MUM: *(Shouts.)* My son's fuckin innocent. All of yuh know it. Found innocent in a real court ah law, not dis stinkin pile of shit. He was provoked...

CHAIRMAN: Tilly...

BLACK MUM: Provoked into stabbing Danny forty times? What type of provocation warrants that? Your son was racist, simple and plain...

WHITE MUM: Don't you go insulting my son when he isn't here to defend himself, bitch!

CHAIRMAN: Come on you two...

BLACK MUM: *(Stands.)* Who the *fuck* are you callin bitch?

WHITE MUM gets to her feet, reaching for the handbag again. DOLE, CHAIRMAN and UNEMPLOYED MAN leap between the two women.

DOLE WORKER: Now come on, there's no need for all that...

CHAIRMAN: Let's put this to rest OK? Tilly, will you please be quiet a moment? Rose – sit down and let's just get this last bit done? Please?

UNEMPLOYED MAN: You're asking a lot…

CHAIRMAN: *(Aggressive.)* Look, will you button it mate? *(UNEMPLOYED balks – he's got mouth, but….)* Now, ladies, can we please sit down? Sit down and calm down, that's what's needed.

After a moment, BLACK MUM sits back down, looking away from WHITE MUM, who waits for her to be seated before taking hers. DOLE and UNEMPLOYED go for their seats, still watching the women. CHAIRMAN looks over everyone, breathing deeply.

CHAIRMAN: Now. I'll give you a sheet of paper each, which has the options in checklist fashion. You guys just tick the box that matches your sentence. Don't be stupid and put your names on 'em, or you'll mess up the whole system. I'll give you ten minutes to think it over.

CHAIRMAN goes to the coffee table and pulls out a folder. He passes out seven A4 OPTION SHEETS to each jury member, then seven PENS too. He takes his seat once more, holding his own OPTION SHEET and PEN.

CHAIRMAN: All right, think this thing over before you make a tick. Think about everything you've heard this evening. Forget about the fact that Rose and Tilly are here. The punishment has got to fit the crime.

There's a moment where CHAIRMAN and NIGHTCLUB make eye contact, but NIGHTCLUB can't hold it for long before he looks back down at the OPTION SHEET. CHAIRMAN's confidence soars.

CHAIRMAN: Begin…

The lights go down once more. When they come back up, CHAIRMAN is sitting with a pile of OPTION SHEETS in his lap. The others wait expectantly, leaning forwards in anticipation.

CHAIRMAN: So…here it is. I just want to take this time out to thank you all before we look at the final sentence. I know it's been hard, but I think you've all dealt with these extraordinary circumstances in an amazing way. One way or another, we're making history tonight. I wanted to thank you for making it possible.

WHITE MUM: Just get on with the fuckin thing will ya?

He gives her another sour look, returns to the OPTION SHEETS.

CHAIRMAN: You all know how the pay system works, right?

Murmurs.

CHAIRMAN: Apart from Rose and Tilly, you'll all be paid a thousand pounds for your services. You should receive the cheques within three weeks. Any problems, give me a call on the number you got with your rules and regulations letter. Cheque usually arrives within the second week.

Everyone's nodding, more eager to hear the verdict than info they already know. CHAIRMAN realises he can stall no longer.

CHAIRMAN: OK... So the sentences are... *(He looks over the OPTION SHEETS, one by one.)* Number one... Number one... Number two... Number two... Number three... Number three... Number two... Number two...

CHAIRMAN lets his head fall. The others ignore him.

WHITE MUM: Which one is that? Fucked if I can remember...

UNEMPLOYED MAN: It's the expulsion. It's been voted that you leave Chamberlayne.

BLACK MUM: Fine with me...

WHITE MUM: Well, fuck you lot, that ain happenin for a start, I'm telling yuh.

YOUTH WORKER turns her way, upset.

YOUTH WORKER: Can't you do one decent thing in your miserable little life? They're giving you a chance and you're throwing it away, just like all the rest of your type. People like you make me sick. Going around making trouble just cos your own life's worthless.

WHITE MUM: The tart with the heart went out with Carry On Movies luv – put it away, you're not fooling anyone. My family's lived in Chamberlayne for over a hundred years, long before you lot and your banana boats come over. My grandfather and father put years into this community, ask anyone that's bin 'ere longer than five fuckin minutes! I'll be dead and buried in this town, dead and buried!

DOLE WORKER: Oi, Jason, you 'ear this – ain you gonna stop her, you're the Chairman?

CHAIRMAN still looks a little bewildered.

BLACK MUM: Nah, just leave her man – let her carry on. Showing yuh true colours are we Tilly? I was wondering how long it'd take you to start.

WHITE MUM: Don't you talk to me, with that smug, smart arse look on yuh face! I'm gonna fight dis shit Rose, I'm warning you! You people think you're better than us, cos you got our jobs and you've learnt to speak English proper, but most of us wouldn't shit on you if you was starving. All your government jobs don't mean fuck all – we know who runs Chamberlayne and they'll never kick us out of this town – not when my father and father's father more ah less built this place.

BLACK MUM: I'd get your facts straight luv, before you go running yuh off mouth. My father came to this country, after *he* fought in the war. Even had to fight to fight, but that's another story an I ain got time. My Grandfather came to Chamberlayne with his wife in '46, who gave birth to my mother in '51 – I was born right here in this town, August 1962. And I swear I heard you say that somewhere down the line, your family could be traced back to Ireland. I suppose that doesn't make you any different from me.

WHITE MUM: Oh, but there is one difference Miss Fuckin' Fing. My son's alive... int he?

BLACK MUM sits back, amazed. Then launches herself at WHITE MUM. CHAIRMAN, snapping out of his trance, also stands, gets between them.

CHAIRMAN: Now that's enough! You better stop that shit, cos if it gets back to you know who...

It takes some time, but yet again, this calms the situation - marginally.

WHITE MUM: Fuck the bosses – I told you we ain leavin Chamberlayne. An if any ah you wants to ave it, let's ave it den! I'll ave the lot ah yuh.

THE FAR SIDE: ACT TWO

BLACK MUM: *(Really vex.)* Just wait till we leave this place, that's all I'm saying. Wait till we leave this place.

CHAIRMAN holds a hand up and shouts for quiet. They all shut up.

CHAIRMAN: Now everybody listen to me, right? It's my turn now. I've bin sitting here thinking about a solution to this shit and all I can hear is you lot whining in my ears. Whine, whine, whine, like a load of fuckin nursery school kids, and all of you thinking about yourselves. No one takes a second to think about what anyone else might need; no one takes the time out to *care*. I see it all the time at the town hall. You see it too Annette, and you Ron, though it hasn't stopped either of you behaving that way. That's why this thing was set up! So we could help ourselves as a community and join together for one, just cause. There's not one of you in here that can do that simple, decent, human thing and give in to the greater good of your fellow man or woman. And that doesn't just make me sad. It frustrates me. And when I'm frustrated it clogs up inside me like…like…fat, in an old man's arteries. But more than anything I'm disappointed. I was stupid enough to have faith in human nature. I was wrong.

The others are stunned.

BLACK MUM: Jason? Are you all right?

CHAIRMAN: Am I all right? Am I all right? No, I'm not all right Rose, and I'll tell you why. Most of the reason I'm not all right has to do with *you*. *(BLACK MUM is in serious shock.)* You come in here with your high and mighty act, nose stuck so far into the heavens that you can't see when someone's doing you a kind deed. You could've pushed for equal revenge like Ron said, an eye for an eye. You could've looked your son's killer in the eye and seen him confess his sins. You could've lived a life of freedom in Chamberlayne, instead of having to face the fear of seeing the Crenshaw's daily. You could have all those things in front of you and what do you do? You fuck it up. And all because you wanna play holier-than-thou. Does that make you happy, knowing they would have moved away, and

you wouldn't have to feel guilty about what you really want? Is that what you'd have liked?

BLACK MUM: You're joking right? I know I didn't just hear that. I'm tired. You didn't say that to me.

DOLE WORKER: He bloody well did you know.

WHITE MUM: You're not making any sense, but I'm not leaving this town, simple as. You can kiss me arse mate.

CHAIRMAN: You're one hundred percent right. You're not leaving.

UNEMPLOYED MAN: What are you *talking* about?

YOUNG NURSE: Can someone please tell me what going on, cos I'm really confused now…

BLACK MUM: Jason. Whatever you got going on in your head, control it. This is getting way too weird.

CHAIRMAN: You still don't understand. Someone chucks you a lifeline, but you prefer to go under. Sometimes tries to reach out to you and you push them away. You know what you want, you know what your family wants, and it's not this bullshit we're talking about right here. But Rose – that's all right. I understand why. You're clinging on to sanity, clinging to that human, moral side of you; the side that's regal, the side that's above anyone else – the side that's wrong. See, in your confused state of mind, you believe it's the English way. You know, stiff upper lip, never let the enemy see your pain, that shit. Trouble is, nobody really does that shit Rose! People just act like Tilly, get what they can when they can. I'll do that for you Rose. I'll do that.

CHAIRMAN reaches into his smart jacket pocket, and pulls out a gun. The others recoil in shock.

UNEMPLOYED MAN: I knew he was dodgy!

YOUNG NURSE: Oh my God!

BLACK MUM: *(Calm.)* Jason – what's this all about?

CHAIRMAN: You know what it's about Rose. It's all about revenge at the end of the day. Plain and simple revenge. Ain it Arthur?

NIGHTCLUB looks up, a pale tinge to his face.

WHITE MUM: If yuh fink you're gonna scare us by holding us hostage you can think again – the Crenshaw family –

CHAIRMAN: Fuck the Crenshaw family Tilly. D'you hear that? Fuck you all, and most of all fuck you. She's not the only high and mighty one around here. The only difference is the fact that you go around like you're untouchable. But you can be touched. Can't they Arthur?

YOUNG NURSE: What's Arthur got to do with all this?

CHAIRMAN: Now that's a good one – tell 'em Arthur, tell 'em why I can touch 'em.

NIGHTCLUB looks unsure.

CHAIRMAN: Go one mate – I won't shoot you. Stand up and tell these good people tonight's surprise.

Finally, NIGHTCLUB gets up.

NIGHTCLUB OWNER: He's got Luke tied up and locked in the storeroom. He's bin 'ere the whole night…

WHITE MUM: No you fuckin well ain!

CHAIRMAN: *(Smug.)* Yes I have. Justice will be done. Tonight. Whether you guys like it or not.

YOUTH WORKER: This gets from bad to worse.

WHITE MUM: *(Venomous.)* You think you're smart, but this will come back to you. You're not gonna get away with this. My brother –

CHAIRMAN: Yeah, yeah, yeah, I know all about your big bad brother, Luke told me. But I think you're missing the point. Whatever happens to me, Rose will have her revenge. Whatever happens, Luke pays for what he did.

WHITE MUM is shocked into silence.

DOLE WORKER: Will you tell us what the hell is going on, or what?

CHAIRMAN: I can do better than that. I'll show you. *(He gestures to NIGHTCLUB with the gun.)* Go and untie him, bring him back here – and if you're longer than two minutes, you know what happens. *(He points the gun at the*

jury, ends with WHITE MUM.) One by one, they all come tumbling down.

NIGHTCLUB gets to his feet without a word and goes into the STOREROOM. The others in the TEAROOM mime. WHITE YOUTH thrashes like crazy.

NIGHTCLUB OWNER: Take it easy. Take it easy, all right? We're gonna try an get you out ah this, but at the moment things are fucked. The chairman's got a gun and right now, he's pointing it at yuh old dear – so just behave yourself, OK? I got two minutes to untie you and take you to the tearoom. You gimme any trouble I'll just go back and tell that nutter right now, then concern myself with saving my own behind.

WHITE YOUTH sits perfectly still.

NIGHTCLUB OWNER: All right – so now I'm gonna untie you OK? Please don't do anything that could come back on yuh mum.

WHITE YOUTH nods.

NIGHTCLUB OWNER: OK...

NIGHTCLUB loosens the gag, then the ropes. WHITE YOUTH takes huge gulps of air, his chin by his chest.

NIGHTCLUB OWNER: Feelin better?

WHITE YOUTH: Wha' d'you think?

NIGHTCLUB OWNER: Well, we're in a sticky situation here mate, I kid you not, though it's not the first I bin through in my time. All I can do is warn yuh to keep yuh head. That's the only thing that'll get us through this mess.

WHITE YOUTH: What's goin on?

NIGHTCLUB OWNER: To cut a long story short, the chairman wants you dead mate. To make up for what you did to that coloured kid.

WHITE YOUTH: But I'm innocent! I never done nothin!

NIGHTCLUB OWNER: Come on will yuh! You're not talkin' to your probation officer you know. I've seen you around.

THE FAR SIDE: ACT TWO

That kid weren't the first was he? Maybe he was the first you got caught for, but... Am I right?

WHITE YOUTH: I wouldn't tell you, even if you were.

NIGHTCLUB OWNER: Fair enough. Now we better get going before all hell breaks loose next door. You ready?

WHITE YOUTH: No.

NIGHTCLUB OWNER: Then let's go.

They walk from the STOREROOM, into the TEAROOM, WHITE YOUTH first, then NIGHTCLUB. WHITE MUM gets up.

WHITE MUM: Luke luv, are you all right?

WHITE YOUTH: Yeah, I'm fine...

CHAIRMAN: Ah, the guest of honour has arrived! Come in, we've been waiting for you! Sit on that chair opposite me.

WHITE YOUTH: Fuck you mate...

NIGHTCLUB OWNER: Luke...

WHITE MUM: Do as he says, and less of your lip all right? You're gonna get us all killed.

WHITE YOUTH sobers up a little, takes the seat wordlessly. CHAIRMAN looks happy now.

BLACK MUM: So what do you propose now Jason? You gonna kill this boy in front of all these witnesses?

WHITE MUM: You'll have to kill me first!

UNEMPLOYED MAN: You can't do us all.

CHAIRMAN: Can't I?

YOUNG NURSE: Oh my God...

YOUTH WORKER: Not and get away with it, you can't. One of us'll get the gun off you, it's only a matter of time.

CHAIRMAN: Yeah, but which of you wants to try? Who's gonna volunteer hero? I'm a pretty good shot you know, so whichever one it is, you're gonna die. Who wants to take that chance?

BLACK MUM: Jason? *(He ignores her.)* Jason! Come on, you know this is ridiculous. You're not helping me at all with

this little display, I hope you know that. You can't bring my son back by killing Tilly's child.

WHITE YOUTH: It was your son's fault anyway!

BLACK MUM: Don't shout at me!

WHITE MUM: Don't bark orders at him, who the fuck d'you think you are?

WHITE YOUTH: It was all your son's fault this whole thing happened.

NIGHTCLUB OWNER: I think you better shut up mate…

CHAIRMAN: No – no that's all right, I think I wanna hear this. You didn't get a chance to speak at your trial did you Luke? Or rather, you took the option not to speak.

WHITE YOUTH: *(Hesistant.)* Yeah…

CHAIRMAN: Well go on, don't be shy. Take the stand. State your case. Tell us why you feel you're innocent.

WHITE YOUTH looks unsure now. He's used to doing the opposite to what he's been told, so this is an entirely new experience.

WHITE YOUTH: Like I said, it was Danny's fault from the start. First, cos his mate's bruvva stole from us.

BLACK MUM: From you?

WHITE MUM: 'From us,' he said, you deaf bitch.

BLACK MUM: Jason, will you please control this woman?

CHAIRMAN: See what I'm sayin? I try and do things right and fair and all you guys can think about is your silly little squabbles. OK then – the next person to speak besides Luke gets shot. Understand?

No one answers, of course. CHAIRMAN laughs.

CHAIRMAN: Oh, so you have got some sense. Go on Luke mate, carry on.

WHITE YOUTH shoots him a deadly glare.

WHITE YOUTH: His mate's bruvva stole from my family, not me directly, but it means the same thing. If that was the only problem, things would've been fine, but we let it go and look what happened.

CHAIRMAN: Tell us.

WHITE YOUTH: Well – firstly, you gotta understand how the manor works. It's a jungle out there, and not just cos ah these bunnies *(The others squirm.)* – there's others that make it just as 'ard to live. And the problem is, you give these fuckers leeway and you're marked down as a soft touch. People walk all over yuh, or they try to. My mistake was not to have that Fly when I could've. We ruffed him up a little, but we didn't seriously beat him. That made us weak in the eyes of all the coons and pakis and everyone else around 'ere. We were open to anything they wanted to do.

CHAIRMAN: Carry on...

CHAIRMAN is sitting with the gun pointed at the youth.

WHITE YOUTH: Well, next thing we know, one ah dem pakis is goin' out wiv me cousin Shawn. Remember Mum, years ago? She don't see him now, but the point is, he had the nerve to think he could get away wiv it – whatever way yuh look at it, he thought we was soft. Then, Fly comes up to us after all the trouble between us, asking us to lay him on an ounce so he can sell to some lad he knew. More fool me, I gave him the ounce and what did the fucker do? Knock me innit. When we looked into things, I found out it was Danny that sold the Oz, not even Fly. So that's why we started rowing all the time. Bet yuh never knew that, did yuh?

He's talking to BLACK MUM, but he's also gaining confidence as he speaks. BLACK MUM ignores him.

WHITE YOUTH: So we started 'avin' regular barneys each time we saw each other. And the barney's got worse and worse. First it was fist to fist, then the knives come out – look.

He gets up and lifts up his shirt.

WHITE YOUTH: You kid done that to me, four years ago. Wiv an ice pick. He sharpened it at his college I 'eard, then went around telling everybody he was gonna stick me. When a guy does that to you, you don't let that go. You let it go and the next time you see, you're dead mate. *(He sits down.)* And that's all I gotta say. Anyone'll tell yuh mate, it

was self-defence. In fact, they *did* tell yuh, you lot just don't wanna listen. I'm innocent. Always have been, always will be, even if you kill me.

He stares defiantly at CHAIRMAN, who stares back with a smile.

CHAIRMAN: Eloquent to the last, some people would say. There's only one problem with your little speech my friend. You did kill that boy. You've said as much –

WHITE YOUTH: It was self-defence!

CHAIRMAN: No it wasn't! He never attacked you just before he was killed. He never chased you down the road and stabbed you forty times. You did that. *(He stands.)* And you got off. So now you're going to pay.

WHITE MUM: *Nooo!*

The jury, as one, moves away from WHITE YOUTH, while WHITE MUM leaps for CHAIRMAN, who hits her with the gun, batting her away with ease.

BLACK MUM: Jason, please don't do this, you're not helping.

WHITE MUM: *(Holding her face.)* You fuckin' bastard... I'll kill you before you hurt my child.

CHAIRMAN: Get back! Get back!

NIGHTCLUB OWNER tries to make a leap for CHAIRMAN and wrestle the gun away. In the confusion CHAIRMAN aims at WHITE YOUTH and pulls the trigger, hitting YOUTH WORKER, who crumples. DOLE WORKER screams her name and falls with her, arms cradling her body. At that point, they freeze. The TEAROOM goes dark and the DRUMMING starts up again. BLACK YOUTH and DRUMMER reappear. BLACK YOUTH's previous hostility is gone and he swaggers with an easy step and pace.

BLACK YOUTH: Boy, oh boy, oh boy. Listen to all dis man... Madness innit? Who woulda believe it would come to dis? People screamin', everyone sayin' they're right, no one believin' they're wrong, even for a second. Dat's the trouble wiv all dis man. Justice I mean, dat's the trouble wiv justice. Cos no matter the way the law looks at tings, there's always someone who's gonna be unhappy. Like Tilly Crenshaw. All right, I admit I had aggy wid her son

– but is it right dat she should be made to suffer? An look at my mum – she got her guilty verdict – but did dat make her happy? Did she look happy? I *know* the face she makes when she's happy, an' truss me, the expression I saw was not her happy face.

So lissen people – I ain tryin' to preach or nuttin, but me an' my friend here *(He points to DRUMMER.),* have been talkin' very deeply about dis matter, an we got a kinda conclusion. We reckon tings like dis – the trial, an any other trial for that matter, are inherently flawed because basically, its what people would call a knee-jerk reaction. A response to a problem, rather than a go at *solvin'* the cause. What I'm sayin is, people like Luke Crenshaw an' myself are kinda moulded by our surroundings. An if people like Tilly, an my mum, an dat Chairman Bonsu, an everyone else in dat room fuh dat matter, took responsibility fuh all the kids like us – serious responsibility – shit like dis wouldn't be necessary. I dunno – maybe since I bin hangin' out up dere I gotta clearer sense ah what community really is. I tell you one thing though – *(He points at the figures in the TEAROOM.)* I know what it isn't.

He turns to walk off stage and then pauses for a second, turning around.

BLACK YOUTH: Well – that's what I feel anyway.

He turns and walks off stage, with DRUMMER in tow. With the last bang of the drum the lights come down.

The End.

IDENTITY

Revealing the Revolution: a Few Home Truths

Paul Anthony Morris's *Identity* was born out of the destructive divisions and paranoia which firstly created and then pursued the implosion of the Grenada Revolution (October 1983) and the subsequent U.S. invasion which seized its moment to intervene and crush regional progress. At the time, Morris had lived close to both Jamaican families in Brixton, London and the West London Grenadian community. In writing the play, he knew his hinterland intimately.

Didacus Jules records, 'In 1979, the New Jewel Movement (NJM), under the leadership of Maurice Bishop, took power in Grenada in a bloodless coup.' (Jules 2009: 109).[1] Maurice Bishop's inspiring cry, 'One Caribbean!' was a commentary on the devoted cultural and political aspiration at the heart of the 'Revo'. The process in Grenada had attracted support from all through the Caribbean Basin and beyond. Believers in Caribbean nationhood and intellectuals and activists throughout the region came to Grenada bringing their skills and hopes.[2] From Guyana, Jamaica, St.Lucia, Trinidad and Tobago, and Cuba they arrived; joining with internationalists from the U.S. and British African-Caribbean communities as: agriculturalists, educationalists, medical personnel, cultural and media specialists,

1 The biographical footnote in the volume of *Race and Class* in which Jules's article is published describes him as serving 'the Grenada revolution from 1979 to 1983 [...] and subsequently became permanent secretary and chief education officer.' (2009:109)
2 Grenadian writer Merle Collins's forty-eight line poem in one enjambed stanza captures the revolution's part in connecting black people internationally, as ex-colonial countries created independence from the oppression of European dominion:
But there an' here
Way over dey
Zimbabwe
Nicaragua
Cuba
Mozambique
Angola
Way out yonder [...]
(Collins 1984:58)

economists, engineers and construction workers.³ As Marcia in the play asserts, 'Grenada was like the capital of the Caribbean.' (this volume). Thus, when it befell, the violent demise of what came to be known as 'the peaceful revolution' produced a regional disaster as well as a catastrophe for Grenadians.

Morris's play skilfully dramatizes this phenomenon by dissecting the tensions, differences and stresses within a single family who become the template for the aspiring regional nation. The Johnson family, the parents Cuthbert and Maureen and their three children, Omar, Marcia and Michael are metaphorically that fractured nation, beset with the chain of distrust and lies, rupture caused by 'infighting', the recrimination of the 'witch hunt' (this volume), cover-ups, falsehoods, threats, secrets and violence, factors which ate up the Caribbean revolutionary movement through the eighties and nineties in the wake of the Revo's fall.

In October 1983, shortly before the massacre of their supporters, both the Revolution's leader Maurice Bishop and Jacqueline Creft, the revolutionary militant and Minister of Education in the People's Revolutionary Government were shot down by their own soldiers. This occurred in the colonial fort renamed after Bishop's father Rupert, who had himself been murdered by thugs commanded by Eric Gairy, the Prime Minister who had led the oppressive regime which the Revo had brought to an end. Thus three generations of the Bishop family were murdered and a generation of the Revo's leaders were imprisoned among an unknown number of Grenadians killed in the fort and through the U.S. invasion. The play's date, 1994, is important as it signals the relentless trajectory of death experienced by these families of the Revo. 1994 is the year of the death of the teenager Vladimir, (the beautiful boy and son of Bishop and Creft), outside a Toronto night club in Canada where he was visiting family. Sid, one of Marcia's father's old

3 Editor's note: As Chris Searle explains in his Introduction to an earlier edited volume, *Callaloo: Four Writers From Grenada* (1984), the revolution impelled a cultural flourishing that burst forth from '400 years of colonialism and nearly thirty years of smothering dictatorial rule under E.M. Gairy' and 'a vast dammed-up flow of creativity, which in the next 4 1/2 years broke out in a fullness of ways before it was stopped short by the tragedy of October 1983 and the subsequent US invasion.' (Searle 1984: 7)

comrades in the People's Revolutionary Army and now in London remembers, 'It's been ten years since the invasion and they're still hunting us down. Who knows which one of *our* children might be next?' (this volume). The paranoia Morris represents in *Identity* had very real roots. As Marcia declares, 'It still feels we're living in a prison' (this volume).

The play's action unfolds in the shadow of Vladimir's death. The Johnsons have come to London to escape persecution and to offer a future for their children. 'Coming here has always been about the children' (this volume) says Maureen, who had worked closely with Bishop during the Revo years. The youngest son, Michael, who 'is so different' (this volume) unlike her older children Omar and Marcia, has no memories of the Revolution, being an infant at the time of its fall, and the 'closed doors' (this volume) of shame and secrecy from the past have been shut against him. However, as the play proves, there is no inner escape, not even for Michael, as the tragic psychological violence imbibed by father, mother and siblings is visited upon him as well. Just as the consequences of the Revo haunted and hunted down families who fled Grenada after the US invasion, so Michael is compelled to know the truth of his parents' own self-concealed involvement. Most movingly, Michael learns that Vladimir was his infant friend and Bishop was his godfather. Other traces of their history are more disturbingly revealed. The smell of burning flesh that agonises his older brother Omar still wafts in their household's memory of the slaughter as his mother eventually confesses to him, 'They turned our island into a prison camp Michael and tortured hundreds if not thousands of our young men. We were betrayed' (this volume). Yet, it is Michael's blatant honesty, relentless curiosity, and desperation for the truth that opens up the family's opportunities for collective understanding and conciliation beyond the apparatus of the Revo – which presented almost impossible conditions for family nurture and loyalty.

MAUREEN: Do you have any more secrets?

CUTHBERT: Maureen!

MAUREEN: Do you have any more secrets?

CUTHBERT: No. That's it.

MAUREEN: We're running out of lives Cuthbert.

CUTHBERT: Then we have to live this one as if it's our last. (this volume).

These realisations are what make *Identity* such a startling and insightful play about the period. Cuthbert's shift from the need 'to carry the burden on my own' (this volume) becomes a signal for all those close to him to begin asking heartbreaking (but necessary) questions of each other following the defeat and loss of their revolution. Through Cuthbert, Morris poses a salient question about the hoped-for social restructuring that girds revolutionary momentum, 'How did the idea to simply better ourselves turn out to be so tragic?' (this volume). Through the Johnson family's personal turmoil, Morris tackles uncompromisingly the coming to terms with failure and injustice, and the powerlessness this engenders for people whose ideals for equality were so decisively crushed. In this respect, the play invokes a working through of Guyanese poet Martin Carter's epochal lines from 'You Are Involved' (1952):

Like a jig

shakes the loom.

Like a web

is spun the pattern

all are involved!

all are consumed!

Rather than turning in upon themselves in an act of self-devouring, the Johnsons seek an open future based upon filial honesty and self-realisation. At a micro-level, their process (as Grenadians) signals new possibilities for all those of the Caribbean nation who saw the Revo as a blast of hope and progress so cruelly betrayed and lost. Consumed by revolutionary fervour, pursued by counter-forces which suppressed it, the play illustrates how the hounds of history unleashed can dog the lives of those migrated-generations of Caribbean young people such as Michael, who are formed from multiple versions of freedom and justice.

Unlike Gloria Hamilton's play *Mercy* (1984) which is set in Grenada as the Revo takes place and ends on a celebratory

'Maurice Bishop, our leader, our saviour. Forward ever, backward never!' (Hamilton 1984: 107-8). [4] *Identity* continues the cross-generational consequences of these offstage momentous events which provoke the happenings on-stage in the tradition of Sean O'Casey's plays set around the Dublin Easter Rising. However, the comparison of Hamilton and Morris's plays reveals the subtle displacement of the subject as represented from a Grenadian or British standpoint and across different time frames of retrospection. There are further points of stylistic divergence worth noting. While Hamilton's play is written using Grenadian vernacular, and the reader or speaker must subscribe to the musicality of the accent as rendered, Morris reveals his firmly British standpoint as characters speak Standard English without any indication of the degree of accent that might plausibly still be traceable in older family members. Hamilton proclaims, 'forward ever, backward never!' In Morris's play to look backwards is not regressive. It is the only salvation possible for progress in a family frozen in the repercussions of unspoken histories. Yet, *Identity* defies the grip of factual events. It is unequivocally a family drama, not agit prop theatre. In the landscape of Caribbean migratory histories that have been planted upon British shores, it is a play about an era which stretches beyond its calamitous times through its symbolic family's potent human agency.

Chris Searle (University of Manchester)

[4] I am indebted to Chris Searle for alerting me to this play. (Editor)

Characters	Age	Ensemble Parts
Cuthbert Johnson	50s	
Maureen Johnson	50s	
Omar Johnson	26	Jimmy
Marcia Johnson	26	
Michael Johnson	18	Sergeant
Vince Stephens	50s	Lt. Reid
Sid Wilson	50s	Soldier 1
Scully Douglas	50s	Perry
Customers		The Cast

Reading Symbols:

/ represents the dialogue being interrupted by dialogue or an action.

VO/ The individual is not visible on stage but shouts from another location in the house.

Identity was the first recipient in 2008 of the Adopt-a-Playwright scheme inaugurated by OffWestEnd.com and a performed reading took place at the Theatre Royal Haymarket, London on Dec. 8 2008.

MAUREEN JOHNSON	Dona Carol
CUTHBERT JOHNSON	Bertrum Jones
MICHAEL JOHNSON	Vinta Morgan
OMAR JOHNSON	Richie Campbell
MARCIA JOHNSON	Christina Carty
SID	Geo Aymer
VINCE	Trevor Thomas
DR MORGAN	Tim Morand
SCULLY	Anthony Ofoegbu
JIMMY & CUSTOMER	Tyrone James
Script Reader	Tony Taylor

Directed by Bethany Pitts & Paul Anthony Morris

Identity was premiered at the Tristan Bates Theatre, London on 29 June 2009.
The cast were as follows:

MAUREEN JOHNSON	Ellen Thomas
CUTHBERT JOHNSON	Jeffrey Kissoon
OMAR JOHNSON	Anthony Taylor
MARCIA JOHNSON	Marva Alexander
MICHAEL JOHNSON	Vinta Morgan
VINCE	Trevor Thomas
SID	Geoff Aymer
SCULLY	Trevor Laird

Directed by Angela Michaels

SCENE1. INT. BARBER SHOP. DAY. 1994

Three elderly men in their early fifties (VINCE a postman, SID a bus driver and PERRY a decorator) are listening to a radio commentary of a cricket match. The commentator has the men on the edge of their seats as he narrates the historic events that are unfolding in the match. As the bowler begins his run up the commentator describes the anticipation of the batsman who strikes the ball to the boundary and secures for himself a new world record. VINCE, SID and PERRY are ecstatic. CUTHBERT, the proprietor of the business enters from the back of the barber shop feeling his jaw. PERRY sits back down in the barber's chair and CUTHBERT resumes cutting his hair.

PERRY: Man I tell you Brian Lara is *now* the finest West Indian batsman to have ever played the game of cricket.

SID: You must be joking Gary Sobers is the greatest batsman ever. Brian Lara isn't even in his class.

VINCE: How can you say that?

SID: Because Gary Sobers' record-breaking innings was as devastating as the expeditions of Hannibal who inspired his depleting army over treacherous snow-capped mountains to take on the mighty Roman Empire.

PERRY: Man you're talking nonsense. Lara is *now* the world record holder for both *county* and *test* cricket.

SID: That doesn't mean a damn thing. Can you compare the Pope with Osiris or Mick Jagger with Nat King Cole? '*Unforgettable that's what you are* Gary Sobers'.

VINCE: That's ridiculous. Whether you want to admit it or not Brian Lara's name has been *immortalised* by the *gods* of test cricket.

SID: And *yet* like the constellations of Orion and Pleiades Gary Sobers has eclipsed them *all* by transcending the gravitational forces of mediocrity to take his rightful place at the head of our cricketing pantheon.

PERRY & VINCE: What!

SID: I remember one reporter who said '*watching Gary Sobers at the crease was like observing the sacred rituals of a mystic.*

He mesmerised his opponents with spell-bounding strokes that suspended the continuum of time'.

PERRY: Man you full of shit. You only favour Gary Sobers because he's from your mother's Island.

SID: UUhhhhh. Are you accusing me of being *prejudice*?

PERRY & VINCE: Yes.

SID: Have you *stooped* so low?

PERRY & VINCE: Yes.

SID: Well as the old proverbial saying goes when in Rome do what the Romans do and when in Britain do what the English do.

PERRY: Which is what?

SID & VINCE: Exaggerate!

The men erupt with laughter. CUTHBERT completes PERRY's haircut and PERRY pays him.

PERRY: Thanks a lot Cuthbert and see you in a few weeks.

CUTH: Will do and thanks.

PERRY: Gentlemen until the next time.

VINCE: Take care now.

PERRY: And you.

PERRY & SID: Howzthat!

The two men simulate making a catch. PERRY begins to exit. VINCE and SID watch him leave. The door closes.

VINCE: Captain, Sid and I were wondering /

The shop bell rings. Another customer enters with a guitar on his back.

JIMMY: Yo Cuthbert, evening gentlemen.

SID: Jimmy! Long time no see.

JIMMY: I've been touring.

VINCE: Lucky for some. You staying?

JIMMY: No, it's just a flying visit. Hey Cuthbert you around tomorrow morning at 9.30? I've got an urgent appointment at eleven. I'm getting married.

SID: *Again.* How many times is that Jimmy?

JIMMY: Three.

VINCE: Where's she from?

JIMMY: The Philippines. I just finished playing a gig out there.

VINCE: Does she speak English?

JIMMY: Love is a universal language.

SID: And unfortunately for you Jimmy so is divorce.

VINCE and SID laugh.

CUTH: Don't pay them any mind Jimmy I'll see you tomorrow. morning at 9.30.

JIMMY: Thanks Cuthbert I owe you one. Gentlemen!

VINCE: Night Jimmy and congratulations.

JIMMY: One love.

SID: One love.

Again SID and VINCE watch the customer exit.

VINCE: Sid.

SID walks over to the door and becomes the look out.

VINCE: Captain, we're getting together at Sid's place for the memorial we were wondering if you would like to join us?

SID: It's been ten years Captain. It's a landmark memorial.

CUTH: I don't think I'd be good company fella's.

SID: Oh come on Captain at least you'll be among friends. Besides I've invited some of the comrades down from Manchester and I promised them that you would *definitely* be there this time.

CUTH: Thanks…but if you don't mind I think I'll give it a miss.

SID: But they've already paid for their tickets.

CUTH: You should have asked me first.

SID: I'm asking you now aren't I? Please Captain, don't embarrass me like this. I promised.

CUTH: I'm sorry but I can't.

SID is visibly annoyed.

VINCE: Well if you change your mind Captain the offer still stands.

CUTH: Thanks.

CUTHBERT begins tidying his station.

VINCE: Well we'll be off then.

CUTH: See you tomorrow?

VINCE: Sure. Night Captain.

VINCE and SID are about to exit.

CUTH: Sid.

SID: Captain.

CUTH: Maybe I'll pop by for a few minutes just to say hello.

SID: What? You mean it Captain?

CUTH: I said *maybe*.

SID: You won't regret it Captain I promise. Thank you and goodnight sir.

CUTH: Goodnight Sid.

SID and VINCE exit. CUTHBERT returns to tidying up his station. He then looks over at the door pensively and after a few moments he sits down burdened by his thoughts.

SC2. INT. FRONT ROOM. EVENING

The front door opens and closes. Enter OMAR.

OMAR: Evening Mum.

VO/MAURN: Evening Omar. What are you doing home so early? Omar!

MAUREEN appears at the entrance of the living room from the kitchen.

MAURN: Omar! What's wrong?

OMAR hands MAUREEN a newspaper.

MAURN: Oh my God.

OMAR: It's like it's starting all over again.

MAURN: No one is going to hurt this family again Omar you hear me? Omar!

OMAR: I hear you Mum.

MAURN: Good. Now pull yourself together and give me a hand setting the table otherwise I'll have to call in the exorcist for your sister you know how grumpy she gets when she's hungry.

MAUREEN exits into the kitchen and returns to the living-room and places the cutlery on the table. OMAR takes off his jacket and begins setting the table. MAUREEN observes OMAR to ensure that he has been sufficiently distracted and then re-enters the kitchen again. The front door opens and closes. Enter MARCIA.

MARCIA: Evening Mum.

VO/MAURN: Evening Marcia.

MARCIA: Hi Omar.

OMAR: Hi Sis.

MAUREEN enters the living room.

MAURN: How was your day?

MARCIA: Tiring. Here's the rent.

MAURN: Did you count it?

MARCIA: I'm not going to start counting money in front of the tenants Mum its bad karma.

MAURN: Did you give them a receipt?

MARCIA: I said you'd pop it in the post in the morning.

MAURN: Marcia!

MARCIA: The universe will take care of it Mum there's no need to stress.

MARCIA sits in a meditation pose but after a few seconds her posture collapses.

MARCIA: Isn't dinner ready yet? I'm starving.

MAURN: No Marcia dinner isn't ready yet but don't worry the *universe* is taking care of it.

OMAR laughs.

MARCIA: Mum you know I don't get a proper lunch break at work we're too busy.

MAURN: Is it my fault you're too mean to buy yourself a sandwich?

MARCIA: I don't like cold food you know that.

MAURN: OMmmmmmm.

MARCIA: Mum that's not funny.

MAURN: OMmmmmm.

MARCIA: Mum!

MARCIA throws a cushion at OMAR. MAUREEN re-enters the kitchen laughing.

OMAR: Oh that reminds me Mum did you know a woman in Grenada called Veronica Douglas?

VO/MAURN: I don't think so. Why?

OMAR: She was admitted to the home today.

MAUREEN enters the living room.

MAURN: Did she recognise you?

OMAR: It's alright Mum she's got dementia.

MAURN: Oh, good. I mean…you know what I mean.

OMAR: Yeah.

They stand looking at each other in the hiatus.

MAURN: Is she bad?

OMAR: Uhm.

MAURN: That's a shame. Does she have family?

OMAR: Everyone has family Mum! Sorry. She's on a different floor to me so I'll probably never meet them.

MAURN: Right.

MARCIA: Be careful Omar. We don't want you getting hurt for something that Dad's done.

OMAR: Yeah.

The front door opens and closes.

MICH: Yo Peps wha'd up?

Enter MICHAEL.

MICH: Evening Mum.

MAURN: Evening Michael.

MICH: What'd up homie? You know what I'm saying.

OMAR: Evening Michael.

MICHAEL does a series of different handshakes with OMAR which leaves him confused. MICHAEL turns and sees MARCIA.

MICH: Oh…hi Marcia.

MARCIA: Michael.

MICH: Guess what happened at uni today Mum?

MAURN: If you've got something to tell me Michael then tell me. Guessing games are *not* part of my repertoire.

MICH: I've been made the captain of the first year debating teammmmmm.

MAURN: That's fantastic.

MICH: I know. I'm the youngest captain ever.

MAURN: Well done.

OMAR: I'm really proud of you Michael.

MICH: Thanks bro.

They all turn and look at MARCIA.

MARCIA: That's…really great… Michael…well done.

MAURN: So tell me more.

MICH: We've got this *wacky* history tutor from Ireland called Mr. Gallagher whose chosen topic for our debate is '*the legitimacy of the American dream* and get this Mum '*using popular comic strip heroes to formulate our conclusions.*

MAURN: Wow. That's…different.

MICH: You telling me.

OMAR: So who did you chose?

MICH: Is it a bird is it a plane no it's Superman.

MARCIA: So does that mean you'll be watching a lot of children's TV Michael?

OMAR: Marcia.

MICH: Kwabena reckons /

OMAR: Who's Kwabena?

MICH: My deputy. That Mr Gallagher's an anarchist. He caught him reading the *Guardian* newspaper in the canteen.

OMAR: Your tutor has lunch in the canteen?

MICH: I told you he was an anarchist.

MARCIA: He sounds like a maverick to me.

MICH: I thought *you'd* be pleased.

MARCIA: Well you know what they say Michael great minds think alike.

MICH: More like old dinosaurs.

MAURN: Ignore her Michael. When's the first round?

MICH: Next Friday.

MAURN: Friday?

MICH: Yeah. Something wrong?

MAURN: No.

MICH: I'm going over to Kwabena's later to prepare our statement.

MAURN: What's the rush?

MICH: I've got to get off to a good start Mum. I've got a lot of people depending on me. I can't afford to make any mistakes.

MARCIA: Ahhhhh.

MAURN: Come on Michael let's continue this discussion in the kitchen. I need to get dinner finished so that I can quickly *feed* the animals.

MARCIA: Roar.

MAUREEN and MICHAEL exit into the kitchen. OMAR looks at MARCIA disapprovingly.

MARCIA: What? I'm hungry.

Pause.

MARCIA: It's the memorial next Friday.

OMAR: So that's what all this is about.

MARCIA: Don't say it like that Omar.

OMAR: How would you like me to say it Marcia?

MARCIA: I don't know but not like that you make it sound so meaningless. I've... I've been thinking about going home for a holiday.

OMAR: Are you mad?

MARCIA: We could go together Omar.

OMAR: What!

MARCIA: I'll pay.

OMAR: No. I'm not going back there. Have you told Dad?

MARCIA: It's got nothing to do with him. He put us in this mess in the first place.

OMAR: I can't believe that you're asking me to risk /

The kitchen door opens. Enter MAUREEN and MICHAEL carrying food into the living room.

MICH: We're going to argue the case Mum that *Superman* is really a symbol of the immigrant communities who came to the United States in search of *life, liberty* and the American dream. No wonder JFK said *'Ask not what your country can do for you but ask what you can do for your country'*.

MARCIA: That's pathetic.

MICH: What is?

MARCIA: Your diatribe.

MICH: What?

MAURN: Michael you better go upstairs and get cleaned up dinner will be ready soon.

MICH: Hold on Mum.

MAURN: No Michael, go now. Pops will be home soon. Quickly, quickly, quickly.

MICH: Yes sir.

He salutes.

MICH: I'll see you later... Gorbachev.

He exits.

MARCIA: If he says another word /

MAURN: Drop it Marcia.

MARCIA: About those bloody Ameri /

MAURN: I said drop it.

The front door opens and closes. Enter CUTHBERT.

CUTH: Evening Maureen.

MAURN: Evening Cuthbert.

They kiss on the cheek.

CUTH: Omar, Marcia.

OMAR & MARCIA: Evening Dad.

Enter MICHAEL wearing a tee-shirt with American images on it.

MICH: Yo Pops whad up?

CUTH: Evening Michael.

MAURN: Aren't you cold Michael it's a bit chilly?

MICH: No I'm fine Mum honest!

MAURN: Well, shall we eat? Omar would you like to pray?

OMAR: Thank you Lord for this day and for providing our daily bread Amen.

They sit down and begin to eat.

MICH: Hey Dad guess what? I've been made the captain of the first year debating team.

CUTH: Captain? That's fantastic.

MICH: I know. I'm the youngest captain ever.

CUTH: Congratulations. So what are you going to be debating this time /

MAURN: Salt Cuthbert?

CUTH: No thank you /

MAURN: Pepper?

MICH: The legitimacy of the American dream. Using popular comic strip hero's to formulate our conclusions.

CUTH: And which side of the fence are you going to be defending?

MICH: Pops!

MICHAEL tugs at his tee-shirt.

MARCIA: I suppose as team captain you're going to dress up as Uncle Sam?

MICH: That's a brilliant idea.

MARCIA: Michael I was joking.

MICH: That would be bad arse.

MAURN: Watch your language.

MICH: Sorry Mum.

CUTH: Look Michael I don't think dressing up as /

The phone rings.

MICH: Hold on Pops. Hello, yo Kwabena, my deputy, whad up gee? Na, my sister came up with the dopest idea – she reckons as team captain, you know what I'm saying, I should dress up as Uncle Sam.

MARCIA: Michael!

CUTHBERT gets up from the table and exits into the kitchen. MAUREEN follows him.

MICH: Yeah I know. It's bad arse man. Everyone will be tripping. OK I'll be over in a minute homie. Peaceeee.

MICHAEL puts the phone down.

MICH: Superman's in the house.

MARCIA: Look Michael I don't appreciate you telling your friends that I told you to dress up as Uncle Sam.

MICH: Chill man it's my debate.

MARCIA: You're the one who needs to chill Michael /

Enter MAUREEN.

MAURN: What's going on?

MICH: Ask her. I'm out of here.

MAURN: But you haven't even finished eating yet. Michael where are you going Michael?

MICHAEL exits into the corridor.

MARCIA: It's like he's taunting us.

MAURN: Why would *he* be taunting us?

MARCIA: Well that's what it feels like.

MAURN: It's a debate Marcia /

Enter MICHAEL wearing a baseball jacket.

MICH: Mum I'm going over to Kwabena's now.

MAURN: OK. Have you got your keys?

MICH: Yeah.

MAURN: See you later then.

MICH: Bye.

MICHAEL exits. MAUREEN looks out into the corridor to make sure that MICHAEL has left the house. Enter CUTHBERT from the kitchen.

MAURN: What's got into you Marcia?

MARCIA: Nothing.

MAURN: Don't take me for a fool you've been acting up ever since you got here. Well? Are you…are you /

MARCIA: Don't say it Mum. I'm not jealous alright. OK I am jealous but not because I'm envious of Michael but because it still feels like we're living in a prison.

MAURN: And Michael's to blame for that is he?

MARCIA: I'm not blaming Michael.

MAURN: So where's all this sarcasm coming from? I'm talking to you Marcia.

MARCIA: I'm struggling Mum alright. It's the memorial next Friday and I'm really finding it difficult.

MAURN: Do you think that you're the only one? Take a look around you Marcia we're all struggling so I suggest you take a few deep breaths and pull yourself together again OK. OK.

OMAR: OK Mum.

MARCIA: No I'm sorry it's not OK. I want to reconnect with my old self again and so I've decided to…to go home for a holiday next month.

MAURN & CUTH: What!

CUTH: No Marcia it's too dangerous.

MARCIA: And so is leaving the house every morning. I'm twenty-six years of age and here I am asking my mum and dad for permission to go on holiday. Can't you see how crazy all this is?

MAUREEN takes the newspaper from the cabinet.

MAURN: Read it Omar.

OMAR: Mum!

MAURN: I said read it.

OMAR: Vladimir Lenin Bishop son of the former Grenadian Marxist Prime Minister Maurice Bishop was murdered last week /

MARCIA & CUTH: What!

OMAR: At a discotheque in Toronto Canada. Vladimir died of a single stab wound to the heart in what witnesses described as an unprovoked attack. Members of the *Maurice Bishop Patriotic Movement* have accused Washington of being involved in the murder.

MAURN: You think that the witch hunt against us is over? Their murderous hands as now stretched all the way over to Canada and *you* want to take a chance in their backyard because you're *struggling.*

MAUREEN pulls up OMAR's shirt to reveal his heavily burnt torso.

MAURN: Do I need to remind you of what we had to run away from?

CUTH: Maureen!

MAURN: Do I?

MARCIA: No.

MAURN: Then pull yourself together because there's no going back to the past you hear me, you hear me Marcia?

MARCIA: Yes I heard you.

MAURN: Good…good.

MAUREEN storms into the kitchen.

MARCIA: Excuse me.

MARCIA begins to walk to the door.

CUTH: Marcia, Marcia /

MARCIA fixes CUTHBERT with a glare that stops him in his tracks. She exits into the corridor.

OMAR: I'll talk to her Dad you stay here.

OMAR exits. CUTHBERT sits down. MAUREEN appears at the entrance of the living-room from the kitchen.

CUTH: Ten years Maureen.

MAURN: They're years we might *never* have had.

CUTH: You never felt like going back home?

MAURN: What would we be going back home to Cuthbert? Besides coming here has always been about the children you said so yourself.

CUTH: Yeah.

MAURN: What is it?

CUTH: Michael. He's so different from us.

MAURN: You know what they would say back home.

CUTH & MAURN: Dog don't make cat.

MAURN: Maybe this is just a phase he's going through. You know how young people in this country are taken in by anything that's American. He'll grow out of it.

CUTH: You hope. It was different with Omar and Marcia they grew up on the island the revolution was in their blood. This country is literally all that Michael knows.

MAURN: Maybe if we didn't keep secrets from him he would be different.

CUTH: We agreed to protect him from my past Maureen. Where I failed with Omar and Marcia we might be able to succeed with Michael.

MAURN: Even if it means that he ends up propagating the beliefs that we fought against.

CUTH: Even if it means just that.

MAURN: Dog don't make cat Cuthbert.

CUTHBERT bows his head.

MAURN: If you could choose between us /

CUTH: Maureen!

MAURN: And the revolution would you make the same choice?

CUTH: Yes.

MAURN: Why?

CUTH: Because we were the only thing that was going to last.

MAURN: You make me sound like a pair of your old army boots.

They chuckle. MAUREEN kisses the top of CUTHBERT's head.

CUTH: Don't you have any regrets Maureen?

MAURN: When I think about what we had and who we were back home I would often question if coming here was really worth it. But when I look at Omar and his recovery I know that coming here was the right choice. You saved his life.

CUTH: Yeah.

MAURN: Oh why does Michael's debate have to take place on the same day as the memorial? That's cruel. Sorry.

CUTH: For what?

MAURN: Dog don't make cat.

CUTH: It's nothing.

MAURN: You sure?

CUTH: Sure.

MAURN: You coming up?

CUTH: In a minute. I just want to gargle with some salt water.

MAURN: OK. Don't be long.

MAUREEN exits. CUTHBERT picks up the newspaper and stares at the article. He then contemplates an idea and exits into the kitchen. He returns with a tool box and begins to screw down the handles on the window. The front door opens and closes. Enter MICHAEL.

MICH: Hey Pops.

CUTH: Michael. I wasn't expecting you back so soon.

MICH: We thought we'd make an early morning start instead.

CUTH: Right.

CUTHBERT glances at the newspaper on the chair.

MICH: Mum gone to bed?

CUTH: Just now.

MICH: Something wrong with the window?

CUTH: The hinges are a bit loose that's all.

MICH: Why don't you use the drill?

CUTH: I prefer the screwdriver less noise.

MICH: Oh.

CUTH: Something on your mind?

MICHAEL opens the living room door looks out into the corridor and then closes the door firmly.

MICH: Does Marcia like me Dad?

CUTH: She's your sister Michael.

MICH: That doesn't mean she likes me. We've never really been that close but I thought that was just an older sister younger brother type of thing but it's now starting to feel much deeper than that.

CUTH: Of course she likes you Michael.

MICH: So why is she so hard on me?

CUTH: That's just Marcia's way even from back home.

MICH: So why isn't Omar like that?

CUTH: Just because they're twins it doesn't mean they're the same.

MICH: I just can't work out why she keeps going on about the past. She's been here for ten years

CUTH: Some things are not so easy to forget Michael.

MICH: She was living in a third world country Dad. Just because she was on the Island when the revolution took place that doesn't really make her a *revolutionary* does it? I mean look at you and Mum. You've got two houses, you your own business you've got savings, a car. You're not exactly socialist material are you pops?

CUTH: No.

MICH: See.

CUTH: Give it some time Michael I'm sure it will work itself out.

MICH: I hope so. She's my sister.

Pause.

CUTH: Michael.

MICH: Pops.

CUTH: No it's OK.

MICH: No go on say it. What is it Pops? You want to give me an arm wrestle talk to me about the birds and the bees? I can handle it Pops really I can.

CUTH: I just wanted to /

MICH: What?

CUTH: Wish you good luck.

MICH: For what?

CUTH: The debate.

MICH: Oh that. Don't worry Pops we've already got all the other arguments pretty much licked.

CUTH: You have, have you?

MICH: Yep, first amendment freedom of speech and all that. I won't let you down Pops I promise.

CUTH: Good. See you in the morning then... Captain.

MICH: See you in the morning pops.

MICHAEL catches CUTHBERT off guard and hugs him. CUTHBERT picks up the newspaper and exits. MICHAEL picks up the tool box and exits to the kitchen.

SC3. INT. LIVING ROOM. MORNING

The radio is on in the kitchen. OMAR enters the livings room from the corridor hopping on one leg whilst trying to put on his sock.

OMAR: Mum, Mum have you seen my filofax?

MAURN: Morning Omar.

OMAR: Morning Mum. I thought I left it /

MAUREEN holds up the filofax and a bag with OMAR's lunch in.

OMAR: Ah thanks Mum.

MICHAEL enters the living room from the corridor with his tee shirt half way over his head.

MICH: Mum, Mum /

MAURN: Morning Michael.

MICH: Morning Mum. Have you seen my /

MAUREEN holds up MICHAEL's multi-coloured top.

MICH: Yes. Thanks Mum.

MICHAEL begins putting on the shirt.

VO/CUTH: Maureen, Maureen.

CUTHBERT enters from the corridor.

CUTH: Have you seen my keys?

MICH: Morning Pops.

CUTH: Morning Michael.

MAUREEN plants a cup of tea in CUTHBERT's hand.

CUTH: I'm sure I left them downstairs when I came in last night.

OMAR: Have you checked the bathroom?

CUTH: No.

OMAR: I'll get it.

OMAR exits into the corridor.

MAURN: Michael your toast.

MICHAEL exits into the kitchen.

MAURN: Have you looked on the dressing table I'm sure I saw them there last night.

CUTH: I've looked there.

MAURN: Well go and search again. Maybe they fell down the side.

CUTHBERT exits into the corridor. Enter MICHAEL from the kitchen munching on a piece of toast.

MAURN: Aren't you having a cup of tea with that you'll get wind?

MICH: I haven't got time Mum. I've got to prepare the study papers for my team.

MICHAEL exits into the corridor. Enter OMAR from the corridor.

MAURN: Omar your egg must be boiled by now.

OMAR: Thanks Mum.

OMAR exits into the kitchen. Enter CUTHBERT from the corridor.

CUTH: I still can't find them.

VO/OMAR: They're not in the bathroom either Dad.

Enter MICHAEL from the corridor.

MICH: Here you are Pops.

CUTH: Where did you find them?

MICH: In the front door.

CUTH: Oh yeah. Thanks.

MICH: Are you going down to the dentist Dad?

CUTH: Yes.

MICH: Can you drop me off at the high street?

CUTH: Sure.

MAURN: OK you guys it's time to go.

MICH: Can I have some money Mum?

CUTH: I'll give it to you in the car. Omar are you coming?

VO/OMAR: On my way.

MICH: See you later Mum.

MAURN: Bye son. Come on Omar. I need my peace and quiet.

OMAR exits the kitchen with his mouth full.

MAURN: Come on let's go, let's go.

MAUREEN ushers them out into the corridor and through the front door. MARCIA enters the front room from the corridor and exits into the kitchen. We hear the car drive off. The front door closes and MAUREEN enters the living-room and begins to move some of the furniture. Having created enough space MAUREEN begins her Tai Chi relaxation exercises /

VO/MARCIA: Morning Mum.

MAURN: Um, morning… Marcia.

MAUREEN quickly puts the items of furniture back in place again.

VO/MARCIA: Want a cup of tea?

MAURN: Two sugars please. Any chance of some toast?

MARCIA enters the living-room carrying a tray with tea and toast.

MARCIA: Here you are.

MAURN: Psychic as well my, my.

MARCIA places the tray on the table and begins serving MAUREEN.

MAURN: Thanks. Look Marcia about last night /

MARCIA: Forget it Mum water under the bridge.

MAURN: Really?

MARCIA: Really. I mean it.

MAURN: OK.

They eat and drink in silence.

MAURN: Nice.

MARCIA: What?

MAURN: Breakfast.

MARIA: It's only toast Mum.

MAURN: I know but it's nice.

MARCIA: Thanks. Oh.

MARCIA runs back into the kitchen and returns with a jar of marmalade. She hands it to MAUREEN.

MARCIA: I almost forgot.

MAURN: Thank you.

MAUREEN spreads marmalade over her toast. They eat in silence again.

MAURN: So, no work today?

MARCIA: All my viewings have been booked for the afternoon so I'm giving myself the morning off to catch up on some paperwork. Well that's what I told my boss.

MAURN: And he didn't mind?

MARCIA: I've been the top sales person for the past six months he's hardly going to grumble. If only they knew I was a Marxist the irony would give them a heart attack.

MAURN: There's nothing wrong with taking a pragmatic approach to your situation Marcia it happens.

MARCIA: I know…but I still feel like a hypocrite.

They eat in silence again.

MARCIA: So how's Trevor?

MARCIA: We broke up three months ago Mum.

MAURN: I know. I was just wondering if you still keep in touch.

MARCIA: Once I cut my ties Mum that's it. I move on.

MAURN: He was nice.

MARCIA: Yeah, but he didn't have the swagger. It's a Caribbean thing I suppose.

MAURN: Yeah.

They eat in silence again. MARCIA gets up.

MAURN: Finished already?

MARCIA: Yeah. I'm going upstairs to do my *thang* and then… cancel my ticket.

MAURN: Right. Look Marcia /

MARCIA: It was just a reunion Mum it doesn't matter. I'm sure there'll be others.

MAURN: Yeah.

MAUREEN stands.

MAURN: Thanks for breakfast.

MARCIA: You're welcome.

MAURN: We should try and do this more /

MARCIA: Yeah.

There is another awkward moment between them as the hiatus lingers.

MARCIA: I'll be off then.

MAURN: Have a good one.

MARCIA: Thanks.

MARCIA exits. MAUREEN slumps down in her chair with her head in her hands.

SC4. INT. BARBER SHOP. DAY

CUTHBERT comes from the back of the shop gargling. He spits the mouthwash into the sink. He inspects his gums and dabs his mouth gently. The shop bell rings. Enter SID and VINCE carrying numerous cases of beer.

VINCE: What a day, what a day, what a day.

CUTH: What are you so excited about?

VINCE: Sid and I were having a few drinks in the pub when we overheard some students discussing how the Soviets were only interested in developing ties with the Caribbean to launch their short range missiles against the Americans.

CUTH: What!

VINCE: Well you know we couldn't just stand there and say *nothing*. But those students knew their stuff Captain. One lad in particular had us on the ropes like George Foreman had Muhammad Ali on the ropes pounding us with thunderous left hooks and right hand upper cuts. At one stage I thought Sid was going to pass out.

SID breathes in his inhaler.

SID: Tell the Captain what I did to that young rascal.

VINCE: You remember how Ali used the roper dope to knockout Foreman? Well that's exactly what Sid did to those young rascals. After rolling about in a flurry of pro capitalist propaganda Sid told them that Marxism was the only ideologue big enough to restrain the /

SID: Predatory instincts of capitalism.

VINCE: And that Black Wednesday was symptomatic of the /

SID: Capitalist one-eyed monster /

VINCE: That almost brought this country to the brink of economic ruin last year. By the time we finished with those young rascals we had them singing the anthem of the People's Revolutionary Army.

The men erupt with laughter.

VINCE: Man I haven't felt that good in a long while. It was like being pumped up with the hallucinogenic drugs of freedom, justice and equality.

There is a brief moment of silence as the men indulge in the moment.

SID: We still on for Friday right Captain?

CUTH: Right.

SID: Good. The last coach back to Manchester leaves at eight so we'll be expecting you at around four. Can we leave these at the back?

CUTH: Go ahead.

SID and VINCE carry the crates to the back of the shop.

CUTH: So how many people are you expecting?

VO/SID: About a dozen. And they're really looking forward to seeing their Captain again.

SID and VINCE re-enter the shop.

VINCE: We'll transfer them to the car when we get back. We still have a few more things to pick up. You need anything?

CUTH: No I'm fine thanks.

SID: You sure?

CUTH: Absolutely.

SID: OK then we'll see you in a short while.

CUTH: Right.

SID and VINCE exit. CUTHBERT puffs his cheeks and then winches. He inspects his gums and then gargles with some water again. The shop bell rings and a customer enters.

SCULLY: Yes man so this is the place?

CUTH: Excuse me.

SCULLY: I must have walked down this high street a dozen times but this is the first time I'm seeing your barber shop. You ready for me?

CUTH: Take a seat.

SCULLY: Don't mind if I do thank you.

SCULLY does a semi-salute and makes himself comfortable in the barber's chair.

CUTH: Excuse me a moment.

CUTHBERT goes to the back of the shop to observe the customer. He then returns placing his razor in his pocket.

SCULLY: Nice place you have here. It reminds me of *home*.

CUTH: What would you like?

SCULLY: A number two please and be careful with the hat my wife says it makes me look like James Cagney '*you dirty rat*'.

SCULLY laughs and then becomes embarrassed at being the only one laughing. CUTHBERT switches on the shears and begins cutting SCULLY's hair.

SCULLY: So what part of the Islands are you from?

CUTH: Jamaica.

SCULLY: Really? So are you PNP or JLP and be carefully how you answer your Prime Minister supported the invasion of my Island.

CUTH: I've never been into politics.

SCULLY: I don't blame you it's a real dirty business.

CUTHBERT continues cutting the customer's hair in silence.

SCULLY: So how long have you been in the neighbourhood?

CUTH: A while.

SCULLY: I moved in last week. It's so expensive around here/

CUTH: How's that?

SCULLY: Everything's almost double the price.

CUTH: I meant the hair cut.

SCULLY: Oh you finish already. I'm as blind as a bat without my glasses.

SCULLY puts his glasses on.

SCULLY: Nice, just how the Mrs likes it. Thank you so much sir. So how much do I owe you?

CUTH: Six pounds.

SCULLY: Here you are.

SCULLY hands CUTHBERT twenty pounds. CUTHBERT goes to the till and realises he doesn't have the correct change.

CUTH: Do you have anything smaller?

SCULLY: Sorry.

CUTHBERT goes into the back of the shop. SCULLY picks up the newspaper article reporting Vladimir's death and then quickly puts it back down again. CUTHBERT re-enters the shop.

CUTH: Here you go.

SCULLY: Thank you. Boy now that I've got my glasses on you really resemble my Captain from Grenada. If you had a beard and a little less /

CUTH: If I was given a tenner every time someone said I looked like some relative from Jamaica I'd be a rich man by now.

SCULLY: You know the same thing used to happen to me in Grenada. When I was younger everyone used to swear blind that I looked just like Harry Belafonte.

SCULLY laughs loudly and then becomes embarrassed at being the only one laughing again.

SCULLY: Anyway I better be going the missus will be wondering where I am. Thanks a lot and take care.

CUTH: Bye.

SCULLY exits. CUTHBERT walks over to the door to make sure SCULLY has departed. He walks back into the shop and sits down thoughtfully. Enter SCULLY.

SCULLY: I forgot my hat *you dirty rat.*

SCULLY grabs his hat from the rail.

SCULLY: Thanks again. Oh by the way how's the gums?

CUTH: They've been giving me a hell of a /

SCULLY: Captain Mcsween! I was one of the soldiers in the revolution.

CUTH: I'm sorry but you must be mixing me up with someone else.

SCULLY: I served in the 2nd division of the Revolutionary guard. Lieutenant Reid was my /

CUTH: I'm sorry but I've never seen you before and I don't know what you're talking about.

SCULLY: We were stationed at Point Salines near /

CUTH: I said I don't know what you're talking about.

VINCE and SID appear at the door.

CUTH: Now if it's money you're after the till is over there. I don't want any trouble OK.

SCULLY: But /

CUTH: I said I don't want any trouble. Just take the money and *go*.

VINCE and SID bundle SCULLY to the ground.

SCULLY: You're hurting me.

SID: Break his arm.

SCULLY: No I made a mistake. Please let me go and I'll be on my way.

VINCE: If you ever show your face around here /

SCULLY: I won't I give you my word. It was a mistake. Please.

VINCE and SID drag SCULLY to his feet. As they are about to throw him out SCULLY and VINCE see each other face to face for the first time.

SCULLY: Vince?

VINCE: Scully?

VINCE and SCULLY embrace like long lost brothers.

VINCE: What the hell are you doing here boy? The last time I saw you the Americans had you pinned down at the airport.

SCULLY: They did but we *still* managed to escape.

VINCE: What! You in touch with any of the fellas?

SCULLY: Cymore is now living in Holland with a wife and two kids. Perry and Douglas fled to Scotland.

VINCE: What about Thaddeus?

SCULLY: I heard he died of a heart-attack six months ago.

VINCE: Man that's too bad. He was a damn good soldier. What about Spider?

SCULLY: No one has seen that scoundrel for years. The last I heard he was in Cuba.

VINCE: That man was fearless.

SCULLY: Tell me about it. I saw him take down three fully-armed Americans soldiers with a *half* broken bottle in his hand.

VINCE: I heard they were after him big time.

SCULLY: Offering rewards and all.

They laugh.

VINCE: So what the hell are doing trying to rob the Captain boy?

CUTH: Vince! Sid, lock the door.

SID locks the door and pulls down the blind.

CUTH: Who sent you?

SCULLY: What!

CUTH: I said who sent you?

SCULLY: No one.

CUTHBERT takes out his razor.

VINCE: Captain what are you doing?

CUTH: Stand down Vince.

VINCE: Captain!

CUTH: I said stand down.

VINCE stands down.

CUTH: Now this is your last chance. Who sent you?

SCULLY: No one.

CUTHBERT lunges forward to cut SCULLY. SCULLY ducks and escapes to the other side of the shop.

CUTH: Who sent you I said who sent you?

CUTHBERT lunges at him again. SCULLY ducks.

SCULLY: Your son, your son.

CUTH: What!

SCULLY: He works at the nursing home that my wife was admitted to.

CUTH: That still doesn't explain how you knew I was *here*. My son would never tell you that.

SCULLY: I followed you here this morning. I was getting into my car when you pulled up at the home.

SID: He's lying Captain cut him.

SCULLY: No I swear it's the truth. My wife's name is Veronica Douglas. She was admitted few days ago. Check with your son. Please!

CUTH: You don't go anywhere near my son you hear.

SCULLY: I won't you have my word.

CUTH: Sid.

SID walks over to SCULLY and searches him. He removes his wallet and throws it to CUTHBERT. CUTHBERT opens it.

CUTH: 35 Lancaster Rd is that where you live?

SCULLY: Yes.

CUTHBERT removes the money from the wallet and hands it back to SID. SID hands it to SCULLY.

CUTH: I'll keep this just in case we need to pay you a visit. Now get out.

SCULLY straightens himself out and begins to exit.

CUTH: Remember you're in the presence of soldier.

SCULLY: Yes sir.

SCULLY salutes CUTHBERT about turn's and exits. SID locks the door behind him.

SID: Who was his commanding officer?

VINCE: Lieutenant Reid.

SID: What!

VINCE: Now hold on Sid not all the soldiers under Lieutenant Reid's command knew what he was planning. Scully proved himself against the Americans. He's a good soldier.

SID: Well if he's so trustworthy why didn't he introduce himself to the Captain at the home? Why did he have to follow him here?

VINCE: I don't know.

SID: Precisely.

SID holds up the article on Vladimir.

SID: It's been ten years since the invasion and there still hunting us down. Who knows which one of *our* children might be next?

SC5. INT. LIVING-ROOM. NIGHT

OMAR is looking through a photo album. MAUREEN is sitting on a chair with MARCIA standing behind her.

MARCIA: Breath in and out. In and out, in and out, in /

OMAR: Remember this Marcia?

MARCIA: Keep holding Mum.

MARCIA walks over to OMAR who is looking at a picture in the album.

MARCIA: Oh my goodness that must have been taken shortly after we got here.

OMAR: Yep. That was our first day at college?

MARCIA: And there's Dad lurking in the background like some Ninja warrior. You know it's amazing we've been here ten years and despite Mum and Dad's worst fears no one's recognized us.

OMAR: Living in Balham instead of Southall might have something to do with it.

MARCIA: Yeah.

MAUREEN begins struggling for air.

MARCIA: Oh sorry Mum breathe out.

MAURN: Murderer, murderer.

MARCIA: Oh stop exaggerating and breathe in.

MAURN: Get your hands off me.

MARCIA: How am I supposed to practise?

MAURN: I wouldn't let you near a cremation.

MARCIA: Mum! Omar?

OMAR: No thanks Sis the last time you laid hands I got constipation.

MAUREEN laughs.

MARCIA: Stop laughing at me Mum you know I don't like it.

OMAR: Do you remember him Marcia?

OMAR points to a picture in the album.

MARCIA: Isn't that Farooq?

OMAR: Yep. He was the head of public services.

MARCIA: Didn't he make that fantastic speech on how Western Capitalism would one day turn in on itself and begin to cannibalise the wealth of its own citizens?

OMAR: That's him. He's now one of the richest men in Grenada.

MARCIA: What?

OMAR passes the newspaper article to MARCIA.

MAURN: He's also the biggest apologist of the revolution.

MARCIA: Farooq? I don't believe it. That speech blew my mind?

MAURN: It makes you wonder what all those years of *struggle* were really for.

OMAR: Oh come on Mum Regan was never going to allow Bishop to become another Castro and Grenada another Cuba. The writing was on the wall.

MAURN: Yes it was, but did we also have to help them? The greatest leader we ever had murdered because of jealousy and infighting. What a waste.

MARCIA: Oh not you as well Mum?

MAURN: Not for me, for you and Omar. You've missed out on so much.

MARCIA: Well I don't see it that way.

OMAR: How?

MARCIA: Because the revolution was exciting. Grenada was like the the capital of the Caribbean. They were the best years of our lives.

OMAR: Not for ordinary people like me.

MARCIA: Ordinary? Bishop gave us *power* for the first time in centuries Omar. He gave us an identity.

OMAR: And then his deputy snatched it all back and paved the way for the Americans. We can't keep romanticising about the past Marcia we have to grow up.

MARCIA: Grow up? Look I don't want to get into an argument here but what Bishop achieved in three years was incredible.

OMAR: Yes it was incredible but like I said Marcia we have to move on.

MARCIA: And that's why you're working in a nursing home looking after dead people because you've moved on Omar.

MAURN: Marcia!

MARCIA: Well if I'm stuck in the past Omar it's only because I refuse to settle for second best.

MARCIA holds OMAR's gaze and forces him to look away. MAUREEN flops down into the chair.

OMAR: Mum I'm just popping out for a minute.

MAURN: OK.

OMAR exits with the photo album.

MARCIA: Mum I need your help.

MAURN: This time you're on your own Marcia.

MARCIA: How am I going to win him back?

MAURN: You're going to have to work that one out all by yourself.

MARCIA: How /

Enter OMAR.

OMAR: Mum I've put the album back in your room.

MAURN: OK. See you later?

OMAR: Yeah.

He exits. The front door opens and closes.

MAURN: This is our home Marcia not a battle field.

MARCIA: I know. I just got carried away I'm sorry.

MAURN: You just make sure that you tell your brother that when he gets home you hear me?

MARCIA: Yes. So what now?

MAURN: Stew.

MARCIA: For how long?

MAURN: You know your brother can't keep a grudge. So fortunately for you it should be over by dinner time.

MARCIA: Are you sure Mum?

MAURN: No I'm not sure Marcia but let's hope so OK.

MARCIA: OK Mum…OK.

SC6. INT. BARBER SHOP. NIGHT

CUTHBERT finishes dusting down his last customer. The customer pays him and exits. The shop bell rings.

CUTH: We're closed I'm just about to lock /

Enter OMAR.

OMAR: Too busy to give your own son a shape-up.

They chuckle and then there is a moment of recognition between them.

CUTH: If you bring in the board and pull down the blind you have yourself a deal.

OMAR brings in the board and pulls down the blind. He then sits in the barber's chair. CUTHBERT switches on the shears and begins cutting OMAR's hair.

CUTH: How was work?

OMAR: Quiet.

CUTH: That makes a change.

OMAR: Yeah. What about you?

CUTH: Let's say it was no *ordinary* afternoon.

OMAR: Why what happened?

CUTH: I had a visitor.

OMAR: Really, who?

CUTH: Scully.

OMAR: Is that supposed to mean something to me?

CUTH: He's the husband of one of your patients a Grenadian called Veronica Douglas.

OMAR: What!

CUTH: He saw me drop you off this morning and then he followed me here.

OMAR: Why?

CUTH: He was under Lieutenant Reid's command.

OMAR: What!

CUTH: Haven't you met him?

OMAR: No. What did he want?

CUTH: To say hello.

OMAR: Or?

CUTH: You just be careful you hear.

OMAR: Yes Dad.

CUTHBERT resumes cutting OMAR's hair.

OMAR: Can I ask you a question Dad?

CUTH: Shoot.

OMAR: Are you disappointed in me?

CUTH: Omar you're my son.

OMAR: I'm not asking you as your son Dad but man to man.

CUTH: What's bought this on?

OMAR: It's OK Dad. You don't need to answer the question. I would be if I were you.

CUTH: But I'm not I've told you that a thousand times.

OMAR: I know but... I still feel like one.

Pause.

CUTH: We still have our deal right?

OMAR does not respond.

CUTH: Omar! Do we still have a deal?

OMAR: We still have a deal Dad.

CUTH: Good because I'm depending on you.

CUTHBERT continues to cut OMAR's hair in silence.

OMAR: One of the nurses has invited me out for a drink.

CUTH: That's good. Does she know about your burns?

OMAR: No.

CUTH: You going?

OMAR: I think so Dad. I think so.

SC7. INT. LIVING ROOM. NIGHT

An audio recording of 'Living in America' is being played at full volume from the kitchen. MICHAEL enters the front-room from the kitchen wearing a suit of stars and stripes. Enter MAUREEN and MARCIA from the corridor.

MAURN: What's that racket? And what are you wearing?

MICH: It's for the debate tomorrow. You like it?

MARCIA switches off the cassette player in the kitchen.

MICH: Oi I'm listening to that.

MAURN: Don't you think your outfit is way over the top Michael.

MICH: That's *exactly* the effect I want to create.

MAURN: You can't wear that tomorrow's the memorial.

MICH: And what's that got to do with me.

MAURN: Mum!

MAURN: Look Michael you don't have to dress like that to make your point.

MICH: But I do it's the only way to highlight the paradox.

MAURN: What Paradox?

MICH: The American dream. Look our lecturer Mr Gallagher is anti-American right *yet* he thinks Bob Dylan is the greatest thing since slice bread. His favourite film is '*On the Waterfront*' and his wife is an *American*. Talk about biting the hand that feeds you.

MARCIA: Things are not always as straightforward as they appear Michael.

MICH: And why's that Marcia because we all want to indulge our hypocrisies?

MAURN: Because some situations aren't black and white.

MICH: For example.

MAURN: Look I don't have time for this right now.

MICH: No come on Mum enlighten me I might be able to use it for the debate.

MARCIA: Take the plight of Black Americans theirs is a complex history /

MICH: Yet whenever their athletes cross the finishing line they're the first ones to drape themselves in the American flag. You see that's what's so intriguing about the paradox Mum – the love-hate relationship that people have with America. Martin Luther King said that he had a dream right? Well I believe in that dream too, that twenty years from now we'll have the first black president of the United States. You see that's why the metaphor of Superman is so important Mum because like the Olympic flame…

He removes his notes from his pocket and reads.

MICH: *It illuminates the aspirations of ordinary Americans by reminding them that not only are their dreams constitutional but they're also imbedded in the legacy of the founding fathers.* That sounds a bit preachy doesn't it? I need to change that Martin Luther King line it sounds too clichéd.

MAURN: Michael, go upstairs and get changed.

MICH: It needs something a bit more personal.

MAURN: Michael /

MICH: I got it. The revolution!

MARCIA: 1776?

MICH: No not that one. The one you guys had to run away from.

MAURN: We didn't run away from the revolution Michael.

MICH: Yeah but it was the *Americans* who got rid of the dictators right, right? Help me out here Mum. Did they or didn't they get rid of the communists?

MAURN: In a sense.

MICH: What does that mean?

MAURN: It means that I want you to go upstairs and get changed.

MICH: This is important Mum. Don't you want me to win? You could give me the personal touch that tips the debate in my favour. Why won't you help me?

MAURN: Look Michael I told you to go upstairs and get changed.

MICH: No. I don't understand what's the problem? Do you want me to lose Mum?

MAURN: Of course not.

MICH: Then why won't you help me?

The front door opens and closes. Enter CUTHBERT and OMAR.

MICH: Dad, Dad did the Americans rescue the Grenadians by getting rid of the dictators?

CUTH: Why are you dressed like that Michael?

MICH: Don't worry about it Dad. I asked Mum and she's refusing to help me.

CUTH: Take it off Michael.

MICH: What?

CUTH: The costume.

MICH: In a minute Pops after you've answered my question.

MAURN: Michael, do as you're told.

MICH: No.

MAURN: There are other ways for you to make your point now go upstairs and get changed…now.

MICHAEL weighs up the situation and then slowly walks to the door and exits / MICHAEL bursts back in.

MICH: No I won't take it off I'll wear what I like.

CUTH: You're not wearing that.

MICH: You can't tell me what to do it's my debate.

MAURN: Will you go upstairs and get changed Michael.

MICH: Not until you tell me why? What's the secret? What are you hiding from me?

CUTH: We're not hiding anything.

MICH: So why are you trying to control me to *dictate* what I can and cannot wear?

CUTH: I'm not trying to control you.

MICH: Yes you are.

OMAR: Michael, please go upstairs.

MICH: No. Dad what's wrong you're upset I can see it. What is it pops, pops?

CUTH: I'm not upset Michael I just want you to take that thing off.

MICH: No. You're lying. I can see it. Why won't you tell me the truth?

CUTH: Take it off Michael.

MICH: No.

CUTH: I said take it off.

MICH: No.

CUTHBERT grabs MICHAEL and begins pulling off the costume.

MICH: Dad you're hurting me. What are you doing? Get him off me. Pops, it's me Michael, Michael. Pops, Pops.

MAUREEN, OMAR and MARCIA separate them. MICHAEL cowers in a corner.

CUTH: Michael I'm sorry. Forgive me. I don't know what came over me.

MICH: Leave me alone leave me alone.

CUTH: Michael please I didn't mean it. I didn't know what I was doing.

MICH: Stay away from me you hear. Stay away from me.

MICHAEL runs out the room. The front door opens and slams shut. End of first half.

SC8. INT. BARBER SHOP NIGHT.

CUTHBERT sees the last of his customers out of the shop. He locks the door and pulls down the blind. He tidies his work surface and removes his overall. He sits down and relaxes in one of the chairs. After a few moments he stands and lifts up the lid of one of the box seats and takes out a plastic bag. From the bag he removes his Captain's army hat. He dusts the hat down with his hand and sits back down looking at it. After a few moments he braves the decision to put the hat on. Feeling uncomfortable he removes the hat and reclines into the chair placing the hat over his eyes. He is disturbed by urgent knocking at the door.

CUTH: I'm closed.

The knocking continues.

CUTH: I said I'm closed.

The knocking stops momentarily and then resumes more aggressively. CUTHBERT places the cap on the counter and walks over to the door and pulls it open.

CUTH: I said I'm /

SID brushes past CUTHBERT with a beer can in his hand. He is drunk. VINCE enters behind him sheepishly.

SID: To the revolution.

SID pours beer onto the floor and then drinks a mouthful.

SID: To comrade Bishop, our beloved Prime Minister, God rest his soul.

He repeats the rite of libation again.

SID: And to the Comrades that gave their lives.

He completes the rite of libation and begins to sing the anthem of the revolution.

SID: The Grenadian Revolution

It is the only solution.

To imperial oppression

Let the bells of freedom ring.

The Grenadian Revolution

It is the only solution.

So come and join our battle

And let the bells of freedom ring.

SID salutes and then slumps down onto one of the chairs. VINCE begins mopping up the beer on the floor.

VINCE: Sorry Captain. He insisted on coming and I couldn't let him drive in that state.

SID: Don't you apologise for me. He promised to join us for a drink and he didn't. And now the comrades are making their way back up the M1. You humiliated me Captain. All they wanted was to have a drink for old time sake. What was wrong with that? Well that's exactly what we're going to do right now.

SID removes two beer cans from either side of his pocket. He opens one can and hands it to VINCE. He opens the second can and staggers over to CUTHBERT and plants it in his hand.

SID: 'To the People's revolutionary army'.

SID gulps down a mouthful of beer and then notices that VINCE and CUTHBERT are not drinking.

SID: Well come on drink up.

VINCE reluctantly takes a sip. CUTHBERT places his can on the counter.

SID: What are you doing Captain? Isn't the beer to your liking or aren't we good enough to have a drink with anymore?

VINCE: Sid! It's the booze talking Captain.

SID: I told you before don't apologise for me. I can speak up for myself. Well Captain /

There is a knock at the door.

SID: Hold on I'm coming.

SID staggers to the door and pulls it open.

SID: Scully nice to see you man happy memorial.

SCULLY: I was just driving by and saw that the lights were still on.

SID: Come in, come in, come in. How's the wife she stop shaking yet? Take a seat, drink, hold on.

SID retrieves CUTHBERT's can from the counter and staggers back to SCULLY and plants the can in his hand.

SID: To the revolution.

SCULLY: The revolution.

SID and SCULLY drink.

SID: Now where was I? Oh yes that's right I was just inquiring from the Captain Scully why he refused to have a drink with his men on such a momentous occasion. I mean if there is a *turncoat* among us it surely isn't Vince and I is it Captain?

SCULLY: I don't think I should be here.

SID: Sit down.

SCULLY sits.

SID: I mean there's no real reason why *you* should refuse to have a drink with *us* is there Captain but on the other hand?

VINCE: Sid!

SID: Not once Captain, not once did Vince and I believe that you were part of the plot that led to Bishop's murder – even amidst the fiercest of rumours. Well I'm now beginning to have my doubts.

VINCE: Sid! We vowed that we would never condemn the Captain.

SID: Well maybe that's the reason why he never wants to join up with the comrades because unlike us Vince they're not as easily fooled. Wouldn't you like to hear Scully how the Captain sacrificed our Prime Minister?

VINCE: Sid!

SID: Or better still maybe you'd like to hear it from the horse's mouth? Well the floor is yours Captain. We're waiting.

CUTHBERT sits back down on the barber's chair.

SID: Well?

SID staggers over to CUTHBERT and stands behind him.

SID: What happened Captain what happened?

SC.9. INT. CELL

Flashback. CUTHBERT is being suffocated with a plastic bag by a man wearing a balaclava. His wrists and feet have been strapped to the arms and legs of the chair. LT. REID enters the spotlight.

LT. REID: That's enough. Killing him won't help. Besides we don't want to make a martyr out of you do we Captain? So why don't you make it easier on yourself and tell us what we want to know?

CUTH: Over my dead body.

LT. REID: Unfortunately that can't be arranged besides it's unlawful for a Lieutenant to order the execution of his Captain.

CUTH: And for the deputy to plot against his prime minister.

LT. REID: You and I are military men Captain what would we know about the affairs of politicians? Our way of life is so much simpler we just follow orders. Open his mouth.

The soldier forces open CUTHBERT's mouth. LT. REID inserts a dentist's drill and begins drilling CUTHBERT's gums. CUTHBERT begins screaming. LT. REID pauses.

LT. REID: Now tell me Captain is Bishop going to accept our demands for *power sharing* or is he going to force us into a civil war?

CUTHBERT doesn't answer. LT. REID begins drilling his cavities again.

LT. REID: What are Bishop's plans Captain what are his plans? Let him go.

The soldier releases his hands from CUTHBERT's jaw.

LT. REID: I've exposed a nerve in your gum that runs through your inner ear up into your temple and across the back of your retina. Now for the last time Captain is Bishop going to accept our demands?

CUTHBERT doesn't answer. LT. REID begins drilling CUTHBERT's gums. Enter SERGEANT. LT. REID stops drilling.

SERGNT: We've got him sir.

LT. REID: Bring him in and make sure you gag him.

SERGNT: Yes sir.

The SERGEANT exits. LT. REID picks up a can.

LT. REID: Taking over the Island Captain will be far easier with you on our side.

Enter SERGEANT with a prisoner covered from head to toe in a blanket. The prisoner is pushed to the floor.

LT. REID: Your backing would certainly help us to appease the Islanders. However, if you decide otherwise Captain…

LT. REID begins pouring petrol over the prisoner.

LT. REID: Then the blood of this comrade is going to be on your hands. So what's it to be Captain?

CUTH: Go to hell Lieutenant.

LT. REID: That's not the answer that I was hoping for.

LT. REID clicks his fingers. The SERGEANT raises part of the blanket to reveal the prisoner's identity to CUTHBERT. LT. REID removes a box of matches from his pocket.

CUTH: No, no Lieutenant. Don't do it, don't do it.

CUTHBERT tries to free himself.

CUTH: I'll tell you what you want.

LT. REID: It's too late Captain.

CUTH: No Lieutenant, I'm begging you.

The LIEUTENANT REID strikes the match.

CUTH: Please Lieutenant. Don't do it. No, no.

LIEUTENANT REID throws the match on the blanket.

CUTH: Omar!

SC10. INT. LIVING ROOM. NIGHT

Flames flare up from a burner that MAUREEN is attempting to light on the dining table.

MAURN: Still haven't got the hang of this damn thing. Marcia, Marcia.

Enter MARCIA wearing a red dress.

MAURN: Light the burner for me please.

MAUREEN hands the torch to MARCIA. MARCIA lights the stove. The flames flare up again.

MARCIA: The burners are too high Mum that's why they keep flaring up like that. You have to remember to turn them down before you light them.

MAURN: That's far too technical for an old country girl like me.

MARCIA: So handling an AK47 wasn't too technical for you Mum?

MAURN: That's different you just point and shoot.

MAUREEN takes the torch from MARCIA and exits into the kitchen.

MARCIA: You were the top markswoman for three years…in a row. Why do you always do that Mum?

VO/MAURN: Do what?

MARCIA: Play everything down?

MAUREEN enters the living room.

MAURN: Sorry.

Pause.

MARCIA: Do you ever miss it Mum?

MAURN: What?

MARCIA: The training.

MAURN: Being the wife of a Captain didn't win me any favours especially among the women. But yes I miss it.

MARCIA: Which bits in particular?

MAURN: All of it. Even those dreaded sleep deprivation exercises. Did I ever tell you how I managed to stay alert at work while all the other women were dropping down like flies?

MARCIA: You know you didn't Mum.

MAURN: Well on the days we returned back to the office after training Bishop would reschedule all his meetings to the afternoon so that I could spend the entire morning locked up in his office catching up on my sleep.

MARCIA screams in disbelief.

MARCIA: Mum! I don't believe you.

MAURN: I had a reputation to live up to and I needed all the help that I could get. There are some habits in *us* women that not even a *revolution* can change.

MARCIA: You cheat.

MAURN: I know. Your father would have hit the roof. But that was *our* little secret.

MARCIA: I used to love going to camp with you during the holidays. I wasn't too keen on all that food rationing stuff but I loved forcing myself to stay awake with you and the other women. I think that's what *I* miss most about being away from home…the closeness and the discipline.

MAURN: You still remember the *drill* comrade?

MARCIA: What!

MARCIA laughs.

MARCIA: Yeah.

MAURN: Well come test me na.

MARCIA: Mum!

MAURN: Yard fowl.

MARCIA: Right.

MARCIA launches into an attack which is skilfully fended off by MAUREEN. However, MARCIA is eventually forced into a submission.

MARCIA: I give up I give up.

MAUREEN dusts her hands off triumphantly.

MAURN: Yard fowl.

MARCIA: Are you still practising Mum?

MAURN: After you've all left the house.

MARCIA: You sneak. Why didn't you tell me?

MAURN: I just…wanted something for myself.

MAUREEN walks quietly over to the table and begins laying out the cutlery.

MARCIA: Happy memorial Mum.

MAURN: Happy memorial.

MARCIA: I got us something.

MAURN: Oh.

MARCIA exits into the corridor and returns with a small packet. She hands the gift to MAUREEN and MAUREEN unwraps it.

MAURN: Where did you get these?

MARCIA: Harrods.

MAURN: You went to *Harrods*?

MARCIA: Believe me Mum it wasn't easy. That place is so intense.

MAURN: Well, I can't allow you to go through all that trouble for nothing can I shall we?

MARCIA: Yeah.

MAUREEN enters the kitchen and returns with the torchlight and lights up the cigars. MAUREEN and MARCIA recline onto the dining-room chairs and begin to make clouds.

MARCIA: Just like the old days eh.

MAURN: Almost, Marcia almost.

Pause.

MARCIA: Mum.

MAURN: Uhm.

MARCIA: Eric's stopping over next week on his way back to Grenada from Paris and he's asked me to meet him.

MAURN: Isn't he already married?

MARCIA: They're divorced. He was hoping that I would make it to the reunion. We've been keeping in touch via my work number…because of Michael.

MAURN: I see. Trevor didn't stand a chance did he?

MARCIA shakes her head.

MARCIA: I know we were only sixteen but what if?

MAURN: Well if your grandmother was still around you know what she would say treat them mean to keep then keen.

MARCIA: So you don't mind if I meet him.

MAURN: No. I turned down your father twice before we got married.

MARCIA: Really? I would have married the *old* Dad in a heartbeat.

MAURN: Me to.

MARCIA: So why did you turn him down.

MAURN: Because all my friends had been proposed to at least twice before they eventually got married and I wasn't about to act like some desperado by saying yes to the first man who asked me.

MARCIA: But suppose Dad had lost interest?

MAURN: There was no chance of that. I made sure we bumped into each other as often as possible just to ensure that I stayed on his mind. The second time he asked me your grandmother told him that if he was really serious about marrying her daughter he should come back and ask me in a year's time – and sure enough one year to the day he returned with an engagement ring and showed it to your grandmother.

MARCIA: What did you say?

MAURN: I wanted to say yes right away but your grandmother told me to pretend that I had forgotten about it.

MARCIA: No.

MAURN: She was a very proud woman your grandmother. My friends were so jealous. Every man that had proposed to them had married another woman within weeks of their rejection and here was I being pursued for well over a year. Vince said your father was hopping mad.

MARCIA: I don't blame him. So how did you eventually tie the knot?

MAURN: Six weeks after your grandmother died. If it was left to her she would have burnt my virginity in the nunnery.

MARCIA: Mum! That's disgusting.

MAURN: It turned out to be the biggest country wedding of the year. Your father would often say that anything good

that came into his life came as a result of our marriage and he was right for a while. When we joined the struggle he said you and Omar were the flowers of the revolution – the symbols of the new hope that would sweep across the Island and capture the imagination of the entire region. But like Omar said *'the writing was on the wall'* and Reagan had other ideas.

MARCIA: Yeah but if the infighting hadn't taken place the invasion might never have happened Mum. I mean think about it unemployment plummeted, manufacturing accelerated, tourism boomed, construction grew and our credit rating soared. With the fastest-growing economy in the region who knows how much more we could have gone on to achieve. What?

MAURN: Maybe you could have made it.

MARCIA: In what?

MAURN: Politics.

MARCIA: What do you want me to say Mum. It's more than I could ever achieve living here.

MAURN: Oh Marcia I failed you. I just assumed that you would cope. I'm really, really sorry. I've spent so much time focusing on Omar and then Michael. I've let you down.

MARCIA: Not you Mum, Dad. Giving up Bishop changed everything…even us.

There is a hiatus between the two women as neither of them knows what to do / the front door opens and closes. MARCIA and MAUREEN quickly stub out their cigars on the burner and begin to waft away the smoke. Enter MICHAEL.

MARCIA: Michael!

MICH: Hi, hello Mum.

MAURN: Hello Michael.

MICH: What's that smell?

MARCIA: The burner it had ash and dust stuck to it. I'll open the window.

MICH: Dad screwed the handles down. He said something about replacing the hinges.

MARCIA: Right. I'll open the kitchen door shall I?

MARCIA exits. MICHAEL places a trophy on the table.

MAURN: So you won?

MICH: It's only the first round Mum.

MAURN: Well done. You don't look very pleased.

Enter MARCIA.

MICH: Are you going out?

MARCIA: No.

MICH: So why are you dressed up like that?

MARCIA: No reason.

MICH: I'm not stupid Marcia. I know it's the memorial you don't have to pretend.

MARCIA: I'm not besides Mum said you were going out for a meal with Mr Gallagher afterwards.

MICH: I left.

MARCIA: Oh.

MICH: What's for dinner?

MAURN: Lambie.

MICH: I fancy hamburger and chips.

MAURN: Not today Michael besides we haven't got any burgers.

MICH: Shall I go out and get some?

MAURN: Tomorrow.

MICH: But I might not fancy it tomorrow.

MAURN: Then the day after.

MICH: What if I don't feel like it then?

MAURN: OK Michael I'll see what I can do.

MICH: Thanks.

MICHAEL walks to the door and then turns back.

MICH: Oh Mum did I tell you that Mr Gallagher's wife works at the university?

MAURN: No.

MICH: Apparently she was airlifted off the Island during the invasion.

MAURN: Oh? How long have they been married?

MICH: They didn't give me a history lesson on their relationship Mum. But they were really surprised when I told them that we came from Grenada.

MAURN: Really?

MICH: Really! They wanted to know if we were going to attend the Maurice Bishop fundraiser next week. Apparently his son was recently murdered in Canada.

MAURN: I heard.

MICH: Small world isn't it.

MAURN: Uhm.

MICHAEL looks suspiciously at MAUREEN and MARCIA.

MICH: Well I'm going upstairs to freshen up.

MAURN: OK. See you in five.

MICHAEL exits.

MARCIA: What are we going to do?

MAURN: Nothing.

MARCIA: And that doesn't worry you?

MAURN: No.

MARCIA: Fibber.

Front door opens and closes. Enter OMAR.

OMAR: Hi Mum, Marcia. Have you seen my black shirt Mum?

MAURN: It's in the basket.

OMAR: What's that smell?

OMAR enters the kitchen and returns with the shirt. He puts it on.

MAURN: Aren't you going to iron that?

OMAR: I'm late.

MARCIA: For what?

OMAR: I'm going out on a date.

MARCIA: You can't it's the memorial.

OMAR: I'm taking my *own* advice Marcia. I'm moving on.

MARCIA: Did you know about this Mum?

OMAR: Marcia!

MARCIA: But it's the memorial.

OMAR: Happy memorial Sis. See you later Mum.

OMAR exits. The front door opens and closes.

MARCIA: I don't believe it of all the days.

Enter MICHAEL.

MICH: Who was that?

MAURN: Omar. He's gone out with some colleagues from work.

MICH: Right! So it looks like it's just us then. Good. I like playing happy families it makes me feel like I belong.

MAURN: I'm just going to check on the Lambie excuse me.

MARCIA: Need any help Mum?

MAURN: No you stay here and keep your brother company. I'll call you if I need you.

MARCIA: You sure Mum?

MAURN: Absolutely.

MAUREEN exits and closes the kitchen door behind her. A tangible silence grows between MICHAEL and MARCIA.

MICH: Why are you so hard on me Marcia?

MARCIA: I'm not hard on you we're just different.

MICH: How?

MARCIA: You wouldn't understand.

MICH: Try me.

MARCIA: Forget it.

MICH: No. I want to know why you're always putting me down.

MARCIA: Because you're a caricature Michael. Look at you, *'yeah boyyeeeee'*. Is that how you intend to repay Mum and Dad for all their sacrifices?

MICH: Sacrifices! What are you on about?

MARCIA: Forget it Michael you wouldn't understand.

MICH: Don't patronise me.

MARCIA: You really don't want to go there Michael, trust me, I'm your sister.

Pause.

MICH: OK then Marcia I will trust you. What happened in Grenada?

MARCIA: Sorry?

MICH: I said what happened in Grenada?

MARCIA: Nothing.

MICH: Don't lie to me. Dad would never have attacked me like that. It was like he had some kind of flashback.

MARCIA: You've been watching too many American movies Michael.

MICH: Don't treat me like an idiot alright. I know something happened /

Enter MAUREEN.

MAURN: What's going on?

MARCIA: Michael thinks we're hiding something from him.

MAURN: Like what?

MICH: That's exactly what I'm trying to find out. All I can remember is Aunty Janice taking me on an aeroplane when I was about four and not seeing any of you again for ages. Why?

MAURN: What's brought this on?

MICH: Answer the question Mum.

MAURN: It wasn't safe to bring you back to the Island Michael.

MICH: So why did it take you so long to come here?

MAURN: Because we were under occupation. And then the house burnt down, Omar got hurt, it was chaos. It took time to sort things out. We had no papers.

MICH: What four years?

MARCIA: Why are you making Mum repeat herself? We've told you what happened already.

MICH: Well I want to hear it again.

MARCIA: For what?

MICH: I just do alright.

MAURN: OK Michael sit down, I said sit down.

MICHAEL sits.

MAURN: Right, what do you want to know?

MICH: I don't know.

MAURN: Don't test me Michael.

MICH: Who's Bernard Coard?

MARCIA: Why the sudden interest?

MAURN: Marcia! He's the former deputy prime minister. He was charged with ordering Bishop's execution.

MICH: So why have you got such a negative attitude towards the Americans?

MAURN: Because their invasion had nothing to do with saving us from some cruel dictator or the assembling of Russian missiles. It was about purging the Island of Marxism. They turned our Island into a prison camp Michael and tortured hundreds if not thousands of our young men. We were betrayed.

MICH: So is that why Dad freaked out when he saw me in that costume?

MAURN: Yes.

MICH: So why didn't you tell me?

MARCIA: We told you to take it off Michael but you wouldn't listen.

MICH: Well I'm listening now aren't I?

MAURN: Because Mr Gallagher and his wife questioned you?

MICH: Yes. It was embarrassing. I didn't know anything.

MAURN: That's because Reagan banned the media from the Island during the invasion. It's why so few people know what really happened. It took place behind closed doors Michael. So don't be too hard on yourself it's not your fault.

MICH: Behind closed doors? Oh. That's alright then.

MAURN: Yes. You still feel like those burgers I could send Marcia out to get some?

MARCIA: Uh.

MICH: No I'll have the Lambie instead please.

MAURN: You *sure* it's no bother?

MICH: I'm sure Mum.

MAURN: Good. Well now that's out of the way you can make yourself useful in the other chair. Marcia can you give me a hand in the kitchen please.

MAUREEN and MARCIA enter the kitchen closing the door behind them. MICHAEL walks over to the door and listens. He then returns to the table and removes a white tee-shirt from his bag and lays it out onto the table. He begins to colour it in.

SC11. INT. BARBER SHOP. NIGHT

SID is vomiting in the sink. VINCE enters from the back of the shop with a mug of coffee. He hands it to SID.

SID: No thank you.

VINCE: Drink it. It will clear your head.

SID takes the cup. Enter SCULLY through the front door.

SCULLY: Still no sign of him. But his car is still there.

SID: Let me go and see if I can find him.

VINCE: Sit down. You're in no fit state to go looking for anyone.

SCULLY: Is there somewhere else he might have gone?

VINCE: Apart from home no.

SCULLY: Maybe that's where he is.

SID: I'm sorry fellas I had no right to judge him. I thought he was ashamed of us.

VINCE: Why would *he* be ashamed of us? They held his son to ransom, remember?

SID: I know.

VINCE: So why did you provoke him?

SID: I was angry. We have to find him Vince I have to apologise.

VINCE: Tomorrow.

SID: No I can't go home feeling like this I have to make amends tonight.

SCULLY: Why don't you call the house Vince?

VINCE: No. If he's not there Maureen will be worried and I refuse to put her through that kind of stress especially tonight. We'll just have to wait here for him he can't have gone too far.

Something falls down from the back of the shop.

SCULLY: What was that?

VINCE: Captain, Captain.

VINCE goes to the back of the shop.

VINCE: It's just some boxes. I must have disturbed them when I was making the coffee. Scully give me a hand please.

SCULLY joins VINCE in the back. We hear them negotiating how to stack up the boxes. SID picks up his keys on the counter and staggers out the front door.

VINCE: Sid, pass me the scissors on the counter please. Sid, we're waiting on you. Sid you fall asleep! Sid.

VINCE and SCULLY appear from the back of the shop and see the front door open.

VINCE: Dam.

SCULLY: He's taken the car keys.

VINCE: Did you drive?

SCULLY: Yes.

VINCE: Come on.

SCULLY: Where are we going?

VINCE: To the house.

SCULLY: I thought you said it was risky.

VINCE: It's too late to worry about that now. We have to try and get there before Sid does. Come on.

SC12. INT. LIVING ROOM. NIGHT

MICHAEL completes colouring his tee-shirt. He puts it on and admires the reflection of the Grenadian flag from the cabinet. The front door opens and closes. MICHAEL quickly runs to his chair and sits down. Enter CUTHBERT. MICHAEL stands.

CUTH: Hello Michael.

MICH: Evening Dad.

CUTH: Yours?

CUTHBERT points to the trophy.

MICH: Yeah. We won.

CUTH: Congratulations.

MICH: Thanks.

CUTH: Nice-tee shirt.

MICH: A student designed it for me.

CUTH: It's…dope.

MICH: Yeah.

CUTH: So where's Mum?

MICH: In the kitchen with Marcia. Omar's gone out.

CUTH: Right. Look about the other day Michael /

MICH: You don't have to explain Dad Mum's already filled me in.

CUTH: She has, has she?

MICH: Yeah. Happy memorial Pops.

CUTH: Thanks. So you did it?

MICH: By the skin of our teeth. I don't think we'll win the next round though.

CUTH: Why?

MICH: The other team was really strong. I thought they were going to counter our arguments with a whole load of socialist cra...stuff but they didn't. Instead their *Captain* compared the aspirations of the constitution with the...

MICHAEL removes a sheet of paper from his different pocket and reads.

MICH: '*Judicial hypocrisy of the American legal system*'.

CUTH: Wow.

MICH: She then used the Rodney King incident to highlight the *illusion* of the American dream. We got whooped pops.

CUTH: Sounds like you had a very *interesting* debate.

MICH: Interesting? We only won because she kept on straying from the brief. I'm sure she got her arguments from her mum.

CUTH: Michael!

MICH: She's one of those human right activists. I don't think she's got a boyfriend though.

CUTH: The mother or the daughter?

MICH: Pops?

Enter MARCIA carrying numerous dishes for the table.

MARCIA: Dad I didn't hear you come in *happy memorial?*

CUTH: Happy...memorial Marcia.

Enter MAUREEN.

MAURN: Cuthbert. Happy *memorial*.

CUTH: Thank you...and happy memorial to you.

MAURN: Well shall we eat?

They gather around the table.

MAURN: Let us pray.

MARCIA: I'll do it Mum. Thank you Lord for our daily bread amen.

MICH: And for the revolution.

They all look at MICHAEL surprisingly.

ALL: Amen.

They sit down to eat.

MARCIA: Nice tee-shirt Michael where did you get it?

MICH: A student designed it for me.

MARCIA: So does that mean you won't be wearing any more of that trashy American designer stuff made in Taiwan?

MICH: Let's just say that there are horses for courses.

MARCIA: Well you just make sure that you're always in the right race.

MICH: That's deep.

MAURN: You know your sister.

MICH: Word.

MAURN: So who's this date that Omar's gone on?

CUTH: She's a colleague from work.

MICH: Err.

MAURN: What?

MICH: I should have gone for the hamburgers. I hope you weren't serving this in the revolution Mum.

MAURN: Oh hush. Did you tell your father about Mr Gallagher's wife Michael?

CUTH: What about her?

MICH: She was airlifted off the Island during the invasion.

CUTH: Really?

MAURN: Really.

CUTH: What else did she say?

MICH: That they want to buy a house there when they retire. Hey Dad, Mum was telling me how the Americans turned the Island into a prison camp can you give me some more tips? I wanna wax lyrical with Mr Gallagher and his wife during lunch-time tomorrow.

CUTH: Sure. Is that the reason why you're wearing the tee shirt?

MICH: Yep, I'm going back to my roots boyeeeee.

They laugh. The front door opens and closes. Enter OMAR.

MAURN: What are you doing home so early?

OMAR: Don't ask Mum.

He sits down at the table.

MARCIA: Your conscience got the better of you didn't Omar? Come on admit it admit it.

OMAR: Alright! Satisfied?

MARCIA: Yes.

The doorbell rings.

MAURN: Who's that?

MARCIA: Probably Omar's date begging him to come back. Omar, Omar, Omar.

OMAR: Very funny.

OMAR exits to answer the door.

MAURN: Marcia, I don't want you making anymore cheap remarks about your brother's date you hear me.

MARCIA: Killjoy.

Enter OMAR.

MARCIA: So who was it?

OMAR: No one. Nice tee-shirt Michael. Where'd you get it?

ALL: A student designed it for him.

OMAR: Nice.

MARCIA: So what happened to your date Omar?

MAUREEN elbows MARCIA under the table.

MARCIA: Owwwww.

The doorbell rings again.

OMAR: I'll get it.

OMAR exits.

MAURN: What did I tell you?

MARCIA: Mum it might be her.

They strain their ears to listen.

SID: Is your father in Omar?

OMAR: He's busy at the moment.

SID: I need to see him right away.

MICH: She's got a deep voice.

CUTH: Maureen!

MAURN: Hold on Omar.

> *MAUREEN quickly exits to the front door however from the clarity of SID's voice he has already gained entry into the corridor.*

SID: Maureen.

MAURN: Sid!

SID: I need to see your husband right away.

MAURN: You're drunk. Why don't you give him a call in the morning?

SID: No I have to speak to him tonight Maureen face to face.

MICH: Who's that?

SID: Please Maureen you have to let me see him.

MAURN: I'm sorry but you'll have to come back tomorrow /

> *SID dashes into the living room pursued by MAUREEN and OMAR.*

MAURN: Sid, Sid.

SID: Excuse me Captain but I have to see you right away sir.

MAURN: This is my home Sid you can't come charging in here like this. I want you to leave right now.

SID: Not until the Captain agrees to see me.

MICH: What's going on?

SID: Don't do this to me Captain. I made a mistake.

MAURN: I said I want you to leave.

SID: Please forgive me. I'm sorry I judged you Captain I was upset.

MICH: Captain?

MAURN: There you've said it now leave.

SID: It must have been terrible to see them set Omar on fire like that.

MICH: What?

CUTH: That's enough Sid /

SID: I know and I'm sorry Captain.

MICH: Why do you keep calling my dad Captain?

SID: All the rumours that you've heard about your father betraying Bishop you mustn't blame him son. I would have done the same.

MICH: Sorry!

SID: You can't listen to people son your father had to take a chance. He had to do it.

MICH: Did you betray Bishop Dad?

SID: No. They forced him. It was more like an exchange.

MICH: Is it true Dad? Answer me.

CUTHBERT bows his head.

MICH: I don't believe it. Why didn't anyone tell me?

SID: You didn't know?

MICH: Suppose someone tried to hurt me?

CUTH: I would never allow that to happen Michael?

MICH: How could you stop it? Oh my God what if, what if Mr Gallagher knows who you are. Jesus how could you do this to me?

MAURN: Michael your father was put in an impossible situation. They held Omar hostage. He saved your brother's life.

MICH: Well if you're so proud of him Mum why have you been hiding it from me?

MAURN: Because we wanted you to have the opportunities that Omar and Marcia never had. Burdening you with our past would have jeopardized your future. It was safer this way.

MICH: For whom?

MAURN: For you.

MICH: How can you say that?

MAURN: Because no one knows who you are Michael. That's why we sent you away. It was too late for Omar and Marcia everyone knew who they were but you, you were young. *Here,* you had a chance.

MICH: That's crap Mum and you know it.

MAURN: Michael listen to me /

MICH: Don't touch me. My dad's responsible for someone's murder and you didn't tell me. You hypocrite!

MICHAEL becomes emotional.

MAURN: Michael!

MICH: How could you do this to me? My own family! I don't even know who you people are.

MICHAEL begins to weep. His emotion becomes unsettling.

OMAR: Dad...Dad.

CUTH: Let it be Omar.

OMAR: I can't.

CUTH: Yes you can.

OMAR: It's got to end tonight Dad.

CUTH: No it doesn't.

MAURN: What is it Omar?

CUTH: It's nothing Maureen. It's just something that's between Omar and me.

OMAR: I told them Mum.

CUTH: Omar! We have a deal remember?

MAURN: Told who Omar?

OMAR: Lieutenant Reid /

CUTH: No he didn't.

OMAR: That Bishop was going to expose their plot to take over the Island.

ALL: What!

CUTH: It's not true Maureen. Omar's lying.

OMAR: On the night that we were arrested I was taken into a cell and forced to listen to Dad being tortured. Then they promised me that if I told them what I knew I would save Dad's life. So I did.

CUTH: No Omar!

OMAR: I told them that I had overheard Bishop planning a press conference to expose their plot to overthrow him and take over the Island. Then they dragged me into Dad's cell poured petrol over me and set me alight.

MAURN: Jesus!

OMAR: I wanted to die so badly but one of soldiers sneaked back into the cell and put the fire out. He then buried me under a pile of blankets and drove me to the hospital. When I came round Dad was the first person I saw. When I told him what I had done he said that I shouldn't worry about it because he was going to sort everything out. So now you all know that Dad had nothing to do with Bishop's murder. It was me who sold him out.

MAURN: Cuthbert?

CUTH: He's my son!

SC13. INT. LIVING-ROOM. NIGHT

Enter CUTHBERT pursued by MAUREEN.

MAURN: Why didn't you tell me Cuthbert? Answer me.

CUTH: Once I made up my mind I was determined not to change it. And the only way I could do that was to keep it to myself.

MAURN: Are you saying that *you* couldn't trust me?

CUTH: Trust had nothing to do with it. If I kept quiet about Lt. Reid he would keep quiet about Omar.

MAURN: How can you say that?

CUTH: Because all he had to do was accuse Omar of being involved in Bishop's murder and he would have been locked up with the same people who tried to kill him.

MAURN: You made a deal with those murders?

CUTH: No I didn't make a deal with them Maureen. It was a hunch and it worked.

MAURN: For Omar, but you took the blame. You could have been killed.

CUTH: Yes I could have but when the rumours started flying around that I was on the CIA's pay-role that made people afraid of me.

MARCIA: So why didn't you tell me the truth when we got here.

CUTH: Because…

MAURN: Because what Cuthbert?

CUTH: Because protecting Omar is the only way that I have been able to cope with the last ten years and I wasn't going to allow anyone to take that away from me.

MAURN: Do you think I would have stopped you from protecting *our* son?

CUTH: No I'm not saying that.

MAURN: Then what Cuthbert what?

CUTH: I failed Maureen. I failed my family and my country because I didn't protect my son. If I hadn't taken Omar to camp with me that night he would never have been burnt.

MAURN: And that's the reason why you chose not to tell me?

CUTH: What should I have told you Maureen? That I took Omar with me to camp that night to use him as a *decoy* is that what you want me to admit?

MAURN: You can't mean that Cuthbert you can't. Cuthbert!

CUTH: No, I don't mean it Maureen but that's the question I keep asking myself over and over again. Why did I take him?

Enter MARCIA she stands at the door.

MAURN: If it were you who had betrayed Bishop would we still have left the Island?

CUTH: Yes I would have gotten you off the Island.

MAURN: I know that. But would you have stayed?

Pause.

MARCIA: Dad?

MAURN: Answer the question Cuthbert. Cuthbert!

MAUREEN and MARCIA are devastated by his silence.

MAURN: Do you have any more secrets?

CUTH: Maureen!

MAURN: Do you have any more secrets?

CUTH: No. That's it.

MAURN: We're running out of lives Cuthbert.

CUTH: Then we have to live this one as if it's our last.

Enter OMAR.

OMAR: Mum.

MARCIA turns to exit into the kitchen.

OMAR: Marcia, don't go, please, Marcia.

MARCIA stops.

OMAR: I know you must hate me but I've been living with this for ten years.

MARCIA: So what do you want me to say Omar that you don't deserve it?

OMAR: I just…just don't want you to ignore me Marcia.

MARCIA: You're asking too much Omar.

OMAR: I know but we've been through so much together. Please Marcia.

MARCIA: You betrayed us Omar not once but twice.

OMAR: I know /

MARCIA: No you don't know. You have no idea. I hated Dad for Bishop's murder. Even though I knew he sacrificed him to save your life a part of me still despised him and… I know that sometimes he could see it. How could you stand there and let that happen? How could *you* do that to me?

CUTH: Because I forced him to. Omar wanted to confess many times but I always found a way to stop him.

MARCIA: You see Omar you're doing it again you're still letting Dad take the blame.

MARCIA begins to cry.

MARCIA: I'm sorry Dad.

CUTH: Don't be. You never really hurt me not once. So please don't hurt Omar. We need to heal all of us. Maybe this is our chance now that everything is out in the open. Please don't hate your brother Marcia I'm begging you.

MARCIA: I'm sorry Dad but I can't do this. You stabbed me in the heart Omar. You've stabbed me in the heart.

MARCIA exits. MAUREEN exits after her.

CUTH: Give her some time Omar…she'll come round…you'll see, you'll see.

SC14. INT. LIVING ROOM. NIGHT

CUTHBERT is sitting quietly. Enter MAUREEN. She places a photo album on the table.

CUTH: How is she?

MAURN: In pieces.

CUTH: I'm sorry Maureen.

MAURN: Please, please don't tell me you're sorry. You've had ten years to think this through. Your apology counts for nothing now. I'm your wife damn it your wife. He's my son too. How dare you Cuthbert, how dare you!

CUTH: I thought I could carry the burden on my own.

MAURN: And now? I don't know whether to thank you for what you did for Omar or to hate you for what you've done to *us*. The old people back home are wrong Cuthbert they're wrong '*dogs do make cats*'.

There is a knock at the door. Enter MICHAEL.

MICH: Seems like we've got a lot to talk about… Captain.

CUTH: Yes we have.

MICH: So where do you want to start?

MAURN: By saying sorry.

CUTH: Please forgive us Michael I know nothing we say /

MICH: Please Dad!

MAUREEN walks over to the album on the table and hands it to MICHAEL.

MAURN: This is for you.

MICH: Where was this?

MAURN: In the suitcase under our bed.

MICH: Right!

MICHAEL opens the album.

MICH: Is that me?

CUTH: Yes.

MICH: I thought you said all the baby pictures of me in Grenada were destroyed.

MAUREEN and CUTHBERT bow their heads. MICHAEL turns the page.

MICH: Where's this?

MAURN: That's the house you were born in.

MICH: I see. Who's that?

CUTH: That's Bishop. He was your godfather.

MICH: What about the babies he's holding?

MAURN: That's Vladimir and the other baby is you. You used to play together.

MICH: Isn't he the one that was just murdered?

CUTH: Yes.

MICH: So am I next?

CUTHBERT bows his head.

MICH: Who are they?

MAURN: John and Nada. They're Bishop's older children.

MICH: And her?

MAURN: That's Delores your godmother. She worked in my office.

MICH: And what was it that you did at the office Mum?

MAURN: I was Bishop's personal secretary.

MICH: Right! So what's so special about this picture?

MAURN: We bought you that bike on your second birthday.

MICH: What's it doing in my bed?

MAURN: You loved that bike.

MICHAEL closes the album.

MICH: So what was the point in hiding this from me Mum?

MAURN: We're all in uniform Michael.

MICHAEL opens the album and scans the pictures again.

MICH: Is that a real life rifle in your hands Mum…Mum?

MAURN: Yes.

MICHAEL looks at his mother in amazement.

MAURN: You just point and shoot.

MICHAEL closes the album again.

MICH: So how many people did this revolution of yours murder Dad?

CUTH: Michael /

MICH: How many acts of *genocide* did you commit?

CUTH: None.

MICH: Oh come on *Captain* you must have ordered a couple of executions - tortured some of your opponents?

CUTH: I never hurt anyone Michael. Ours was a bloodless revolution.

MICH: Oh come on *Captain*, you must have tear gassed a few demonstrators and shut down a few newspapers.

CUTH: No Michael.

MICH: You don't expect me to believe that do you Pops? You were the captain of a dictatorship. Come on Pops there must be one skeleton in your cupboard?

CUTH: No Michael. There's none. It's the truth. Honest.

MICH: It better be Dad because if I hear /

CUTH: You have my word Michael there's nothing…nothing.

MICHAEL looks intensely at his parents and then softens.

MICH: I'm going upstairs to my room now so excuse me.

MICHAEL tucks the album under his arm and begins to exit.

MAURN: Michael /

MICH: Don't Mum please I've got everything I need.

He exits.

SC15. INT. BARBER SHOP. DAY

VINCE is asleep in one of the chairs. The door of the barber shop is pushed open. Enter CUTHBERT carrying a large box. He observes VINCE and then gently touches him on the arm. VINCE rises.

VINCE: Captain. I couldn't sleep so I thought I'd wait for you here.

CUTH: Thanks. Where's Sid?

VINCE: He's distraught Captain. We caught up with him as he left the house.

CUTH: It's OK Vince. I don't hold anything against him. We'll make up when I see him next I promise.

Pause.

CUTH: There's someone out there who saved my son's life Vince and I don't even know who he is. How did the idea to simply better ourselves turn out to be so tragic?

CUTHBERT begins placing items from the shop into the box.

VINCE: What are you doing Captain?

CUTHBERT looks around the barber shop.

CUTH: I'm starting again Vince. I'm starting again.

SC16. INT. LIVING ROOM. DAY

OMAR enters the living room with a suitcase pursued by MAUREEN.

MAURN: Wait Omar wait.

OMAR: For what?

MAURN: You can't leave without saying goodbye to your father.

OMAR: I need to go *now* Mum.

MAURN: Where to?

OMAR: I'll let you know where I am in a couple of days.

MAURN: That's not good enough.

OMAR: Don't make this any harder Mum please.

MAURN: Do you think I want you to go?

MAUREEN blocks his path.

OMAR: Move out of the way Mum.

MAURN: You have to wait for your father.

OMAR: No I can't.

MAURN: He'll be distraught.

OMAR: He'll get over it.

MAURN: Don't speak like that Omar.

OMAR: What do you want me to say Mum? Tell me and I'll say it.

MAURN: I want you to wait for your father.

OMAR: No I can't.

The front door opens and closes. Enter CUTHBERT with the box in his hands. He senses the tension in the room and then sees OMAR's suitcase. He quickly puts the box down.

CUTH: Now wait, wait. Not like this Omar.

MARCIA appears at the entrance of the living room from the kitchen.

OMAR: Don't try to stop me Dad.

CUTH: We can work this out Omar isn't that right Marcia?

MARCIA doesn't respond.

CUTH: You see. Not like this Omar. No.

CUTHBERT removes the suitcase from the chair.

OMAR: Put it down Dad.

CUTH: No.

OMAR: I said put it down.

OMAR tries to wrestle the case from CUTHBERT. The contents in the case fall on the floor. OMAR walks away. MICHAEL enters the living-room from the corridor.

CUTH: We don't have to do this. Not now.

CUTHBERT looks around the room and sees how dislocated his family are.

CUTH: Omar, Marcia, Michael. We mustn't let this happen. We can get over this.

OMAR: It's too late Dad.

CUTH: No. It's never too late we're strong enough *all* of us. Please Marcia, tell Omar you want him to stay.

MARCIA remains silent.

CUTH: Tell him Marcia.

OMAR walks towards the door. CUTHBERT grabs him.

CUTH: No you're not going. I love you Omar. Somebody help me. Don't go please, not like this. We can do it.

CUTHBERT is now openly emotional.

CUTH: We can do it. Please I'm begging you. Omar, Marcia, Michael, Maureen! You all are all I have. We have to stay together. I promise no more secrets no more lies you have my word my life.

CUTHBERT's emotion declines into soft whimpering. MAUREEN walks over to him and starts to console him.

MAURN: Let it go.

CUTH: I can't, I can't.

MAURN: We must. We have to… *we* have to. You can go now Omar you too Marcia. No one's forcing anyone to stay.

OMAR walks over to his clothes and stuffs them into the case and walks towards the door to exit. MICHAEL blocks his path. OMAR attempts to walk around MICHAEL but MICHAEL blocks him again. MICHAEL takes the suitcase from OMAR and walks to the centre of the room

MICH: So now that I've found out who I *really* am everyone wants to run away.

MICHAEL puts the case down by his feet.

MICH: So what now?

SC17. INT. LIVING ROOM. DAY

MICHAEL forces open the window that CUTHBERT had screwed down. A gust of air blows into the room. MICHAEL stands for a while inhaling the clean air. He walks over to the door and opens it. Enter CUTHBERT, MAUREEN, MARCIA and OMAR. MICHAEL signals for them to sit at the table. They sit down. MICHAEL exits into the kitchen and returns to the living room carrying various dishes on a tray. He places the dishes on the table and remains standing at the head of the table.

MICH: Thank you Lord for our daily bread. Amen

The family reply 'Amen' individually in their own time. MICHAEL sits down. The family begin to serve themselves. No dialogue is spoken apart from the requests for salt, pepper or a dish. We watch the family eating in silence for a while and then fade slowly.

URBAN AFRO SAXONS
(WHAT MAKES YOU BRITISH?)

Putting It Together: An Interview with Kofi Agyemang and Patricia Elcock

Introduced and edited by Deirdre Osborne

Kofi Agyemang and Patricia Elcock's *Urban Afro Saxons* represents something of an unrecognised landmark in British theatre history. The play's genesis arose from a unified and concerted artistic decision to foster experimentation in black dramatists' playwriting within a black-led creative context. Both writers and their commissioning director Paulette Randall sought to avoid the pitfalls of the mainstream's over-determined tendency for subject-matter that represents black families beset by dysfunctionality and violence, and the arc of the well-made play or melodrama.

To restore the project's achievements to contemporary theatre history requires awareness too, of the late-twentieth century cultural context which preceded its commissioning. Renewed possibilities for black theatre practitioners had begun, both in recovering from the razing by 1980s Arts Council funding policies, and also in attempting to loosen the grip of 'the developmental torpor and incessant identity politics trope' which, while vital for black artists' politicised entry into the citadels of white-dominant culture on their own creative terms, had begun to restrict the scope of black writing for the theatre (Osborne 2011: 436). From this period too, can be traced the ongoing tension between white-dominated commissioning agendas and black writers' creative aspirations. As Elcock conveys in the interview, for Black British dramatists, the narrative of expectations and envisaged reception of a writer's ideas seems pre-written, before the commissioning of any actual writing.

In the programme, Randall recalls how the intriguing and evocative title came about.

'A girlfriend of mine – Dona Croll, once described herself as an Afro Saxon and I thought that was quite funny,' [...] Defining who we are, how we think and how we relate to one another is

an issue I was keen to explore, especially as today's definition of Britishness is constantly evolving' (Programme Notes, 2003: n.p.). The practice of self-terming is significant. As has been well noted, up until the 1980s, the term black in Britain has housed a diverse range of ethnicities, nationalities and accompanying cultural identities.[1] Britain's black citizens have had a distinctive association with urban contexts both demographically (in terms of settlement patterns), and in cultural representation that excludes them from any sizeable presence in relation to the English countryside and its pastoral heritage. Post-war migrants from the Caribbean islands suffered the shock of a transition from a tropical climate and accustomed proximity to a nearby rural environment, to Britain's industrialised, polluted cityscapes. Links to the countryside became severed both actually and imaginatively, and if rendered, were reconstructed reminiscences about Caribbean rather than any English arcadia. While the consequences of this rupture of relocation underpin *Urban Afro Saxons*, the play also draws upon English bucolic and festive traditions of midsummer and the transformative power of the green world that reaches back to Renaissance comedies. For while the setting is an inner-London housing estate, the play's action is located in the playground. This signifies a verdant, communal space amid a concrete built-up area of separate apartments, and provides the opportunity of liberation from usual constraints. The associations of estate playgrounds with no-go zone or gang territory that proliferate in media reports of urban and social decay, are relegated to the background so as to loosen from the outset, the oppressive perceptual parameters that might be placed around the creative material. As a contemporary City comedy, *Urban Afro Saxons* echoes the heritage of the genre developed by Ben Jonson, Thomas Middleton and Thomas Dekker and their English Renaissance contemporaries. For the male playwright of that period, urban settings provided a social semiotics, 'a code through which he could efficiently communicate his characters' reputations and plans' (Griswold 1986:17). Those City plays mediate the changes wrought by the demographics of increased entrepreneurial and commercial enterprises upon class mobility

[1] See: Phillips (2002), Arana ed. (2007) and Dabydeen, Gilmore and Jones eds. (2007).

of the Elizabethan and Jacobean streets and stages, a period in which the trade in human beings was becoming integral to the acquisition of wealth. The historical trajectory of shifts in the cultural geography and ideology spanning this period to that of Agyemang and Elcock's play, is of course seismic. But the threads of continuity traceable to City comedy can be found in the expectation of audiences' recognition of familiar places in the London setting, debates about social mobility, personal, material and sexual gratification, and civic order.

In this interview, for the first time since its production, the writers take stock of their collaboration, and of working with Randall, a longstanding presence in British theatre who was the newly appointed Artistic Director of Talawa, Britain's premier black-led theatre company. Their recollections testify to the adventurousness, trust and risk-taking that underpinned their process of devising and re-writing, a dynamic which clearly forged symbiotic relationships between writers, director and actors. Alongside this, the Programme Notes exude a macro-contextual positivity regarding black theatre in prefaces by both Ken Livingstone as Mayor of London and Baroness Howells of St Davids, the Chair of Talawa's Board. At the time of its writing, Britain had been considered a multicultural nation for over forty years, yet a poll (taken one year after the play's premiere), by the Commission for Racial Equality found that ninety per cent of white people had few or no friends from amongst their fellow black, Asian or Muslim Britons while 'Three in ten of ethnic minority people surveyed said all or most of their friends were Asian or black' (Dodd 2004:1). The plot is not centrally concerned with an Afro-Caribbean migratory sensibility or diasporic inheritance, nor does it stage the anxiety politics fusing religion and identity which have entered much of the post-7th July 2007 referencing of contemporary London. While it does negotiate various rites and rights of citizenship, by layering the complexities of belonging and unbelonging as voiced through the indigenes and new claimants to Britishness, (its strapline is 'What makes you British?'), also debated are the models for citizenship, ethical behaviour, and social responsibility.

The play's characters are positioned in a tentative acquaintanceship born of the enforced proximity firstly of housing estate living and the subsequent intensification of this through their corralling together during the hostage and siege situation. As both dramatists note, an extraordinary situation was needed to plausibly bring the residents together in conversation. A nineties-Thatcher-entrepreneurial figure is identifiable in Patsy, the hairdresser, who also vehemently resists her British-born identity (specifically of Dalston origin). Patsy's disjuncture between her accented vernacular, cultural affiliation, self-employment and welfare state entitlement is filtered through her sense of territorial claim to her immediate surroundings. This matrix of paradoxes is dramatized through comic exchanges that hint at deeper xenophobic problems arising from identity displacement.

> PATSY: I ain't British though.
>
> TANYA: Yes you are. You're as English as I am.
>
> PATSY: No I ain't.
>
> TANYA: Yes you are. You was born here.
>
> PATSY: So? Just 'cause you born in a stable, that don't make you a horse.
>
> [...]
>
> DENNIS: Have you ever been to Jamaica?
>
> PATSY: Yes
>
> DENNIS: And did they class you as Jamaican?
>
> PATSY: No, they kept calling me foreigner. (this volume)

However strongly Patsy rejects her indigeneity, she does stake her claim to the geography of England in the spirit of an Englishman's home is his castle, 'You know how long I've been waiting to move out of my flat?...every five minutes someone else comes in to the country, they got nowhere to live, the council has to house them so my name goes straight down to the bottom again' (this volume). Part of the humour is derived from a usurpation paranoia, that newcomers are displacing those with a superior claim to social housing, an irony given that many

post-war migrants from the Caribbean aspired to and rapidly achieved home ownership as a result of racist rental contingencies and the fact that Councils would not offer them social housing.

PATSY: They'll do anything to stay in this country…

DENNIS: How did you get to be such a racist?

PATSY: How can I be a racist? I'm black.' (this volume)

The recognition that Patsy's parents would have been recipients of the very same resentment and hostility that she now displays, illustrates how Agyemang and Elcock explore uncompromisingly, the concept and practice of prejudice beyond customary parameters, to problematise the sense of entitlement and being owed something by society for having survived migration and racism. Valerie Mason-John, a Black British-born writer and performer who began her career in the 1980s has similarly observed this shift in prejudice across generations.

I can remember being on the train and being quite angry with a couple of young black girls because they were being abusive to some people. I turned around said, 'you know what, that's what they were saying to your mothers and grandmothers when they came here and you need to be really aware of that'. So already we're getting this generation of black people who feel the sense of claim to England and feeling superiority (Osborne 2009: 16).

In retrospect, *Urban Afro Saxons* appears to have been an idealistic and even utopian project, for the promise its production signalled proved to be unsustainable in promoting and consolidating black-led playwriting initiatives into major productions as a matter of course. After a successful season at the Theatre Royal, Stratford East, fragmentation followed, continuing the often bleak narrative for a sustainable black theatre in Britain – one which finds a parallel in the chequered fortunes of another black-centred institution, the Black Cultural Archive.[2] Soon after *Urban Afro Saxons* for various reasons, Talawa, Randall, Elcock and Agyemang all went their separate artistic ways.

2 In receipt of considerable Heritage Lottery funding, the latest challenge faced by the BCA in 2012 was the deferral of it opening due to the insolvency of the company of building developers contracted to refurbish its dedicated site. See Kennedy (2012) and www.bcaheritage.org.uk

Although combinations of factors from discriminatory arts funding policies, organisational in-fighting, lack of opportunity for training and professional work, exclusion from networks, and artistic differences, have created impediments, it should be remembered that the maintenance of systematic archival processes for black theatre have also been problematic in comparison with those of white-dominant equivalents. Perhaps the legacy to be derived from this play's production, its creative methods for generating a milieu for black dramatists in Britain, may, like the acacia seed, germinate growth against all apparent odds, from under the burnt earth policies that have characterised the sector.[3] While indigenous black British playwrights are just as much inheritors of Britain's aesthetic cultural legacies as their white peers, they frequently add unique perspectives of African diasporic influences shaped within and by a British context that is inherent to Britishness.

With the economic contingencies produced by Britain's financial demise at the close of the new millennium's first decade, another long shadow is cast upon the future generations of black playwrights as they seek to enter and consolidate their rightful place in British drama and theatre circles, a commissioning and programming world that still remains decidedly, white, Euro- and US-centric.[4]

3 The use of the term 'sector' was coined by SuAndi as part of the consultative process for the report compiled by Lola, Baroness Young for the Arts Council of England. See Young (2006).
4 Although Talawa Theatre Company, has sustained longevity in the British theatrescape, and was set to develop the old Westminster Theatre (in London) into Britain's first black-led, black-managed, dedicated theatre with Paulette Randall as Artistic Director, two years after *Urban Afro Saxons* the company faced disarray as its board members clashed with the chair whose inspiring record in campaigning for racial justice did not correspond to a theatre-making perspective. An application of business management criteria to the company's artistic detriment resulted in Randall's departure. In other areas of black-centred cultural opportunities, in the new millennium, 'longstanding black arts enterprises such as the Black Arts Alliance and Centreprise were disinvested after drawn out appraisals, demands for restructuring in unrealistically limited time frames and conclusions that there was no need for the kind of black specialist arts hub both organisations offered' (Osborne 2011:438). Critical and cultural legitimation is contingent upon the adequate development, continuation and archiving of work which has suffered a legacy of disappearance. Alongside the Afred Fagon Award, the establishment

PERSONAL INTERVIEW, 13TH DECEMBER 2011.

Deirdre Osborne: *What led you to write for the theatre?*
Patricia Elcock: I wrote by accident I suppose rather than by any conscious decision. As a drama student at university I couldn't find a piece I wanted to perform at my end of degree show, so I wrote my own monologue.[5] That's how I started. I never thought 'I'm going to be a writer'. That necessity led to an invitation to do a Carlton Comedy Scriptwriters' Course where I met Trix Worrell, then Paulette.[6] When Paulette started with Talawa she wanted to do an inaugural piece and she invited me to be one of the writers who would put something together for it. Originally she approached four people. Answering the question, 'What makes you British?' was irresistible.

Kofi, you had been part of the Stratford East Young Writers group?
Kofi Agyemang: How I actually started was when I went to see a production there about Josephine Baker, because my friend was in it. Afterwards I was chatting to this woman, and I went 'Oh that was rubbish', and she goes, 'Why don't you come to the writing group here?' I did go – every week. Then one day they said, 'You need to actually *write* something' not just talk. My first piece was read by Yvonne Brewster and Mona Hammond.[7] People really liked it. They were laughing and I hadn't even

 of the Barry Reckord bursary to nurture a new generation is a recent positive step towards redressing this (see www.talawa.org.uk for details of both schemes).
5 Bernardine Evaristo profiled solo performance as a key dramatic vehicle for Black artists in Britain when she noted, 'aspirant actors [...] emerging from the pale, hallowed halls of drama schools where usually the only Black character on offer is the bard's traumatised Moor'. Writing one's own drama Evaristo concludes was 'as much a powerful assertion of Black culture as a flowering of creativity.' in providing both employment and a vehicle for talent (Evaristo 1994:14).
6 St. Lucian-born Worrell wrote and directed the long-running and landmark television series *Desmond's* among other numerous and significant achievements in breaking ground for black people's representation on British television. See www.screenonline.org.uk/people/id/559692/index.html and Pines (1992).
7 Talawa was founded by Yvonne Brewster, Carmen Munroe, Mona Hammond and Inigo Espejel in 1985. See: Cochrane (2011), Chambers (2011), Goddard (2007), Griffin (2003) and individual chapters by Victor Ukaegbu and Alda Terraciano in Godiwala ed. (2006).

realised it was funny! When I won a BBC radio competition, people started saying, 'You write like Arthur Miller'. At that point I didn't know who he was. I went from somebody 'having a go' at writing, to becoming almost legitimised, straight away. I *am* inspired by Arthur Miller now, and Chekhov. I began to read them after people started taking me to the theatre. The thing for me was that if the story was good, I enjoyed it. They took me into their world.

PE: I'm a product of my background so Toni Morrison, Alice Walker, they all influenced my youth. My ideal dinner party would be chock-a-block with black women, but then I also love Thomas Hardy, especially his mother and son relationships.

Working together as co-authors can be challenging. What were the tests and also the triumphs of your writing relationship?

PE: When the two other initial writers dropped out, I was a bit nervous, thinking this could go horribly wrong. But people had said to me 'You need to meet Kofi you'll love him', and I think they had said the same to you Kofi about me? There were things we really gelled on, a world view I think. We really clicked.

KA: The speed of what happened and the circumstances meant there wasn't really much time for preciousness. I didn't really realise it then, but Paulette took a big risk. She got us as novices and said 'You can do it'. Pat hadn't written for theatre before but everybody cohered and wanted to make it work.

PE: I'm thinking of Paulette now as Artistic Director, starting the whole process with a single question and doing something that wasn't tried and tested – it was a *huge* risk. We wanted to base the play in London, so we started with the way Londoners don't speak to each other. What does it take to make people who live side by side have a conversation? The idea of the siege was to create a space which forces people to acknowledge each other through the shared, out-of-the-ordinary situation. At the time this actually happened in Hackney. On the news it showed a range of residents' reactions: the danger of being shot and killed, to people haranguing police officers for the inconvenience of restricted access, to an almost carnival-like atmosphere as people gathered together – all because of the siege. It was midsummer and we wanted to use the tradition that magical things can happen – all night conversations, unexpected liaisons. We knew we wanted to talk about a place like Hackney where you have

gentrification going on apace in privately owned properties, but in the shadows of people who are in the Local Authority-owned ones. With the situation, we knew the starting point and where we wanted to get to –

KA: – because you know when you're held outside and a siege finishes, you go back in and find out what happened. At the point of casting we had this minimal idea of who the people were. We knew we wanted a mother and son (Patsy and Jermaine), a kind of *Who's Afraid of Virginia Woolf* type of couple (Scott and Evelyn), the Dennis character, trying to make that change in his life, (had had a trade but was now looking to go a different route). Then there was the Tanya character who was perhaps the most problematic I think, for all sorts of reasons.

PE: One of our original ideas was to have that kind of stalwart, stoic person, you know, who faced the Blitz, hung out their washing on the Siegfried Line, that kind of heart and spirit -

KA: – who runs the tenants' association – actually inspired by a woman on my Estate (who I couldn't stand at first). But she did a lot of work nobody else wanted to and in the end I actually became good friends with her. She'd parade around the Estate like she owned it, swanning about in cheap shoes, (but she thought she was Mrs Bouquet), someone who was still getting used to black people. She ran a tight ship and everybody wanted to come into that block as she'd be the one to go to the Council, do petitions or get benches put in, flowers, you know. But we actually lost this character in the final version because the actress didn't want to play her.

Were the actors involved in creating their action and dialogue? How did you end up shaping the narrative arc?

KA: Because of the piecemeal process, we worked with the actors' opinions about their characters. But in the end, you actually have to translate that to paper and a lot of people might think they're helping when they're not. We might spend the morning watching improvisation or some hot seating, and then we'd go and write in the afternoon. It felt organic, that we could put things into each other's scenes. I'd forgotten about how we did that until now! You had to actually trust that the other person's going to 'get' the character.

PE: I think that's one of the reasons why Kofi and I bonded so well, because we always started with the characters. We could

both write all of the characters and edit each other's writing. There was that fluidity and trust. A dramaturg was introduced to the process, but –

KA: – he helped us realize we didn't really want him there!

PE: It was a very swift process, this constant conversation at strange hours. 'Kofi I'm on the screen now, what do you think if he said this?' at one o'clock in the morning and then be in the rehearsal room at 9.30am with the scene written.

As you note in the programme 'Paulette, Patricia and Kofi would particularly like to thank the cast for their invaluable contribution towards the script' (Programme notes, 2003, n.p).

KA: To be honest with you I didn't really know *what* it was, until it *was*. Normally in rehearsing a production of a play, you'd have a read through and an idea of how it's going to be. Even the actors didn't have full scripts, or a beginning, middle and end until –

PE: – a couple of weeks before we opened! Some panicked more than others.

KA: Yeah, but to the whole cast's credit, they just went with it because they liked Paulette and because of Paulette's reputation. They trusted it was going to be okay.

PE: It was a *huge* trust exercise.

You used sampling to a degree in the look and sound of the play, the traditional English national anthem became a Bhangra version –

PE: – and a reggae version! Delroy Murray did the music. He's somebody who Paulette had collaborated with long term. We didn't consciously think of music when we were writing but I knew the generation and the era that Patsy had belonged to. I knew what Jermaine would like, and that Evelyn's character wouldn't want to go too black! The mix of the music fitted the green and red Union Jack flag on the programme –

Which is super-imposed over the faces of three people whose ethnicities are merged –

KA: – yes, as green and red are not the normal colours. The aim was to reclaim the flag in having it prominently on the programme but in an altered form, to not fear the flag, to be able to say, 'Well it's our flag too.'

The play is a comedy which is unusual as in much black British drama, comedy functions as an annexe within the enclave of tragedy. Were you consciously writing comedy?

KA: We weren't trying to be comedic *per se* it was just how the

characters responded – like my first piece of writing when I asked, 'Why are they laughing'? The characters have this opportunity, a life-changing event but we don't know whether they're going to speak to each other ever again, or even see each other again.

PE: And we're talking about the Midsummer topsi-turviness that sometimes allows you to behave in ways out of the ordinary. By the end, we closed the door, the shadows dispersed and life went on.

The playground is a striking liminal space. Can you talk more about that?

KA: We wanted to create the idea of the veranda, where people can come and chat a while. It's only because the siege happens that these characters are there. For a lot of people living in areas like Estates, playgrounds have become areas to avoid. Paulette had this idea of the non-descript hoodies to reinforce the no-go aspect. At certain points they drift across the stage to suggest they own the territory. Although they're in the background, they're haunting figures. That's the first time I ever remember seeing hoodie characters used in this way. I've seen them subsequently in quite a few things.[8]

Placing these figures as a backdrop rather than the focal point redresses the mainstream commissioning preference for plays by black writers that feature a 'dead male centre stage' motif. A memorable aspect of your play is its total sidestepping of that genre.[9] Even the hostage situation while foundational to the plot remains off-stage. How did this eventuate?

KA: Paulette didn't want that violence, none of us wanted it. She allowed us to do something different. Had it been now, or someone else commissioning it, you know Jermaine (Patsy's teenage son) would have been slain....

PE: I'm more interested in the effects of what happens rather than the sensationalism of the act of violence. A lot of those plays are reactionary plays. I'm expecting a whole spate plays about

8 *Da Boyz* staged at the same theatre in May (2003) was based upon William Shakespeare's *The Comedy of Errors* and represented overtly, a streetwise style of black-garbed, hoodie-wearing protagonists. The spectral hoodie figure can be seen in two later plays, Roy Williams's *Little Sweet Thing* (2005) and Bola Agbaje's *Gone Too Far* (2007).

9 See Winsome Pinnock's Introduction to Courttia Newland's *The Far Side* (this volume) for more commentary on what she identifies as a consequentialist genre and Patricia Cumper's stance against the commissioning of black writers' work as circumscribed by white programmers' notions of black experience (this volume).

the riots soon.[10]

Alecky Blythe's verbatim play about the same siege Come Out Eli *was staged at the Arcola Theatre in the month before yours. What are your views about the verbatim genre? It's not really associated with black dramatists in Britain is it?*[11] *One thought might be that black writers haven't had enough chances yet (literally) to create imaginative plays.*[12]

KA: I love Robin Soans's work and I *almost* like the idea of verbatim as an exercise but I don't know whether I could do it. It is another way of constructing text, but you choose from existing raw factual material. Is that really creative writing? I try to come from as an authentic place as possible, so people identify with what I write. I can choose which idea I'll wear, so there's still a manipulation going on but I think verbatim is almost like people are telling you what to write.[13]

10 In August 2012, a spate of inner-city riots occurred at their most extreme in London (where they were initially sparked by police violence in Tottenham), but also in other urban spaces around the UK. The complex factors underpinning the phenomena have yet to be fully analysed but point to a cocktail of disenfranchisement of a young generation, through austerity measures, widespread pessimism regarding future prospects in education and employment, interfaced with a desire for consumption beyond one's material means which became expressed through acts of public disorder. The Tricycle Theatre staged its own inquiry in the form of verbatim writer Gillian Slovo's *The Riots* (from spoken evidence) in January 2012 following this interview with Elcock and Agyemang. See: Slovo, Gillian. *The Riots* London: Oberon Modern Plays, 2012.
11 For a comprehensive exploration of British practitioners in the technique, see Hammond, Will. and Steward, Dan. eds. *Verbatim Verbatim* London: Oberon Books, 2008.
12 *Come Out Eli* was the first outing of Blythe's Recorded Delivery technique and was based upon her interviews with people in the streets during the siege. While Michael Billington suggested it influenced *Urban Afro Saxons* (although neither Elcock nor Agyemang saw Blythe's production), Lyn Gardner found Blythe's production flawed, 'Of more concern is the way that the technique of re-creating the voices of the witnesses often makes people – whether absurdly posh or desperately inarticulate just sound stupid, particularly when their testimonies are edited to sit side by side'. (http://www.guardian.co.uk posted 9 Sept. 2003 14.56 BST, accessed 17 Jul. 2012)
13 Jessica Blank and Erik Jensen make a case for the emotional verification that verbatim theatre offers to source material that is not served by documentary versions of reality, 'Reality television and cable news don't ask us to identify: they ask us to judge, to stand outside what we are watching, even while we indulge in and are entertained by the spectacle of it all.' Gardner's review of *Come Out Eli* offers counter-evidence in relation to live theatre, a comparison

Is that a familiar experience?

PE: I was talking recently with a producer about a particular story I had in mind, who said 'Oh I'm thinking about Damilola Taylor here', and I'm like, 'But that's actually *not* what I'm thinking'! One of the characters was a white young man in East London involved in car crime. I can't help thinking because I'm a black writer that Damilola Taylor came up. You can find yourself having quite difficult conversations, having to really hold your own, to say 'Okay that is maybe what interests you, but maybe you need to work with someone else, because *I'm* interested in *this*'.

KA: And why? We don't sit around thinking 'I'm black' nor do I always write about gay things. The Royal Court didn't stage writing about black British gay people from a black British gay person's perspective but they staged the American production *Wig Out*. It's not that I don't want to be part of the mainstream but the problem is they don't see the value in my work. At the end of the day, the people who commission plays have their agenda. They know what *they* want. Very recently, Talawa sent me to a Royal Court/ BBC writing project. I wrote a ten-minute piece and they used five minutes of it. I was one of the winners of this thing, and then they did nothing with it. So I turned my piece into a little film. It's had 55,000 hits from America on YouTube – the same play that I sent to the Royal Court. I feel quite vindicated. I'm quite happy with it now.

It's salutatory to read in the programme both Baroness Howell's introduction about the custom-built space for Talawa, with Ken Livingstone's optimistic prophesising of its future. In ten years none of it has happened.

PE: In terms of what we did with Paulette and *Urban Afro Saxons*, I do think Talawa missed a trick – the opportunity to carve out something, go in a direction that made them really relevant to a theatre-going audience again. I think they dropped the ball personally. A foundation was built, something very different, very interesting and exciting. There were new audiences who came to see the play. New themes were touched upon....

KA: It's almost like Talawa was trying to get this high-brow theatre profile, but ordinary people didn't really know about

to theatrical and performance conventions, not those of other media. ('Theatre Blog' http://www.guardian.co.uk/stage/theatreblog/2 posted 15 Jul. 2010 17.02 BST accessed 17 Jul. 2012).

them – black people not knowing who you are, that's a real shame. *Urban Afro Saxons* was a show that they wanted to see. For the press night people wanted to stay on afterwards and talk about the play. In fact the theatre stayed open until 1.30 am. It was real to them, it was accessible.

Director Emma Wolukau-Wanambwa has said about British theatre, 'the art form is accessible, but the institution isn't always'...[14]

KA: That's true. There's all these West Indian farces performed constantly in London. Personally, I could take them or leave them, but people pay £30 a ticket, and they get packed out. Mainstream theatres might put one of these on, but nobody would go. I wrote something about bingo, because lots of different people could be in bingo. It wasn't about being black. We put it on at Hackney. The audience was packed out.

PE: If people don't think it's relevant to them or that it's about them, then they're not going to participate.

Should people go to the theatre hoping their own life is played back to them?

KA: I'm from a West Indian background and essentially, if you go to certain parts of the West Indies, they're almost Victorian in their attitude. The first time I saw Ibsen, I thought 'that's my grandmother speaking'. I identified with it even though it's a nineteenth century play.

PE: It's the small things that really throw up how a black writer brings a certain perspective into sharp relief. I remember the opening moment of Doña Daley's *Blest Be the Tie* upstairs at the Royal Court when Lorna came out dressed as my grandmother might dress, with a pair of trainers on. I didn't even need to hear anything else said. Dona had got this down pat. Then I saw the other play on in the downstairs theatre, Tanika Gupta's *Sugar Mummies* about women as sex tourists to the Caribbean. From the opening moments, it was 'come and get two rum cocktails', black boys with their tops off. If I had written that play, maybe that woman tourist could be truly in love. It would be interesting to examine that. That's one of the reasons I celebrate debbie [tucker green] because I like the fact that she pushes to do something different. Why was Tanika Gupta allowed to write about that but I'm not supported to? She was even flown to Jamaica! I find it quite boring that white

14 See Pool (2003).

people can write about black people, but we are not encouraged to write about them – they don't want to hear – or rather, the commissioning people have ideas about what *they* want you to do as though '*you're* not going to get the *real* story' about being white. It's only ever slices of reality – for everyone.

Looking back, is Urban Afro Saxons *a play of its times?*

PE: Absolutely. Remember this was a pre-7/7 world. I don't think we'd be able to set something like that in London now without having a different set of people. We felt good because we represented black and white characters. When we were creating *Urban Afro Saxons* there was no time to actually reflect on what the process was, what potentially could have been a model for other people to create work from. It's the first time we've really reflected on it.

KA: I realise now, looking back on it after all these years, it was a very magical experience. I'm still friends with Pat to this day. It just feels like it was meant to be. I'm really glad to have been part of it, and even gladder that it's going into print! The worst thing for any creative person is when you feel there's no outlet for you.

Do you think Michael Buffong's recent appointment as Artistic Director will presage a new direction for Talawa?

PE: We're really hopeful about him –

KA: – also because Michael is of Paulette's ilk.

<div style="text-align:center">

Introduced and edited by Deirdre Osborne
(Goldsmiths, University of London)

</div>

Characters

SCOTT
34, White cockney, easy-going, BT engineer.
Married with two children to Amanda.

DENNIS
39, Black Londoner. Trainee social worker.
Part-time painter and decorator.

PATSY
35, Black Londoner. Feisty, single mother of three –
including Jermaine. Officially a 'job seeker', works from
home plaiting and weaving hair.

JERMAINE
17, Black Londoner. Sixth form student.
Pensive. Eldest son of Patsy.

AMANDA
34, Black Londoner. 'Bougie' (Pseudo-bourgouisie).
Events organizer. Married with two children to Scott.

TANYA
25, White Londoner. Bank clerk.
Lives with grandmother.

First performed at Theatre Royal, Stratford East, October 2003.

Inspired by Eli Hall and the 'Hackney Siege' 2003

Urban Afro Saxons was premiered at the Theatre Royal Stratford East, London in association with Talawa Theatre Company on 29 October 2003.

The cast were as follows:

JERMAINE	Ben Bennett
AMANDA	Evelyn Duah
PATSY	Suzette Llewellyn
TANYA	Doraly Rosen
SCOTT	Jay Simpson
DENNIS	Steve Toussaint

Directed by Paulette Randall
Design by Libby Watson
Lighting Design by James Farncombe
Composer Delroy Murray

SCENE 1

6.15pm. Courtyard/Children's Playground outside The Forest Housing Estate. It is a warm summer's evening. An official police line prevents residents from entering. SCOTT waits confused about what's going on.

SCOTT: *(Speaks into mobile.)* It's me babe. Call me when you get this message.

DENNIS enters. He is preoccupied in his own thoughts and, in a bid to get home quickly, hurries past SCOTT.

SCOTT: Oi mate! You can't get...

SCOTT goes back to his waiting until DENNIS re-enters, slightly confused.

Yeah mate, I tried to tell you...you can't get in.

DENNIS: What's going on?

SCOTT: Don't know.

DENNIS: *(Pause.)* Well how long have you been here?

SCOTT: Not long.

DENNIS: Not long?

SCOTT: Not long.

DENNIS: Ten minutes?

SCOTT: Bit longer.

DENNIS: Fifteen?

SCOTT: 'Bout that.

DENNIS: *(Indicating tower block.)* Probably someone threatening to jump.

SCOTT: You reckon?

DENNIS: Police are probably just keeping the area sealed while they clear up the mess.

SCOTT: Not a pretty sight.

DENNIS: Fu...flippin' nuisance.

SCOTT: Don't suppose they were thinking about that.

DENNIS: Looks like it's happening in Walnut.

PATSY enters. DENNIS makes a faint attempt to tell her about the police line. SCOTT seeing her going off, calls out to her.

DENNIS: Excuse me.

SCOTT: Eh Miss…you can't get through. It's blocked off. The police…

PATSY: *(Disbelief.)* But I only just stepped out! I couldn't have been gone more than five minutes!

SCOTT: About quarter of an hour now.

DENNIS: *(To PATSY.)* A jumper.

PATSY: I run out of hair *(Kisses her teeth.)* I had to go clean across the way to the little Indian shop because I knew, fast as I try, I couldn't reach the Black one on the high street in time because they close at six.

SCOTT: *(To DENNIS.)* You're right. They're getting a bit busy round Walnut.

PATSY: *(Getting Angry.)* I have to get back in.

SCOTT: There's someone on the roof right now.

DENNIS: I can't see anything.

PATSY: *(Panicked.)* Jesus.

SCOTT: Why would you wanna do that?

DENNIS: Sometimes desperate people do desperate things.

PATSY: Just wasting people's time! Like I ain't got nothing better to do than just park up outside this shithole.

SCOTT: Steady on. It ain't that bad.

PATSY: From I been here eleven years I'm telling you, it's gone from good to bad and now from bad to worser.

SCOTT: I've never had no trouble.

PATSY: Why these people can't just find some other way to kill themselves without all this inconvenience to people, I don't know. It's just selfish. And that last one. How long was he up there? How long? And after all that. Did he even have the consideration to think of anybody but himself? Did he? No! He didn't even jump!

SCOTT: Bastard.

DENNIS: Well I just hope this one makes his mind up soon. I mean it's hardly multiple choice is it? Either you do or you don't. Either way, I just wanna get back in my flat.

PATSY: I tell you if it anything like the last one, all Christmas two thousand and four we'll still be waiting and the fool no even rass jump yet.

SCOTT: *(To PATSY.)* I'm Scott. I live over in Maple Street, the Oak end.

PATSY: I wanted one of them.

DENNIS: Yeah it's nice there.

PATSY: *(Vexed.)* You got a garden innnit?

SCOTT: Only a little one.

PATSY: I knew they weren't gonna give it to me anyway.

DENNIS: Have you got a shed in it?

SCOTT: A shed?

DENNIS: In the garden.

SCOTT: Yeah. But I don't really use it much.

DENNIS: Shame. Must be nice having a shed.

SCOTT: It's more for the kids than anything.

DENNIS: *(Confused.)* The shed?

SCOTT: No the garden.

PATSY: *(Frustrated.)* How long is this thing gonna go on for?

SCOTT: Don't know. Could be a while yet I reckon.

PATSY: What do you mean?

SCOTT: They don't go round blocking people out for nothing do they? I reckon it's a bit more serious than they're letting on.

PATSY: Yeah, but what's the police saying?

SCOTT: We can't get back in until the situation is clear.

PATSY: Ain't they told you more than that?

SCOTT: We just have to wait.

PATSY: Nah man, there must be more than that. Where are they? I'm gonna get some answers. I can't just stand around waiting like this.

SCOTT: It's alright! I'll go.

PATSY: Don't trouble yourself.

SCOTT: It's no bother.

SCOTT exits.

PATSY: *(Cutting her eye.)* He's gone anyway. Good.

PATSY and DENNIS are left in an awkward silence. JERMAINE enters. He sees DENNIS and goes to greet him. PATSY is agitated at being overlooked.

DENNIS: *(To JERMAINE.)* Ah ha, Beckham boy!

PATSY: Jermaine.

JERMAINE hears her and turns. He moves slowly towards her.

JERMAINE: What?

PATSY: Where's Jamal?

JERMAINE: He's over at Craig's house.

PATSY: I've left a woman up there with only half her head weave. If you had come home straight, like you supposed to, this wouldn't have happened.

JERMAINE: I was at the library.

PATSY: I don't care. And now I'm out here and Jamilia's in there with some half-weaved woman. You should have been where you ought to have been.

JERMAINE: But...

PATSY: I don't wanna hear no excuse. She would have been done by now and satisfied. Now as it is I gonna have to put back my next client.

JERMAINE: But I told you this morning I was going to the library...

PATSY: I don't know what's the matter with you these days. I'm gonna lose money because of this. And who's gonna get it back for me eh?

JERMAINE walks off towards DENNIS.

DENNIS: What's up?

JERMAINE: Nothin'

DENNIS: What you reckon this is?

JERMAINE: I don't know. *(Pause.)* Drugs. All it ever is here.

DENNIS: So how you been?

JERMAINE: Everything's safe man.

DENNIS: You told her yet?

JERMAINE: It's my life.

DENNIS: I ain't gonna argue with that. I'm just saying…

JERMAINE: My ankle's fixed up now.

DENNIS: You coming for a kick around on Sunday?

PATSY: Jermaine. *(Long pause.)* Jermaine. *(She is forced to walk right over to JERMAINE and DENNIS.)* So what? You didn't hear me calling you?

JERMAINE: I was just coming.

PATSY: I'm glad you can find time to have conversations with strangers. This is your fault Jermaine. Yours.

JERMAINE shoots a looks at DENNIS.

PATSY: *(Picks up on look.)* What?

JERMAINE: Nothing.

PATSY: You been chatting me and my business out of doors. And on top of that, you're chatting it to a rass stranger!

JERMAINE: Why you gotta embarrass me like this?

PATSY: I wanted to talk. *(Pause.)* But I guess you were too busy talking to someone else.

JERMAINE: We were just talking about football.

PATSY: Well I didn't know. *(Whispering.)* I wanna phone Jameliea. I'm worried about her.

JERMAINE: Well phone her.

PATSY: I can't.

JERMAINE: *(Whispering.)* They blocked the phones?

PATSY: No, fool! I've run out of credit. Now hurry to the shop and get me a ten.

PATSY hands JERMAINE money, he exits. Two HOODED CHARACTERS enter. It is impossible to distinguish their race or gender. They cross the stage wordlessly, but with real swagger and exit.

DENNIS: He's a good kid isn't he.

PATSY: Sorry?

DENNIS: I'm Dennis. *(Long pause.)* You're Jermaine's mother.

PATSY kisses her teeth.

DENNIS: I just wanted to introduce myself properly. Didn't want you getting the wrong idea or anything.

PATSY: And why would I do that?

DENNIS: Well Jermaine's a young boy… I mean man… I ain't no kind of pervert or anything. We met playing football. I just think he's a good kid. That's all.

PATSY: *(Long pause.)* Well, Mr Dennis with no surname. I don't know you. I don't wish to know you. So what you think or don't think ain't got nothing to do with me.

DENNIS: I'm sorry. I didn't mean to offend you.

PATSY: What is it exactly you got to do with my son?

DENNIS: It's Walker. *(Pause.)* Dennis Walker. I live in Cedar House as well. Me and Jermaine we just talk sometimes.

PATSY: But you's a big man to him!

DENNIS: Sometimes it's easier to talk to someone outside. It can't be easy for a woman, any woman, bringing up a young man on her own. Men sometimes need to talk to other men. It's natural.

PATSY: What are you? Some kind of battyman or something?!

DENNIS: Me?! Don't be stupid.

PATSY: Just stay away from my family. You get me. Stay away.

PATSY turns her back and walks off. AMANDA enters carrying a large handbag, two shopping bags and a multipack of bottled water. She is slightly out of breath and harassed looking. She straightens her back on first sight of the people in the courtyard.

She looks for her phone.

AMANDA: *(Into mobile.)* Where are you? Look, just call me as soon as you get this message. *(She hangs up and paces up and down, speaking to no one.)*

Dead silence between DENNIS, PATSY and AMANDA until SCOTT returns with a news update. He rushes over to AMANDA.

SCOTT: You alright babe?

AMANDA: Scott what's going on? I've had to walk all the way over from the One Way. They wouldn't let me drive in.

SCOTT: They're stopping everyone babe. There's a…

AMANDA: Well how long has it been going on? Surely they can't just expect us to stand outside here indefinitely. Who's in charge?

SCOTT: I've just been talking to them. They said the situation will soon be under control, then we can go back in.

AMANDA: What about the children?

SCOTT: They're alright. They're with your mother.

AMANDA: Why didn't you let me know?

SCOTT: I tried.

AMANDA: *(Sarcastically.)* Yeah.

SCOTT: I kept getting your voicemail.

AMANDA: You could have left a message.

SCOTT: I did. Two.

PATSY, irritated that SCOTT has not brought news straight to her in favour of speaking to AMANDA, interrupts their conversation.

PATSY: Excuse me, but we all want to know what's going on.

AMANDA: I beg your pardon.

PATSY: You can beg all you want. I wasn't talking to you.

SCOTT: It looks like it's hotting up. It's full of armed units round the back.

DENNIS: But when they saying we can go back in?

SCOTT: They're not.

PATSY: This is rubbish. How we supposed to just wait outside here?

AMANDA: Do you mind? I'm trying to speak to my husband.

PATSY: Look woman, all I want to do is find out what's going on.

AMANDA: This is too much.

SCOTT: It's alright babe.

Frustrated, PATSY walks off, back to JERMAINE

AMANDA: I hate the way you just back down for everything. Why didn't you just tell that woman you were speaking to your wife?

SCOTT: Look, we all just wanna get back in. People…

AMANDA: I don't care about them. Why can't you, just for once, see it how I see it.

AMANDA's mobile bleeps indicating it has a message, she walks away to listen to it.

DENNIS: I think you're right.

SCOTT: You what?

DENNIS: I think I just saw someone moving up on the roof over there.

SCOTT: What do you reckon then? It's gotta be more than just some nut wanting to jump.

DENNIS: My bet – it's drugs.

TANYA enters. Shy and awkward, she heads straight for a corner of the playground.

SCOTT and DENNIS try to draw her in by telling her what's going on.

SCOTT: Well it's gotta be something. *(To TANYA.)* There's been some kind of bother up at Walnut. No one can get in.

TANYA: Yeah I know.

DENNIS: It's drugs, I tell you. Probably some major bust or something.

TANYA turns her back and starts dialling on her mobile.

TANYA: Hello Nan. *(Pause.)* Nan are you in? Pick up the phone. It's me. Nan, are you there? Call me back, okay.

PATSY: You alright?

TANYA: Alright.

PATSY: I tell you, I don't know what this place is coming to when you can't even leave your house and expect to come back in.

TANYA: *(Not really listening.)* Hmmm.

PATSY: It's all this drugs business nowadays. Shootings, stabbings, killings, you get me? It's like, you ain't got my money…and boom! Over. Argument done. That's what I blame it on. The drugs. And I don't mean a little weed and ting. I'm talking big drugs. Cause back in the day, everyone knew where the weed house was and it was cool. You just went in, sorted out your business and you come out.

TANYA: *(Puts on headphones.)* Thank you.

PATSY is left standing apart from DENNIS and SCOTT but still within earshot.

DENNIS: *(Excited.)* Look. Look. See!

SCOTT: What?

DENNIS: There. Can you see it?

TANYA: Where?

SCOTT: What?

DENNIS: That. Over there.

SCOTT: What? Do you mean that? Over there?

DENNIS: Yes. That.

SCOTT: Well that ain't nothing.

DENNIS: Yes it is.

SCOTT: It ain't.

DENNIS: It is.

SCOTT: It ain't.

DENNIS: Is.

SCOTT: Ain't.

DENNIS: Well what is it then?

SCOTT: It's just somebody's washing they've hung over the balcony.

PATSY: I can't take that you see! Now why they have to go and do that? Nah man! It's not necessary. Not these days. So what! You ain't got a garden – but that don't mean you can't get a tumble dryer. You don't have to hang your washing out like that all over the balcony. Makes the whole place look messed up.

SCOTT: Well it looks like we could be out here for a while.

PATSY: Is that what they said?

SCOTT: They ain't giving much away. They're just saying it's a situation. And they've got it under control. They just want us to cooperate by being patient and understanding. They're sorry for the inconvenience.

PATSY: And that's it? Nothing about how long? Not even about what this is? It's fucked up man. What are we supposed to do?

SCOTT: Wait?

DENNIS: *(To PATSY.)* I reckon it's drugs.

PATSY: They're letting anyone on this estate now. All sorts. Crackheads, pimps *(Pause.)* Battymen.

DENNIS: Look, I'm just trying to be nice. I know I went in too deep back there. *(Pause.)* Look, we talk, that's it. Mostly about football. Sometimes about school. I'm not gay. I don't have a problem with people being gay, but I'm not gay.

PATSY: Well I've never seen you with no woman.

DENNIS: Oh, so you been watching me?

PATSY: I might have just happened to notice you on the odd occasion. My kitchen window faces the entrance to the building.

DENNIS: So you must see a lot.

PATSY: I don't have time to sit and study other people's business.

AMANDA moves towards SCOTT.

AMANDA: *(Reconciliatory.)* I got your messages. Both of them.

SCOTT: The kids will be fine. Why don't you call them?

AMANDA: I have.

SCOTT: So now you know they're fine.

AMANDA: I just expected a quiet night in. *(Laughs lightly.)* I even bought a nice Pinot Grigio.

SCOTT: We could have it out here.

AMANDA: I'm not wasting it. *(The light mood is over.)* It needs to be chilled.

JERMAINE enters with PATSY's mobile phone credit voucher.

PATSY: *(To JERMAINE.)* I thought you was making it. *(Hands him phone.)* Here, do it quick. Damn crackheads.

SCOTT: I've got a mate on the other side of the estate, and they've found needles on the stairs.

PATSY: That's what I was saying.

DENNIS: It's mostly kids. Young people need things to do. Otherwise they get bored and that's when the trouble comes.

PATSY: Bored? They have time for bored? They have too much excuses.

DENNIS: If you find something that interests them, you'd have none of this crime and vandalism.

SCOTT: At least it's not like that over this side.

AMANDA: Yet.

SCOTT: Well I like it round here.

PATSY: You mean round by you. You buy yours?

SCOTT: Yeah, we did.

PATSY: Yeah, one of them would suit me nice.

SCOTT: Yeah, they're alright.

JERMAINE: *(Hands PATSY her mobile.)* Mum.

PATSY: Thank you son. *(Pauses to look at him.)* I'm gonna do your hair later. *(She moves away from others, phones home.)* Jamelia… Jameilia… It's Mummy…shu…just be quiet

and let me tell you what to do… Yes…yes. You can watch *Cinderella* after you finish doing what I tell you. Now darling, I want you to listen… Mummy's outside. Outside by the road. I can't get back for a while. Now go and check on that woman. See what she's doing. Hurry up!

AMANDA: I'm getting sick of this. I'm going to see somebody. Somebody who knows something and can do something about it.

SCOTT: But babe I just been down there.

AMANDA: And look what you came back with. Nothing. I'll see you when I get back.

AMANDA exits.

PATSY: *(On phone.)* She's where? Where? What's she doing in my bathroom? All right…just watch her for me…Yeah… like a game. Watch and make sure she ain't going through all my business. Is everything alright? You okay? Now put the phone down… Mummy loves you too. I'll be back soon. Bye darling.

SCENE 2

7.45pm. The residents have scattered themselves around the Courtyard/ Childrens' playground. AMANDA is on her mobile. SCOTT hovers nearby.

AMANDA: … You might as well put them to bed Mum. It doesn't look like we're going anywhere for now… They're just getting over tired, that's why JoJo's playing up…

SCOTT: What's he done?

AMANDA: Put him on Mum. *(To SCOTT.)* JoJo's been hitting Maya again.

SCOTT: *(Mouthing.)* Let me speak to him.

AMANDA: *(Holds hand up to SCOTT.)* Joseph don't play Star Wars with Maya, okay?… I know you were only pretending darling but she doesn't like it…

SCOTT: 'Mand…

AMANDA: JoJo, Daddy wants to speak to you. *(Slaps phone into SCOTT's hand.)*

SCOTT: Hello boy!... Leave your sister alone son... *(Whispers.)* Do your Nan instead, she's gone over to the Dark Side. *(Laughs.)*

AMANDA: Scott!

SCOTT: *Don't* do your Nan boy...no...I can't hear you mate... Why's she screaming?

AMANDA: Who's screaming?

SCOTT: *(Holds hand up to AMANDA.)* Give her the phone son.

AMANDA: Who's screaming?!

SCOTT: *(To AMANDA.)* Maya wanted the phone. *(Into phone.)* Hello Princess, you been a good girl?

DENNIS: Guys! Guys look! They're going in!

There is a hush, they all look up at Walnut House.

JERMAINE: *(Excited.)* Ra'!

SCOTT: ... Sweetheart, I'll call you back.

DENNIS: *(Points.)* That lot weren't there a minute ago. You see that black brother there? He came up the stairs first.

PATSY: Him too fast. Why 'im waan go first for?

JERMAINE: He must be like the best shot or something.

TANYA: What you talking about?

DENNIS punches his chest and gives a 'keep it real' salute.

PATSY: You too fool. You don't watch films? They always send the black man in first for him to get him arse shoot up.

SCOTT: I don't think they're going in you know. It looks like they're just changing shifts.

All look at DENNIS accusingly.

DENNIS: Yeah, sorry, false alarm.

TANYA dials her phone.

PATSY: They must think people got time to waste sitting out here all night. If they gonna shoot him, they should just go in there and shoot him rass. It's alright for them, they're all on some nice piece of overtime. And look at that one. Look how him just stand up there and skin up him teet'!

(Shouts up at building.) This ain't no joke business! People got tings to do!!

DENNIS: Cool it sis, you don't want them to turn their guns on you.

AMANDA: *(Under breath.)* If only.

SCOTT: Easy 'Mand.

AMANDA: I don't care. I'm out here because I have to be.

SCOTT shakes his head and dials his phone.

SCOTT: Hello sugar plum… Oh, sorry Cynthia. Can you put Maya on?

SCOTT and AMANDA go back to their phone call.

TANYA: Hello Nan, it's me again. Pick up the phone if you're there Nan… Please… I'm on my mobile…07932… Actually just do 14713 and you'll get straight through to me. Bye.

DENNIS: Things are really changing boy. A black police officer with a gun. When I was young there was only one black police officer in the whole of London.

JERMAINE: Don't lie.

DENNIS: It's true. Ask your Mum, she'll remember.

PATSY: What you saying? I ain't as old as you. I had my pickney young.

DENNIS: *(Gives her a teasing wink.)* They used to bring him out for carnival. He'd get his picture taken, then they'd send him back to Brixton.

PATSY: People always shock when I tell them my age.

DENNIS: Why, how old are you?

PATSY: Your mother never tell you, you don't ask a lady her age?

DENNIS: Yeah, but she also told me if I didn't eat my greens I wouldn't grow.

DENNIS pulls himself up to his full height – towering over PATSY. PATSY looks him over appreciatively. She catches herself suddenly and becoming embarrassed looks around for something to do.

PATSY: Jermaine. Let me do your hair for you. Come!

JERMAINE goes to her.

JERMAINE: Where am I going to sit?

PATSY: Just sit down here.

JERMAINE sits on the floor between PATSY's legs. PATSY inspects his plaits. She redoes the ends on a couple of them.

PATSY: Your hair's too soft man. Look how it's coming out already. That's what I can't take about you people with your coolie hair. Every five minutes you got to do your hair again. Look at Jamal, I can't tell you how much comb I break in that boy's head. But once you put kainrow in, it ain't coming out for nuttin. Him favour him father anyway. *(Plaits JERMAINE's hair roughly.)* Keep your head still Jermaine. *(Pause.)* You know what? I'm gonna put some beads in your hair.

JERMAINE: *(Sulkily.)* I don't want no beads.

PATSY: They look nice.

JERMAINE: I don't wanna look like Stevie Wonder.

TANYA: You did my mate Stacey's hair.

PATSY looks around as if to see who TANYA is speaking to. She ignores her and carries on speaking to JERMAINE.

PATSY: I ain't gonna go mad or nuttin. Just a couple here and there.

TANYA: I said, you did my mate Stacey's hair.

PATSY: Who?

TANYA: Stacey? White girl. Works in the bank with me.

PATSY: I only do friends and family.

TANYA: She said it was you. She's got long blonde hair.

PATSY: Look, a lot of people do hair nowadays. Maybe she got me mixed up with someone. Cause I don't work, you know what I mean.

TANYA: She said it was some woman in Cedar House. You live in Cedar don't you?

PATSY: Yes I live in Cedar House. *Sometimes* I do hair for friends and friends of friends. And *sometimes* they give me a little something, but I-do-not-work. Do you know what I'm saying?

TANYA: Shame. Stacey's hair looked really nice.

Exasperated, PATSY *rolls her eyes.*

JERMAINE: You remember her Mum.

PATSY: What? *(Pulls JERMAINE's hair tightly.)*

JERMAINE: She had that birthmark on her neck. *(PATSY continues to pull JERMAINE's hair.)*

PATSY: *(Weakly.)* Oh *that* Stacey.

TANYA: Yeah, that Stacey.

PATSY: *('Coofs' JERMAINE in his head.)* You love chat too much.

AMANDA: *(Ending call.)*... Mum, just take the light sabre off him... *Sabre* not saver...anyway if he starts again, just take it off him... Bye Mum.

SCOTT: *(Smiles to himself.)* Little fucker.

AMANDA: Not the *exact* word I'd choose. But he's high spirited, I'll grant you that.

SCOTT: He's just a boy. That's how they play.

AMANDA: Sophie's boys don't play like that.

SCOTT: Sophie's boys wouldn't last five minutes around here.

AMANDA: That's nothing to be proud of Scott. He's turning into a thug. He terrorises Maya with that light sabre.

SCOTT: Fair enough. I tell you what, next time there's a gun amnesty down the nick. I'll hand it in.

PATSY: *(To TANYA.)* Hello. Do you want me to do your hair?

TANYA: No thanks.

PATSY: I bet your hair could tek it too. It looks strong. I can do all kind of hair you know. Black, white, coolie, Chinee. I don't discriminate.

TANYA: It wouldn't look right.

PATSY: Rubbish! The living white people put plaits in their hair nowadays. Look at that whatshisname?

JERMAINE: David Beckham.

PATSY: Yeah, David Beckham.

TANYA: Yeah. That's what I'm saying. It don't look right.

PATSY: That's only if it don't do good. If I met Posh, I'd have to say respect to the weave, because that weave looks good, you get me. Now if that girl…What's her name again Jermaine, the skinny, skinny one?

JERMAINE: Christina Aguilera.

PATSY: Yeah, yeah that one. If she came down here in that big curly piece of weave she had that time. I'd have to fling a stone after her. And I ain't a violent person, you get me?

TANYA: Well, I like her.

There is a long pause. Bored, people look around for things to do.

PATSY: I could eat something. Jermaine?

JERMAINE, who is eating sweets, grunts.

PATSY: You hungry?

JERMAINE grunts 'Yes'.

PATSY: I don't know how you can eat so much and stay so magre. *(PATSY takes money from purse and gives to JERMAINE.)* Here, go and get some chicken. Tell Faraz don't bother give you any wings. I want breast and thigh. The man's too tief!

JERMAINE: His name's Farzad Mum, and he let me off 20p the other day.

PATSY: What's he want a medal? He should give you shares in that place the amount of money you spend in there.

DENNIS: Hold up young blood, I'll come with you.

SCOTT: I'm gonna get something an' all. I'm so hungry I could eat a scabby horse and rider. D'you want anything babe?

AMANDA: Not really.

SCOTT: Is that a yes or a no? This ain't some diet bollocks is it?

AMANDA: I'm just not that hungry. Scott darling, have you got your proper clothes in the van?

SCOTT: Yeah, sorry babe. I'll get you something anyway.

AMANDA: Yeah, whatever. Surprise me.

SCOTT, DENNIS and JERMAINE exit. The Courtyard is silent. Long pause.

PATSY: How's your nan?

TANYA: Oh, you know how she is.

PATSY: Yeah. She's a piece of work that woman. I heard they was gonna move her out of Walnut and put her in a bungalow.

TANYA: You're joking ain't ya. The only way she's coming out of there is in a box.

SCENE 3

8.15pm. PATSY, JERMAINE, DENNIS, TANYA, SCOTT are all happily eating their chicken and chips, while AMANDA sits picking at hers in a mood.

JERMAINE: Mum, you got any ketchup?

PATSY: *(Hands ketchup to him.)* More time I prefer to cook my own food.

DENNIS: You like cooking then?

PATSY: Like it or not, I got three pickney to feed.

JERMAINE: You got any more?

PATSY: What's the matter with this boy?

SCOTT: How's yours babe?

AMANDA: I'm not hungry.

JERMAINE: Mum.

PATSY: Just drowning out the flavour.

DENNIS: You sound like my mum.

JERMAINE: I like it.

PATSY: Sometimes I get vex seeing him water the whole plate with it.

JERMAINE: Mum.

PATSY: *(Gives him ketchup.)* Here.

JERMAINE: Thank you.

PATSY: I ain't really into fast food too tough. But Farzaz and them are all right. They're clean.

DENNIS: Last night I had this wicked Thai green curry. It tasted so good, I wanted to just rewind and eat it all over again.

PATSY: You ain't ever tasted my cooking!

DENNIS: You inviting me to dinner then?

PATSY: I ain't got time to cook for no man.

SCOTT: Babe, try and eat something.

AMANDA: I said I'm not hungry.

JERMAINE: Nobody can fry chicken like Nan though.

DENNIS: Yeah, I like that peri peri stuff.

JERMAINE: No you fool, not *Nando's*. My Nan's chicken. If you tasted hers, days later you'd still be licking your lips.

SCOTT: I bet she does a blinding rice and peas then your nan?

JERMAINE: Standard.

PATSY: What you know about rice and peas?

SCOTT: It's me favourite.

PATSY: Serious?

SCOTT: I could eat it every day and never get tired of it. If it's anything like the way 'Mand's mum does it.

PATSY: What's your favourite meal then? Apart from rice and peas.

SCOTT: Years ago it would've been easy. Sunday roast, straight off. But now there's so much choice.

DENNIS: And I remember when English people would just nyam chips day and night. Every corner had a chip shop. And pure Chinese people running it.

TANYA: You can't even find a proper chippie anymore.

JERMAINE: They sell chips everywhere.

TANYA: No. They sell *fries*.

SCOTT: *(To AMANDA, gently.)* You should eat something. You want some of mine?

AMANDA: How can you even think of food?

SCOTT: I was only saying.

AMANDA: God only knows the danger our children are in and you expect me to sit here and chow down with the locals?

SCOTT: They're not in danger. They're inside with your mother. We just spoke to them.

AMANDA: Thanks for your concern Scott, but I'd rather not eat any of this food.

SCOTT: Suit yourself.

PATSY: Starving yourself ain't gonna help nobody.

AMANDA: Yeah well I guess some people are just not that bothered where their children are.

PATSY: Sorry?

AMANDA: Don't be. You are what you are.

TANYA: Oh shit…

PATSY starts taking off her earrings, preparing to fight. AMANDA stands her ground.

PATSY: I soon fuck up your face.

AMANDA: You think I won't fuck up yours?

PATSY and AMANDA lunge at each other and start fighting. SCOTT jumps in the middle, pulls AMANDA off. JERMAINE grabs PATSY and pulls her away.

SCOTT: Fucking shut up the pair of you! *(To AMANDA.)* What you doing?! What are you doing?! *(To both.)* Calm down both of you! *(To AMANDA.)* What's the matter with you?

PATSY: You see you, from you come here you been going on like say your shit don't stink.

AMANDA: At least I don't chat shit.

SCOTT: *(To PATSY.)* Do you wanna see your kid?

PATSY: What?

SCOTT: Do you want to see your kid? 'Cause if you carry on, you're gonna end up in the back of a van. *(To AMANDA.)* And you. *(To both.)* There's Filth all over the place.

SCOTT and AMANDA walk away from the others.

SCOTT: You've made a right show of yourself. Why couldn't you for once just leave it?

AMANDA: How dare you?! How dare you back her over me? I'm your wife, do you know what that means?

SCOTT: Yeah, I know what that means.

AMANDA: How dare you let her disrespect me?

SCOTT: If you disrespect people. They'll disrespect you back.

AMANDA: Don't treat me like a kid.

SCOTT: Don't act like one. You're always telling me don't fight Scott, don't fight. Now you're at it in the street like a… fishwife! All night you've been waiting. Everyone's getting on, but oh no – not you. It was just too much for you. They're our fucking neighbours! Why couldn't you just make an effort?

AMANDA: I don't want to be in this street. I don't want to be in this shithole.

SCOTT: None of us want to be here, but this is the closest I can physically get to my kids so I'm staying put. If you don't like it you can sit in the van. Here, take my keys.

SCOTT throws keys to AMANDA.

AMANDA: I'm not sitting in the fucking van.

SCOTT picks up keys and exits.

PATSY: I can't take her you see. She think is she one special in the world. *(PATSY kisses her teeth.)* What? 'Cause she's got a white man?! She ain't fooling me.

DENNIS: She's probably just tired. Pissed off she can't get into her own house.

PATSY: You know what? 'Nuff white man rush me. I could have any white man I want but true say I don't wanna go there. Anyway, more time they don't wash properly.

DENNIS: Patsy you know that's rubbish. All white men don't wash? What, none of them? So what do they do when we're washing? Morris dancing?

PATSY looks shamefaced. JERMAINE shrugs and shakes his head.

PATSY: Anyway, if it's one thing I know – I look after my kids. And no one can say they look like they need anything. They always look presentable. I make sure of that. *(Pause.)* Jermaine, you want this apple pie?

JERMAINE: Nah, I'm alright.

PATSY: I can't let it waste.

JERMAINE: I don't want it.

PATSY: What about you? Yes you Mr Dennis. Dennis Walker.

DENNIS: Thanks. *(Takes pie.)*

JERMAINE gets up to go.

PATSY: Where you going?

JERMAINE: Over there.

PATSY: What you going there for?

JERMAINE: I'm just going over there.

PATSY: I'm just asking. All right, you go about your business.

JERMAINE walks off.

DENNIS: I was saying to Jermaine, it's a big world out there. He's young, he can get somewhere.

PATSY: I thought he was somewhere already.

DENNIS: I mean go different places. See different things.

PATSY: There's a lot for a boy to learn before he can call himself a man.

DENNIS: When I left school I was packing biscuits. I never knew I had a choice. No one told us. I'm doing alright now, but Jermaine, he could be…You did a good job.

PATSY: So far, so good. So tell me…a man like you must have a few children of his own.

DENNIS: Why do you say that?

PATSY: You seem to like them a lot.

DENNIS: It's my job.

PATSY: Really?

DENNIS: I'm a social worker.

PATSY: *Really?*

DENNIS: Well nearly. I've just got to sit my final papers.

PATSY: Nice. You still haven't answered the question.

DENNIS: Sorry?

PATSY: How many?

DENNIS: One, but I don't see her. Me and her mum don't get on.

PATSY: What's that got to do with seeing your child? That's your blood.

DENNIS: I know, I'm working on it.

PATSY: Good. Children don't need bringing into bringing into big peoples arguments do they?

TANYA and JERMAINE are sitting together.

TANYA: You alright J? Your mum ain't changed.

JERMAINE: D'you know what I mean.

TANYA: Do you remember when she took her shoe off to Nutty Jim? *(Both laugh.)*

JERMAINE: She hurt him bad that day.

TANYA: That's right. She's proper old school ain't she?

JERMAINE: Old school?

TANYA: Like my Nan.

JERMAINE: My Mum ain't like your Nan.

TANYA: She is.

JERMAINE: She ain't.

TANYA: Why's she always chatting in that Jamaican accent.

JERMAINE: She's Jamaican.

TANYA: What, was she born there?

JERMAINE: No. Dalston.

TANYA: Oh, right.

JERMAINE: She ain't English.

TANYA: Then what is she?

JERMAINE: She's my Mum.

SCENE 4

9.15pm. PATSY, DENNIS, SCOTT and AMANDA are scattered about the courtyard.

PATSY is speaking on her mobile.

PATSY: Jamal, anyhow you misbehave round Craig's house, it's me and you, you understand?... I ain't joking Jamal... And make sure you leave your trainers outside. I don't want you stinking up the poor woman's house... Alright son, I'll see you in the morning... Love you... Bye.

TANYA and JERMAINE enter carrying a tray of teas.

TANYA: It's a nightmare in that hall. It's all going off in there.

JERMAINE: And it stinks.

SCOTT: Yeah, it's like walking into an ashtray.

TANYA: I couldn't remember who wanted what.

DENNIS: Hey, no worries.

TANYA: Who was it that wanted the herbal tea? *(To AMANDA.)* That was you weren't it? Well they ain't got none.

People help themselves to the teas.

SCOTT: Cheers love. I don't normally drink tea at home do I 'Mand?

AMANDA ignores him.

SCOTT: I drink so much of it at work, I just don't fancy it when I get home.

DENNIS: It's a bit like that where I'm working now. It's like if they ain't drinking tea, then they're talking about whose turn it is to make it next.

SCOTT: *(To JERMAINE.)* You wait till you start mate. Don't matter what it says on the job description, if you can make a good cup of tea – you're in.

PATSY: My Jermaine not making tea for nobody. He's going to university.

SCOTT: Good for you. What are you going to do?

JERMAINE: Music and I.T.

PATSY: It's something with computers innit Jermaine? Gonna earn big money and have to wear a suit to work. If Jermaine want tea, somebody gonna have to go and make it for him.

SCOTT: Amanda loved university. Didn't you 'Mand?

AMANDA ignores him.

SCOTT: I hated school. I only went for the dinners.

AMANDA: *(Under breath.)* It shows.

PATSY: Did they say when we can get back in?

TANYA: No, they're still not saying nothing. But I was talking to one of the women who comes in the bank. She reckons some bloke's gone off his head and locked himself in one of the flats.

DENNIS: What's that got to do with the police? Ain't it his flat or something?

TANYA: Well apparently he's a bit mad the geezer and he's got a gun and he's gonna shoot anyone who comes near him, or something. I don't know, whatever, whatever. I wasn't really listening, 'cause she really goes on this woman and I wanted to get back with the teas.

PATSY: You shouldda listen man. You see how you English people so craven for your tea!

TANYA: *(Goes to take PATSY's cup from her.)* I'll take it back then, shall I?

PATSY kisses her teeth, cuts her eye at TANYA and downs a large gulp of tea.

SCOTT: Here, you don't think it's that geezer do ya? Old fruit and nut? The one with the shirt. Always shouting at the CCTV, 'I know you're watching me Mr Blair!'

A look of recognition passes between the group.

JERMAINE: Nutty Jim?

SCOTT: Yeah, that's the one. He lives in Walnut don't he?

PATSY: Them shouldda lock him up long time. Remember how him used to walk street naked cover in him own shit?

DENNIS: It's not his fault. He just forgets to take his tablets sometimes.

PATSY: What you telling me for? I look like a nurse to you?

SCOTT: That's the trouble with Care in the Community. The community don't really care.

DENNIS: It's personal choice I suppose, but I think we've got a responsibility to the people we live with.

SCOTT: Even if they're covered in shit?

DENNIS: Yes. Placing vulnerable people in substandard social housing isn't really the solution.

PATSY: Substandard? Which part? I got laminate flooring right through my yard.

TANYA's phone rings.

TANYA: Nan, where have you been? I've been worried sick here. How have you just woken up? It's 9.30! I told you not to drink in the afternoon. I'm outside innit. I'm stuck out in the siege. The siege… Look out the window. You know what, don't worry about it Nan. Go back to sleep. Just don't open the door.

A text message alert sounds. They all check their phones. It's JERMAINE's.

JERMAINE: There's some people from the news in the hall. Tyrone says they're asking people questions and that.

TANYA: I'd best get these bits back.

PATSY: Look how she's trying to get on TV.

TANYA: Bollocks, I am. *(Straightens hair.)* But I said I'd bring the tray back.

SCOTT: Well I'm gonna go and have a look. You coming 'Mand?

AMANDA ignores him. SCOTT and TANYA exit.

PATSY: *(Trying to appear nonchalant.)* I might just go and see what's going on.

PATSY exits.

JERMAINE: *(To DENNIS.)* You think I can't do it?

JERMAINE runs up the slide.

DENNIS: You'll have to tell her soon. The longer you leave it, the harder it's gonna get.

JERMAINE: I ain't gonna tell her.

DENNIS: Come on man, she's your Mum.

JERMAINE: She'll kill me.

DENNIS: You haven't done anything wrong. You're only going to university.

JERMAINE: In Manchester!

DENNIS: You do know that's still in England right?

JERMAINE: Mum won't see it like that. She's gonna switch, trust me.

DENNIS: She'll probably be a bit upset at first.

JERMAINE: A bit?! Listen man, you don't know my Mum. I remember when I was about twelve, I let a stink bomb off in my class. I thought it would be funny. At first it was, 'cause it only stank out the class. But fifteen minutes later the school had to be evacuated. They dragged my Mum up the school and she beat me from the Head Teacher's office, through the school, across the playground, past the shops, through the park…

DENNIS: Look, everybody got licks.

JERMAINE: No, you really don't know my Mum. We got indoors. It stopped. She went quiet. Then she said, 'If you ever do that again, I will blind you.'

DENNIS: But she loves you J. And if you truly love someone you can set them free.

JERMAINE: Yeah, whatever Trisha.

DENNIS: Jermaine, you can't be a man under your Mother's roof.

JERMAINE: I'll tell her. I will. I'll just wait 'til she's in a good mood.

DENNIS: You ain't got that long bro! Just talk to her.

JERMAINE: Can't you tell her? I think she kinda likes you.

DENNIS: It'd be better coming from you.

PATSY approaches.

PATSY: Jermaine!!!

DENNIS: And besides, I ain't ready to die yet.

Two HOODIES cross the stage. PATSY enters, laughing.

DENNIS: I'll leave you to it.

JERMAINE: *(Panicked.)* Now? Dennis...?

DENNIS exits.

PATSY: The TV ain't there. It's some woman from the radio. I told her straight, I only listen to pirate. What you looking like that for? Close up your mouth before you catch flies.

JERMAINE: Mum... I...erm...

PATSY: What?

JERMAINE: Nah, it's alright.

PATSY: Come on, you was gonna say something.

JERMAINE: Dennis fancies you.

PATSY: Yeah? Mek Dennis gwaan. You know I don't have no luck with men. Anyway, you is the only man I need, innit.

PATSY links arms with JERMAINE.

SCENE 5

9.45pm. Two HOODIES cross the stage. AMANDA sits motionless on the swing.

SCOTT approaches from behind. He gently pushes the swing, she stops him.

AMANDA: *(Stiffens.)* Don't.

SCOTT: *(Continues pushing swing.)* Come on.

AMANDA: Please, I'm not in the mood.

SCOTT continues pushing swing, laughing.

AMANDA: I said no.

SCOTT moves away from AMANDA, throws his hands up exasperated. He sits on the bench. There is a long uncomfortable silence.

AMANDA: Are you just going to sit there now?

SCOTT: *(Points to Oak House.)* How high?

AMANDA: What?

SCOTT: How tall do you reckon Oak House is?

AMANDA: *(Irritated.)* I don't know. I don't care.

SCOTT: Nah, go on…have a guess.

AMANDA: I don't know Scott.

SCOTT: I know you don't *know* but have a guess.

AMANDA: Oh, five thousand, four hundred and twenty-nine metres and sixteen centimetres.

SCOTT: See, that's it.

AMANDA: What?

SCOTT: You said metres. *(Pause.)* I would have said feet. I miss feet.

AMANDA: What are you talking about?

SCOTT: At work it's all metres and centimetres now. I miss inches. *(Pause.)* What would you miss if it was gone?

AMANDA: I wouldn't miss anything about this place.

SCOTT: Yeah… I really miss imperial.

AMANDA: *(Cuts her eye at SCOTT.)* And I really miss intelligent conversation.

AMANDA realises, she's gone too far. She sits on the bench next to SCOTT.

AMANDA: *(Pause.)* I'm tired, sorry.

SCOTT: What would you miss if I wasn't here?

AMANDA: I wouldn't miss anything If I weren't here. I'd be glad to see the back of it.

SCOTT: I'd miss the kids.

AMANDA: Why would you miss the children? We're not going anywhere without them?

SCOTT: I like it here.

AMANDA: But it's not what I planned. I know we've talked about it and you think we can't afford it yet but…

SCOTT: I get on your tits don't I?

AMANDA: What?

SCOTT: I really get on your tits, don't I?

AMANDA: No, sometimes you get on my nerves.

SCOTT: You're not having a good time are you?

AMANDA: I'm not like you Scott. I can't laugh when inside I don't find anything funny.

SCOTT: Time was I could always make you laugh.

AMANDA: Yeah…

SCOTT: Now every time I walk into a room, your face falls. You're not happy with me, are you?

AMANDA: Please don't.

SCOTT: I don't like making you unhappy. It might be better if I go.

AMANDA: So you want to walk out now. Is that it? You want to leave your kids?

SCOTT: I don't want to go anywhere. I'm happy with you. But I drive you mad. I don't mean to but I can't help it. I just wind you up. It's me. Maybe if you had a bit more… maybe things would be…I'd still see the kids every day. I'll stay at me dad's…

AMANDA: It's not you. I come home tired, and there's still so much to do. Since the children I haven't been able to stop.

SCOTT: I don't think that's it.

AMANDA: Please Scott. Let's sell the house and move on. It doesn't have to be far. Just away from here…

SCOTT: That ain't the answer is it? Wherever we pitch up, it's still gonna be us. *(Pause.)* What do you think's good about us?

AMANDA: The children. We've got two beautiful children.

SCOTT: No, not the kids. I'm talking about us.

AMANDA: Our children are us. They're something we made together.

SCOTT: Yeah, but what's good about us? You and me.

AMANDA doesn't answer.

SCOTT: At work, if something's wrong, I fix it. That's what I do. I fix things. But I can't fix this. I ain't no use here. You'd be better without me.

AMANDA: What if, I'm not unhappy with you? What if, I'm unhappy with me? I know I don't always laugh at your jokes anymore but deep down inside, I know you make me happy. *(Pause.)* Whatever it is with me, I'll find out and put it right. I don't mean to push you away.

SCOTT: 'Mand…

AMANDA: I do love you. I really do.

SCOTT: Fuck. I love you. I just don't think it's enough.

SCOTT exits. PATSY and DENNIS enter, laughing.

DENNIS: I used to rave from Friday night to Sunday morning.

PATSY: You?! I don't think so!

DENNIS: What you saying?

PATSY: I ain't being funny or nothing but you…you couldn't keep up with me.

DENNIS: I'll have you know, I've raved with the best of them. Don't worry 'bout me. I got stamina.

PATSY: Self praise ain't no recommendation.

DENNIS: Well there's only one way to find out. Test me.

PATSY: *(Kisses her teeth.)* You best sit down, 'cause if I ever brok' a piece of whine 'pon you, you finish!

DENNIS: Chicken!

PATSY: You think you could handle me?! Man just settle yourself and done! *(Laughs.)*

DENNIS: I could settle you, no problem.

PATSY: Come, if you think you bad.

DENNIS: Alright, I'm joking.

PATSY: So when you last went out raving?

DENNIS: I can't remember.

PATSY: You go on like an old man!

DENNIS: I've been working and studying. I ain't had time.

PATSY: You never hear what happen to Jack?

DENNIS: Jack?

PATSY: All work and no...

DENNIS: Yeah, yeah, yeah! Well I'm almost finished now so...

PATSY: So how come you don't got no woman?

DENNIS: I just wanted to get myself together before I got into anything serious. Besides, you know what women are like. You let them in and next thing you know, they're booking a church.

PATSY: I don't run down man you know.

DENNIS: Is that why you ain't got nobody either?

PATSY: Who tell you I ain't got nobody?

DENNIS: I just thought...

PATSY: I'm very particular about the company I keep. Especially when it comes to men. They can't be trusted.

DENNIS: We're not all the same you know.

PATSY: So you say.

DENNIS: Why do you always have to act so cynical?

PATSY: Whoa! That's a big word.

DENNIS: A big word for a big man.

PATSY and DENNIS lock eyes. PATSY breaks the stare.

PATSY: I really wanted to go to this dance as well. Why this fool have to go lock himself in?

DENNIS: You might still be able to make it.

PATSY: Which part? That's it! I lost my money.

DENNIS: Next time.

PATSY: But this time I actually bought, paid cash money, for a ticket. *(Pause.)* You know how much money I lose already tonight? I had to phone and cancel that other weave. *(Pause.)* And if you hear how the little dutty, dry head bitch try cuss me. I had to tell her about her wrenk self. Some people just too ignorant. *(Kisses her teeth.)* It was a turnaround as well.

DENNIS: A what-around?

PATSY: A turn around. Where woman ask man to dance. I can't believe you ain't heard of one before. What kind of black man…?

DENNIS shoots her a look.

PATSY: That's why they call it a turnaround. Because it's the woman who does the asking.

DENNIS: I'd love to go to one of those.

PATSY: *(Laughs.)* Last time it was wicked. Lights come on and I was still raving. In the end they had to turn off the music. I was getting on something bad you see!

DENNIS: Did you meet anybody?

PATSY: Of course I met people. How could I rave on my own?

DENNIS: You know what I mean. How many men did you dance with?

PATSY: I don't know.

DENNIS: Roughly.

PATSY: I wasn't counting. I was raving!

DENNIS: So when you're in this dance, right, you just ask the man to dance?

PATSY: Yeah.

DENNIS: What do you say?

PATSY: You just say, 'You wanna dance?'

DENNIS: Show me. Let's pretend, and you ask me to dance. Go on.

PATSY: Alright. You gotta pretend you're at the dance as well, OK? Stand up.

DENNIS stands, pretending to hold a drink.

DENNIS: OK, I've got my drink.

PATSY: No, that'll dash way.

DENNIS mimes dancing in a club. PATSY walks slowly over to him.

PATSY: You wanna dance?

DENNIS: No, I'm too sweaty. Dance with my friend.

PATSY hits him playfully.

PATSY: No, that's not nice.

DENNIS: Someone said that to me one time. Go on, ask me again.

PATSY: You wanna dance?

PATSY and DENNIS slow dance, as if to Lover's Rock. They are tentative to begin with, then relax into it.

PATSY: Woman can be bad too.

A gunshot rings out from Walnut House, startling PATSY and DENNIS.

Blackout.

SCENE 6

11.15pm. PATSY, DENNIS, AMANDA and TANYA are scattered around the courtyard. There are bags from the Off Licence spread about. DENNIS has a bottle of Wray and Nephew rum. PATSY is drinking a Bacardi Breezer, with an empty beside her. TANYA is drinking Smirnoff Ice, with an empty beside her. AMANDA is on her phone.

AMANDA: It's me. Again. Call me.

DENNIS: *(To AMANDA.)* You sure you don't want some? We've got cups now.

AMANDA refuses.

AMANDA: If Scott comes back, could you tell him I'm in my car.

AMANDA exits.

DENNIS: Tanya?

TANYA: *(Pours herself some rum.)* Cheers.

DENNIS: Patsy, you'll have a chaser to go with that?

PATSY: I ain't a big drinker you know. *(She drinks deeply from her Bacardi Breezer.)*

DENNIS: I can see that.

PATSY: Hush your mouth! I've had a shock. Damn policeman letting off guns. What them think this is, a sound clash?

TANYA: They could've killed someone. I'm not being funny right, but how do you *accidentally* fire a gun?

PATSY: Typical man. Them get all excited and then can't control them weapon.

TANYA laughs raucously.

JERMAINE enters.

DENNIS: J! Come sit here.

JERMAINE: Why?

DENNIS: I'm feeling a bit outnumbered man.

PATSY: Never you mind Jermaine. Big people talking.

JERMAINE: I'm nearly eighteen you know.

PATSY: Me know. I'm just having a joke with you. Look at his face, he looks like he wants to eat me.

JERMAINE looks at them, quizzically.

JERMAINE: Are you drunk?

PATSY: Not yet!

PATSY holds out cup for DENNIS to fill. TANYA jumps up and starts moving uncomfortably from foot to foot.

TANYA: I can't face that toilet again.

JERMAINE: Go in a bush.

TANYA: Piss off.

PATSY: Stay there and wet up yourself then.

TANYA: *(Crossing legs.)* Bollocks. You got any tissues?

PATSY takes a screwed up tissue from her pocket.

TANYA: *(Turning her nose up.)* Nah, it's alright.

TANYA rushes off. SCOTT enters, looks around. His phone rings, he looks at the caller ID then cancels the call.

DENNIS: *(To SCOTT.)* Your wife told me to tell you she's in the car.

SCOTT: Right. Thanks. *(Noticing carrier bags.)* Oh shit, I've missed the Offi.

DENNIS holds out a beer to SCOTT.

DENNIS: Have one of these.

SCOTT: You sure? Cheers mate. What's the damage?

DENNIS: You're safe man. Jermaine, you want a drink?

JERMAINE: I don't drink.

DENNIS: Never mind, you'll grow out of it.

He gives JERMAINE a playful dig.

DENNIS: *(To SCOTT.)* D'you want some rum to chase that?

SCOTT: No thanks, I can't.

PATSY: Can't or won't?

SCOTT: Both. I got absolutely ruined on the stuff on honeymoon. First time I went to St Lucia.

DENNIS: Is that where your wife's family come from?

SCOTT: Yeah.

PATSY: I knew she never come from Yard.

SCOTT: No, Morne D'or. It's a little village in St Lucia.

PATSY: They're all little villages in St Lucia.

SCOTT: Yeah, alright. I don't get involved in all that.

DENNIS: Me neither. So the rum mash you up yeah?

SCOTT: Not many. I was out with Amanda's cousins in this rum shop and they're all going on about how they're gonna teach me how to drink, right? Stupid really. But I thought, bollocks, I ain't having none of that. So I gets the geezer in the shop to pour me a big, fuck off glass of rum. It was massive. And it's the home made gear, you know – 'under the counter'. He pours it out and they're all watching me. And I've gone *(Mimes downing drink.)* 'Whallop!' Down in one.

DENNIS: Eh, eh!

PATSY: You good!

SCOTT: No, I knew I'd done a wrong'un straight off, cause my insides were on fire. It was like I had an ulcer popping. I should've stopped there, but they're all slapping me on the back going 'Eh-eh, English man can drink!' Well now it's a matter of national pride innit. So, when I get back the use of my lips I ask him to hit me again. And again. And again.

DENNIS: Gwaan!

They clink drinks.

SCOTT: I think I passed out. I say think, because to this day I don't remember leaving the shop. But they must have carried me home because the next thing I remember was hearing all this shouting. It's Amanda's Nan and she's going mental. She's going 'How am I gonna tell his mother you bring him to St Lucia and kill him?!' She starts laying into them. Proper beats, and they're just standing there trying not to laugh while I puke on me sandals.

JERMAINE: Sounds like my Nan, innit Mum?

PATSY: No. She would've beat Scott too.

TANYA enters carrying blankets.

TANYA: Here's some blankets if anyone wants 'em. They was giving them out in the hall.

PATSY takes one.

DENNIS: Actually, it's still quite warm innit?

TANYA: It's been lovely. I got a blinding tan. *(She examines her arms.)* And that's just from walking around, I ain't even been laying out.

DENNIS: *(Holding arms out, playful.)* Me neither.

TANYA: Oh, shut up! We don't normally have a summer do we?

PATSY: Last year, the summer last two days. By the time I find my shorts, summer done!

SCOTT's phone goes. He looks at the caller ID and ignores the call.

SCOTT: They could've sent someone down here to let us know what's going on.

TANYA: They did. There's someone in the hall.

DENNIS: And what's he saying.

TANYA: Nothing. But I was talking to one of the old dears in the queue for the toilet and she was telling me the police can't do nothing 'cause the fella's got an hostage up there.

DENNIS: Well that's it then. They could keep us out for days.

SCOTT: What's he take an hostage for? Were they gonna section him or something?

TANYA: No, he's not mad. He's an Asylum Seeker. Apparently. They wanted to send him back to where he came from but he's gone and barricaded himself in.

JERMAINE: Did they say who the hostage was?

TANYA: Course not.

PATSY: Damn out a order. Why he have to take a hostage? He stay too long, he get *ketch*, so now him have to go back.

DENNIS: Back where? What if he's in danger? What's he gonna go back to?

PATSY: Well, if he's in trouble they should let him stay. But half of them, they come here and they ain't in danger. They just know this country's a soft touch.

DENNIS: No it isn't.

TANYA: We have got a lot of 'em over here. They ain't coming for the weather.

DENNIS: You know why they come? Because, believe it or not, England's got a reputation for being a tolerant society.

PATSY: Which part? You need to take your head out of that book and start living in the real world. You know how long I've been waiting to move out of my flat? Since Jamelia was born. She's six now and I ain't got nowhere on the list. Why? Because every five minutes someone else comes in the country. They got nowhere to live. The council has to house them, so my name goes straight down to the bottom again.

TANYA: They're just bunking the queue all the time.

DENNIS: Sometimes you have to help the people whose need is greatest. What if it was you and you had nothing but the clothes you're stood up in. Wouldn't you want someone to help you?

PATSY: Of course. But there's a lot more who say that just so they can get a stay.

DENNIS: So what if they just want to better themselves? That's why we're here, because our parents wanted a better life for us.

PATSY: That ain't the same thing.

DENNIS: Yes it is.

PATSY: No it ain't. First of all, our parents were invited. And second, they worked damn hard. Nobody gave them food vouchers when they came off the boat. Nah man. This country didn't give them nothing except a cold.

TANYA: Nobody's ever given me nothing. I left school and went straight to work. I've paid poxy tax and national insurance all my life, yet when I had my cartilage done I had to go private because I had to wait so bloody long. Now how is that fair?

DENNIS: It's not. But you can't blame it on the Asylum Seekers.

PATSY: They'll do anything to stay in this country. Look at my man up in the flat. 'Bout him take hostage. They should just dash his Kosovan, Somalian arse out yes!

DENNIS: How did you get to be such a racist?

PATSY: How can I be racist? I'm black.

SCOTT: You wanna hear some of the shit I've had off black people since I've been with Amanda.

PATSY: Some people don't like seeing black and white together. I only check for black guys. That don't make me a racist.

DENNIS: So how do you define a racist then?

PATSY: Someone who hates you just because you're black.

SCOTT: Or white.

DENNIS: Exactly.

TANYA: Yeah.

PATSY: To me, if you're chatting racism you need to look at her Nan.

TANYA: My Nan ain't racist…like that.

PATSY, SCOTT and JERMAINE look at TANYA disbelieving.

JERMAINE: She is.

TANYA: Look, she's old alright.

SCOTT: It is hard for the old ones sometimes. My Mum still calls Amanda coloured but she loves her to bits. In her day it was rude to call someone black.

TANYA: That's like my Nan. She can't keep up with it all.

PATSY: Don't make excuses. The woman just wicked. Always hanging off her balcony bawling out about jigaboo and sambo…

SCOTT: Hold on. *(To TANYA.)* That's your Nan? The one with the blue hair? She called my Jo Jo a nig-nog.

JERMAINE: She called me a coon. I didn't even know what it was. I had to ask my Mum.

PATSY: I make sure she well a know if she can't call him the name I christened him then don't call him at all.

JERMAINE: Tyrone dashed a stone at her.

TANYA: That's bang out of order.

SCOTT: Oh what, and calling someone a coon ain't?

TANYA: There was only white people round here when my Nan was growing up. I'm not saying what she did was right, but you have to try and understand. Everyone talked the same, everyone looked the same. It's all changed now and she can't keep up. That's all. That don't make her a bad person. *(To SCOTT.)* It's like he said. They just get it wrong sometimes.

DENNIS: There's a big difference between not knowing and not caring.

TANYA: What is this? Have a pop at my Nan day? Fucking hell!

DENNIS: Don't get upset. We're just talking.

TANYA: Well I am upset, right. She's my Nan. And I know she's out of order sometimes, but she's my Nan alright.

PATSY: I ain't taking her on anyway. She old. She soon dead. How many bedroom she have in her place?

TANYA: Fuck off.

SCOTT: I don't understand. Why stay here if you hate everyone? Why don't she fuck off, no disrespect, but why don't she go to Hornchurch like the rest of 'em.

TANYA: Why should she? Why should she go? She was here first. This is her home.

JERMAINE: Yeah. But it's my home too.

TANYA: Yeah, and everyone knows that and that's great. But you know what? Sometimes I don't feel like this is my home anymore. I feel like a stranger in my own country.

DENNIS: How can you say that? You of all people should feel at home here.

TANYA: Why's that? What just because I'm white? I'm in the minority here. You can say what you want, but it's true. I grew up with blacks, Asians and all kinds right. And I respect their culture, but no one has to respect mine. You try saying I'm white and I'm proud.

DENNIS: That's because it's the dominant culture already. And maybe we don't think we have to make an effort to respect it, because it's in such a powerful position.

TANYA: That's not what it feels like from where I'm standing. How about the Jubilee? They did that lovely party for the kids in the hall, but the council made them take down the bunting with the union jacks on. They said it was offensive. Now you tell me, what harm can a little bit of bunting do?

DENNIS: I have to admit I do have issues with the flag. Every time I see it, I remember how the skinheads used to say there ain't no black in the union jack.

SCOTT: Unless it's wrapped around Linford Christie. Fuck 'em. It's our flag as much as it's theirs.

PATSY: Well they can keep them union jack and stick it. Is only one flag I wave and that's Jamaica.

TANYA: Well I'm proud of the flag and I ain't some stupid skinhead. And if you're British, then it's your flag too.

PATSY: I ain't British though.

TANYA: Yes you are. You're as English as I am.

PATSY: No I ain't.

TANYA: Yes you are. You was born here.

PATSY: So? Just 'cause you born in a stable, that don't make you a horse.

DENNIS: So what are you then Patsy?

PATSY: You deaf. You done hear me say Jamaican already.

DENNIS: Have you ever been to Jamaica?

PATSY: Yes.

DENNIS: And did they class you as Jamaican?

PATSY: No. They kept calling me foreigner.

SCOTT: What about you Dennis? What island do you come from?

DENNIS: England. Now if you ask me where my *family* come from, then that's different. But if you ask about *my* nationality then I always say Black British.

JERMAINE: What makes you British?

DENNIS: What d'you mean?

JERMAINE: Well, how comes you're British and my Mum ain't?

DENNIS: I ain't gonna try and speak for your Mum, but I know that I'm British because I choose to be. I didn't always feel British, but I do now.

SCOTT: I don't feel British. Not really.

PATSY: And you the living Cockney.

SCOTT: I know. I can't leave London without a translator. I feel more of a Londoner than anything else. I'd rather play for me club than country. I'd have a London passport if I could.

JERMAINE: I ain't even got a passport.

SCOTT: You know who the biggest group of immigrants are? The Australians and South Africans, and no one moans about them.

SCOTT's phone rings. He looks at the caller ID, takes a deep breath and answers.

SCOTT: Hello…Hello…? Shit, they always die when you need 'em.

SCOTT runs off.

PATSY: I'm surprised you know Dennis. It's not many black man say them British. Only Frank Bruno. And look what happen to him. Poor ting.

DENNIS: I just decided that it's up to me to say who I am. I'm not gonna allow others to define me.

TANYA: Well, I'm English.

DENNIS: You can call yourself what you like. Patsy's Jamaican. Scott's starting the People's Republic of London. *(To JERMAINE.)* What about you youngblood?

JERMAINE: I ain't really thought about it. British I guess. I ain't been much places in England. Maybe I should be London innit?

DENNIS: That'll all change when you're in Manchester. You'll meet people from all over and you'll want to get out and explore.

PATSY: What's he talking about?

JERMAINE looks at PATSY, unsure of what to say.

DENNIS: *(Realisation sets in.)* I thought you told her.

PATSY: *(Ignores DENNIS.)* Told me what Jermaine? *(Pause.)* Told me what?!

JERMAINE remains silent. PATSY readies herself to leave.

DENNIS: Patsy, just hear him out.

DENNIS puts a hand on PATSY's shoulder, as if to restrain her.

PATSY: *(Controlled.)* Tek your hand off me.

PATSY exits. DENNIS and JERMAINE are left looking at each other not knowing what to say. JERMAINE exits. Three HOODIES cross the stage in the scene change.

SCENE 7

12.15pm. PATSY and JERMAINE are alone in the Courtyard.

PATSY: What have I done Jermaine?

JERMAINE: Nothing. I just wanna do my music Mum.

PATSY: You can't do that here?

JERMAINE: Even the teachers say it's the best course for me.

PATSY: There's plenty of universities in London. You don't have to go so far.

JERMAINE: I've found out…

PATSY: How long have you been planning this? Behind my back?

JERMAINE: I was going to tell you soon as I'd made up my mind.

PATSY: *(Fighting back tears.)* I can't talk about this. *(Turns away.)*

JERMAINE: Mum…

PATSY: *(Coldly.)* When?

JERMAINE: Not 'til next year.

PATSY: No. When was you going to tell me? Was I just going to come home and find you pack up and gone?

JERMAINE: I was gonna tell you.

PATSY: All this time, and me proud, like a fool. I thought I raised you better than that.

JERMAINE: It ain't like I'm gonna be gone forever. I just wanna try something else.

PATSY: Well you really showed me.

JERMAINE: I need to go.

PATSY: What about your brother and sister? Have you even thought about them? What are we gonna do Jermaine? You can't go.

JERMAINE: I'll be able to see you in the holidays. You won't even get time to miss me. I just want to make something of myself.

PATSY: You don't have to go. We can find somewhere here. Somewhere better.

JERMAINE: You ain't even hearing me! It's my life. Mine. And I wanna go. It ain't even about you.

PATSY: And I'm telling you, you ain't going nowhere!

JERMAINE: See! That's why I ain't told you. I knew you'd go on like this.

PATSY: I could have gone to college. I could've made something of myself. But I stayed. I stayed because I had you. People said I should have dashed you when I had the chance. I didn't have no choice.

JERMAINE: I didn't ask to be born. *(Pause.)* Mum, everyday here it's just the same old thing. Nothing changes. If it ain't police pulling me in for something I ain't done. It's people trying to shot drugs to me. Or some next man's hating on me cause I wanna do something with my life. I just wanna better myself. I've tried telling you, but you don't listen.

PATSY: All right then… All right, go! Go! Go about your business. We'll be just fine without you.

JERMAINE: You see. That's how I know about you. Soon as you can't get your own way you switch. Well this time I don't care. Watch me see if I can't switch too. *(Pause.)* I'm coming tomorrow to get my things.

JERMAINE starts to walk off.

PATSY: *(Calling after JERMAINE.)* Jermaine!

JERMAINE keeps on walking.

PATSY: I'm sorry. You're my little man Jermaine. What am I going to do without you?

JERMAINE stops and turns.

JERMAINE: I can't be your little man no more.

PATSY: So you don't need me.

JERMAINE goes to her.

JERMAINE: You're my mum. I'll always need you.

They embrace. They separate when DENNIS enters.

DENNIS: Look, I'm sorry… I'm really sorry.

JERMAINE: It's safe. We sorted it out.

DENNIS: You sure?

JERMAINE: Course I'm sure. I've got the best mum in the whole world. I told you that.

DENNIS: You did.

PATSY: *(To DENNIS.)* Look, I know I ain't always…

DENNIS: We're all like that at times. The most important thing is owning it. Otherwise we stay stuck.

PATSY: Oh shut up man.

JERMAINE: *(Laughing.)* Shame.

SCENE 8

1.15am. AMANDA is alone in the courtyard. She is on the bench crying quietly.

PATSY and JERMAINE enter.

PATSY: I've got to sit down, my feet are burning me.

JERMAINE: *(Points to AMANDA.)* Look.

PATSY: What happened to she? She must have seen that weave in a mirror.

JERMAINE: Mum, that ain't funny. *(Pause.)* Ain't you gonna see what's wrong?

PATSY: Me?! That bitch done tell me to stay out her business already.

JERMAINE: I'm gonna find her husband.

JERMAINE exits.

PATSY: Jermaine!

PATSY makes as if ignoring AMANDA, but after a short while gives up and goes to her holding out a tissue.

AMANDA: Thank you. *(She blows her nose and regains some composure.)*. I'm sorry about earlier.

PATSY: Forget it.

AMANDA: I mean it.

PATSY: I'm sorry too.

AMANDA: I don't normally behave like that.

PATSY: Well I do, but I still sorry.

AMANDA: I don't condone violence. I've always told my children that there's nothing that can't be solved by talking and I go and lose it. *(Appalled.)* On the street.

PATSY: Children can make up them own mind you know. So your head get a little hot. That don't make you a bad mother.

AMANDA: I suppose not. Thank you.

PATSY: As they say, duck and fowl feed together but they no roast together.

AMANDA looks at her blankly.

PATSY: Anyway…

They laugh. PATSY exits as SCOTT rushes on, out of breath, face full of concern.

SCOTT: You alright babe? Jermaine said something had happened.

AMANDA: I'm fine.

SCOTT: Well I'm glad you are. I'm having a fucking heart attack here.

AMANDA: I'm okay, don't panic.

SCOTT: I ain't panicking. I just run all the way from the van. It nearly killed me. I've gotta start football again, this is ridiculous.

AMANDA: You only used to go for the drink afterwards.

SCOTT: And the oranges at half time.

They laugh. Pause.

AMANDA: I thought you were going to leave me.

SCOTT: So did I.

AMANDA: I don't want to lose you.

SCOTT: Yeah, but do you want to keep me?

AMANDA: Who else would have you…? I'm joking. I love you.

SCOTT: *(Teasing.)* Alright, don't go mad. *(Pause.)* Look, we got to…

AMANDA: Get some help, I know. Go and see someone maybe, a counsellor or something.

SCOTT: Yeah, alright.

They hold hands. Pause.

SCOTT: I bet you're hungry now ain't you.

AMANDA: I am actually.

SCOTT: *(Suggestively.)* I've got a Crunchie in my van.

AMANDA: Oh yeah? I bet you say that to all the girls.

SCOTT: No. Only the good looking ones.

Pause.

AMANDA: Are we alright?

SCOTT: I don't know… I hope so.

SCENE 9

3.00am. Residents are scattered around the courtyard.

DENNIS: What time is it?

SCOTT: 3 o'clock.

Lights down.

SCENE 10

3.10am. Residents are scattered around the courtyard having changed positions.

DENNIS: What time is it?

SCOTT: Ten past three.

Lights down.

SCENE 11

4.00am. Residents are lying around the courtyard, snoozing, covered in blankets etc.

SFX – Police helicopter approaching. A searchlight swirls over the courtyard a few times.

PATSY wakes with a start.

PATSY: Lord God! A wha' de…?!

She goes to JERMAINE and tries to wake him. JERMAINE turns over groggily and mumbles. She moves over to DENNIS and gently shakes him.

DENNIS: *(Half asleep.)* What? What is it?

PATSY: I don't know. Take the sleep out your eyes and have a look innit.

TANYA, SCOTT, AMANDA and JERMAINE wake. All look to Walnut House, where the siege has been taking place.

TANYA: Here we go at last.

AMANDA: Are they going in?

SCOTT: No they're outside. They still got their guns pointed at the door.

PATSY: It's time they just done this ting!

TANYA: Oh look! Someone's coming out.

DENNIS: It's a woman!

PATSY: She don't look like no hostage. Look how she's laughing.

AMANDA: I think she's crying.

TANYA: You don't think it was a domestic do you?

JERMAINE: Nah. She ain't beat up or nothing.

AMANDA: At least she's safe now.

SCOTT: This must be him now, look. He's got his hands up.

PATSY: That little, little piece of a man?

SCOTT: Well, they ain't taking any chances. Look how many of them have steamed into him.

PATSY: If I did know him was one little magre something. I would a just bus' in there and rush him with my heel bottom from time. Siege done!

DENNIS: Size don't matter when you've got a gun in your hand.

The Police helicopter is heard receding. It goes. Pause.

JERMAINE: Is that it then?

DENNIS: I suppose.

Music starts. TANYA and JERMAINE nod goodnight. TANYA gets bag and exits. JERMAINE goes to his bag and puts on his headphones. AMANDA gets her handbag and gestures for SCOTT to pick up their shopping. They exit. PATSY indicates to JERMAINE fold up his blanket. DENNIS and PATSY say an awkward goodbye. PATSY exits. DENNIS turns to JERMAINE who, busy with the blanket, doesn't see him. DENNIS exits.

PATSY calls from offstage.

PATSY: Jermaine!

JERMAINE exits.

The End

MARY SEACOLE

SuAndi's *Mary Seacole*: A Hybrid Cartography in Libretto

SuAndi's *Mary Seacole* (2000), a two-act libretto, is centered on three pivotal events: Mary Seacole's Jamaican and Creole background and her education (by her mother) in local medicinal practices and knowledge; her growing awareness of her racialized and gendered position when she crosses the borders of the empire to offer her services as a nurse in the Crimean War and becomes estranged from both her colonial and British identities; and her encounter with Florence Nightingale, the Victorian icon to which she is represented as a foil against which she resists with her adventurous and entrepreneurial spirit. SuAndi, a performance poet whose work has 'expanded into diverse locations from galleries to public artwork,'[1] rewrites and, thus, remaps the story of Seacole as retrieved from her autobiography, *Wonderful Adventures of Mrs. Seacole in Many Lands* (1857).[2] The libretto form that SuAndi uses hybridizes the narrative history of Seacole's autobiographical text and creates affiliations between genres, narratives and cultures. SuAndi wrenches Seacole's voice from her autobiographical narrative and thrusts it into a radically different genre, to enable Seacole to be represented before a different audience to that of her autobiographical text. A libretto that relates and combines musical and narrative structures from the Western, Caribbean and African traditions, *Mary Seacole* translates autobiography into intercultural narration. Seacole's singular voice becomes a singularity that represents the conflicts and politics of a hybrid and hyphenated identity, and Seacole's double heritage

[1] See the author's profile at <http://www.lancs.ac.uk/fass/projects/writersgallery/content/SuAndi.html>

[2] All pages from the text refer to the original edition as reproduced by the Project Gutenberg eBook of Mary Seacole's *Wonderful Adventures of Mrs. Seacole in Many Lands*, at <http://www.gutenberg.org/files/23031/23031-h/23021-h.htm>

of Caribbean and Scottish origins creates questions around community and belonging.[3]

The first four scenes of the first act of SuAndi's libretto delineate Seacole's family and particularly the social, historical and cultural details that constitute her heritage, her Creole identity and the education she receives from her mother, Mrs. Grant, a healer of her community who bequeathes to her daughter the skill to 'nurse and care' (Act 1, Scene 3 & 4). In the first scenes of Act 1 (Scenes 3-5), Mrs. Grant teaches Seacole the mixing of herbs, which is the 'best schooling' her daughter will ever get. The use of Calypso music that accompanies this act of a mother passing on her knowledge and practice to her daughters alludes to the intercultural origins of the Caribbean diaspora, its African and creole traditions, memories and practices and their dense network of epistemologies and aesthetics. The obeah skills represented here as the medicinal knowledge and practice that arises from Mrs. Grant's attachment to her land and its herbs, and the Calypso music as the heritage of the larger African diaspora, represent a different understanding of epistemology and aesthetics to the western discourses that represent the world of the diaspora as a world of coloniality that can only be enlightened by the West and has nothing to offer. In this economic representation of Seacole's colonial upbringing, SuAndi deconstructs the myth of the colonial communities as the world of darkness and backwardness and shows how it is a world of different knowledges and aesthetics by expounding on what takes up minimal space in Seacole's autobiographical (pre)text. SuAndi represents Seacole's Creole origins, and her mother's experience of the politics of racism that forge the present and future possibilities (and limitations) in detail in order to draw the richness of a world often forgotten and defied as the colonized space that can be made useful only

[3] For an analysis of the role of Mary Seacole's autobiographical text as one of the first narratives by black women see Joan Anim-Addo's '*The Black Woman as Subject and Object in Britain from 1507*'; for an analysis of the controversial politics of her narrative and Mary Seacole's representation of her Scottish origins and her underplaying of her hybrid identity, see Giovanna Covi's '*Footprints in the Sand*' and Joan Anim-Addo's '*A Brief History of Julian "Lily" Mulzac of Union Island, Carriacou and Grenada: Creole Family Patters and Scottish Disassociation*' (2007b).

through its systematic exploitation. SuAndi portrays the seminal significance of the colonial heritage as the network of enabling knowledges and practices that help Seacole travel beyond her boundaries and, hence, transform the imperial cartography that regulates her world and her being as the periphery. With the power of these knowledges and practices, the gift of her mother and her land, she insists, 'I am no beggar I am a dutiful healer' (Act 1, this volume). To a world that is constantly rejecting and deriding her, Seacole responds with care and responsibility for those who are in need, independently of their class, race and ethnic origins. These acts of care and responsibility for the world make Seacole a cosmopolitical, rather than cosmopolitan, subject: a subject whose travelling inscribes her in the world to whose political and historical troubles she responds with a political and social responsibility. SuAndi here performs an interesting counter-representation of the cosmopolitan woman traveller of the Victorian times: Seacole is afflicted by the others' affliction as she cannot afford to resort to the comfort position of a disengaged traveller. Neither her race, nor her class can allow for such a position of luxury and comfort. Seacole inhabits the discomfort zone of a gendered and racialized subject who treads water to prove that she is equal to the ones who reject her, even if they refuse to acknowledge so throughout her life. SuAndi thus accounts for Seacole's historical silencing by the official discourses of the imperial nation that monumentalize the Victorian lady, Florence Nightingale, while forsaking Seacole's parallel path as a hybrid woman of and in the Empire.

Seacole and Nightingale's encounter (Act 1, Scene 7), which does not occur in Seacole's autobiographical text, is at the centre of SuAndi's libretto. This important scene stages the two women together addressing the audience simultaneously, two soliloquies of two singularities whose lives are affected by the forces of the Empire from across the two different positions of the imperial cartography, namely, of centre (the metropolitan culture) and periphery (the colony). Parallel as their soliloquies are, the two women do not address each other. There remains between them the absence of an interactive and dialogic relationship that bewilders Seacole in her autobiographical text when she recounts

the scene when Nightingale rejects the offer of her services without any really good excuse. This unaccountable rejection that initially silences Seacole symptomatically represents the historical forgetting of Seacole's text – until its republication in 1984) – and, with the passing of time and the diminishing of her word-of-mouth fame,[4] her social and political contribution to the work of the Empire through her medical treatment of soldiers in the Crimean war. These first five scenes demonstrate the hybrid, Creole background and accentuate the diasporic culture of the Caribbean, its intercultural and counter-hegemonic formation against the imperial mapping of an Englishness gone global.

The concurrent performance of their soliloquies, with the one succeeding the other, does however give that silence a voice; the gap between these two women is laden with the one's 'astonishment' (this volume) at the recognition that she is rejected on account of her being a 'yellow woman' and therefore not the 'lady' fit for the role of the nurse, and the other's disapprobation of the 'heathen' and 'unclean' grounding of Seacole's creole identity (this volume). Although not conversant with each other, the two women are represented in a disjunctive and discontinuous but nevertheless powerful affiliation; their bond is constituted by the imperial network that binds their cultures in structures of dominance but also interdependency. Despite their incommensurable differences, they share another condition, that of their gender role that these two women, each in her own manner, transform by way of performing or destabilising its mandates. They cross the borders of the Empire and the domestic boundaries that befit the women of their times, the one to be a heroine Yellow woman and the other to be an English lady who upholds and sustains the morality and values of her Englishness in the remote borders of the Empire. They thus share the need to

[4] For a comprehensive description of the history of the text and the significance of the academic attention it has been receiving since its republication in 1984, see Sara Salih's ' *"A gallant heart to the empire." Autoethnography and Imperial Identity in Mary Seacole's Wonderful Adventures.*' See also Helen Rappaport's '*The Invitation that Never Came: Mary Seacole after the Crimea*' for a meticulous analysis of how Mary Seacole's achievments were forgotten after her return to London by Queen Victoria and her entourage; despite Seacole's contribution to the Empire as a 'loyal colonial subject who endorsed the values of empire and revered the Queen'. Victorian society cannot see in Seacole what they see in Florence Nightingale, a 'lady' (p.14).

reaffirm their identity by way of acting away from home, albeit within its range. Seacole wishes to play the role of the mother, a different (because yellow) mother who can still heal and nurture the soldiers of the nation. Nightingale insists on the salvaging of a certain kind of Englishness against the threatening expanse of the imperial space contaminated by the heathens, natives and locals. Seacole and Nightingale's anxiety about finding or losing their identity reveals the 'conflicts and contradictions' generated, as Ian Baucom argues, by the reconfiguration of the English identity and its racial redefinition of Englishness that 'meant that Britishness, at least as a legal concept, has to become as elastic as the nation's imperial boundaries' (Baucom 1999: 8).

SuAndi's staging and writing of the encounter that never happens points to the aporias of Mary Seacole's autobiographical text. Seacole's conflicted and complex affirmation of her hybridity generates aporia in her text that relate to Seacole's social and political awareness of the politics and institutions of racism and orientalism. Her initial response to her color while visiting London for the first time, 'I am only a little brown – a few shades duskier than the brunettes whom you all admire so much' (Seacole 1857: 4), develops in her travels when she slowly becomes aware of how the Americans she meets on her way back from Panama to Kingston see her as a 'nigger woman' (Seacole 1857: 40) and force her to disembark the American steamer that would carry her to Jamaica. When affronted by their racist treatment, Seacole interestingly enough distances herself from her autobiographical self and becomes a third person in her narrative, 'I cannot help if I shock my readers; but the *truth* is, that one positively spat in poor little Mary's frightened yellow face' (Seacole 1857: 40). Seacole here represents herself in terms that invoke the racist representations of black men and women as children, that is, as emotionally and intellectually undeveloped and immature subjects, even worse as adults doomed to be treated as children because of their presumed natural depravity. Such thinking was advocated by a number of European and American philosophers to redeem the violence of racism and the slave trade and to support (or underwrite), the colonisation of Africa, the West Indies and the New World.

Seacole's detachment from the autobiographical self, who affirms her position and praxis as a nurse and woman of action

through travelling, and the representation of her position above, as a 'poor little' child, reveal the conflict in her awareness of her being the object of racism. This of course does not stop Seacole from seeing the Orient through the eyes of a representative of the Empire. The Pacha, as the symbol of an Oriental Empire, is represented as the most civilised of the so-termed Orientals, a shadowed alter ego of the British imperial mind. Impressed as she is by his efforts to sustain an Anglo-Turkish alliance by collaborating with the English army and facilitating the work of the British Empire in the Orient, she represents the Greeks as the fallen Oriental subject. They boycott the Pacha's enterprises, forgetting that they are the negroes of the Ottoman Empire, the colonised subjects.

In SuAndi's libretto, Seacole is fully aware of her racial and class position by the end of Act I, after her rejection by Nightingale and the powers that be. Her anger at the Englishman that is vented through what reads like an incantation, 'Dam the Englishman, Dam the Englishman (Act I, Scene 8, 20-21 this volume), awakens her to her cause. If she cannot serve the Englishman, she will serve the man, the everyday man, everyday soldier on the frontline. In Act II, Seacole turns her attention to 'the many of the ordinary men/The lower ranks (Scene 4, this volume) who could not be attended in Nightingale's hospital, located hundreds of miles way from the front line. Seacole thus transforms her position as a subject whose racial and class origins do not befit the imperial project abroad and at home; the reasons on the account of which she is rejected become the opportunity for her to reconfigure her relation to the world through affiliative connections that break the class, race, and gender binaries.

SuAndi's rewriting of Mary Seacole's history and story performs a double task: it rewrites the history and story of Mary Seacole's autobiographical text by colouring and accentuating the pauses and silences sedimented in her narrative. Her Mary Seacole is not a better and more historically accurate Mary Seacole, but an other-ing voice, free to celebrate its mobility, speak across cultural boundaries, share her grievances and desires and imagine the world *other*-wise by crossing and travelling it in tune with her different but compassionate song.

<p align="right">Mina Karavanta (University of Athens)</p>

Mary Seacole was premiered at the Linbury Studio of The Royal Opera House on 3 October 2000, produced by Gyenyame for Performing Arts. The cast were as follows:

WILLIAM RUSSELL, Ian Jervis
MARY SEACOLE, Hyacinth Nicholls
MRS. GRANT/AFRICAN WOMAN, Bianca Campbell
MR. GRANT/CAPTAIN/SOLDIER, Nicholas Garrett
LOCAL MAN/MONSIEUR JULLIEN, Wills Morgan
FLORENCE NIGHTINGALE, Caroline Leeks
OFFICER/SOLDIER, Jeremy Birchall
PAPERBOYS, Omar Davis, Gavin Mark, Tamer Mostafa, Leslie Owusu-Appiah, Tristan Rankine, Michael Fenton
The children by kind permission of Southfields Academy.
SERGEANT/SOLDIER, Ron Samm
SOCIETY LADY/NURSE, Helen Gasztowt-Adams
SOCIETY LADY/NURSE, Helen Astrid
YOUNG MAN/SOLDIER, Andrew Clarke
YOUNG GIRL, Davina Wright
NURSES, SOLDIERS, SOCIETY LADIES AND GENTLEMEN, Pro Musica Chorus
Bagpiper by association with International Highlander Glen Gordon

Composer, Richard Chew
Conductor, Richard Chew
Repetiteurs, Julia Richter, Jonathan Gale, Annette Saunders
Violin one, Steve Morris
Violin two, Eloise Prouse
Viola, Rebecca Chambers
Cello, Robin Thompson-Clarke
Double bass, Charlotte Hooper-Greenhill
Flute/piccolo, Susie Hodder-Williams
Clarinet/bass clarinet, Graham Casey
Trumpet/flugelhorn, Oliver Preece
Horn, Richard Ashton
Percussion, Tim Gunnel

Director, David Edwards
Producer, Larry Coke
Production Manager, Alison Fellows
Assistant Lighting Designer, Guy Hoare
Choreographer, Jackie Guy
Costume Supervisor, Rosie Gwilliam
Wardrobe Assistant, Lee Croucher
Company Stage Manager, Pam Alien
Deputy Stage Manager, Annabel Busher

Characters

Act One cast in order of appearance

RUSSELL – William H Russell

SEACOLE – Mary Seacole

MRS GRANT

MR GRANT

LOCAL JAMAICAN

SOUTH AMERICAN

GENTLEMAN

NIGHTINGALE

OFFICER

Supporting cast in order of appearance

CHORUS

WOMAN

First man

Second man

Non-singing cast

Frocked doctor taken from chorus

Act Two cast in order of appearance

FOUR PAPERBOYS

WILLIAM H RUSSELL

CAPTAIN

SOLDIER

FOUR FOOTMEN.

FIRST WOMAN & SECOND WOMAN
(THE 'GOSSIPING WOMEN')

CLUSTER OF WOMEN.

MARY SEACOLE

THE DUPPIES [1]

SOLDIER ONE

SOLDIER TWO

SOLDIER THREE

GROUP OF SOLDIERS

THIRD WOMAN

SOLDIER FOUR

SOLDIER FIVE

SOLDIER SIX

SOLDIER SEVEN (CAPTAIN PEEL)

MONSIEUR JULLIEN

WILD AFRICAN WOMAN

NURSE ONE

NURSE TWO

YOUNG MAN

BOY

JAMAICAN GIRL

Supporting singing-cast in order of appearance

WOMAN

First man

Second man

Choir

[1] Duppy is a Jamaican Patois word of Northwest African origin meaning ghost or spirit. SOURCE Wikipedia.

Mary Jane Seacole (née Grant)
by Albert Charles Challen, oil on panel, 1869

ACT ONE

SCENE ONE

The Crimean.

Smoky dark stage, man sits at a camp table & lights an oil lamp. He begins typing and reads aloud as he works.

RUSSELL: This is William H Russell Special Correspondent in the theatre of war of 1856 and we fight an enemy who knows no limits.

Indeed, he is a fool with no regard to the danger.

We do not honour him; we honour and respect only those who have joined the battle, the men at arms.

Readers the battle is fierce, the suffering enormous, the Queen's sons are brave but not invincible.

The battlefield is awash with blood, who could not weep at the sight?

Miss Nightingale has established her hospital away from the action, it is not enough.

You, in the comfort of your homes, please give what support you can.

Linen for bandages, hand knitted socks for warmth and your prayers to help end this devil of a war.[2]

Battle sounds and groans getting louder until it becomes a human hum.

CHORUS: Mother help me.
Oh God, Oh God.
I don't want to die.
My leg, where is my leg?
I'm blind I can't see.

[2] William Howard Russell (28 March 1820 – 11 February 1907) was an Irish reporter with *The Times*, and is considered to have been one of the first modern war correspondents, after he spent 22 months covering the Crimean War including the Charge of the Light Brigade. SOURCE Wikipedia.

SET – a warm glow begins in the centre of the smoke, like a fire beginning to catch light.

WOMAN: *(Off stage.)* –
 There my son, there.
 Let this ease you
 So you can sleep.

FIRST MAN: I'm so cold.
 So cold.

WOMAN: *(Off stage.)*
 Here is my hand son.
 Here take my hand.

SECOND MAN: Is that you Mother,
 Is that you?

SET – SEACOLE steps into the light stage left as frocked doctors dash about calling out orders spoken by the chorus.

CHORUS: –
 Bring me bandages.
 Some rum.
 A saw.

SEACOLE tries to catch their attention and then facing the rising dawn she speaks to the heavens.

SEACOLE: I tried to volunteer.
 They rejected me.
 Ms Nightingale humoured me.
 But still I came full steam and independent
 And now like a beggar seeking alms
 I try to catch their attention.
 I am no beggar I am a dutiful healer
 And that is what I came to do
 And will do.

SET – SEACOLE turns up stage and walks slowly into the smoke of the battlefield calling out.

SEACOLE: –
> I am here my sons.
> I am here
> *Off stage voices cry out her name.*

CHORUS: Mother Seacole,
> Lord Bless you
> Mother Seacole.

RUSSELL: *(Spoken.)*
> One woman, steadfast, determined
> And independently resourced
> Eases the moral, physical wellbeing of the men.
> They call her 'Yellow Woman'
> But her colour matters little,
> Her origins are of no interest.
> Ladies and Gentlemen I
> Give you the life of Mary Seacole,
> *Sung.*
> Mother of our men.

SCENE TWO

Jamaica.

Interior of SEACOLE's parents house

The grey tones of war are replaced by the warm orange of a tropical climate. A heavyset man approaches the table covered with a white cloth and as he sits, he calls out to Mrs Grant his 'Wife'.

SEACOLE enters stage right sits by his feet as a child.

GRANT: Girl, girl
> Can you no see me sat here?
> With my belly groaning.
> How many times have ah to tell ye
> The way to a man's heart
> Is through his belly.
> A body canna love without fuel
> And food is the fuel.

A smiling Black woman (MRS GRANT) carries a plate of food across to him. MRS GRANT brushes her hand across his head and he almost unconsciously pushes away her gesture of tenderness to turn all his attention to the plate before him.

GRANT: You can cook,
 I give you that.
 Aye and you can look after a man
 After dark too,
 That so you can.
 He rubs his stomach satisfied and she immediately clears the table. He stands using the white cloth as a napkin to wipe his mouth.

GRANT: Fare de well lassie I'm going home.
 Fare de well lassie my orders have come.
 And I know you will weep and aye you might cry
 But take it from me this is goodbye.
 I've nothing to leave you but memories
 And hope (you) no regret your time with me
 You're a Creole woman no young but you're strong
 So go catch ye a nigga and make him your man
 He throws the white cloth at her and turns stage left falling into the band's military march that has taken up the rhythm of his singing.
 SEACOLE the 'child' stands takes the tablecloth and wraps it like a shawl around her head and shoulders.

 The military tattoo begins to play out indicating the increasing distance of the departing army GRANT marches on the spot facing stage left SEACOLE moves towards him.

SEACOLE: See how he goes steadfast and strong
 A soldier and a gentleman of him I am so proud
 He was my father though he never stayed
 He was my father though he went away
 When I am careful of money in my hand
 I think of my father that sure and canny man
 I am his daughter though he never knew me
 I am his daughter I am sure he would be proud of me

MRS GRANT now takes up the tattoo but bringing to it the tilt of calypso. SEACOLE the 'child' hands the table cloth back to MRS GRANT and leaves stage right.

MRS GRANT: –

So yuh pack up and leave mi

Deafh to mi cri

Yuh never tel mi yuh love mi

Mi nev'r hear dat lie

Yuh jus pack up and leave mi

Kiss the air goodbye

Kissing her lips MRS GRANT stands and turns upstage. Her body rocks to the closing notes of music as she rolls the cloth and holds it cradled in her arms.

SCENE THREE

Jamaica.

Exterior of SEACOLE's parents house.

A local man enters he is clutching his stomach causing him to almost hop into the room. It is obvious he is in pain but he is also excited indicated by his gesticulating. His dress though poor also indicates his life role of a bit of a wag.

LOCAL JAMAICAN: Sistah Nurse mi need yuh bad-bad.

Mi belli bawling like it fire

An' as soon as mi stand so, mi must sit.

Feel like mi dun lost half mi stomach already

and if yuh no fix it quick,

into the latrine the whole of mi body will go.

MRS GRANT only turns her head.

MRS GRANT: Wat yuh drink?

LOCAL JAMAICAN: Rrrrrrrr. Rhum

Sistah Nurse,

but don't cuss mi

De whole island is afire wiv excitement

Now de army dun gwan.

> Wat dey brings nuthink.
> Wat deys do nuthink.
> Wat dey leaves nuthink.
> Gawd save Jamaica an' dam de King.

MRS GRANT: Noh soh quick wiv yuh mouth
> Some leave someting
> Look here see dis
>
> *She holds out her arms that carry the cloth now rolled into baby swaddling.*

LOCAL JAMAICAN: Gad Sistah Nurse
> yuh gon got yuh a yellow child
> Who will nurse folk?
> whilst yuh breed dat

MRS GRANT: I muss give her up
> But only short-short time.
> Den from mi she will learn
> De herbs and secrets to cure,
> So stupid men like yuh
> Caan ruin dire bellies
> Until they run as fast as yuh mouth.
>
> *She lays down the cloth and turns her attention to the man*
>
> *The light dim. SEACOLE the 'child' picks up the cloth moves out of the ever dimming lights to stage left and begins to rip the fabric into uniform lengths.*

MRS GRANT: *(She repeats herself.)*
> I muss give her up
> But only short-short time.
> Den from mi she will learn
> De herbs and secrets to cure,
> So stuupide men like yuh
> Caan ruin dire bellies
> Until they run as fast as yuh mouth.

She gives him a potion and he swallows it eagerly then she turns her attention to the baby leaving stage left.

The man crawls into a small ball, centre stage front and closes his eyes to sleep.

SCENE FOUR

Jamaica.

Seconds on he rolls over, opens his eyes, stretches and yawns, patting his belly with satisfaction.

LOCAL JAMAICAN: Mi fel good an' mi promise
 Nevah to fel badd aging
 Mi fel good and mi promise
 Nevah to fel bad again
 No more rhum an' wimmin
 No more rhum an' wimmin,
 Lawd!
 No more rhum an' wimmin
 He rubs his head looking puzzled.
 But I is a man who does need to take
 A lickle rhum fi mi old health sake
 For mi back it do ache
 And mi bones dey do creak
 And without any rhum
 mi go dizzy and weak
 But if de brew be badd
 Den mi belli explode
 So no
 No more rhum an' wimmin
 Lawd
 No more rhum an' wimmin
 He nods his head trying to convince himself.
 Mi a simple mhan and mi needs are de same
 Fi de odd night mi need a woman to lay
 At mi side to ease de pain of de life

So I should get mi a wife but den she a breed
An' make more mouth fi mi to feed
Dey will demand more an' more
An' den no more rhum for sure
Lawd
no more rhum for sure

MRS GRANT returns stage left.

LOCAL JAMAICAN: Dere a fine woman over der
See de skill she has to nurse and care
From simple herb she mix an' boil
She do stop mi belli painful roar
Maybe someting she could Obeah
To stop mi belli play bad on mi
Den I'll still have rhum an' wimmin
Lawd
I'll still hav rhum an' wimmin

The man performs a little dance it is almost lewd then suddenly he grabs his stomach with one hand, with the other obviously grabs his bottom, and runs exiting stage right.

SCENE FIVE

Jamaica. Exterior SEACOLE's parents house

MRS GRANT is intent on mixing brews, periodically she halts to peek at the baby, whisper to it and kiss it.

Orchestra plays intro bars of 'Yellow Bird' [3] *before MRS GRANT starts to sing*

MRS GRANT: Yellow Bird up high in banana tree
Yellow bird yuh sit all alone like me
Did your lady frien'
Leave de nest again
Dat is very sad

[3] 'Choucoune'(Haitian Creole: *Choukoun*) is a 19th century Haitian song composed by Michel Mauleart Monton with lyrics from a poem by Oswald Durand. It was rewritten with English lyrics in the 20th century as 'Yellow Bird'. SOURCE wikipedia.org

Make yuh feel so bad
Yuh can fly away
In the sky away
Yuh more lucky dan mi.

MRS GRANT laughs to herself, takes up the child tucking it into the bone of her hip and binding it there with cloth so her hands are free to continue her work.

SEACOLE who has been watching everything from the sidelines now moves closer so that she can see exactly what MRS GRANT is mixing.

MRS GRANT: Take dis herb and mix just soh
Watch mi Mary Jane
For dis is de best schooling
Yuh will hever get
Jamaicans are proud
But de world she ist cruel
Even to ah baby as yella as yuh
If yuh life to prosper
To make it better dan dis
Take heed of wat I teach
For over der place
Where travel yuh go
The Obeah skill is de best to know.

SEACOLE sing in reply directly to her mother.

SEACOLE: –
That's how your doctrine became mine
I listened, watched
The herbs you prepared
The poultice you blended
As people gathered for your cures
I too took my patients
First the doll, silent to my care
Then cat, dog or a lizard I might catch
Practice over error to reach perfect
And make ready in 1850 for that whore

Cholera
Men fell of all classes
Jamaican Natives, Creole, and Black
And my precious 97th infantry
They had surgeon skills but some things they lacked
So I gathered your herbs together
Knowing soon there'd come the call
To doctrine officers and lower ranks of men
To banish out that she devil
And restore their constitutions good again
Your spirit burns anew in me
So I am at pains to nurse all suffers
And banish their misery.

SCENE SIX

South America.

A local South American man walks across the stage carrying a small bundle.

He begins to chant 'Cholera' a cappella then he starts to hum at a higher pitch hum

SOUTH AMERICAN: Cholera is a killer
Cholera will take them all
Take your mother and your sister
Kill a baby barely born
Cholera is a killer
Kill a child that's part way grown
Take your father
Take a brother
Cholera will take them all.

SEACOLE: Give me the child that you carry
before you lay it in its grave
If I might see death's first face of glory
I might discover how to stop the killer plague

SOUTH AMERICAN: –

Will you cut it?

SEACOLE: I must cut it

But think how many I might then save

SOUTH AMERICAN: –

This is a child

SEACOLE: No.

No, it's just a body

And for life

Sacrifices must be made.

SEACOLE turns away cradling the child's corpse in her arms then she lays it on the ground and kneels beside it.

SEACOLE: Soft skin

Soft skin

Is it right

what I'm doing?

It must be right

What I'm doing

Hold the blade steady

Then cut, snip, pull back the skin

This heart small,

In death so swollen

Cut, snip, pull back the skin

I see yellow to the core

Poisonous infliction on rich and poor

Like a rat spreading vermin

Like a hunter trapping prey

Here in this baby I see the ruin

Now cholera you will pay

Stitch. Stitch. Stitch. Stitch.

Small and dainty.

For this child I stitch

SOUTH AMERICAN: Is it is done?

SEACOLE: It's over for him

My need is done

SEACOLE bows her head and then turns her face towards the sky before reaching down to pick up the corpse and hand it back to the SOUTH AMERICAN man

I will never wash away his memory
As so easily, I will wash away his blood
Take him now to a place restful
Take him and bury him as though a prince
He has been a martyr to my learning
And to the whole of medicine
I have no cure but better understanding
And some day of cholera we will be rid.

She wipes her hand on the now bloody white cloth. A GENTLEMAN appears wearing a monocle, which he uses to peer closely at the sight. In his left hand he holds a walking cane, which he uses to address SEACOLE.

GENTLEMAN: Good God woman, what is this savagery?

SEACOLE: I believe it is called an autopsy

GENTLEMAN: You would cut a child M'arm.

SEACOLE: It is dead sir,
 I do it no harm
 I only wish to see an end
 to the pestilence of
 Cholera, cholera, cholera.

The stage pitches into darkness.

SCENE SEVEN

The Crimean, and London, England.

RUSSELL is sat at his desk typing, the desk lamp is the only lighting on stage.

There are four or five chairs in a line to indicate a waiting queue of women to be recruited by NIGHTINGALE.

RUSSELL: *(Spoken.)* 14th November 1854. Post-battle conditions at Balaclava and Inkermann are almost too demonic to tell. Those men injured by the vile Russians now lay awaiting

death by the shipload, heading to the hospitals at Scutari where their only hope is a quick passing from this life to the next. The injured are so many that hands cannot begin to tend their needs. '*I was sick and ye, visited me*'. But who will visit these shores where the death sits upon the shoulder of those who can barely breathe life into each new day.

NIGHTINGALE enters stage left and walks down stage. She is agitated appearing to start walking about but she remains on the one spot.

The stage is fully-lit to indicate the scene has now shifted to England.

Three uniformed men are milling about.

NIGHTINGALE: They must be clean
 They must be sober
 They must be dedicated women to the task
 No fat dames of fourteen stones or over
 The provision of bedsteads is not strong enough.
 For fifty thousand soldiers
 I too need an army
 Of women capable of care
 To nurse the wounded
 Not weep for the dying
 For weeping is a weakness
 I will not bear.

NIGHTINGALE takes the seat RUSSELL has vacated at the table.

SEACOLE enters stage right, walking upstage left turning towards NIGHTINGALE.

SEACOLE: And visit I did.
 Eager and naive
 Carrying upon my person testimony of my skill
 Her peculiar fitness, in a constitutional point of view,
 For medical attendant, need no comment.
 And so I was received in silence
 With eyes full of astonishment.
 That my skin should surprise them
 Was only as I had expected

Not black as Negro but brown and not dark
But surely not a sight to shock.
Some never even saw this one who in time to come
Would carry with pride the name Mother
Crimean heroine Yellow Woman.

SEACOLE sits on one of the row of chairs and makes as to write a letter.

SEACOLE: Dear Secretary at War
I write to offer my skills in medicine
What I am apt to call doctrine
There are many who can pledge to my ability
Please find enclosed a few of their testimonies

One of the uniformed men rips a letter into small piece tossing the paper into the air.

SEACOLE: What time I wasted on the postal services
What intelligence I lacked for I never realised that
My letters were directed to bin.

NIGHTINGALE: Fourteen women rallied to the call.
Fourteen volunteers,
Good God Why isn't there more.

NIGHTINGALE gathers her papers together still in an agitated manner and leaves the stage.

SEACOLE: Remembering the stamina of my Scottish father
I never wavered from my goal
That the Secretary at War might ignore me
Failed to deter me
So to the Quartermaster-General I made to implore.

SEACOLE again sits to write.

SEACOLE: Dear Quartermaster-General
I write to offer my skills in medicine
What I am apt to call doctrine
There are many who can pledge to my ability
Please find enclosed a few of their testimonies

Whilst SEACOLE has been writing an OFFICER has arrived on stage moving the table to stage right he sits and begins to open and then

discard letters. His action with one in particular is deliberate. He listens with his head to one side and a barely hidden grin on his face. When SEACOLE has finished he stands and with his hands clasped behind him addresses her directly

OFFICER: You want to go to war madam.

Are you sure madam?

This is the army madam.

We do not recruit women

SEACOLE walks to indicate a distance travelled finally sitting again on the row of chairs. Her back is very straight.

NIGHTINGALE pushes the officer to one side and takes his place at the table, which is now centre stage. She is singing while as she settles herself.

OFFICER: You want to go to war madam.

Are you sure madam?

This is the army madam.

We do not recruit women

NIGHTINGALE: We have to do what we need to do

For war has its own demands

We need to care for every man

do the best we can

And my standards are always English

as lady I'll always be

Any tardy and sluttish behaviour

will have to deal with me

Cleanliness, I demand only cleanliness

I want no heathen practices on my wards

Ban all the natives

They only come to steal

If they are local to the land

They are not wanted here

It's English soldiers we heal

It's only English soldiers we'll heal

So we are set to do what we need to do

for war makes its own demands

And I offer a balaclava of comfort
for every wounded man
We came to save the English
Only the English soldier
It's what my birthright commands
I light my lamp to guide the way
For the wounded English man.

NIGHTINGALE rises and walks upstage right gazing into the distance. She speaks to herself.

NIGHTINGALE: If my arithmetic does not fail me.
This is a bloody equation indeed,
Twenty thousand soldiers wounded
and I have only thirty-eight nursing trainees.

NIGHTINGALE returns to the desk resting her chin in the palm of one hand. SEACOLE rises and slowly walks towards her to lightly touch her on the shoulder saying.

SEACOLE: *(Spoken.)* Miss Nightingale.
You seemed to be daydreaming

NIGHTINGALE's posture is immediately rigid and composed.

NIGHTINGALE: *(Spoken.)*
I can ensure you madam that wasn't the case.
Have we been introduced?
What you see here, are all the horrors,
The scavenges of war.
Men are dying;
I have no time for social entertaining.
Madam,
Is there anything more?

SEACOLE: From you, oh no.
From you, oh no.
I do not berate you;
For in truth I do respect you
But I wonder what you see
When you see the colour of me.

Healing is not your monopoly
Like death, it is a human reality.
You need not dismiss me
I am free like you to go
But do not be fooled
By this retiring
For it is to the battlefront I go.

NIGHTINGALE: Madam I choose to ignore your insolence
For you say you need a place to sleep
The laundry in there
Is a woman who space for you will make.
I have no time for petty quarrelling
I know my place
I suggest that you learn yours
For though a nurse
I am still a lady
And on that,
I choose to end this discourse.

NIGHTINGALE walks towards SEACOLE pausing for a moment then sweeps past her with a flourish of her skirts to talk with one of the uniformed men. He acknowledges her with a salute. He then obviously turns his back to SEACOLE giving his full attention to the clipboard in his hand

OFFICER: Officer Cromby,
Lieutenant Smyth,
Lady Bartholomew,
Miss Price,
Elizabeth Henry,
First Sergeant York,
Servant girl Mary,
Common maid Ann,
Mrs Henry Norman.
Sorry we have taken all we can.
Anyone who is still waiting
You may leave

Wait no more.

The Quartermaster thanks you for your intention

But we have enough for this war

Laughter follows his announcement, he now looks directly at SEACOLE.

OFFICER: Madam!

SEACOLE: Sir!

OFFICER: You want to go to war madam.

Are you sure madam?

This is the army madam.

We do not recruit women

OFFICER marches off his laughter is audible.

SCENE EIGHT

Dockside.

SEACOLE is sat on a trunk looking dishevelled

SEACOLE: Then I shall sail by any means

I would walk t'is sorrow I cannot fly

But I will arrive there by and by

I am not defeated by rejection

It serves to heighten my determination

Of this one thing I am sure

SEACOLE stands and storms forward to centre stage then back to the table turns and bangs her fist on it.

SEACOLE: Damn the Englishman

Damn the Englishman

Who do they think they are?

See how they look at me

Am I such a sight to see?

I am a Jamaican born free

These hands can cure illness

These lands have yet to see

This mind can make remedy

Their doctors will beg know from me

Damn the Englishman
Damn the Englishman
As they turn from me
My sweet men of 97th and 48th infantry
Defend England's territory.
I'm pledged to nurse the ailing
To doctrine any who have need of me
This is my fate and my destiny
Damn the Englishman
Damn the Englishman
Damn the Englishman
Damn the Englishman

Loud crashing sound like cannon fire the stage is blacked out.
Interval.

ACT TWO

SCENE ONE

Crimean and London.

As the audience returns to their seats, sat at each theatre entrance is a young ragamuffin hawking newspapers. They ignore the women and reject the men who cannot proffer a farthing in order to buy.

On stage with their back to the audience stand a Captain and regular soldier, their smoke is settling in front (far back) of them.

RUSSELL is madly typing at his desk.

PAPERBOYS: Only a farthing sir,
> Only a farthing.
> Get your paper Sir
> Only a farthing.
> The Turks are defeated sir
> And the Russians are running,
> Read about the Crimean victory sir,
> Only a farthing.

The hold up their sheets for the audience to see as they walk through the theatre towards and over the stage. They speak.

FIRST PAPERBOY: *(Spoken.)* We'd be better off boy outside
> There they 'ave a better class of audience.

SECOND PAPERBOY shoves another boy, he staggers backwards as he recovers he starts to dance a jig, and the others begin to sing.

PAPERBOYS: Old King Cole was a merry old soul
> And a merry old soul was he
> He called for his pot and he called for pipe
> And he called for his fiddlers three [4]
> The Russians are dead and the Crimean is red
> From the soldiers who paid the price
> For daring to anger the English might

4 'Old King Cole' is an English nursery rhyme.

We flattened them just like lice. [5]

PAPERBOYS jump about then stamp their feet four times before running from the stage.

RUSSELL begins to hum and speak the original version of King Cole allowing the change of tempo to register.

SCENE TWO

Crimean.

RUSSELL is walking slowly singing the Punch version of the song.

RUSSELL: Dame Seacole was a kindly old soul

And a kindly old soul was she

You might call for your pot, you might call for your pipe

In her tent on 'the Col' so free

That berry-brown face, with a kind heart's trace

Impressed in each wrinkle sly,

Was a sight to behold, through the snow-clouds rolled

Across the iron sky. [6]

Two SOLDIERS stand facing up stage left their backs toward the CAPTAIN.

CAPTAIN: *(Speaking.)* You may stand at ease soldier.

SOLDIER: *(Speaking.)* Thank you sir.

Moving exactly together they stand-at-ease, their hands clasped behind their backs palms towards the audience.

CAPTAIN: *(He turns as he sings.)*

Another war another memoir,

Another memory to take home to England.

How company will rally

To hear of my escapades

And the stories I have

Are wondrous, gallant,

Valiant and victorious.

And you soldier

Want memory do you have?

5 Second verse source unknown.
6 First published in *Punch* magazine 6 December 1856.

SOLDIER: *(He now turns to face down stage.)*
 Captain may I make my report on all that I have see
 I swear to God I have never seen before the sight that met my eyes
 For amongst the fallen and wounded as gentle as an angel
 I came across the one they call the yellow woman
 I heard her speak to the injured
 In a voice so full of love
 And those who are not destined to returned
 Through cloud of death before they died
 Clasped her hand and called her mother
 They called her mother
 And not breaking hearts she replied yes my son.

CAPTAIN: A woman you say

SOLDIER: Yes Sir

CAPTAIN: Not Nightingale you say

SOLDIER: No Sir

CAPTAIN: By heavens
 We will have to make sure
 She is mentioned in dispatches
 We have to make sure
 She receives due respect
 That this woman isn't forgotten
 Seacole you say
 A native you say
 A Jamaican
 Well war has its surprises
 And Nightingale still busy
 But protected in her hospital
 Women!
 I'll never understand them

RUSSELL: *(Starts singing 'Old King Cole' again.)*
 Still she'd take her stand, as blithe and bland
 With her stores and jolly old soul

And – be the right man in the right place who can
The right woman was Dame Seacole.
And now the good soul is 'in the hole'
What red coat in all the land
But to set her upon her legs again
Will not lend a willing hand.

RUSSELL stands pushing his chair determinedly away and with a flourish pulls the paper from the typewriter.

'In every bush and on every yard of blood-stained ground lay a dead or dying Russian. The well-known bearskins of our Guards, the red coats of our Infantry, and the bright blue of the French Chasseurs, revealing each a silent horror in the glades, and marking the spot where stark and stiff a corpse lay contorted on the grass, pointed out the scenes of the bloodiest contests. The dead were happy, the dull, cold eye, the tranquil brow, the gently opening lips, which had given escape to the parting spirit as it fled from its bleeding shell, showed how peacefully a man may die in battle, pierced by the rifle ball. The British and the French, many of whom had been murdered by the Russians as they lay wounded, wore terrible frowns on their faces, with which the agonies of death had clad them. Some in their last throes had torn up the earth in their hands, and held the grass between their fingers up towards heaven.'[7]

SCENE THREE

Surrey Gardens, London.

FOUR FOOTMEN walk from the back of the theatre to the stage. They hold candelabra aloft singing in slow a cappela. As they begin singing, the full cast begin to take the stage in groups.

A map of Surrey Gardens projected on backdrop. [8]

FOUR FOOTMEN:
Surrey Gardens welcomes the Mary Seacole Fund

7 *The War* by W.H. Russell. Published 1855 Open Library OL14053528M Internet Archive warrussell01russ.
8 The Music Hall, Surrey Gardens, 1858. Source 'Old and New London' published 1897.

And her patrons wish the best to everyone.
By the pledge they have taken
To solicit funds
By this auspicious occasion
And improve her lot
Her majesty the Queen
In gratitude for the lady's work
For the navy
For the army
For the British nation's men
Does acknowledge this service
With concern for the lady's welfare.
And so says His Royal Highnesses
The Prince of Wales
The Duke of Cambridge
And the Duke of Edinburgh.
As her patrons.

Two gossiping women.

The women cluster together like hens moving their necks to see as much as possible without turning their bodies.

FIRST WOMAN: Have you,
 Have you,
 Have you,
 Have you seen her

SECOND WOMAN: Have you,
 Have you,
 Have you,
 Have you seen her

FIRST WOMAN: My dear
 My dear
 My dear
 One thousand tickets

SECOND WOMAN: My dear
 My dear

My dear
One thousand tickets

FIRST WOMAN: Ten thousand tickets
And the woman is Black

SECOND WOMAN: What do you mean she is Black,
Like in coloured
Or in Black!

FIRST WOMAN: Coloured. Black.
Coloured. Black.
What does it matter
She's a coloured

SECOND WOMAN: Oh, it matters.
Indeed, it matters.
My son called her mother.
What shame and scandal
To have a coloured mother.

The two women scatter whispering and are joined by more women.

CLUSTER OF WOMEN: What shame and scandal
To have a coloured mother.
What shame and scandal
To have a coloured mother

RUSSELL enters waving his arms grandly. He sings an extract of the same lyrics from Act One Scene One.

RUSSELL: They call her 'Yellow Woman'
But her colour matters little,
Her origins are of no interest.
Ladies and Gentlemen
I give you Mary Seacole,
Mother of our men.
Mother of our men.

SEACOLE is in a bath chair and wheeled on stage left RUSSELL fusses about her.

RUSSELL: I hope you are comfortable

SEACOLE: I could not be better

I'm ill but not frail
I'm sick but yet I'm strong
And for all who have come
To honour me this night
I shall yet stand
Indeed I'll walk
I think I'll dance.

The orchestra plays a reggae beat in andante that changes into a slow waltz as its crescendo the tempo changes to an 'Alla Marcia'.

SEACOLE and RUSSELL dance together for under a minute.

While this is going on the bath chair is removed and replaced with an old armchair.

SEACOLE staggers as though to faint and RUSSELL quickly assists her into sitting down.

The marching tempo is now played at a hushed volume as the one-by-one members of the cast walk past SEACOLE.

SEACOLE raises her hand towards each face and they grasp it and bow or courtesy their respect.

SEACOLE repeats to each of them.

SEACOLE: I remember you,

I remember

One again the orchestra plays the first note of a waltz but SEACOLE raises her hand to stop them and rising walks downstage until she reaches the edge and looks upwards towards the heavens.

SEACOLE: *(Spoken.)*

Wait don't close the door.

Let the duppy come

Let the duppy come

Let the duppy come

All my boys are welcomed here

Let the duppy come.

The stage and auditorium falls silent as the lights of the full house are dimmed to almost blackout.

THE DUPPIES: From boy to man

I wanted to go to war
To take my stand
For the rights of an English man
All my comrades were as loyal as I
Willing to fight
Though not eager to die
Then on the morning of the battle cry
They died.
They died.
Do you remember the roar of the cannon
The crack of the gun
The sniper's gun
The screeching shredding of skin
The wet explosion of a beating heart
Then the earth-shattering silence
As they died
As they died
They died.
Immediately as SEACOLE turns, the lights flash up.

SCENE FOUR

Surrey Gardens, London.
A woman's laughter peals out, glasses clink and there is the hum of happy voices.
Soldiers are stood about in groups of 1 x 2, 1 x 3, and 1 x 6.

SOLDIER ONE: The first time I saw her for the first time
 Before the smoke of battle had lifted from the air
 Who would have thought a woman
 Especially of her creed and colour
 Would want to come to the aid of the British soldier

SOLDIER TWO: The first time I saw her for the first time
 As I came to consciousness
 In the bosom of her arms
 I know that it sounds ridiculous

But I thought that she was my mother
That was the confusion from the pain

A third soldier walks towards the first two mimicking the action of the Local Jamaican from the first act.

SOLDIER THREE: I couldn't stand I couldn't sit
But I could squat
Lord,
Did I squat.
Oh, my belly was so heavy
Swollen like a mother near her time
I like my prog[9] but as soon as I swallowed
Make room. Make room.

He groans bends double and makes as though to dash across the room.

The soldiers scatter in repulsion to let him pass.

ALL SOLDIERS: There's a man in need
There's a man in need
Make room
Make room

SOLDIER THREE pulls himself up in recovery loudly sighing his relief.

SOLDIER THREE: You can laugh
But let me tell you
What ever she gave me worked.

The full cast meander around the stage. Three women stand upstage left pointing, laughing and applauding as though they are watching something.

THIRD WOMAN: *(Singing directly to a SOLDIER.)*
Your letters brought joy to our mother's heart
Though your affection it seemed was confused
For you called a woman we had never met
Mother too.
For God's will we had prayed for you
For his blessing to keep you alive
But I know understand it was Seacole's hand

9 slang for food

That turned the healing tide.

Another soldier mimes horse riding he crosses the stage and stops near SEACOLE.

SOLDIER FOUR: Lie down mother,
Mother lie down
Don't you hear that the guns are firing
You take risks mother
That you should not mother
What is the use of you dying
See the men in the trench over there
Hear their pathetic cries
Who will nurse them
Who will nurse them
If you allow yourself to die
So lie down mother
Mother lie down
For today let the snipers cry.

The company laugh into their drinks.

CAPTAIN: Many of the ordinary men
The lower ranks I'm sure you understand
Were nervous of going to hospital
They objected to the last man
But it was nourishment they yearned for
A little chicken broth can be a mighty cure
To what ails a soldier-at-war and keeps him fighting
She had the skill of a master chef
Like a magician she conjure a dish
That would keep an army marching
And make a gentleman enlist.

A soldier holds his hands high as though he is telling a fisherman's 'big catch' whopper story.

SOLDIER FIVE: They were this big I tell you
I had jammed them at Frenchman's Hill
Three doctors had looked at them

One two three
One two three
And not one had a cured for me
So down the hill I did go
To put my faith in Mother Seacole.

SOLDIER SIX to the original cholera tune.

SOLDIER SIX: Cholera took my body
Like with poison I was sick
And I thought my life was over
As cholera took its grip

Music moves accelerando.

SOLDIER SIX: I don't know what she gave me
I never heard her say it would cure
But as I swear here…

He raises his arm to a salute.

William Adams of the Royal Navy HMS Wasp
Within hours, I was no longer sick

SOLDIER SEVEN: 18th October 1854 Captain Sir William Peel.
Third son of Prime Minister Peel
Following the June fall of Redan
I was awarded the Victoria Cross
But my arm wouldn't heal
And I knew from being in Kingston
Of the Jamaican woman
Who could brew and cure where others failed
So I called upon her services
Knowing she wouldn't refuse
Be it rank or men
She would solicit to them
The equality of her skills.

He salutes SEACOLE turns and marches away.

Background music becomes more lively to indicate that the party is now taking hold of the company of guests. It is played in-between each soloist

CHOIR: We are here in our thousands
 To honour Mary Seacole
 We are here in our thousands
 To honour Mary Seacole
 Give a 'rah, give a 'rah
 Give a 'rah for Mary Seacole
 Give a 'rah, give a 'rah
 Give a 'rah for Mary Seacole.

MONSIEUR JULLIEN: I am Monsieur Jullien
 Patron of this evening
 All things spectacular
 Will amaze your eyes
 Death-defying artistes
 Lark-like singing maidens
 All the best performers
 From around the world.

The orchestra plays 'The Daring Young Man on the Flying Trapeze'. [10]

MONSIEUR JULLIEN: Close the gates no more may come
 Close the gate no more may come
 Hundred and hundreds beg to come in
 I am sorry this night is full

CHOIR: We are back, we are back,
 We are back in our thousands
 We are back, we are back,
 We are back in our thousands
 Soldiers, Lieutenants,
 Sailors and captains
 Men of the artillery,
 Corporals and their Generals
 All have gathered
 From near and far
 To honour Seacole

10 First published in 1867, with words written by the British lyricist and singer, George Leybourne, with music by Gaston Lyle, and arranged by Alfred Lee.

MONSIEUR JULLIEN:
> Gentlemen I beseech to look to your ladies
> And cover their eyes if they be weak of heart
> For the sights I bring before you
> Never before have been seen in these parts
> Strongmen who can lift an elephant
> A strange woman with a bearded face.
> A creature who is half man and monkey
> And from darkest Africa a Lion and its mate.
>
> *Orchestra plays bars from 'Entry of the Gladiators: Thunder and Blazes'.* [11]

MONSIEUR JULLIEN: Close the gates
> No more may come
> Close the gates
> No more may come
> Hundred and hundreds beg to come in
> I am sorry this night is full

CHOIR: We are back, we are back,
> For a third night in our thousands
> We are back, we are back,
> For a third night in our thousands
> We are back, we are back,
> To honour Mary Seacole
> Give a 'rah for Mary Seacole.
>
> *JULLIEN moves to the wings stage right leaning in he pulls a black woman onto the stage. She is dressed in rags, her head is bowed but she pulls against the rope she is tethered to. Her expression is one of madness the crowd gasps in horror at the sight of her.*

MONSIEUR JULLIEN: Over the globe,
> north, south, west, east
> Searching for the best to entertain
> Never. I repeat never
> Has this act been seen before
> She was found primitive

[11] Written in approximately 1899 by Czech composer Julius Fucik.

Naked for all to see
A wild untamed creature
And not one word could she speak.

WILD AFRICAN WOMAN: I am far from my home
I am so far from my home
I am in a strange land where people point at me
I am so far from my home
I am far from my home
I am so far from my home
Here no one speaks
a language like me
I am so far from my home
I sleep in a cage
Like an animal in a cage
I long to kill those who captured me

She suddenly lunges at JULLIEN. The crowd's gasp is loud and audible one woman is heard to scream. JULLIEN strikes her and she falls to the ground.

WILD AFRICAN WOMAN: I am so far from my home
I will die far from my home
I will die so far from my home
I will never again see my family
I am so far from my home [12]

MONSIEUR JULLIEN: Close the gates no more may come
Close the gate no more may come
Hundred and hundreds beg to come in
I am sorry this night is full

CHOIR: We are back, we are back,
We are back in our thousands
We are back, we are back,
We are back in our thousands
Four nights at Surrey Gardens

[12] The lyrics for the African Woman have been included for this publication only. In performance, the character sang a song, which did not meet the correct timeline of Seacole's history.

> Thousands and thousands
> and thousands and thousands
> Pledge their money to the special fund
> To honour Mary Seacole

MONSIEUR JULLIEN: I Monsieur Jullien
> Have little more to say
> The world's best in entertainment
> Have all passed this way
> Little midgets dancing
> Giants wrestling
> Gypsies playing fiddle
> Magicians with their craft
> Great actors reacting battles
> But like the end of the war
> This night must be the last.

CHOIR: We have come
> We have come
> to honour Mary Seacole
> We have come
> We have come
> To honour Mary Seacole
> Give a 'rah, give a 'rah
> For Mary Seacole
> The nursing heroine
> of the Crimean war
> Hip hip hooray
> Hip hip Hooray
> Mary Seacole
> Mary Seacole
> Mary Seacole
> Mary Seacole

SCENE FIVE

The stage is dimmed. Stage right is the old armchair used by SEACOLE who is standing her back to the audience.

SEACOLE turns as she sings.

SEACOLE: I remember,
 I remember them.
 I remember,
 I remember them.

 SEACOLE moves to the armchair and sits.

 On the other side of the stage, propped up in bed is NIGHTINGALE, furiously rearranging her pillows.

 Their duet is as if they are in conversation even though the stage is light to indicate they are in different rooms.

NIGHTINGALE: Each night ten thousand people
 Over four nights
 makes forty thousand people
 Are they mad?
 Is it the Great Exhibition
 Or a parody of English society
 Bring me paper
 Give me paper
 I need to write
 I need to write
 some letters

SEACOLE: I shall write to everyone
 to thank them
 Well not everyone
 But I should thank them
 And acknowledge their sacrifice
 For a simple woman of herbs
 Who without their grateful patronage
 Would surely meet the destitution
 That eagerly awaits at every turn

> For my company.

NIGHTINGALE: Do not accompany my words with diffidence
> Heed what I say comes from experience
> Whilst others idled, I walked in war
> Read what I write and know, I know more
> That hygiene must prevail in the battlefield
> That more men die from dirt then those who are killed
> And it is sluttish behaviour
> that brings the deathly disease of dirt
> Pamper if you will to this coloured woman
> With her simple cures of herbs
> But understand that the words I have written
> Are deeply engrained with a nurse's wisdom.
> Heed my words.

The two women are silent for a moment pausing to think then turning their attention once again to their writings.

NIGHTINGALE: One, two three, four,
> Turn two, three four
> So walked the sentry
> Down the corridors of death
> Four miles of wounded soldiers
> Fighting for their last breath
> Legs would lie in the gutter
> That ran between their beds
> Very few men cried out
> Very few men cried.

SEACOLE: Cry my son
> Let the tears flow my son
> There's nothing like weeping
> A man's allowed to cry

NIGHTINGALE: I had my own battles
> With the Quarter Master's stores
> Supplies they ran out
> Or never did reach me

What treachery did send the thieves
What bureaucracy did waste those lives?
That a few pennies more would have kept alive
Just a few pennies more.
The music changes to Ska rhythms.[13]

SEACOLE: Every penny, every penny
I used every penny for stock
And passage to this world of hell
Ev-ery penny, ev-ery penny
They would not send me come
Would not recruit me no
So I took my purse and every penny
Ev-ery penny I needed
Ev-ery penny I needed
To use my skill to heal the men
Who have fallen by the Hussar's gun
Every penny I needed
The music changes tempo back to adagio.

NIGHTINGALE: Every morning I would go to check
What the Purveyor had hidden
For supplies were sold to the highest bidder
For they care not a jot for the fighting soldiers.
So I didn't just nurse them
Half the army I clothed
Uniforms be dammed
I saw half-naked men
Bundled from ships to fight wars
And it would only have taken
A few pennies more.
The music changes back to Ska.

SEACOLE: Every penny I need-ed
Every penny I need-ed
<u>Like a slave I</u> did toil

13 A music genre that originated in Jamaica in the late 1950s, and was the precursor to rocksteady and reggae.

This was my life's call
No one to pay me
They didn't want me
See my recommendations
Written by very best gentlemen
Who could stop me?
Who dare try?
Enough of this foolishness
I Mary Seacole
Yellow Woman
Mother of the Soldier
Did come
Did arrive.
Check them
Check I!
And remember

Again the tempo slows.

NIGHTINGALE: Remember that though I lie here defeated
It is only my body that wastes away
Not my mind nor my memory
But will you remember me
Validate for all that I have said
And remember well Florence Nightingale.

The following recording is played.

NIGHTINGALE's famous speech in support of the Light Brigade Relief Fund, recorded on Edison Parafine Wax Cylinder, on July 30h, 1890.

SCENE SIX

London.

NURSES enter as the light on NIGHTINGALE dims to the halo of a light before it blacks out. They walk to the centre of the stage where RUSSELL stands on a podium.

RUSSELL: Today London celebrate
By the generous donation of Soldiers
That enabled the founding of the Nightingale Fund

The opening of St Thomas's Hospital
As a dedicated school for nursing

The NURSES exchanges places with RUSSELL on the podium and they place their hands down as though upon a Bible.

NURSES: I solemnly pledge myself before God and in the presence of this assembly, to pass my life in purity and to practice my profession faithfully. I will abstain from whatever is deleterious and mischievous, and will not take or knowingly administer any harmful drug. I will do all in my power to maintain and elevate the standard of my profession, and will hold in confidence all personal matters committed to my keeping and all family affairs coming to my knowledge in the practice of my calling. With loyalty will I endeavour to aid the physician, in his work, and devote myself to the welfare of those committed to my care. [14]

SCENE SEVEN

RUSSELL dons a black clock and tall hat, he bows his head, takes two steps backwards and walking in a funeral march takes a seat at the table. His posture indicates the dejection of his situation.

He pushes his typewriter to one side and leans his head in his hands. A younger man appears carrying a decanter and glass, which he waves under RUSSELL's nose. RUSSELL indicates that he might be seated. The YOUNG MAN roots in his pockets bringing out a pen and paper, as RUSSELL helps himself to the brandy.

YOUNG MAN: You liked her

RUSSELL: I admired her
You had to see how she was
Unnerving in her courage
Caring for all who had fell
And humorous in her giving
And a bloody good cook as well.

14 'The Nightingale Pledge' composed by Lystra Gretter, an instructor of nursing at the old Harper Hospital in Detroit, Michigan, and was first used by its graduating class in the spring of 1893. It is an adaptation of the Hippocratic Oath taken by physicians.

YOUNG MAN: How did she manage
 After the war was won.
 With a rapid evacuation
 Did all forget what she'd done?

RUSSELL: She and her business partner
 were penniless
 The moment they stepped to shore
 And in 1856 as bankrupts
 they could trade no more
 But you forget this woman
 And all that she had done
 Had walked the path of so many
 That something had to be done.

YOUNG MAN: Surrey Gardens were spectacular
 I have read your reports
 But Jullien's costs were enormous
 And the dammed Company
 Was secretly insolvent
 Before the first performance had begun.

RUSSELL: Two hundred and thirty-three pounds
 Nine shillings and eight pennies
 Was all that was left from ticket sales?
 That quadrupled each evening's capacity.

YOUNG MAN: So Mr Russell was it you
 Who championed her again
 Rallying the people
 with the skill of your pen

RUSSELL: It was not I who caused
 Parliament's attention
 I confess it was *Punch*'s editorial
 That demanded action
 From Lord Palmerstone
 And with Victoria's blessings
 The states purse was opened.

And though less then hoped for
Her income was secured.
YOUNG MAN: But I hear she gave not pennies
But in pounds to those in need
RUSSELL: Indeed, she was most benevolent
Especially to orphans and widowers
Who had lost a loved one to war?
And in '58 she did not hesitate
To take
One hundred pounds from her purse.
YOUNG MAN: All of this is admirable
But surely then, Count Gleichen lies[15]
For in his bust of her
Four medals on her breast are designed.
RUSSELL: The French Legion of Honour
The Turkish Order of Mejidie
And the Crimean Medal
And the last one with drink
Fogs my memory.
YOUNG MAN: Was she then perfect
RUSSELL: No far from perfect
To those that knew
She had the temper of a vixen
And a nasty disposition too
At times, she caused a quandary
That though coloured her thoughts were white
For sometimes her attitude to the Turks
Was not a pleasant sight
YOUNG MAN: But you'll miss her
RUSSELL: Yes, I will miss her

15 Major-General Lord Albert Edward Wilfred Gleichen, KCVO, CB, CMG, DSO (1863–1937) was a British courtier and soldier. Born Count Albert Edward Wilfred Gleichen, he was the only son of Prince Victor of Hohenlohe-Langenburg. SOURCE Wikipedia 1871 he produce a sculpture of Seacole.

As much as everyone will
From Princess Alexandra
Who she befriended
To the most common soldier
She cured.

RUSSELL pulls the typewriter towards him and with obvious reluctance takes up a sheet of paper inserts it and begins to type.

A piano soloist of the opening bars of 'Jamaica Farewell'.[16]

RUSSELL: May 14th 1881

The sun in London was more dim then usual
Though the day was fine
And no birds could be heard to sing
For sixteen days men who have known battle
Held their breath as apoplexy retained its hold
On the dusky woman we all had come to respect
Then on the 17th day she slipped from all who loved her
To lie in a coma for three days and three nights
Never to gain consciousness again.
What wonderful adventures have the heavens yet to hear
When she opens her store by St Peter
And how many lads both young and old
Who too took their leave before their time
Will once again enjoy her ale and well-cooked broth
And be charmed by Mary Seacole
She is buried far from her place of birth
But what land could hold her
What race claim her
A good catholic to all she knew
In Kensal Rise
She has finally laid to meet her maker.

[16] Written by Lord Burgess (Irving Burgie) SOURCE Wikipedia.

SCENE EIGHT

Jamaica.

RUSSELL stands the lights reflect the glare of a harsh sun. RUSSELL removes his jacket, then his tie and undoes his collar button. He takes a handkerchief out and mops his head and neck almost feverishly. A Black 'boy' enters carrying a camera, he trips and RUSSELL admonishes him for his clumsiness. Russell has now become a World War Two journalist. A BOY enters stage right and as he walks across the stage he stumbles.

BOY: Whop mi foot nearly tip mi up
 Mi left want to move wid mi right
 Mi heart almost stop cos mi tink mi drop
 Dis camera that mi hold soh tight

RUSSELL: Good God boy are you stupid
 Don't move
 Don't flinch
 If the likes of you join the army
 Hitler's bound to win

RUSSELL grabs the camera and pushes the boy away and busies himself with the apparatus. The BOY watches him, then lifts the cloth to peer underneath.

BOY: Wat yuh do uder der mister White man
 Tel mi wat yuh seh
 For mi uncle he sails now to Ingland
 To fight de British enemi
 And he tel mi he will send mi
 A picture of de King
 And him do it with someting
 Dat look just like dis thing

RUSSELL: Good God boy are you stupid
 don't move
 don't flinch
 If the likes of you join the army
 Hitler's bound to win

Again he pushes the BOY away. The BOY looks back at RUSSELL then goes to sit next to a young GIRL. The GIRL is sobbing.

375

BOY: Why yuh cry soh
 Why yuh cry soh
 Why yuh cry soh
 Why yuh cry soh
 Come look here
 Check dis man here
 If dis man not a fool then mi lie
GIRL: I cry for mi fadher
 Who do sail today
 To join the RAF
 An' mi uncle
 In de merchant navy
 Now only mi mudder left
 Now dey come cry
 To the wimmin too
 Qualified nurses
 An' those who wish to train
 Sayin
 Ingland she needs yuh.

The BOY sings in the same rhythm of the local MAN from Act One Scene Two who drank too much rum.

BOY: All dis war is curse for we
 Jamaica should be independent
 For de English to dis colony
 Have only brought lament
 What dey brings nuthink?
 What deys do nuthink?
 What dey leave nuthink?
 Gawd save Jamaica and dam de King.
 Gawd save Jamaica and dam de King.
GIRL: Sshh! yuh is badd bhoy
 Someone shou'd cum lick yuh
 Fi dat mouth of yuh
 Dos run like fool
 Wat yuh don't know

yuh show
Wat yuh don't know
yuh show

The GIRL skips over to the white man who pops his head from under the cloth and without speaking pushes her into a pose.

The BOY watches for a time then wanders away.

RUSSELL: Let me take your picture little urchin
Your image will be a change in my reporting
Now we are recruiting from the Caribbean
You're an inspirational sight.
Do you have a mother, do you know her?
Is she still on the island or has she gone?
To join the call for Nurses
So Miss Nightingale's spirit lives on.
And when you are grown will you join too
Miss Nightingale School could make a nurse of you

GIRL: Miss Nightingale who is dat sar
I never before heard that name

RUSSELL: She is the most famous nurse in the world

GIRL: Noh sar not here sar
But a nurse I will be
But in the name of Mary Seacole
She is a heroine to mi

RUSSELL: Mary Seacole

GIRL: Yuh not know her
Fancy yuh all clever
An' fine cloths
Sit an' I will tell yuh
How her story goes
No Anansi did tell mi
Wat I sey is de truth
She is heroine of history
And I is proud dat she
Was a Jamaican too
Speech.

GIRL: It was a long time ago in Kingston Jamaica
 Dat she borne
 Mary Jane Grant
 Daughter of Mrs Grant
 and she husband a white man
 who did wear a skirt
 and call himself Scottish.
 And she wanted to be a nurse
 But they would not let her
 The orchestra begins to play in a reggae beat as the GIRL sings.
 I am not defeated by rejection
 It serves to heighten my determination
 I am not defeated by rejection
 It serves to heighten my determination
 Of this one thing I am sure
 The choir joins in to what is now is a chant.
 we are not defeated by rejection
 It serves to heighten our determination
 we are not defeated by rejection
 It serves to heighten our determination
 SEACOLE walks on singing.
 Of this one thing I am sure
 I am not defeated by rejection
 It serves to heighten my determination
 Then I shall sail by any means
 I would walk t'is sorrow I cannot fly
 But I will arrive there by and by
 I am not defeated by rejection
CHOIR: We are here
 To honour Mary Seacole
 We are here
 To honour Mary Seacole
 Give a 'rah, give a 'rah

Give a 'rah for Mary Seacole
Give a 'rah, give a 'rah
Give a 'rah for Mary Seacole.

The End.

ABSOLUTION

'The Waltz Gone Mad: the Poetics of Departure and Arrival in *Absolution*'

The Jamaican poet Lorna Goodison aptly describes the island home as the 'country we leave from to go and make life' (Goodison 2006: 106). Like Goodison, who divides her time between Jamaica and the United States, Malika Booker's own heritage and that represented in her work bears this out.[1] First produced in 1999, *Absolution* was developed under the aegis of 'The Waltz', a commission from the Austrian Cultural Institute administered by Apple and Snakes, Britain's premier performance poetry organisation.[2] Booker was among five artists given the brief to respond to the bicentenary of the birth of the waltz.[3] Dance bands across the former British colonies of the Caribbean adopted and altered the Austrian waltz with instrumentation that favoured bass, drums and brass. Inspired by the social dance traditions of her Caribbean heritage, Booker wanted to write a piece that represented the rite of passage, that fathers once taught their daughters to dance, by having the girls stand atop their own feet. She explains, 'I had concerns about who teaches girls to dance now that we no longer do those old-fashioned dances'

1 Booker's poetry has been widely anthologized and performed. Her first collection, *Breadfruit* (2007), was published by Flipped Eye Publishing. In addition, she is the lynchpin for a community of writers based in and around London through having founded 'Malika's Poetry Kitchen'. This salon grew out of impromptu gatherings in the kitchen of Booker's Brixton home. They published an anthology of poems *a storm between fingers* (2007) which was developed in 'the kitchen' as it is known.
2 www.applesandsnakes.org
3 First named in the late-eighteenth century, the waltz's precise origins are not known but it combines features of 'the volta, the weller and the landler', a ¾ or ⅜ turning dance as danced in Austria and Bavaria for centuries. (Craine and Mackrell 2000: 506) It was initially controversial as couples shared a close physical embrace to execute the dance, and authorities attempted to prohibit it. As a dance form, it appears widely in the nineteenth-century classical ballet repertoire. Numerous adaptations and styles have tailored the form to specific national and cultural dance traditions all over the world as indicated by The Viennese Waltz, The American Waltz and The Cajun Waltz – to name a few examples.

(Personal interview with Imani e Wilson, 2012).

Although the formality of the waltz is a starting point, *Absolution* also conjures another sort of dance often between couples, in the complex and improvisatory choreography of migration routes. Tracking motion from both poles of the globe, across the Atlantic, and from the colonised islands to the imperial motherland and back, Booker's monodrama *Absolution* maps one young woman's journey to a wider world that she has only imagined while growing up in the Caribbean.[4] The monodrama's characters take a post-war journey similar to that of Booker's own parents: departing separately from the British colonies of Grenada and Guyana by steamer, then meeting and marrying on board ship, settling in London, starting a family there, and ultimately, moving to a South American country that is home for one and foreign soil to the other. In this way, *Absolution* recalls Guadeloupian author Maryse Condé's *Tree of Life* when she writes from a Caribbean perspective:

'I wanted to show that West Indians move around a lot, though some people incorrectly believe they never leave the islands. In fact, West Indians have gone all over: to Panama, Africa, Europe. I wanted to show that the West Indies is a place of generation and dispersion, not confinement... It's interesting to see the constant movement of the community to which you belong.' (Pfaff 1996: 68).

Absolution reflects upon the liminal aspect of life on board ship, a state of transition, neither having completely left, nor having wholly arrived. Named after the vessel that transported nearly 500 Jamaicans to England in 1948, the Windrush generation heralded the first wave of mass migration from the Caribbean regions to the United Kingdom.[5] Due to their current

[4] Her previous theatre pieces include the one-woman show *Unplanned* (Battersea Arts Centre, 2007), as well as the musical, *Catwalk* (Tricycle Theatre, 2002), which was commissioned by NITRO and *Three Way* (Birmingham Repertory Theatre, 2009), co-written and performed with Yusra Warsama and RT.

[5] A whole body of work has emerged since the marking of the fiftieth anniversary of the HMS Windrush's docking in Britain which recognises the influential presence of black people in modern British history. See: Phillips, Mike. and Phillips, Trevor. *The Irresistible Rise of Multi-Racial Britain*, London: Harper Collins, 1998; Francis, Vivian. *With Hope in Their Eyes*, London: Nia, 1998; Korte, Barbara and

geographical locations, Booker was not able to interview her own parents as she had originally hoped. Instead her research in London comprised of interviews with other Windrush-generation Caribbean migrants to Britain about the circumstances under which they met their partners and the role that dance played in their courtships. She also worked with Roger Robinson, the original production's dramaturg, a renowned poet and short story writer. Connections between poetry and prose writing similarly underpin Booker's work. As she herself began her writing career with narrative poetry, she describes her expansion into other genres thus: 'Sometimes the work decides it does not want to be a poem, it has to be a larger body of work. Sometimes the work dictates that I have to collect new tools to execute the piece. So I do research, homework. I study the craft.' (Personal Interview with Wilson, 2011). She cites amongst her influences, 'the work of playwrights and performance artists like Spalding Grey, Ntozake Shange and Dael Orlandersmith. I am a student of great women performers who, by telling stories, radicalized theatre' (Personal Interview with Wilson, 2012). As the *Oxford English Dictionary* defines it, absolution is 'a formal release from guilt, obligation or punishment, an ecclesiastical declaration of forgiveness of sins' (*OED* 2008). Booker, who feels her choice of title has its roots in her Catholic upbringing, reflects, 'I like the confessional element of the monologue and felt that once a confession is made the speaker is in some way seeking to redeem themselves, understand their faults and seeking redemption in some way' (Personal Interview with Imani e Wilson, 2012).

Booker embraces a broad literary heritage to address questions of identity, family and community in *Absolution*. Her impetus illustrates what African American playwright August Wilson pointed to – the importance of identity reclamation as foundational to anyone's future – when he commented, 'In order to understand who you are, you have to understand your immediate ancestors. You've got to make this connection with your recent past in order to understand the present and then to plot the future' (Bryer and Hartig 2006: 237). Booker views the

Pirker, Eva Ulrike. *Black History, White History: Britain's Historical Programme Between Windrush and Wilberforce Piscataway*, NJ: Transaction, 2011.

waltz's bicentennial through the lens of her parentage, inserting a Caribbean perspective into a pre-existing European cultural practice and transforming it.

When the drama begins, Shevaun, the eldest child in her family, is boarding a ship bound for London where she plans to obtain nursing certification so that she can help to support the family. When she gathers the nerve to leave her cabin on the ship, she encounters other young people similarly hoping to make their fortune in London. Amongst them is the dapper Aubrey Blake, a young Guyanese architect, who sets his sights on Shevaun. Despite Shevaun's initial resistance, Aubrey woos her at the dances that take place on the ship. Dance becomes a minor but pivotal character. Aubrey's initial attempts to court Shevaun on the ship are the first and last opportunities for dancing in the piece, as music and dancing seem to leave their lives when the ship docks. Thus the couple meet and marry at sea, where their imaginings of the opportunities before them are unchecked, and far from the pressures of the English world they will soon encounter.

From this point onwards, *Absolution* is a metaphorical waltz gone mad as their hopes are dashed by the harsh realities of surviving in hostile surroundings, one where the couple are constantly wrong-footed in trying to fulfil their expectations. His qualifications meaningless in London, Aubrey becomes fed up with his menial jobs and the fact that he and his bride share a house with five other families.[6] He announces to Shevaun that they are going back to Guyana, his country of origin, a country notably drawn into the Caribbean cultural embrace but located on the South American continent. As the British Empire began its transformation into a Commonwealth of sovereign nations, many Caribbean migrants made such a return trip, to their respective homelands. According to Robinson, 'Lots of people write about people leaving the Caribbean, very few write about going back' (Personal Interview with Wilson, 2012). Shevaun and Aubrey are

6 The squalid and exploitative living conditions many migrants faced have been captured in fiction such as, Levy, Andrea. *Small Island*, London: Picador, 2005; and in non-fiction, Procter, James. *Dwelling Places: Postwar Black British Writing*, Manchester: Manchester University Press, 2003; McMillan, Michael. *The Front Room; Migrant Aesthetics in the Home*, London: Black Dog Publishing Ltd., 2009.

required by circumstances, to do new dances in encountering unfamiliar environments – first on the ship, then in England, and then as the Guyanese Blakes, when they encounter their new Grenadian in-laws in Georgetown, Guyana.

Booker draws each character as both choreographer and self-taught dancer, a device that at first blurs the line between sympathetic and unsympathetic characters. Shevaun clearly attracts the sympathies of the audience and Booker maintains suspense throughout her piece, encouraging vacillation between judging Aubrey as inept or malevolent towards her. We see Aubrey translated through Shevaun's eyes. Throughout the piece, she states that she is not sure what to make of him. His thoughts and motivations are a great mystery to her. Booker interweaves her misgivings with forgiveness, or even wilful blindness to what life with him augurs.

'What can I tell you about the family?...ah thought to myself, "Well, maybe this is the way Guyanese women does treat you when you first come to the house…maybe is a way of giving yuh a rough time until yuh know, until yuh, yuh know until yuh sort yuh self out or until they welcome yuh…" This might just be the way Guyanese women are.' (in this volume)

Her musing is punctuated paradoxically by 'yuh know' when the reverse is true. Neither Shevaun nor the audience know, and the Blakes are no more able to accept or understand Shevaun than she is them. It is apparent that they find her domestic skills wanting in regard to Aubrey.

'They aint' eating no food from me, they don't know what Grenadian cooking ah doing, but all they know is ah not minding they brother… They don't know what food ah cook on the street to give she brother to tie him down but they going to protect they brother interest and they don't want no damn thief-ing upzucky Grenadian woman cooking he food.' (in this volume)

Furthermore, his sisters are suspicious of Shevaun, whose speech, habits and cooking all mark her as a foreigner to them. Where language fails, the simple offering and gracious acceptance of food or drink communicates the potential for alliance and fellowship. When Aubrey's sisters reject Shevaun's food, it becomes plain that they will not allow her to join their family.

In her handling of the interaction between Grenadian Shevaun and her Guyanese in-laws, Booker deftly complicates notions of Caribbean and South American identity. Ironically, the one thread connecting Grenada to Guyana is the British Empire and the English language bequeathed them by colonization. While the journey to the United Kingdom brought Caribbean people of many islands into contact with one another (highlighting the distinctions between one culture and the next), Windrush immigrants would soon encounter a British population ignorant of and uninterested in those distinctions. *Absolution* undermines the concept of home and recalls Antonio Benitez-Rojo's seminal work where he writes that 'This... [Caribbean]...archipelago, like others, can be seen as an island that repeats itself [...] and as a meta-archipelago it has the virtue of having neither a boundary nor a center. Thus the Caribbean flows outward past the limits of its own Sea with a vengeance.' (Benítez-Rojo 1992: 4). In maintaining the tradition of orality from which monodrama has grown, Booker's writing flows beyond formal and conceptual limits to speak with authority and authenticity of lives that are still finding their way to centre stage in British theatre.

Imani e Wilson

Characters

SHEVAUN

Absolution was premiered at the Battersea Arts Centre 2, London in December 1999.

The cast was as follows:
 SHEVAUN Malika Booker

Directed by Tom Morris

During Absolution*'s two week run at Battersea Arts Centre Malika was accompanied by Jason Yarde who had composed music particularly for this piece during the rehearsal phase. He provided the musical background and sometimes the music symbolised certain characters. So the original Monologue was underscored by music. This script omits the music and will only mention it when music replaced words or sound is necessary.*

Malika enters the lit stage dressed in black. She walks to centre-stage where she stands under a single spotlight and faces the audience. She addresses the audience for the entire performance as SHEVAUN is a Grenadian accent.

SHEVAUN addresses the audience and waits for a response.

So yuh want to know about the waltz and what it means in my life? *(Audience answer yes.)* Yuh sure? Yuh sure want to know about my life story? *(She waits for the audience to answer.)* Is a long long story yuh know – yuh have the time? *(She waits for the audience to answer.)* Eh he! Well take a drink nuh, you have to sit down it's long girle. Alright! Okay yuh ready? *(Waits for the audience response.)* Yuh sure yuh ready?

It started in 1959 when ah left mi family, yuh know! ah was going to England to start mi little nursing qualifications and things like that, and ah was leaving Grenada for the first time. And all week ah was happy happy happy everybody in the village celebrating with me you know. But then that day we on the pier and ah saying goodbye to mi mother and mi father and mi brothers and mi sisters, I am the oldest of twelve and all mi brothers and sisters come to see me go yuh know! And I standing there. As ah saying goodbye ah start to feel so sad, yuh know! And then Mummy was standing there in her best dress and she just fiddling with it nervously and Mummy was crying. I never see mi mother cry before in mi life and mi father standing there in his best suit looking so tight on him and looking so uncomfortable and every time ah hug up Mummy, *(She mimes hugging her mother tight.)* you know! He

just come and pull mi hand away and tell me I have to go. And ah can't let go of mi mother at all and ah just holding on to she and she look so small and ah thinking, 'ah don't know when I am going to see you again, ah am going so far away and ah never left yuh before.' But I realise that everybody getting on the ship and ah not going anywhere so ah hug mi mother and them for the last time and ah kinda dash of a quick kiss to mummy because ah know if ah hug she again I ain leaving and mi father just put out he hand to shake my hand because is like he didn't want to hug me at all because he know he didn't want to let me go. Ah mean I am the oldest! And ah just turn from them and ah pick up mi suitcase *(Bends down and mimes picking up a suitcase.)* and ah square up mi shoulder and I say, 'yuh know what don't look back, because if yuh look back yuh not going anywhere.' And I just slowly make my way onto the ship, yuh know. And ah couldn't look back at them and ah really wanted to look back but ah just kept my head straight.

Well when ah reach the top of the ship it was so shocking, it wasn't as ugly and big and horrible like it looked when ah was on the pier. It was huge and nice. Oh My God is a luxury liner they put us on. If yuh see the ship! And they have everybody milling about, you know, talking with all these different accents, from all these different islands and things like that. And as ah standing there ah just felt overwhelmed as ah realize that this ship huge like the space between me and where I am going and ah don't even know what that is. And then ah realize is like the gap between me and mi family that ah just leaving and I get so frightened, I just find out where mi cabin was and ah pick up mi suitcase and ah make mi way to mi cabin. Well when ah get to the cabin ah lock the door. When ah tell yuh ah lock the door ah made sure the door was locked.

And then ah went and ah lie down on mi bed and ah pull the covers over mi and I pull the pillows over mi head and ah just stayed there. Ah was so scared that ah stayed there for three days ah didn't want to come out. And on the third day ah say, 'Shevaun this is stupidness, Shevaun yuh have to leave this room,' and ah just kinda make my way slowly to the door and ah open the door and ah peep out and ah just step out and ah turn and lock the cabin door. Well ah hear a little noise behind me and ah turn back and three girls were standing there. If yuh see these girls! And they looking at me kinda funny, like they in shock. Then one of them bawl, 'Girl is wey you come out?' I said, well yuh know ah never left mi home before so ah was a bit, yuh know, a bit...well ah just stayed in mi cabin for three days just to meditate. Well the first girl look at me like ah was some alien or something, she couldn't believe that ah stayed in the cabin for three days and she look me up and down and she say, 'Girl I can't believe you stay in your cabin for three days! Hear nuh! They have nuff waltz dance on the ship, every night we dancing up and down, is like parties back home yuh know and you been missing it. Yuh ain't hear the music?' I said, 'erm no.' Well the second girl come out with, 'well hear nuh, me, I erm, I don't care bout the music and the waltz dance is the fellas on the ship I care about. They have some nice handsome fellas on the ship and yuh see me my ambition is to get a husband before we reach England, so I just making eyes and biding mi time.' Well the third one if you see she, she look a mess. She had all the colours of the rainbow on she. She turn to me and say how, 'she ain't got time for the two of them, just looking at fellows and studying dance, she have one fella she studying and that is this fella name Aubrey Blake.' She say, 'If yuh see Aubrey Blake yuh would know he.' Well the other two pipe in, 'Aubrey Blake,

that boy nice yes. He come from Guyana and he is some kind of architect.' And she come back with, 'I know, that's why ah don't have time for them other fellas on the ship. I just looking at Aubrey Blake. If yuh marry he yuh set up for life. He is an architect, he done get he qualifications already. The other night he make eyes at me across the table and tonight I going to sit next to him and sometime tonight he going to dance with me. He going to marry me before we get to England, yuh mark my words. I come out for him!'

Ah said, 'right.' Ah said, 'eh he.' Ah said, 'ah just want to get some thing straight with all yuh, ah just leaving Grenada to go to England to get mi little nursing qualification right. I have obligations to my family, they put all their money together to send me to England and ah have to send back for all of them, so I ain't have time to come on no ship and look for no husband and things like that I just looking for England and what go happen when ah get there, you know.' But ah went with them to the banqueting thing nuh, and the hall and where they does hold the little dance thing. And when ah reach the hall it was huge. If you see...! They set up tables and we had dinner. When ah tell yuh, it look like they had long long tables. It look like yuh know, when yuh read them books about England and they talking about banqueting, well it look like one of them banqueting places things nuh. And I sitting there and I thinking, 'oh gosh ah feel like ah reach England already.' And it have these chandeliers things nuh, these light things. They look kinda dangerous. They look like if one fall on yuh they could kill yuh. But it... it add to the atmosphere and ting nuh. So I looking at the light and I looking at the table and we eating the food and I wondering, 'where they holding this waltz dance because by the time they clear up all this food and thing and these

tables, I mean its time for everybody go and sleep.' I didn't know English people. When we finish before you say bim bam they clear everything. English people efficient too bad you know. Everything clear out. A band form over there, set up nicely and all the men went on that side of the room and all the women went on this side. And the floor...if yuh see the floor! The floor was gleaming gleaming gleaming. Ah wondering... 'Ah wonder who polish them floors boy? They must have give it some good polish, you could just slide on the floor, good for dancing,' And ah standing there and ah thinking, you know, ah thinking, 'what yuh going to do when yuh get to England?' I wondering, 'well... I wonder if I should get a job first or if I should apply for mi little nursing qualification, yuh know? And how yuh does really go round getting a job, yuh know? I hope it not hard.' And I standing there and I thinking about my life and things like that and then all of a sudden all the women around me start titivating and fixing up *(Starts to fiddle with her clothes, stroke her hair and push out her chest in an exaggerated manner.)* ah see him *(Her gaze fixes on a spot to the right of her – this will be Aubrey through out the show.)* and ah knew that was Aubrey Blake. If yuh see Aubrey Blake man! *(She mimes the hat, ribbon and pat down Afro as she says it.)* The man had he hat on and he have it slanted to the side with a little ribbon around it and underneath yuh could tell he hair pat down neat neat with a little part in he afro, yuh know and the white shirt was gleaming crisp crisp, starched and he had he blazer thing on *(Mimes buttoning up a jacket.)* with he black double breasted suit or whatever yuh call it, buttoned up and the trousers was seamed. If yuh see the trousers! There is nothing, nothing on earth as wonderful as a man with freshly seamed trousers, yuh know. Seamed properly. As for the shoes... the shoes...well the shoes was shine shine shine. Aubrey

must have been shining those shoes since he left Guyana, fus the shoes shine.

But yuh know what, I ain't studying men and things like that cos ah know what ah got to do when ah reach England, so I go back to my little thinking you know. And ah thinking as ah looking around the room, ah realise wait nuh, everybody in the same boat as me, everybody leaving they family and they home and everything they know and nobody know what they going to and everybody kinda frighten and scared and a bit apprehensive and things like that. So ah not feeling so bad anymore, yuh know. Ah start to feel calm and less frighten and ah realise that ah should ah left the cabin sooner, as ah put myself through too much anxiety yuh know. And ah standing there and ah…and ah, ah realise that Aubrey making his way slowly across the dance floor yuh know and ah thinking now, yuh know, 'how I going to send for mi mother, should I send for her first or mi father or mi younger brother or, yuh know, or one every two years or…' and Aubrey only coming across, walking across, walking across and all the girls titivating and thing and ah standing there just thinking cos ah ain't got time for non of that. And ah thinking ah hear the streets of England paved with Gold and ah wondering how yuh does walk down gold streets if yuh does walk posh or tiptoe. Ah standing there lost in thought and Aubrey come up to me Shevaun and ask me 'can he have this dance please.' Ah said no. No thank yuh. Well is like ah write challenge all over my forehead. Is like Aubrey didn't understand the word no. He was a sweet-boy and no one had ever refused him before in he life. So every night he just walking across the dance floor to ask me Shevaun to dance. He stop dancing with any one else. Ah practise all kind of no for him just in case he didn't understand the first few times. *(She mimes saying no, shaking her head, waving*

her hands, turning her back, and finally blocking him palms outstretched and kissing her teeth.) And everyday ah walking on the ship and people only stopping me saying things like, 'yuh using nice strategy they girl, you going to hook him you know,' and ah thinking, 'they too fast they need to mind they own business... I tell them ah looking to hook any body, ah trying to stop this man from dancing with me.' And he stop dancing with everyone else and he only walking across the dance floor song and after song after song. Ah feeling so shame because every time he walk across the dance floor, everybody would get quiet and kinda lean in, the band would slow down the music and it would get low low low and when ah say no you would hear an ahhhhh sigh sweep across the whole dance floor. That made me so embarrassed yuh know. And the woman with the colours of the rainbow who trying to hook Aubrey only standing up everywhere I turn and staring at me she face puff up like a bull frog. Well one night ah say ah going to put a stop to this once and for all. You know I shy right. Ah here telling yuh this story but I am real shy. So ah had to practise mi no for him in front of the mirror first *(Behaves like she is in front of a mirror.)* I thought I was going to look at him, look him up and down, *(Mimes the action as she speaks.)* cut mi eye and look away and give him one big kiss teeth and tell him, 'I don't want to dance with you what part of no yuh don't understand, every night yuh just harassing me harassing me, leave me alone,' then walk of and make sure everyone gets the idea that ah really don't want to dance with him.

So ah prepare for him that night, you know. But Aubrey walk across the dance floor straight to me because he had stopped dancing with anyone else so is just me he molesting and he stand in front of me and he bow down he head and he voice get deep deep deep deep deep and

he look me in mi eye and he said *(Puts up a really deep male voice.)* 'Shevaun could I please have the honour of this dance tonight.' And I don't know what happen: if it was the way he walked across the dance floor, *(Does a male swagger.)* ah don't know if is the way his voice went so deep, or is the way he dipped his head. But when he said, 'Shevaun could I please have the honour of this dance tonight.' Ah went to say no. Ah swear ah went to say no, but is the deep voice thing an ah I end up opening mi mouth and saying *(Her voice sounds breathy and shy and her whole body shudders.)* 'Yeeesss.'

Then he just take mi hand and he lead me onto the dance floor – right in the middle. He didn't do things by half this Aubrey, yuh know. And he place mi hand behind his back and he took mi other hand in his own and we started dancing. The man could dance so nice. He move yuh with out yuh knowing yuh were being moved, yuh know *(Mimes dancing in a waltz for a little while, then starts speaking the next bit of the text whilst dancing.)* And Aubrey ain't dancing with nobody else, he only dancing with me Shevaun, so ah come like his dancing partner, every night we dancing song after song after song, week after week after week, me and Aubrey just dancing.

Then we reach Tenerife and Aubrey say how he have to come of the ship and go and explore. Next thing I know Aubrey come back on the ship with a whole heap of presents saying they are for me. Ah said, 'Aubrey, don't take your eyes and pass mi giving mi presents and thing, yuh know, because we are not like that…ah am not no kind of kept woman yuh know and ah not going there, so if you hinting at something stop it right now yuh hear.' I said, 'we just dancing, we are dancing partners okay, we not like this eh.'

Well that night we were dancing and it was such a nice dance and we were dancing respectfully apart as you do in those days and then Aubrey became like this magnet and I felt myself drifting closer and closer to him *(Mimes dancing closer to some one, then continues talking whilst miming.)* And we get so close mi hands move up his back and mi head lean on his shoulders and we stop two stepping and start swaying. *(Mimes swaying with Aubrey after the text has finished – in silence – until only her hip starts to gyrate.)* And all of a sudden ah realise, 'wait nuh, Aubrey and I dancing hug up!' And is like Aubrey realise that I realise the same thing cos he take mi hand quick quick quick and put it back behind he back and he take mi other hand and put it back in he hand so we were dancing back respectfully.

And then Aubrey look at me and he say, 'Shevaun can I take your hand.' Ah said Aubrey yuh already have mi hand.' He said, 'no will I marry him.' Ah said, 'no Aubrey no.' Well that was the next challenge. Every night Aubrey just asking me to marry him, every night song after song after song, Ah don't understand what happen to the boy! I don't know! It got so much that one night we were dancing and I said, 'Aubrey stop whispering in mi ears, yuh just tickling it stop...........'

So ah decide that ah can't take it no more, so you know ah shy. Well I practise in front the mirror. Ah say *(She mimes the movement as if standing in front of a mirror.)* If he ask me to marry him tomorrow night. Ah go stop dancing in the middle of the dance floor and tell he, 'ah never wanted to dance with you in the first place, much lees marry you and ah can't take this stupidness every night so if you keep it up ah not going and dance with yuh on this dance floor ever again,' and then walk of and leave him on the dance floor. I had it all planned.

So that night we dancing and I kinda tensing up mi shoulder waiting for the proposal to come cos every night is the same damn thing, when Aubrey just kinda bow he head and he voice just get deep deep deep and he said, 'umm I will go down on bended knees, because I really really really want you to be my wife.' He say it too nice and ah open my mouth to say no. Ah swear ah go to say no and ah end up saying yyyesss, alright then.

And Aubrey get glad glad glad. Aubrey just drop mi hand turn round and announce it to the whole place, 'yes she said she go marry me.' People start to cheer and clap, he start to talk bout buying drinks and I just trying to repair mi dignity, ah saying, 'Aubrey stop telling everybody, Aubrey quiet nuh, hush up nuh.' But Aubrey just happy happy happy, then Aubrey just turn to everybody, clap he hand and say 'yes we have to get married and we getting married now now now.' Well I look at Aubrey, ah said, 'Aubrey we can't get married now you know.' Ah said, 'listen,' Ah said, 'I need a little white dress and mi little veil and ah need mi hand bag and the shoe to match you know.' Ah said, 'and what about the parents you know, my family and your family and things like that.' Well Aubrey just turn to me and he say, 'listen it take him so long to get me to dance with him much less to get me to agree to marry him that he ain't waiting until we get to Dover for me to change mi mind so we getting married now.' Well thank God we couldn't get married that day. But the Captain married us the next day. It was a lovely marriage. *(She sways, elbow crooked as if arm in arm with Aubrey and gazes at the ring o her hand for a long time.)*

Ah realise ah don't have to go to England on mi own anymore ah going with Aubrey, mi husband. *(She raises her palm to show of the ring, and her arm is still clasped.)* And I don't have to send for my family one by one anymore. I

can send for them two by two because of Aubrey *(She pats her arm as if Aubrey hand is there, and stands there gazing down loving at the ring. She even throws a snide gaze to the onlookers.)*

Well we reach England and England was cold, gosh it was cold. If yuh see England! Ah don't know how people living there, it was like a refrigerator ah tell yuh and the houses… every house brown brown brown look just like the other. I don't know how people does find they self in the street, how they does find they address. Ah getting lost everyday. And it was hard eh! Everywhere we go is just No No No, everywhere. You couldn't get no house, no job, no nothing. But yuh know we find a little place, is just a little room, but it will do yuh know. It was me and Aubrey sharing with five families. But sometimes yuh have to make do with what you get, you know. And everyday Aubrey going out to work in the cold cold and I staying home and every time ah knew that Aubrey was about to come home and Aubrey is a man he like his little dinner and his food, you know. Ah would prepare his food nicely for him. Ah would just set out the table and ah would put his little rice in a bowl and his little gravy in a bowl for him you know and his meat or fish or whatever ah cooked for him that day in a little bowl and ah would just do a little jug of his favourite juice and have his place laid out. Ah would lay it out nicely cos I wanted Aubrey to come home and feel like a king cos ah knew that life was hard for him so this was his little paradise. And every time he come home, he could just sit down and help himself and feel happy.

Well that day Aubrey come in the house and he wasn't… he didn't look all that good and he standing there and he look at the food and he look at me kinda…and ah look at Aubrey and ah say, 'Aubrey what's wrong?' And Aubrey just turned to me and he said, *(Aubrey's voice is deep and angry and builds up with every word.)* 'ah can't take it

Shevaun, ah can't take this country no more Shevaun. This country just driving me mad Shevaun. Every day I wuking wuking wuking for no money at all, I am an architect yuh know, an architect in my country and they have me washing dishes and working for London Transport and the landlord here, the landlord only talking to me like I am a little boy. I can't take it and yuh have a baby coming and we living in a house with all kinda people in one room, I wouldn't be treated like that at home Shevaun. We going back! We going back to Guyana.'

Ah said, 'ermm Aubrey, Aubrey we can't go back to Guyana.' Ah said, 'ah don't know if yuh realise but ah from Grenada and you from Guyana and we meet on a ship Aubrey and England is we home Aubrey so we can't go back to Guyana.' Ah say, 'Aubrey furthermore you know I have obligations to mi family Aubrey. Mi family put together all they money to send me to England and ah have obligations to send for every single one of them. Ah don't want to seem like a thief Aubrey. Ah can't leave here and go somewhere new again. Ah already uproot mi self Aubrey. Ah can't leave England. This is where ah am meant to make my home Aubrey. Yuh know things does start out a little hard but after a while yuh does make it, yuh know.' And Aubrey, Aubrey just look at me and said, 'ah can't take it no more, ah can't take this blasted country!' And he just box down the table with the food. And ah look at Aubrey and ah see how Aubrey just looking he shoulder all slump down and he head all buried in the ground and ah remembering that proud man who used to walk across the dance floor every night song after song to ask me to dance, yuh know and not take no for an answer. And ah looking at mi husband how he looking now and ah thinking to myself , 'well I not qualified. Ah ain't even start to get mi little nursing qualification yet,

yuh know. ah don't know how it feels to be qualified and be treated this way and is mi husband and is true we have a child coming. I have to think about mi husband first. ah look at him and ah say 'alright we going back.'

If you see Guyana! Guyana noisy noisy noisy. It not as quiet and nice as Grenada you know. In Grenada yuh have yuh little water that was blue, yuh have yuh little houses and yuh have people who ain't so loud and boisterous. Not Guyana! If yuh see what mi husband call he country! The place hot hot hot hot. I mean Grenada have a little sun but Guyanese sun was the worst and they mosquitoes just trying to kill you and the rain just falling hard hard hard, ah swear the rain water could kill you off with concussion. And the people loud loud loud loud, loud, everyday is pure noise. But the worst thing...when ah tell you the country huge the country ginormous. Grenada is a nice tiny little paradise not Guyana. But the worst thing ah ever see in Guyana is the seawater. The water brown brown brown, yuh ever see brown sea water? Guyana have brown sea water. But yuh know ah say to mi self well it can't be that bad because it create Aubrey mi husband so ah could learn to like it yuh know.

Then we went to meet the family. What can ah tell you about the family! We walk in and ah was so proud. Ah had Aubrey's hand and he was holding mine and we walk in together and ah thinking, 'hmm ah going to meet mi husband's family.' And ah put out mi hand to shake they hands and they just leave mi hand there, ah didn't know what to do. Ah didn't know whether to pull the hand back or leave the hand there and ah standing there and ah looking at Aubrey and ah smiling at the family. And then they decide to take the hand and shake it. They might as well not have, the handshakes limp limp limp.

Aubrey had five sisters and he mother and they just standing there staring at me like they see something sour. If yuh see they face! And he had a brother name Gordon. Well Gordon come out from behind the bunch and he come in front of me and Aubrey and he welcome we and he give a nice speech along the lines of, 'is nice to see someone manage to tie he brother down eventually you know and he'd like to welcome me to the family and he hope that we have a nice long and prosperous marriage.' The poor boy gave a lovely lovely speech, ah felt better. And then ah thought to myself, 'well, maybe this is the way Guyanese women does treat you when you first come to the house. Yuh know they does treat yuh a bit bad and things like that or maybe Aubrey ain't send them a letter and they in shock and they not recovering.'

Eh he! Then I find they coming to mi house and they having big conversation with Aubrey and everything and when the baby come they playing with the baby and everything, every time I come in the room and ah get involved with the conversation they getting quiet quiet quiet, after ah say my piece they all turn round and look at me and then they say, 'well anyway' and they carry on with what they saying. Well you know I didn't think too much of it. I thought, 'well maybe is a way of giving yuh a rough time until yuh know, until yuh, yuh know, until yuh sort yuh self out or until they welcome yuh. This might just be the way Guyanese women are.'

One day ah cooking in the kitchen and ah putting a lot of love in the food cos ah thinking if yuh put a lot of love in the food yuh going to get love back and ah set out the food and everything and ah call them all to eat. They just look at the food and then they start saying how, 'they ain't eating no food from me, they don't know what Grenadian cooking ah doing, but all they know is ah not minding they

brother how he getting skinny skinny skinny and meagre meagre meagre and they don't like it and they don't...' and they start to carry on about my food and then they start saying how, you know, 'they not able with this and they need to look after their brother because he is their brother and family so they going to cook and bring food to mi house for their brother.' Ah thought they was being funny, ah laugh you know. But then Monday, Tuesday, Wednesday, Thursday, Friday, Saturday, Sunday, they bringing food and they not bringing one dish yuh know. They bringing BREAKFAST, LUNCH AND DINNER EVERYDAY.

Well one day ah couldn't take anymore yea. So ah look at Aubrey and ah say, 'Aubrey, Aubrey darling yuh better talk to yuh family and them, yuh know. Yuh better talk to them and tell them to stop bringing food to mi house. Furthermore I need it to stop today cos yuh see tomorrow morning – Saturday morning, don't make no food pass mi gate.' Aubrey look at me and say how this is all women's business and he don't know why ah trying to involve him, why ah can't deal with the situation mi self and he ain't getting involved. Ah say, 'but Aubrey,' Ah say, 'Aubrey who did yuh marry? Who Did Yuh Marry? I am Mrs Aubrey Blake, yuh know. They are Miss Blake, so yuh have to sort out yuh priorities. Ah mean where are yuh priorities Aubrey?' Well the priorities talk must have sparked something in Aubrey cos all of a sudden he say how yes he will talk to them. I say, 'hmm right.'

Well ah know Aubrey talk to he sisters and them. Ah know Aubrey talk to them. So when ah look out mi gate and mi window on Saturday morning and ah see dust making it way down mi road, ah say no. Ah had to look again. Ah say, 'no.' Ah say, 'Aubrey, Aubrey ah thought I told you to talk to you sisters.' Aubrey say, yes he talk to his sisters.

Ah say, 'but Aubrey look outside,' ah say, 'that's not your sisters coming down the road?' Aubrey say, 'yes,' but he say how he ain't got time to deal with them and he ain't got time for this. So ah say to him, 'Aubrey go out and talk to them and tell them don't come back in mi house. Don't come back in mi house with no food Aubrey, don't…' Aubrey say well he ain't got time for this for true and he went to the furthest back room and ah swear ah hear the bolt slide on the door. Ah say, 'alright.' Ah say, 'alright Aubrey you leaving me to deal with this myself, well ah could deal with it.' And ah go out to deal with them. Well ah walk out on the front landing and ah standing there, but then ah realise, 'wait nuh they going to have to walk up the stairs and walk in the gate to get up here,' So ah said, 'no no no no no that mean food passing into my house in some way or form. No.' So ah walk down the stairs and ah waiting there to deal with them, yuh know. But then ah realise they going to have to walk over the bridge and through the gate and ah say, 'no that can't happen either,' so ah walk outside and ah waiting on the bridge and ah was so frightened, let me tell yuh, because the person leading the pack is Aubrey' eldest sister called Mindy. I have to tell yuh bout Mindy.

When we first come to Guyana we was walking down the road. Aubrey went out and buy these shiny bicycles, yuh know the latest bicycle that was in, shiny shiny and we walking. We say we going for a walk but is show of we showing off and we walking down with the bicycles yuh know. It was me, Aubrey and Mindy and this fella spit, he didn't spit at Mindy yuh know cos ah swear Mindy was over here *(Points to one side of the stage.)* and the fella spit land way over there, *(Points to the other side of the stage.)* But Mindy find that the fella spit at she so she drop she shinny new bicycle and run across and start to beat up the fella. I

turn to Aubrey and say, 'Aubrey, Aubrey go and help yuh sister nuh, go and help she yuh don't see Mindy fighting in the street.' Aubrey say, how Mindy can fight she own battles, she been fighting them forever and she too hot tempered and he not getting involved. He tell Mindy about that temper.

So ah standing up there in front of the bridge waiting *(She stands, hands on her hips.)* and is Mindy who leading the pack, yuh know and Mindy ain't short yuh know. Mindy is six foot two and I am my little short height. And ah standing there and ah looking at Mindy, but ah say to mi self, 'if Mindy think she is breeze I am the hurricane. If she feel that she is some kind of bird spreading she wings today today today, Ah waiting for Mindy. Ah waiting to clip them wings for she.' When ah find they come far enough ah say, 'stop, stop right there.' And ah thought to myself, 'start off polite yuh know.' So ah said, 'good Morning Mindy,' ah said, 'ah don't know if Aubrey told yuh, because ah told him to speak to yuh and tell yuh. Ah don't want any food coming in mi gate anymore.' Ah said, 'you know ah really appreciate what yuh and yuh family are doing.' Ah said, 'don't think that this is ungratefulness but yuh see ah can provide for Aubrey and furthermore it was nice when you was bringing the food and everything when the baby was first born yuh know, helping me out and thing, but the baby is two now so ah don't need yuh help anymore.' Ah said, 'so ah would appreciate it if from today no food pass mi bridge.' Ah thought ah handle it very nice too and ah standing there congratulating mi self entirely.

Mindy square up she shoulder and ah tense eh! And Mindy say how she ain't know what ah come out in the street to bring she business out in the street for but all she know is since they been cooking for mi husband, mi husband looking nice and fat and thing and the Grenadian

food that ah feeding mi husband not good for he and how it not good for he at all, he getting sick from it and they don't know what food ah cook on the street to give she brother to tie him down but they going to protect they brother interest and they don't want no damn thief-ing upzucky Grenadian woman cooking he food. Well ah had enough and ah bawl, 'Mindy Mindy stop right there.' Ah said, 'ah come out here today polite polite polite, ah don't want to cause no trouble in the street but yuh insulting me, yuh insulting me in front of mi own house. Leh me tell yuh something Mindy, leh me tell yuh something I didn't try to throw any kinda vexness at yuh at all, when you was coming up bringing yuh self in mi house. But cooking food and bringing it into mi house that is another thing! Ah am a West Indian Woman and ah know how to cook for mi husband yuh hear me. Ah don't care if he is yuh brother or whatever else that ended when ah marry him. So leh mi tell yuh something now, yuh ain'ts bringing no food into mi damn house today today today, yuh ain't bringing no food and furthermore leh mi tell yuh something else don't come into mi house unless yuh have some respect and don't put no food across this line *(She draws an imaginary line in the ground while she is saying this line.)* today at all.' And like Mindy must of find that ah carry on very Badjohnist yuh know, because she tek she self and she turn round and she start to walk of. Ah start to feel nice. Then she turn round walk back up and put the pot over the line. Well ah find that was going too far, ah just tek up the pot man and pelt it at she. 'Ayayyy! Stups!' And ah wiping mi hands *(Slaps her hands together.)* and ah thinking, 'well that done, that business done, ah going to forgive Aubrey yuh know because Mindy is erm Mindy is something else.' I go back in and I saying, 'good Morning' to Aubrey, now you know, all now Aubrey ain't say good morning.

Aubrey look at me and tell me how ah nearly give he sister concussion just now and ask, how ah could carry on so in the street.

Well ah had to look at Aubrey. ah say, 'Aubrey what is your opinion exactly of the affair between me and yuh sisters? Cos yuh don't look like yuh have an opinion and yuh don't look like yuh taking sides.' Ah say, 'Aubrey.' Aubrey look at me and tell me how he ain't able for no nagging in he ears this Saturday morning, he going to the rum shop and drink some drinks with the boys. Ah say, 'Aubrey we having a reasonable discussion, we trying to iron out something, yuh can't go out to no rum shop until we finish. Aubrey yuh can't go out to no rum shop.' I said, 'yuh have to take a side in this affair Aubrey. Aubrey where yuh going? Aubrey Aubrey... Yuh know Aubrey walk out the door while ah talking to Aubrey. That is rudeness. Tell mi how Aubrey could walk out while ah talking to him.

Ah hear something coming up the stairs, you know. Ah say, 'if that is Aubrey, is me and Aubrey, cos mi mother didn't bring up nobody so! I ain't drag up! Yuh have to finish a conversation before yuh leave.' and ah open the door.

But it was Gordon. If yuh see Gordon! Gordon standing there and the sun just beating on he brown skin and he gold teeth just sparkling and he white shirt looking sooo starched and nicely pressed. Oh Gosh!

I said, 'umm Gordon, yuh just miss Aubrey yuh know, he just went to the rum shop to drink some drinks so yuh can catch him.' And Gordon look at me and he say, 'umm is not Aubrey ah come to see yuh know, is yuh.' Ah say, 'eh he! well come in.' Well Gordon come in to tell me how he talk to the sisters and them and they say how, yuh know, they find it disrespectful to be bringing food to mi house and they understand my position and he just coming to

apologise on behalf of the family and tell me that that wouldn't be happening again. Ah said, 'yuh did that for me Gordon, yuh did that for me.' Ah said, 'well it's nice to know someone listens to me in this family and that someone has my…my welfare at heart, you know and its nice to know that someone sticking up for me.' Ah say, 'well thank you kindly,' and ah show him to the door.

Well as ah standing there, ah think, 'well, yuh know Shevaun, yuh should go to them market women that yuh does see.' They have these Market women they right at the back back back of the market but they really nice, ah does go to them all the time to get a little Guyanese recipe trying to build up on mi Guyanese cooking and ah hear they have this dish in Guyana name pepper pot, some brown brown dish with sugar or something in it, it sweet sweet sweet. But Guyanese like it and mi husband like it. So ah say, 'well leh me go and find out how to do it, yuh know.'

And ah making mi way in the market and the market loud loud loud and everybody shouting and they have nice mangoes over there and they have some fresh big leaf thyme, yuh know and ah smelling it and ah sniffing and ah looking at the vendors and ah thinking how the market so busy but ah know where ah going to the back of the market.

Yuh know when people have they stall at the back of the market is not because they trying to sell yuh know, is because they trying to make friends and talk people business. Well is them two women ah does go and see. So ah making mi way to the back of the market. Well when ah get to the stall now, the two women like they busy talking, so while they talking I feeling up the food and smelling it and ah just biding mi time. And as yuh biding yuh time yuh can't help but listen. Yuh ain't eavesdropping yuh

know, yuh just listening to the conversation. So I just stand there and ah listening and they talking bout some woman, some woman who…and they saying things like, 'well you know every night she washing she husband' shirts and she ironing dem up and she dressing him up to go out and she shining up he bicycle and feeding him she don't is woman he going and see, is woman he going and see. He going to all kinda dances: Bel air dance and Rendezvous dance and family picnic dance and he waltzing up with the woman and he dancing hug up with the woman.' And I standing there, yuh know, minding mi own business, listening but not eavesdropping, because ah can't go on mi way ah waiting for them to done their conversation. Ah held up the time, *(Holds up her hand like she is holding up a wrist watch.)* and ah thinking, but Aubrey would never do something like that, thinking, at least Aubrey does just go to the little rum shop and have a little drink with the boys and them. But then they carry on talking and they start saying, 'well is the family fault because the family want the man to get married to this light skin woman but the man come back from England with a wife.' And I thinking ah wonder if ah know she, so ah could commiserate and thing with the woman cos people shouldn't be treated that way. But ah still not eavesdropping, ah listening. And they still talking! Then they start to say, 'well you know the family is terrible. The family don't eat the wife' food cos the wife is Grenadian.' Well ah stop listening and ah start listening. They say, 'the family don't eat the food cos the wife is Grenadian and they don't like the wife cooking, but every Sunday they does tek themselves and go to the woman' house with the man and have dinner.' ah listening and ah thinking, 'hold on is not Aubrey and he family they talking about nooo!' And then they look at me and yuh know Caribbean women have this way when they

talking and they throwing words for yuh that they does
try to indicate that is you they talking to. So they start to
look mi in mi face and ah stop feeling up the food now
and standing there kinda looking at them and they say,
'well the Grenadian woman nice you know, not saying no
names or anything, but she does come to us for she little
recipes and things like that.' And ah looking at them and
ah start shaking mi head so *(Shakes her head to indicate no.)*
and they start shaking they head so *(Shakes her head in a yes
motion.)* and I realise eh he! Is Aubrey and he family they
talking about! I come to the market to try and cook food
and find recipes for this man and finding out about salt, pot
and cooking. And the cooking have a lot of spice in it I see.
And ah standing there and ah thinking, 'this is my husband
they talking about,' and ah feeling so shame cos ah still
shaking mi head so and they going *(Shake her head in a yes
motion.)* and they saying, 'well what you come for today,
you ain't come for a recipe and you ain't Grenadian?' And
ah realise, 'yes is Aubrey my husband they talking about.'
And ah making mi way from the market and ah thinking to
mi self, 'Aubrey have me every night going by the sea wall
with him for a little walk with the baby and ah holding on
to he hand thinking this is mi husband and everything and
ah proud proud proud and he have the whole of Guyana
talking mi business. I hearing about things from market
women, no no no! And ah making mi way home thinking
about Aubrey going to the rum shop, not standing up for
me, and he family coming and making mêlée in my house.'
And ah thinking and ah going home and when ah get
home Iah just take a chair and ah sit in front of the front
door because Aubrey wasn't home, I think he was still
in the rum shop eh! And ah sit down in the chair and ah
waiting for Aubrey *(Sits in silence for a while, each few minutes*

she says.) 'and ah waiting for Aubrey. And ah waiting, ah waiting for Aubrey.'

Well Aubrey walk in smiling. So ah say, 'good afternoon Aubrey.' Ah say, 'Aubrey darling you had a nice time today? yuh had a nice day?' He said, 'yes.' Ah say, 'good.' Ah say, 'yuh had a nice night on Friday night Aubrey?' Aubrey start to scratch he head and think. Ah say, 'well since we playing these questions and answers ah want to ask yuh, yuh and yuh family had a nice dinner on Sunday Aubrey?' And Aubrey start to mumble. ah say, 'ooh,' ah say, 'ah asking yuh questions and yuh thinking Aubrey! yuh thinking! When ah was standing on the ship minding mi own business and yuh was walking up and down the dance floor yuh had a lot to say for yuh self, yuh wasn't thinking then, nooo yuh wasn't thinking and when you was dancing asking mi to marry yuh, putting up yuh long campaign, yuh wasn't thinking then, nooo, yuh wasn't thinking! Nooo! And when we was in England and ah had mi obligations to mi family and yuh knew what yuh wanted, yuh had plenty of words then to tell me Aubrey. Yuh wasn't thinking. But when yuh family was coming to mi house disrespecting me, I didn't know they was disrespecting me because they taking they leaf from yuh. Yuh walking out deh… Aubrey yuh mean to say ah had to be in the market, in the market getting my affairs from market women Aubrey. Eh! That is what yuh bringing me to and then ah asking yuh questions and yuh just standing there and yuh thinking Aubrey.' Ah say, 'but Aubrey what have you got to say for yuh self?' And yuh know, when people, they guilty as sin, so they ain't have nothing to say so they does just pull things out of the air. Aubrey look at me and tell me well at least he mother never open she legs, 'what,' twelve time to make no twelve children.

Ah say, 'and…that's…what…you…have…to…tell…
me… Aubrey.' Ah say, 'eh he,' ah say, 'that's what you
have to tell…' Ah say, 'let me tell you something at least
my mother open she legs twelve times to make twelve
children, ah am one of those children Aubrey, yuh marry
one of those children. Eh! When yuh family was doing
me all they was doing I din bring up…ah never cuss yuh
family in mi life, never bring yuh family into we argument.
Well if yuh bringing me family into yuh argument ah have
to tell you something. Leh mi tell yuh something. Yuh see
mi mother she marry mi father. From the time she marry
he, he knew where he obligations lie. He wouldn't ah let
no sisters come to the house bringing food for him. Cos he
woulda realise he cut he nappy strings already and how he
ain't got no bottle in he mouth. He would ah cut that tie
already. So if yuh want to talk to me bout mi family, let me
tell yuh bout your family and yuh, cos you are not a man
Aubrey, you are a little boy! You are a little boy! Yuh can't
stand up for what yuh want in life. Furthermore tek yuh
things, tek yuh things, go on and get out mi house today
Aubrey. Yuh not staying in this house today Aubrey' / and
Aubrey just *(She slaps her right palm against her cheek and
stands there in shocked silence.)*

Aubrey…slap…me! Aubrey trying to be wrong and strong
and slap me! I CAN'T BELIEVE AUBREY LOSE HIS
FUCKING MIND IN HERE TODAY AND THINK
THAT HE SLAPPING ME SHEVAUN AFTER ALL HE
PUT ME THROUGH.

And then he standing there and he just smiling at me! He
smiling! And I looking at him and I thinking 'if is me and
you you want to have it out today then me is me and you
having it out and I sight ah broom stick and I thinking, 'I
going to take that smile of you blasted face today Aubrey'
and I pick up the broom stick and ah looking at Aubrey

and ah thinking after all you put me through you have the fucking cheek to slap me and ah pick up the broomstick *(Mimes clasping a broom stick with both hands.)* and I look at Aubrey and I look him and I look at the smile *(Holds on to the broom stick with both hands and slashes it into the air each time she says hit him.)* And I hit him. And I hit him. And I hit him. And I hit him. And I keep hitting him. Aubrey start to bawl for murder and police and ambulance and everything. And the neighbours pulling Aubrey and they pulling me, *(Moves backwards, arms pulling back as if someone is pulling them, but she pulls it away to deliver more hits.)* And I still hitting him. And I hitting him. And I hitting him.

I woulda kill Aubrey in that house today. My father never raise his hand to me and my husband coming in my house have to be wrong and hitting me. NOOOO!

He had to sleep **out** that night, because he knew, he would **ah dead** that day.

(There is a long pause where she stands thinking.)

Well hear nuh! The next morning I just kinda thinking bout Aubrey and how he carrying on and the family and Guyana and things like that and the doorbell ring and ah open the door and is Gordon. So I say, 'come in Gordon.' And Gordon come in to tell me how Aubrey stay by Mindy last night. I say, I don't want to know that, I don't want to know where he stayed. And Gordon said, oh ho!

And Gordon sitting there so I want to talk small talk with Gordon. I don't want to involve Gordon in what happening between me and he brother, you know. But I find mi self just looking at Gordon and saying, 'Gordon you find that I don't look the same as when I first came here? I put on a little weight you know. And you know sometimes yuh does have a baby and when you have the baby yuh does spend so much time with the baby, that

you does forget how to talk to people. Maybe I don't know how to talk to yuh brother anymore, you know. Maybe I don't fix up mi self anymore and things cos I always in the house and maybe that's why yuh brother…'

And I trying to think when was the last special time I had with Aubrey and I thinking wait it was on the ship when we was dancing.

And ah saying, 'Gordon, I don't know when last ah danced. I think Aubrey and I used to have special times on the ship when we used to dance with each other and since then life just kinda take us away from that, now he dancing hug up with some woman, maybe I can't dance anymore you know. Maybe I just not showing any interest in that kind of thing and maybe maybe Aubrey just getting bored. And Gordon just look at me and stand up and walk over to me and he said, 'Umm, *(Voice gets deep.)* Shevaun may I have this dance?' Well I look at Gordon, I mean here I am telling Gordon all mi problems, telling Gordon how ah feeling, I feeling so bad and he asking me to dance! And while ah looking at him he turn round and walk over to the record player and take out the record *(Blows as if blowing dust of the record.)* and take out the needle *(Sound of breath blowing the needle, then the sound of a record starting to play.)* and then he walking back over to me and I looking at him like… I can't believe he asking me to dance. And he put out his hand and he just kinda, just pull me up, He put his hand in mine and he put mi hand behind he back and he take mi other hand in he own and he put he other hand around mi waist and then *(Sways dancing with another person for a long while in a two step waltz, then moves closer till her arms are around his neck and they are dancing hug up and just moving their hips.)* and then I hear a noise outside and Gordon and I just jump apart and Gordon just jump and run and take of the record and I standing there looking,

all you know. *(She fiddles with her clothes and pretends to look innocent.)*

It was Aubrey. If you see Aubrey! Aubrey look ah state. And ah turn round and ah look at Gordon *(Looks for a long time.)* and I look at Aubrey *(Gives Aubrey a weird look.),* and ah think about the child that me and Aubrey have…and then ah look at Gordon again *(Loving look.)* and ah look back at Aubrey. Ah say Aubrey you want something?

'I Will Not Put Another Dead Young Black Man on Stage'[1]

Forget the vogue for tales of knife crime and hoodies – I'm interested in the full range of the black British experience. Talawa, the UK's largest black-led theatre company, has been around for almost a quarter of a century. We've survived and persevered through funding trouble and a major shift in the company's focus and weathered political change. At the same time, we have always strived to produce work that showcases the best of black British talent in everything from Shakespeare, Wilde, Walcott and Soyinka to now, where we focus on producing new black British writing.

As artistic director of Talawa, I've felt strongly for a long time about the portrayal of young black people in theatre. I am interested in stories that talk about the full range of the black British experience, that draw on our lives to create universal theatre rather than ghettoise black experience to a narrowed, archetypal representation. Romances, comedies, musicals, examination of class and history – the synergies created when immigrants arrive: these topics interest me. Another play that assumes black men are violent, profligate and oversexed, or that black women are earth mothers, church sisters or sexual predators does not.

I may be accused of ignoring the most serious issue facing black Britons. I don't agree. I feel that gang violence is only a symptom of a much deeper malaise. Young black people are growing up in a society where they are frequently stereotyped and alienated. They respond in many dynamic and creative ways – but we don't hear much about that. What makes it into the newspapers and on to the stage is dysfunction, criminality and violence. And if programmers can't find enough of these things in the work of Roy Williams, Kwame Kwei-Armah or debbie

[1] This article was first posted as a blog: Wed. 4 March, 2009, 09.48 GMT. http://www.guardian.co.uk/stage/theatreblog/2009/mar/03dead-young-black-man-stage

tucker green, they may import plays such as *The Brothers Size* and *The Emperor Jones* to keep the stereotypes going.

Die-hard black theatre lovers will go to those plays and admire the craft of them. But if you want to see black audiences actually enjoying themselves at the theatre, look at Kwame Kwei-Armah's *Statement of Regret*, Karena Johnson's *Sweet Yam Kisses*, Angie Le Mar's *The Brothers* and even the continued sell-out performances of *Black Heroes in the Hall of Fame* for a clue.

I am much more interested in creating theatre that explores the complicated and dynamic relationship between Europe and Africa and the creativity that is released when cultures meet. I find it terribly frustrating that the gatekeepers at most theatres – the programmers, artistic directors, marketeers and such – are not excited by this work or the audiences they could potentially attract. Instead, it's preferable to find work considered 'urban and gritty' (and usually working class) on the stage and believe that it represents the black experience. It does not.

But, perhaps, the time for explaining why a diversity of stories should be told has past. The question then becomes: how do black theatre practitioners put their own stories on the main stage of those big theatres?

Patricia Cumper
(formerly Artistic Director, Talawa Theatre Company)

References and Some Further Indicative Critical Studies on Black British Culture and Drama

Addai, Levi- David. *Blacklands* unpublished manuscript. Courtesy of the author. 2011.

Alibhai-Brown, Yasmin, 'Black art can be bad, just as art by whites' *The Independent* 5 February, 2005. www.independent.co.uk/opinion/commentators/yasmin-alibhai-brown/yasmin-alibhaibrown-black-art-can-be-bad-just-like-art-by-whites-489793.html.

Anim-Addo, Joan. 'The Black Woman as Subject and Object in Britain from 1507.' Joan Anim-Addo and Suzanne Scaffe, eds. *I Am Black/White/Yellow: An Introduction to the Black Body in Europe*. London: Mango Publishing, 2007. pp.17-37.

-----. 'A Brief History of Julian "Lily" Mulzac of Union Island, Carriacou and Grenada: Creole Family Patters and Scottish Disassociation.' Giovanna Covi, Joan Anim-Addo et al. *Caribbean-Scottish Relations: Colonial & Contemporary Inscriptions in History, Language and Literature*. London: Mango Publishing, 2007b. pp.46-92.

Arana, R. Victoria. ed. *Dictionary of Literary Biography: Twenty-First-Century "Black" British Writers* Sumter, South Carolina: Bruccoli, Clark, and Layman; & Detroit, Michigan: Gale Research Company, 2009.

----- ed. *"Black" British Aesthetics Today* Newcastle: Cambridge Scholars Publishing, 2007.

----- and Ramey, Lauri. eds. *Black British Writing* New York: Palgrave Macmillan, 2004.

Armstrong, Stephen. 'Now you see us, now you don't' *Guardian* 4 December, 2006. http://www.guardian.co.uk/media/2006/dec/04/mondaymediasection32?INTCMP=SRCH

Association of Black Social Workers and Allied Professionals (ABSWAP), *Black Children in care: Evidence to the House of Commons Social Services Committee*. London: ABSWAP, 1983a.

Aston, Elaine. and Harris, Geraldine. eds *Feminist Futures?: Theatre, Performance, Theory* New York: Palgrave Macmillan, 2006.

Bakhtin, M.M./ V.N. Volosinov. *Marxism and the Philosophy of Language* L. Matejka and I.R. Titunik (trans.), Cambridge MA and London: Harvard University Press, 1986.

Bal, Mieke. "Guest Column: Exhibition Practices." *PMLA* 125.1 (2010), pp.9-23.

Baluch, Layayn. 'British East Asian artists lambast "racist" British theatre for lack of acting roles' 9 June, 2009. http:/www.thestage.co.uk/news/newstory.php/24658/british-east/ Accessed 05/10/12.

Barn, Ravinder. *Black Children in the Public Care System*. London: Batsford, 1993.

Baucom, Ian. *Out of Place: Englishness, Empire, and the Locations of Identity*. Princeton, New Jersey: Princeton University Press, 1999.

Benítez-Rojo, Antonio. *The Repeating Island: The Caribbean and the Postmodern Perspective* translated by James Maraniss, London and Durham: Duke University Press, 1992.

Booker, Malika, *Breadfruit*. London: Flipped Eye Publishing, 2007.

Brewster, Yvonne. ed. *Black Plays*. London: Methuen, 1987.

-----. *Black Plays Two*. London: Methuen, 1989.

-----. *Black Plays Three*. London: Methuen, 1995.

Bromley, Roger. *Narratives for a New Belonging* Edinburgh: Edinburgh University Press, 2000.

Brown, Stewart. and MacDonald, Ian. eds. *Poems by Martin Carter* Oxford: Macmillan Caribbean, 2006.

Bryer, Jackson R. and Mary C. Hartig, eds. *Conversations with August Wilson*. Jackson: University of Mississippi Press, 2006.

Caballero, Chamion., Edwards, Rosalind. and Puthussery, Shuby. *Parenting 'Mixed' Children: Negotiating Difference and Belonging in Mixed Race, Ethnicity and Faith Families*. London: Joseph Rowntree Foundation, 2008.

Carter, Martin. 'You Are Involved' from *The Kind Eagle* (1952) in Brown and MacDonald (eds), 2006. p.10.

Chambers, Colin. *Black and Asian Theatre in Britain* London and New York: Routledge, 2010.

Cochrane, Clare. *Twentieth Century British Theatre: Industry, Art and Empire* Cambridge: Cambridge University Press, 2011.

Cohen, Philip. 'Yesterday's Words, Tomorrow's World: From the Racialisation of Adoption to the Politics of Difference', in Gaber, Ivor. and Aldridge, Jane. eds. *Culture, Identity and Transracial Adoption: in the Best Interests of the Child*. London: Free Association Books, 1994. pp. 43-76.

Collins, Merle. 'Beyond' in Searle (1984), pp.58-60.

Craine, Debra. and Mackrell, Judith. *The Oxford Dictionary of Dance*. Oxford: Oxford University Press, 2000.

Croft, Susan. *Black and Asian Performance at the Theatre Museum: A User's Guide* Theatre Museum: London, 2002.

Cumper, Patricia. "I will not put another dead young black man on stage." Posted Wed. 4 March, 2009, 09.48 GMT. http://www.guardian.co.uk/stage/theatreblog/2009/mar/03dead-young-black-man-stage accessed 22/12/09.

Dabydeen, David., Gilmore, John., and Jones, Cecily. eds. *The Oxford Companion to Black British History* Oxford: Oxford University Press, 2007.

Davis, Geoffrey. and Fuchs, Anna. eds. *Staging New Britain: Aspects of Black and Asian British theatre Practice* Oxford: Peter Lang, 2006.

Dodd, Vikram. '90% of whites have few or no black friends' *The Guardian*, 19 July 2004. p.1.

Dokoupil, Tony. 'Raising Katie' *Newsweek* 22 Apr. 2009,

http://www.thedailybeast.com/newsweek/2009/04/22/raising-katie.html
accessed 19/07/12

Donnell, Alison. ed. *Companion to Contemporary Black British Culture* London and New York: Routledge, 2001.

Eliot, T.S. *Christianity and Culture: The idea of a Christian Society, and Notes towards the Definition of Culture* New York: Harcourt, Brace and Co.,1949.

Evaristo, Bernardine. 'Going it…alone: solo performers – the art and the ache'. *Artrage* November 1994. pp.14-15.

Flynn, Ronny. 'Black Carers for White Children: Shifting the Same-Race Placement Debate', *Adoption and Fostering Journal of the BAAF*, Vol. 24, No.1, (2000), pp.47-52.

Frankenberg, Ruth. *Displacing Whiteness: Essays on Social and Cultural Criticism*, Durham, N.C: Duke University Press, 1997.

Fryer, Peter. *Staying Power: The History of Black People in Britain* London: Pluto Press, 1984.

----. *Aspects of Black British History* London: Index Books Ltd, 1993.

Gainor, Ellen J. ed. *Imperialism and Theatre: Essays on World Theatre, Drama and Performance* London: Routledge, 1995.

George, Kadija. *Six Plays by Black and Asian Women Writers* London: Aurora Metro, 2005.

Gerzina, Gretchen. ed. *Black Victorians: Black Victoriana*, New Brunswick: Holbrook, 2003.

Goddard, Lynette. *Staging Black Feminisms: Identity, Politics, Performance* Hampshire, GB and New York: Palgrave Macmillan, 2007.

-----. '"Death never used to be for the young"'. *Contemporary Black British Women's Writing*. ed. Deirdre Osborne. Special Issue for *Women: A Cultural Review* 20.3 (2009), pp. 299-309.

Godiwala, Dimple. ed. *Alternatives Within the Mainstream: British Black and Asian Theatre* Newcastle-upon-Tyne: Cambridge Scholars Press, 2006.

-----. ed. *Alternatives Within the Mainstream II: Queer Theatres in Post-War Britain* Newcastle-upon-Tyne: Cambridge Scholars Press, 2007.

Goodison, Lorna. *Goldengrove: New and Selected Poems.* London: Carcanet Press, 2006.

Griffin, Gabriele. *Contemporary Black and Asian Women Playwrights in Britain* London: Cambridge University Press, 2003.

Griswold, Wendy. *Renaissance Revivals: City comedy and Revenge Tragedy in the London Theatre 1576-1980* Chicago and London: The University of Chicago Press, 1986.

Hall, Stuart. 'Race Culture and Communications: Looking Backward and Forward at Cultural Studies', *Rethinking Marxism*. Vol. 5, No.1, 1992, pp.10-18.

Hamilton, Gloria. *Mercy* in Searle ed. (1984), pp. 79-108.

Harris, Perlita. *In Search of Belonging Reflections by Transracially Adopted People.* UK: British Association of Adoption and Fostering (BAAF), 2006.

Higgins, Charlotte. 'Actors' union rallies theatres to create more parts for women'. *Guardian* 30 June, 2012. p.15

Hirsch, Afua. 'Clybourne Park: The joke's not funny if only middle-class white people laugh', 18 September, 2010.

hooks, bell. *Black Looks: Race and Representation.* Boston, MA: South End Press, 1992

Howe, Darcus. 'Review of *Fallout* Theatre Record, Vol. XXIII, No. 11-12 (2003), p.760.

http://www.bnvillage.co.uk/news-politics-village/96096-more-blacks-appear-adopting-white-children.html accessed 28/08/11

http://www.thedailybeast.com/newsweek/2009/04/22/raising-katie.html accessed 21/08/11

Johnson, Catherine. 'Where are Britain's black writers?' *Guardian* 5 December, 2011, p.31.

Jules, Didacus. 'A British Anti-Imperialist Lion in the Grenada Revolution' *Race and Class* Special Issue on Christopher Searle, Vol.51, No.2, 2009. pp.109-11.

Kennedy, Maev. 'Black history Archive Project Set Back by Collapse of building Firm', 7 May, 2012.

http://www.guardian.co.uk/culture/2012/may/07/black-history-archive-collapse-firm?INTCMP=SRCH accessed 10/05/2012.

King, Bruce. *The Internationalization of English Literature* Oxford: Oxford University Press, 2004.

Kirton, Derek *Race, Ethnicity and Adoption*, England: Open University Press, 2000.

Knowles, Caroline. *Family Boundaries: The Invention of Normality and Dangerousness.* Canada, New York and Essex: Broadview Press, 1996.

Kolawole, Helen. 'Look who's taking the stage' 26 July, 2003.

http://www.guardian.co.uk/stage/2003/jul/26/whoswhoinbritishtheatre.features?INTCMP=SRCH Accessed 12/05/2012.

Kwei-Armah, Kwame. Interview http://www.youtube.com/watch?v=6jzPWjdRniU - accessed 21/08/2011.

-----. *Elmina's Kitchen.* London: Methuen Books, 2003.

-----. *Plays by Kwame Kwei-Armah Vol.1.* London: House of Theresa Books, 2001.

Lavrijsen, Ria. *Black Theatre on the Move.* Amsterdam: Nederlands Theater Instituut, 1990.

Low, Gail. and Wynne-Davies, Marion. *A black British canon?* Basingstoke: Palgrave Macmillan, 2006.

Macpherson, William. *The Stephen Lawrence Inquiry: Report of an Inquiry by Sir William Macpherson of Cluny, Advised by Tom Cook, the Right Reverend Dr John Sentamu, Dr Richard Stone.* London: The Stationery Office, 1999. Cm 4262-I

Malika's Kitchen. *a storm between fingers.* London: Flipped Eye, 2007.

McAlmont, David. 'Black Actor, White Script? Posted 17/05/2012, GMT 00.00 http://www.huffingtonpost.co.uk/david-mcalmont/black-actor-white-script_b_1520237.html Accessed 26/06/2012.

McGuinn, Caroline. Review of Clybourne Park. *Time Out* 9 September, 2010.

McLeod, John. 'Some Problems with "British" in a "Black British Canon"' *Wasafiri* Vol. 36, 2002. pp.56-59.

-----. 'Extra Dimensions, New Routines: Contemporary Black Writing of Britain.' *Wasafiri* Vol.64, 2010. pp. 45-52.

McMillan, Michael. 'Re-baptizing the World in Our Own Terms: Black Theatre and Live Arts in Britain' *Canadian Theatre Review* No.118, Spring 2004. 54-61

Mercer, Kobena. *Welcome to the Jungle: New Positions in Black Cultural Studies*. London and New York: Routledge, 1994.

Middeke, Martin., Schierer, Peter Paul., and Sierz, Aleks. eds. *Methuen Modern British Playwrights* London: Methuen Books, 2011.

Mirza, Heidi Safia. ed. *Black British Feminism: A Reader* London and New York: Routledge, 1997.

Newland, Courttia. and Sesay, Kadija. eds. *IC3: An Anthology of Black British Writing* London: Penguin Books, 2000.

Olumide Jill. *Raiding the Gene Pool: The Social Construction of Mixed Race*. London: Pluto Press, 2002.

Osborne, Deirdre. 'Black British Drama' in *A History of British Drama: Developments, Interpretations* Baumbach, Sibylle., Neumann, Birgit., and Nünning, Ansgar eds. Trier: Wissenschaftlicher Verlag Trier, 2011. pp.429-49.

-----. Personal Interview with Kofi Agyemang and Patricia Elcock, 13 December, 2011b.

-----. '"How Do We Get the Whole Story?": Contra-dictions and Counter-narratives in debbie tucker green's Dramatic Poetics' in Tönnies, Merle. and Flotmann, Christine. eds. *Narrative in Drama* Trier: Wissenschaftlicher Verlag Trier, 2011c. pp.181-206.

-----. '"I ain't British though / Yes you are. You're as English as I am": Belonging and Unbelonging in Black British Drama' in Linder, Ulrike., Mohring, Maren., Stein, Mark., and Strothe, Silke. eds. *Hybrid Cultures, Nervous States: Britain and Germany in a (Post)Colonial World*. Amsterdam & New York: Rodopi, 2010. pp.203-227.

-----. "No Straight Answers: Writing on the Margins, Reclaiming Heroes" *New Theatre Quarterly* Vol. XXV, Part 1 February, 2009. pp.6-21.

Owusu, Kwesi. ed. *Black British Culture and Society: a Text Reader* London and New York: Routledge, 2000.

Parks, Suzan-Lori. 'An Equation for Black People Onstage.' in Parks, Suzan-Lori. *The America Play*. New York: Theatre Communications Group, 1995.

Peacock, D. Keith. 'Black British Drama and the Politics of Identity', in Holdsworth Nadine. and Luckhurst, Mary. eds. *A Concise Companion to Contemporary British and Irish Drama*, London: Blackwell Publishing, 2008. pp.48-65.

Peters, Fiona. *Who Cares About Mixed Race?: Care Experiences of Young People in an Inner City Borough*. Unpublished PhD Thesis, 2010. http://eprints.gold.ac.uk/2885/

Pfaff, Françoise. *Conversations with Maryse Condé*. Lincoln and London: University of Nebraska Press, 1996.

Phillips, Mike. 'Re-writing Black Britain' *Wasafiri* Vol.36, 2002. pp. 62-4.

Pines, Jim. *Black and White in Colour: Black People in British Television Since 1936* London: B.F.I Publications, 1992.

Pinnock, Winsome. 'Breaking Down the Door'. *Theatre in a Cool Climate* Gottlieb, Vera. and Chambers, Colin. eds. Oxford: Amber Lane Press, 1999. pp. 27-38.

-----. *Can You Keep a Secret* in *Connections 99: Theatre For Young People*, London: Faber and Faber, 1999a.

Pool, Hannah. 'The Directors' 26 July, 2003.

http://www.guardian.co.uk/stage/2003/jul/26/whoswhoinbritishtheatre.healthand wellbeing2?INTCMP=SRCH accessed 12/05/12.

Procter, James. *Dwelling Places: Postwar Black British Writing* Manchester: Manchester University Press, 2003.

'Programme Notes' *Urban Afro Saxons*, London: Theatre Royal Stratford East, n.a., n.p.

Rapi, Nina. and Chowdhry, Maya. eds. *Acts of Passion: Sexuality, Gender and Performance* New York and London: Harrington Park Press, 1998.

Rappaport, Helen. 'The Invitation that Never Came: Mary Seacole After the Crimea.' *History Today* 55.2 (2005): pp. 9-15. Wilson Web. Accessed 20 October 2010.

Rees, Roland. *Fringe First: Pioneers of Fringe Theatre on Record* Oberon Books: London, 1992.

Reichl, Susanne. *Cultures in the Contact Zone: Ethnic Semiosis in Black British Literature* Trier: WVT Wissenschaftlicher Verlag Trier, 2002.

Reinholdt, Janelle, 'Selective Affinities: British Playwrights at Work 1' *Modern Drama*, Vol.50, No.3, 2007, pp. 305-345.

Rose, Reginald. *Twelve Angry Men* London: Samuel French, 1965.

Runnymede Trust, *The Future of Multi-Ethnic Britain: The Parekh Report* London: Profile, 2000.

Salih, Sara. '"A gallant hear to the empire." Autoethnography and Imperial Identity in Mary Seacole's *Wonderful Adventures*.' *Philological Quarterly* Vol.83, No.2., 2004. pp.171-95.

Sandhu, Sukhdev. *London Calling: How Black and Asian Writers Imagined a City* London: HarperCollins Publishers, 2003.

Sartre, Jean-Paul. *No Exit and 3 Plays* New York: Random, 1955.

Seacole, Mary. *Wonderful Adventures of Mrs. Seacole*. London, 1857.

The Project Gutenberg EBook.

http://www.gutenberg.org/files/23031/23031-h/23021-h.htm.

Wilson Web. Accessed 30 October, 2010.

Searle, Chris. ed. *Callaloo: Four Writers From Grenada* London: Blackrose Press, 1984.

Sesay, Kadija. ed. *Write Black, Write British: From Post Colonial to Black British Literature* Hertford: Hansib, 2005.

Shenton, Mark. Review of Clybourne Park, *Sunday Express* 12 September,

2010) http://www.sundayexpress.co.uk/posts/view/198509/Review-Clybourne-Park-Royal-Court-London Accessed 12/05/2012.

Sherwin, Adam. 'Black British actors told to head to Hollywood if they want big roles' *Independent* 1 February, 2012. http://www.independent.co.uk/arts-entertainment/theatre-dance/ Accessed 12/05/2012.

Shevtsova, Maria. *Sociology of Theatre and Performance*, Verona, Italy: Qui Edit, 2009.

Soanes, Catherine. and Stevenson, Angus. eds.

Concise Oxford English Dictionary. 11th ed., rev., Oxford: Oxford University Press, 2008. http://clio.columbia.edu/ accessed 30/04/2012.

Soyinka, Wole. 'The Critic and Society: Barthes, Leftocracy and Other Mythologies' *Wole Soyinka Art, Dialogue & Outrage: Essays on Literature and Culture* Ibadan, Nigeria: New Horn Press, 1988. pp.146-79.

Stephenson, Heidi. Langridge, Natasha. eds. *Rage and Reason: Women Playwrights on Playwriting* London: Methuen, 1997.

SuAndi (1990) *Style in Performance* Manchester: Pink Heater Press, Rep.1991.

-----. *Nearly Forty* Liverpool, UK: Spike Books, 1992.

-----. *There Will Be No Tears* Manchester: The Pankhurst Press, 1995

-----. *Mary Seacole: Opera*. 2000. TS. Courtesy of the author. Print.

-----. *The Story of M* in SuAndi ed. *4 For More* Manchester: Black Arts Alliance, 2002. pp.1-18.

-----. ed. *Acts of Achievement Colloquium 2001* Manchester: artBlacklive, 2002.

-----. 'Africa Lives on in We' in Aston and Harris eds., (2006), pp.

-----. 'Cultural Memory and Today's Black British Poets and Live Artists', in Arana, R. Victoria. ed. (2007), pp.31-49.

-----."SuAndi OBE. Profile." http://www.lancs.ac.uk/fass/projects/writersgallery/content/SuAndi.htm.

Accessed 20 October 2010.

The 1989 Children Act http://www.opsi.gov.uk/acts/acts1989/ukpga_19890041_en_4 1989 accessed 21/08/11

Tompsett, A. Ruth. ed. *Performing Arts International* Special Issue: 'Black Theatre in Britain'. Vol. 1., Part 2. 1996.

Topping, Alexandra. 'Subsidised theatres have too few female roles, Equity says' *Guardian* 28 June, 2012. p.6 tucker green, debbie. *Random* London: Nick Hern Books, 2008.

Ugwu, Catherine. ed. *Let's Get It On: The Politics of Black Performance* London: ICA, 1995.

Wilson, Imani e. Personal Interview with Malika Booker, 14 April, 2012.

Wilson, Imani e. Personal interview with Roger Robinson, 24 August, 2011.

Wisker, Gina. *Post-Colonial and African American Women's Writing* London: Macmillan Press, 2000.

Young, Lola. ed. *Whose Theatre? Report on the Sustained Theatre Consultation*, 2006.
www.artscouncil.org.uk/publication_archive/whose-theatre-report-on-the-sustained-theatre-consultation/ accessed 10/05/2012.

A SELECTION OF USEFUL WEBSITES – OPERATIVE AT THE TIME OF WRITING

http://www.applesandsnakes.org England's leading organisation for performance poetry.

http://www.bcaheritage.org.uk Britain's foremost Black History archive.

http://www.nbaa.org.uk The site for the longest running black arts organisation in the UK, that continues the work of the Black Arts Alliance.

http://www.blacknet.co.uk A cultural events website.

http://www.futurehistories.org.uk National repository of African, Asian and Caribbean Performing Arts in the UK (Nitro, Black Theatre Forum and Moti Roti archives)

http://www.nationaltheatre.org/archive/blackplaysComprehensive digitised collection of all production data for plays by Black writers in Britain to date.

http://www.nitro.co.uk Leading black music theatre.

http://www.talawa.com/about/archive.html Britain's leading black theatre company.

http://www.theatremuseum.vam.ac.uk Victoria and Albert Museum – Black Theatre History archive.

<div align="right">
compiled by Deirdre Osborne

(Goldsmiths, University of London)
</div>